THE POWER OF PHOTOGRAPHY

W9-BGM-840

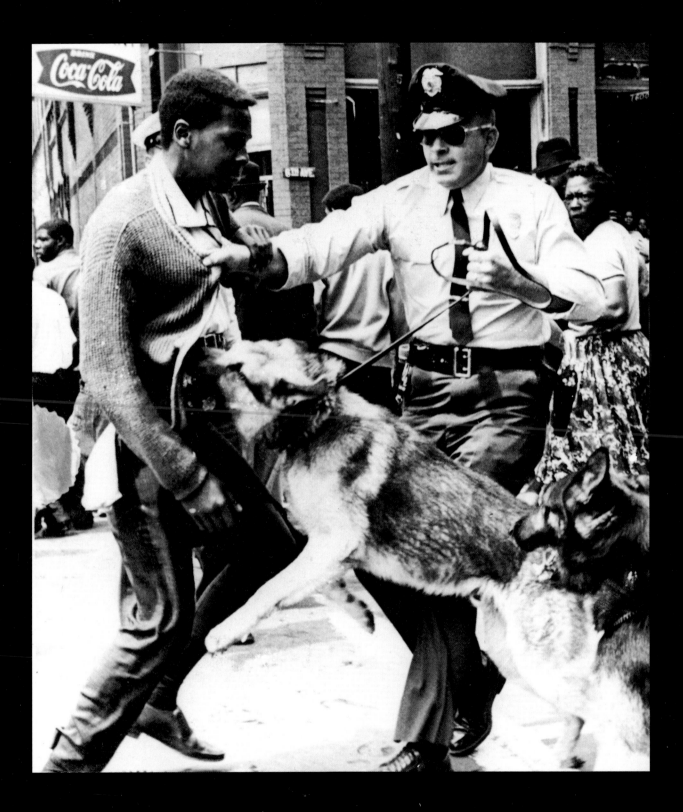

THE POWER OF PHOTOGRAPHY

EXPANDED AND UPDATED

HOW PHOTOGRAPHS

CHANGED OUR LIVES

VICKI GOLDBERG

ABBEVILLE PUBLISHING GROUP

NEW YORK • LONDON • PARIS

For Loring, as always,
and for William Russo, and Jeannette Walls

EDITOR: Nancy Grubb
DESIGNER: Julie Rauer
PRODUCTION SUPERVISOR: Hope Koturo
PICTURE EDITOR: Adrienne Aurichio
PRODUCTION EDITOR: Philip Reynolds

Front cover and page one: John Paul Filo (born 1948). *Kent State—Girl Screaming over Dead Body*, May 4, 1970. Collection of John Paul Filo.

Back cover: William Anders (born 1933). *Earthrise*, December 24, 1968. National Aeronautics and Space Administration, Washington, D.C.

Frontispiece: *"To the Attack"—A Police Dog Lunges at a Negro during Racial Demonstration in Birmingham, Alabama*, May 3, 1963. AP/Wide World Photos, New York.

Text copyright © 1991 Vicki Goldberg. All rights reserved under international copyright conventions. No part of this book may be reproduced or utilized in any form or by any means, electronic or mechanical, including photocopying, recording, or by any information storage and retrieval system, without permission in writing from the publisher. Inquiries should be addressed to Abbeville Publishing Group, 488 Madison Avenue, New York, N.Y. 10022. Printed and bound in Hong Kong.

First paperback edition, expanded and updated, 1993

Library of Congress Cataloging-in-Publication Data

Goldberg, Vicki.
 The power of photography: how photographs changed our lives / Vicki Goldberg.
 p. cm.
 Includes bibliographical references and index.
 ISBN 1–55859–039–0
 1. Photography—Social aspects. I. Title.
TR147.G63 1991

770'.1—dc20 91–3116
 CIP

CONTENTS

INTRODUCTION: UNDER THE INFLUENCE OF PHOTOGRAPHY 7

1 THE UNIMPEACHABLE WITNESS 19

2 THE EYE OF DISCOVERY 39

3 SOMEONE IS WATCHING 59

4 POLITICAL PERSUADERS & PHOTOGRAPHIC DECEITS 75

5 FAME & CELEBRITY 103

6 ICONS 135

7 SOCIAL REFORM 163

8 NEWS PHOTOGRAPHS AS CATALYSTS: THE MAGAZINE ERA 191

9 NEWS PHOTOGRAPHS AS CATALYSTS: THE TELEVISION ERA 217

AFTERWORD 252

NOTES 260

INDEX 278

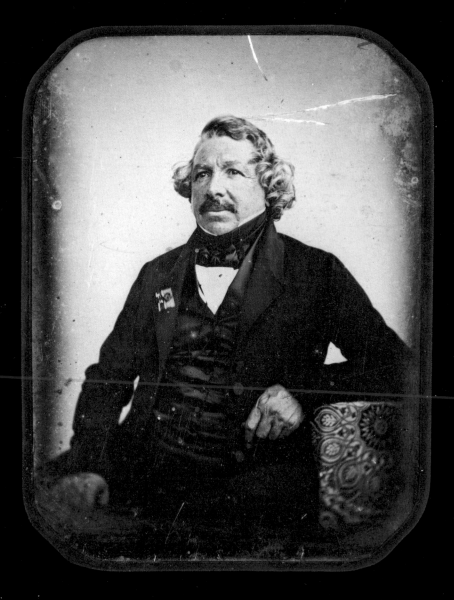

Jean-Baptiste Sabatier-Blot

(1801—1881)

Daguerreotype Portrait of

Louis-Jacques-Mandé

Daguerre, 1844

International Museum of

Photography at George

Eastman House, Rochester,

New York

UNDER THE INFLUENCE OF PHOTOGRAPHY

Photographic images have been altering people's minds and rearranging their lives for a long time. In 1839, the year of photography's invention, an American gentleman secretly photographed his wife in a tryst with a lover; no doubt this affected their marriage. A Scot serving in the far colonies thirty years later received some photographs from friends back home and immediately "fell head and ears in love with the portrait of a young lady of 18." He took the first steamer back to Scotland, proposed to the girl immediately, "gracefully allowed her two hours to consider of the matter," and soon the pair were wed.[1] "Wanted" photos of criminals have made one kind of difference, radio photos of outer space another. Even the absence of photographs has been significant: think what the effect would have been had someone snapped a picture of Jack the Ripper or if Viking I had sent back images of city streets on Mars.

Photographs have a swifter and more succinct impact than words, an impact that is instantaneous, visceral, and intense. They share the power of images in general, which have always played havoc with the human mind and heart, and they have the added force of evident accuracy. A recent book on the power of images argues that a good part of the faith in representation depends on "the felt efficacy . . . of the exactly lifelike," whether the image be a votive figure, a religious icon, a nude, or a portrait.[2] Lifelike images produce responses that closely resemble our reactions to actual people and events, as every teenage boy with a girlie magazine knows.

Religions have long attested to the persuasive and subversive power of images. Jewish and Moslem prohibitions against representations of the deity go back to ancient times, and Christianity has undergone repeated outbreaks of iconoclasm. In the nineteenth century, even before photography, governments were as convinced of the influence of images as religions were. Louis-Philippe took the throne in France in 1830 to free the press, but five years later he reestablished censorship over one form alone: caricatures. A pamphlet was considered only a "violation of opinion," but a caricature amounted to an "act of violence," too dangerous to go unchecked.[3]

Photographs have tended to make governments more nervous still. Today, fears of photography are steadily mounting—as Israel, South Africa, and China have gone to great pains to prove. South Africa has even prohibited sketches or photographs of prisons, as well as photographs of the security police headquarters in Johannesburg, where many prisoners were interrogated.[4] Prohibitions against photographs testify directly to their power. Suppression works. When South Africa banned foreign journalists

and photographers, repression in that country drifted off the front pages to an inside spot. When China cut off television broadcasting of the 1989 demonstrations, army repression necessarily vanished from the screen.

History might have worn a different face had certain photographs been let loose. In India in 1946 Mohammed Ali Jinnah's doctor developed a set of X rays that spelled a death sentence for his patient. Tuberculosis had already severely damaged the lungs; he was not likely to live more than two or three years longer. Jinnah, the iron-willed leader of the Moslem League, was determined to create the Moslem state of Pakistan, no matter what the cost. He swore his doctor to secrecy; if his opponents were to find out he was under a death sentence, they would probably try to outlast him, and Pakistan itself would die before it ever existed. The doctor sealed the film in an unmarked envelope and locked it in his office safe. At midnight on August 14, 1947, in the wake of bloody riots and untold deaths throughout India, Pakistan became a nation with Jinnah at its head. Thirteen months later, the Father of Pakistan died. The photographs of his lungs were still sealed in an envelope in an office safe.[5]

In the late twentieth century we know at first hand a good deal about the effects of photography. Its visible results are everywhere, promising experience we have not earned. Those of us who have never been in a war zone share memories of World War II, Korea, and Vietnam with the men who fought the battles. We know how General MacArthur waded ashore in the Philippines, how dead were the eyes of GIs in Korea, how a prisoner was shot at point-blank range in Saigon. And that is one of the subjects of this book: how photography has created a communal reservoir of memories, and how certain images gained entry. We are inundated with images and threatened with drowning, yet in this flood of visual blandishments and assaults, only a few have changed some aspect of the world in even a tiny degree. It is those that are the heroes and villains of this story.

Photography came into a world that was already crazy about pictures and drove it mad. A populace that was at first charmed, fascinated, thrilled, and a little bewildered by the new images eventually became addicted. Photographs took up residence in daily life, they moved in, they took over. Within half a century it was impossible to imagine a life without them.

Western culture was in the process of being reinvented just as photography came to light. New opportunities, new wealth, a new merchant class were slowly changing the structure of society, and in the wake of the American, French, and industrial revolutions, ideas of entrepreneurial freedom and individual worth had begun to take root. The potential for information gathering and distribution exploded at the very instant that such cultural change made expanded information desirable. The railroad sent people and news across miles at frightening speeds; after the mid-1840s the telegraph sent the news even faster. Machines made cheap paper quickly, iron printing presses replaced wooden ones, steam drove the presses fast and hard. Cheaper, quicker, better: new ways to get there, new ways to find out.

In the growing industrial economies and burgeoning urban centers, literacy rose and governments encouraged it: French and English law instituted state-subsidized education in the 1830s. The penny press was established at the same time—a cheap source of news with more columns to fill than news to put in them. By 1840 the number of American newspapers had increased more than 70 percent, and circulation had almost quadrupled during a decade when the population had grown by only a little more than a third.[6]

With life being lived more in public than before, in the streets and on the factory floor, in offices and shops, and with travel by rail and steamship becoming more common, people grew ever more curious about the strangers among them, strange lands abroad, and strange events in the news. The expanding information system responded. The penny press filled its half-empty pages with new "human interest" stories,[7] increasingly illustrated by engravings of shipwrecks and foreign capitals. Soon the camera would add accounts of fisherfolk in Scotland and judges in America. Whether the desire to know called forth the information or the potential for information piqued the appetite is the kind of chicken–egg question that a chicken would answer differently than an egg would, but certain it is that supply and demand kept pace with one another.

The cheap press and wider literacy coincided with the graphic revolution, which had been picking up speed since the late eighteenth century, when broadsides and satirical prints streamed off the presses. In the century before the advent of photography, the popularity of caricature and social satire, the proliferation of illustrated books, the publication of Denis Diderot's profusely illustrated *Encyclopédie*, and the timid beginnings of illustrations in newspapers all testify to the growing appeal of images. Wood engraving was revived and lithography invented in the last quarter of the eighteenth century. Photography would eventually shoulder them both aside, but until it did they fed an image-hungry public a rich diet of pictures.

Pictures sold papers. In England in 1821 the *Observer* published four engravings of the coronation of George IV and sold sixty thousand copies. In 1832 (seven years before the invention of photography) the *Penny Magazine*, founded in Britain by the Society for the Diffusion of Useful Knowledge, began to put illustrated information before the public on a regular basis for the first time. In 1837 the *Weekly Chronicle* printed a picture each week illustrating the notorious Greenacre murder case and claimed sales of one hundred eighty thousand an issue.[8] But the biggest step toward picture communication was the founding of the world's first illustrated weekly, the *Illustrated London News*, in 1842. Picture papers were soon established across Europe and North and South America.

In their first volume the editors of the *Penny Magazine* had solemnly announced their participation in a revolution: "Cheap communication," they wrote, "breaks down the obstacles of time and space—and thus bringing all ends of a great kingdom as it were together, greatly reduces the inequalities of fortune and situation, by equalizing the price of commodities, and to that extent making them accessible to all."[9] The penny press, the telegraph, and pictures, cheap pictures of everything, were about to sow the seeds of common knowledge across the world. The *Penny Magazine* sold its plates to French and German publications; already people who would never so much as pass each other in the street were having their minds stocked with common visual memories.

This fascination with printed images was accompanied by a mounting respect for realism that would have major historical consequences. When coins had been the chief means of identifying a king, rulers easily went incognito among their subjects, but when Louis XVI tried to escape the fury of the Revolution, a citizen who knew his features from a portrait on paper money saw through his disguise.[10] Before photography a certain laxity in matters of realism had been perfectly acceptable. Faithful copies had been as faithful to the conventions and prejudices of their time as to the objects themselves. A seventeenth-century engraving of Notre Dame, for example,

eliminated the cathedral's Gothic irregularities by making it more symmetrical and rounding its pointed windows. An 1836 lithograph of Chartres reversed the procedure by stretching that church's rounded windows up to Gothic points. Then photography stepped in with an immutable reality; it left the windows intact, no matter which style the photographer favored.

The public was enchanted, for the desire was abroad to catch nature in a net. In the late eighteenth century the camera obscura (which projected an image of the surroundings on the wall of an enclosed box, where it could be traced) and the camera lucida (a mechanical device to help artists precisely record the contours of landscape and urbanscape) caught the fancy of professionals and amateurs alike. William Henry Fox Talbot's experiments that led to the first negative process in 1839 were sparked partly by the fact that he drew so badly. He wanted to put down on paper, permanently, the lakes and forests he could not get right even with mechanical assistance. Louis-Jacques-Mandé Daguerre did better with pen and brush: before perfecting his process (also in 1839), he was the painter and proprietor of a diorama that had astonishing powers to fool the eye.

After Daguerre had demonstrated what he could do with a camera in 1839, a Frenchman said the daguerreotype "is not a picture . . . it is the faithful memory of what man has built throughout the world and of landscapes everywhere. . . . You will write to Rome: Send me by post the dome of St. Peter's; and the dome of St. Peter's will come to you by return mail."[11] When the painter Paul Delaroche first saw a daguerreotype, he cried out (or so it is said), "From this day painting is dead!" (To paraphrase Mark Twain, the report of painting's death was greatly exaggerated.)

Photography came along when society wanted pictures and proof and was prepared to believe the two were the same. It is no accident that the medium's early years coincided with the reign of positivism in Europe and the realistic novels of Honoré de Balzac and Gustave Flaubert. The public was ripe for photography; millions were longing all unconsciously for what fate (and a couple of clever men) were about to confer on them. At a time when realism was all, the medium was considered so nearly synonymous with truth that a religious tract with no illustrations of any kind called itself *Sunday-School Photographs* and a magazine that had nothing to do with photography took the name *Daguerreotype*. As late as 1898 the *New York Journal* labeled several pictures from Cuba "photographs" to lend them authenticity, although they were obviously, even blatantly, pen-and-ink sketches. As one critic put it, "The nineteenth century began by believing that what was reasonable was true and it wound up believing that what it saw a photograph of was true—from the finish of a horse race to the nebulae in the sky."[12]

Not everyone was pleased with the arrival of the picture culture. As early as the 1840s William Wordsworth wrote a sonnet decrying the degradation of "Man's noblest attribute," the printed word. Fearful that "a dumb Art" would lead his "once-intellectual land" back toward life in the caves, the poet cried, "Avaunt this vile abuse of pictured page! / Must eyes be all-in-all, the tongue and ear / Nothing? Heaven keep us from a lower stage!" Yet the advancing images could not be stopped. When Joseph Pulitzer bought the *New York World* in 1883, he planned to pump up circulation by the sensational use of woodcuts, then gradually reduce the number of illustrations until the paper reached a dignified level once more. But when he started to cut pictures, circulation fell so precipitously he was forced to bring them back again.[13]

It was clear from the moment photography was announced that the new

arrival would change the life of everyone touched by it, although it may not have been so clear at the beginning that none would remain untouched. The first change was the possibility that almost everyone could have a portrait made. The production of portraits had already increased during the late eighteenth century in response to the desires of the expanding mercantile class. Equipped with a heightened sense of self and self-importance but not necessarily with the money for a painter, the new middle classes had run to have silhouettes of their profiles traced. In 1786 a device called the physiognotrace made it possible to engrave and multiply these profiles.

After 1839 people who were not wealthy enough to commission portraits by a painter like Jean-Auguste-Dominique Ingres no longer had to make do with silhouettes or with the stiff pink renditions of their faces turned out by itinerant painters but could afford to have their presence in the world doubled on a polished silver surface. The daguerreotype, beloved for portraiture, dominated the field until the 1850s, but it was relatively expensive in the beginning, and each image was unique. Millions were taken—in 1859 Charles Baudelaire raged, "Our squalid society rushed, Narcissus to a man, to gaze on its trivial image on a scrap of metal." Painted portraits could not match the magical presence of photographs. Elizabeth Barrett yearned "to have such a memorial of every being dear to me in the world. It is not merely the likeness which is precious in such cases—but the association and the sense of nearness involved in the thing . . . the fact of the *very shadow of the person* lying there fixed forever!"[14]

As early as 1843 it was understood that the new medium would heighten the sense of life's fragility: "In the transition forms of his offspring, the parent will discover the traces of his own mortality; and in the successive phases which mark the sunset of life, the child, in its turn, will read the lesson that his pilgrimage too has a period which must close." And photographs rapidly altered connections to personal and family histories—in the Western world one's mother-in-law and great-grandfather had not previously been so eternally and visibly present. Photography could keep the dead around forever. On a table in the widow's front parlor, in a velvet-and-gilt case, stood a portrait of her late husband in the black-bearded vigor of good health. Beside his stern image rested the portrait of a dead infant carried off by diphtheria ten years earlier, photographed in gentle counterfeit of sleep. The nineteenth century was preoccupied with its own mortality; it must have been comforting that photographs allotted longer life than the Lord had seen fit to bestow. Portraits of the dead were big business in America. In 1854 *Humphrey's Journal* carried the following ad: "DAGUERRIAN GALLERY FOR SALE—The only establishment in a city of 20,000 inhabitants; and where the pictures of deceased persons alone will pay all expenses."[15]

Photography formulated a new sense of what knowledge was and a new estimate of the kinds of knowledge anyone might hope to have. Today everyone—not duchesses alone, not lawyers educated at the Sorbonne, but waitresses, druggists, accountants, postmen—recognizes the pyramids. Photography tore down many of the fences put up around knowledge and information by class distinctions. Yet it could not do so for the first twenty years. A baron, an Oxford don, and a chimney sweep were unlikely to have the opportunity to view the same unique daguerreotype. Even the reproducible processes, such as Fox Talbot's calotypes, took so much time and effort to print that they were never produced in great quantities. Photography could not wield the kinds of influence examined in these pages until it achieved wide distribution.

Frederick Scott Archer's collodion-on-glass negative process of 1851 provided the key. Collodion on glass was simpler and faster; a commercial photographer could parcel out the printing operations to unskilled printers who produced photographs in quantity in a kind of assembly-line operation. The tintype, invented in 1856, brought the price (and the level of skill) of portraiture down further and immeasurably widened the market for photographs. But it was the stereograph and the carte de visite that turned ordinary picture lovers into addicts. The single prized photograph became a group, a hoard, a treasure trove. The stereograph and the carte transformed families, neighborhoods, whole populations into collectors.

Stereographs are paired photographs taken with a twin-lens camera. Viewed in a stereoscope, they open up the two-dimensional image into a fully convincing three-dimensional world. The stereograph became a practical object in 1849 when Sir David Brewster invented a viewer. Queen Victoria was so impressed at the Great Exhibition of 1851 that Brewster gave her a specially designed stereoscope. And what Victoria loved, her subjects doted on; English parlors soon enshrined these little monuments to binary vision. The London Stereoscopic Company, founded in 1854, sold one million pictures in 1862 alone. Europe liked stereographs even better, and the United States best of all. About 1864 Oliver Wendell Holmes—who had remarked that stereographs offered "a surprise such as no painting ever produced"[16]—designed a more convenient viewer. For the rest of the century everyone with leisure time and a bit of money (the photographs cost as little as $1.50 a dozen) kept a stack of Niagaras and sphinxes on the front-room table.

The stereoscope performed some of the functions of television back in the nineteenth century. Family and friends gathered around it for entertainment, and it was an enormous, if superficial, source of education about a world beyond the reach of average experience. Holmes predicted that the

Daguerreotype of Dead

Child, c. 1850

International Museum of

Photography at George

Eastman House, Rochester,

New York

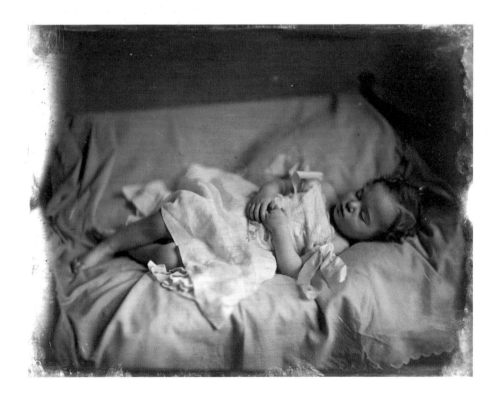

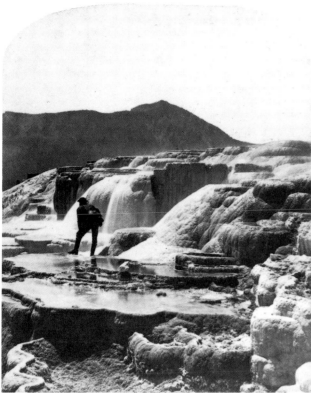

William Henry Jackson

(1843–1942)

Hot Springs on the Gardiner

River Upper Basin, Thomas

Moran Is with His Back to the

Camera, Yellowstone, 1871

Stereograph

International Museum of

Photography at George

Eastman House, Rochester,

New York

stereograph would be "the card of introduction to make all mankind acquaintances"[17]—the global village at an early stage. The stereoscope delivered the news from every corner of the world and placed it before a family's eyes right in their own living room. This was a repetitive sort of news, the same pictures on view night after night, but some might say that television is not so very different.

The carte de visite, invented in 1854 and popular everywhere by the end of the decade, was a small photograph (most commonly a full-length portrait) the size of a calling card (3½ by 2½ inches). The carte made every citizen avid for a glancing acquaintance with famous figures. Not that depictions of famous people were new, or that people had had no taste for them before. Inexpensive reproductive processes had long ago put prints of rulers' faces and figures within the reach of most of their subjects. By the mid-nineteenth century the print and publicity industries had advanced so far that a fan of Lola Montez (a mediocre dancer and exceptional courtesan) might purchase a lithograph of her, or an engraving, aquatint, woodcut, even a portrait on a stickpin or a tobacco box—or, for that matter, a daguerreotype. Social changes and the popular press had quickened interest in the famous to such a point that one American lithographic company in 1849 was turning out three to four thousand copies of popular prints each day, most of them portraits, and most good citizens had a picture or two on the wall, or maybe five or six.[18] Until the 1890s, when the halftone took over, lithographs and engravings would remain the most widely available illustrations in the press.

But none of these reproductions was a photograph, which is precisely the point. Photography changed the terms. First it changed the degree of reality, making the person present in the image to a degree unknown before, and

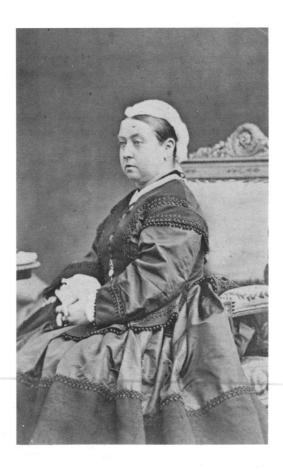

Disdéri & Co.

Carte de Visite of Queen

Victoria

International Museum of

Photography at George

Eastman House, Rochester,

New York

then it made that uncanny presence easy to buy. Photographs magnified the life of images. The identity of self and appearance in a photograph was so complete that even Balzac hesitated to have his picture taken. He had an idea that the body consisted of layers of ghostlike images that the camera would use up, depleting the very essence of life. Objects and their photographic equivalents were also totally identified: it was reported that a group of French nuns would put little photographs "of the heart of Jesus into their soup and eat them!"[19]

Once the obviously superior (i.e., closer to life) photographic product became cheap and plentiful, collecting began in earnest. Cartes, stereographs, tintypes, cabinet cards, collodion prints in large sizes: like a species let loose in a new territory with no natural enemies, the photographic population grew unchecked. Cartes, like stereographs, were bought in quantity; it was no longer sufficient to have a picture of your husband on the table and a hero or two on the wall. Cartes by the dozen could be slipped between covers—fifty is not an unusual number of spaces in an album—and displayed for visitors. Every front parlor became a kind of private gallery in miniature.

The intensification of photographic influence was marked by major turning points in production and distribution. After the stereograph and the carte came the Kodak, first marketed in 1888. Once photographic technology had been simplified ("You press the button, we do the rest"), every man and woman became a potential photographer. The halftone sparked another revolution when it came into wide use at the end of the century. One of its first great successes was the picture postcard, which responded to changing

postal regulations in the 1890s by clogging the mails with pictures of sunny beaches and smiling children.

In the last century and a half, invention and ingenuity have continually come up with new ways to make the world accessible, affordable, and desirable to masses of people who would not otherwise see it. *Les Carabiniers*, a 1963 film by Jean-Luc Godard, tells the tale of two peasants who join an unnamed modern army, lured by the promise that looting will make them rich. At last they come up with a suitcase full of treasure: hundreds of picture postcards with views of nature, stores, machines, and monuments.[20]

The halftone turned the world upside down; photographs began to collect people. For most of the nineteenth century, someone who wanted a photograph had to make a conscious effort to get one, but with advances in technology and the postal system, photographs soon came calling. They waltzed into homes on the arm of the news, they winked at passersby from newsstands. They were the come-ons on front pages, in fashion magazines, fan magazines, theater lobbies. They pulled people out of their homes to lectures designed for their edification. The moving picture, glamorous off-

Population Chart

The World, New York,

September 9, 1900

Letterpress on newsprint,

20 3/4 x 17 3/4 in.

Collection, The Museum of

Modern Art, New York;

Purchase

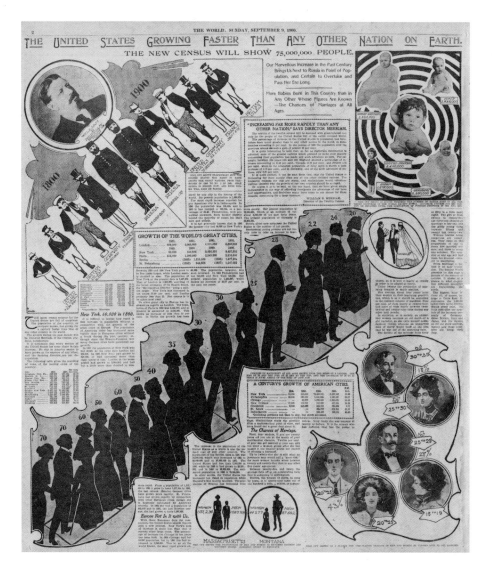

spring of still photography, added to the enticements and aggravated the addiction to images. In 1915 Vachel Lindsay wrote, "Moving picture nausea is already taking hold of numberless people. Forced by their limited purses, their inability to buy a Ford car, and the like, they go in their loneliness to film after film till the whole world seems to turn on a reel."[21]

A new form of photograph now took over: the disposable image. In one week in 1899 the *Illustrated London News* published twenty-eight photographs (and nineteen drawings), a magazine called *Black and White* had sixty photos (and thirteen drawings), and *Leslie's Weekly* in New York had forty-four photographs (and three drawings). (On the Continent the numbers were smaller.[22]) No one needed to keep so many pictures around each week. Photographs had become superabundant, transient, superfluous.

In 1900 a writer remarked that "the daily press, advertisements, posters, scientific literature, the popular lecture, decoration, and now the kinetograph, not to speak of the coming colored photography, have all contributed what is probably slowly coming to be a new mode of pictorial thought." In 1911 an editorial in *Harper's Weekly* complained: "We can scarce get the sense of what we read for the pictures. We can't see the ideas for the illustrations."[23] The visual culture of the second half of the twentieth century is not an aberration; the groundwork was laid for it many years ago.

In recent years aspects of photography's influence have been written about with sorrow and loathing and occasionally with admiration, but the legible marks that specific photographs have left on history have received much less attention. The influence of *photography* has been more carefully considered than the influence of particular *photographs*, which, when dealt with at all, has been buried in studies of individual photographers or periods or genres. The images that became part of the cultural blueprint loom up like monuments; seldom does anyone ask how they were built. In this book I mean to propose some preliminary questions and answers.

Each of the photographs in this book was a catalyst in one way or another, "precipitating a process or event, especially without being involved in or changed by the consequences," as the dictionary puts it. None acted alone. No photograph ever changed anything all by itself, for photographs are highly dependent creatures and their influence is entirely contingent on words, circumstances, distribution, and belief systems. A photograph has power only if the right people see it in the right context at the right time. The photographs on these pages met all the criteria and contributed to changes in law, science, elections, culture, opinion, or the fate of individuals.

In assessing the importance of these images, I have considered only their effects. Thus a Mathew Brady picture of Abraham Lincoln in 1864, when war and personal loss had mapped his face with sorrow, may be the deeper psychological portrait, but Brady's first portrait of Lincoln in 1860 is investigated instead, because it had political ramifications. Thus Eadweard Muybridge's pictures of the horse in motion are included because they revealed a fact never known before, but Harold Edgerton's beautiful image of a milk splash is not discussed because Edgerton's electronic flash, although it is much faster and discloses more than Muybridge did (or A. M. Worthington, who studied splashes in 1908), essentially does what earlier investigations had done, only better.

The photographs have been divided into categories corresponding to the kinds of influence they exerted—revelation, proof, political persuasion, social reform, and so on. But because photographs are multivalent, most cate-

gories turn out to be highly permeable. Photographs that are credited with effecting social reform often worked partly because their images were such revelations at the time. Similarly, although fame and political persuasion are separated here for convenience and to make a fine point, each may be a kind of subcategory of the other: fame is in itself persuasive, and conversely, the power to persuade can confer fame.

Studies of the impact of any medium—television violence and children's behavior, pornographic images and crimes against women—generally come to very little. No one ever seems to find proof of what nearly everyone believes. Although public opinion is a notoriously unreliable guide to anything but public opinion, it is hard to deny what intuition, common sense, and personal experience keep drumming into the mind—that certain images influence behavior. And recently, the media themselves have started questioning the power in their hands, so strong has been the evidence that political campaigns, affairs of state, demonstrations, even revolutions have been staged largely for the benefit of cameras.

It may be that the influence of images cannot be proved to a scientist's satisfaction, yet we always seem to be living with the results, like a man with a back pain that doesn't show up in an X ray but nonetheless ruins his life. Still, influence is a sticky business. Photographs do act on history, but seldom is it a simple matter of cause and effect. A photograph is not a vote that swings an election but more like a lobbyist that sways a legislator. Photographs change nothing but spread their influence everywhere.

If photographs act on history, they act in history as well. A photograph is little more than a cultural and historical artifact that is constructed by its own time, reconstructed by each succeeding era, and altered by editing, placement, and audience. Understanding the influence of a photograph requires some understanding of the world it was born into, Roland Barthes repeatedly stressed that photographs are bound in a matrix of cultural meanings; so too is their impact. A photograph must answer some need, belief, and expectation of its times. If the audience is not ready for the message, the image may be seen but the message will not be recognized. It's like telling a child about sex when he's too young to understand; he hears what his age permits and ignores the interesting parts.

The list of photographs studied here does not pretend to be complete. Readers will have their own choices, and I hope this investigation will prompt others. This is not a survey of great photographs, or of aesthetically remarkable pictures, or even of photographs commonly thought of as important, although most of these pictures are all those things. Some did a significant job at one moment, then vanished into the wilderness of forgotten images. The issue is solely whether the world is (or was) any different because of this photograph or that one, and if so, how. These photographs walked into our lives and in some way managed to change them. So it seems appropriate to ask the questions one would ask any intruder: How did you get in? And what are you doing here anyway?

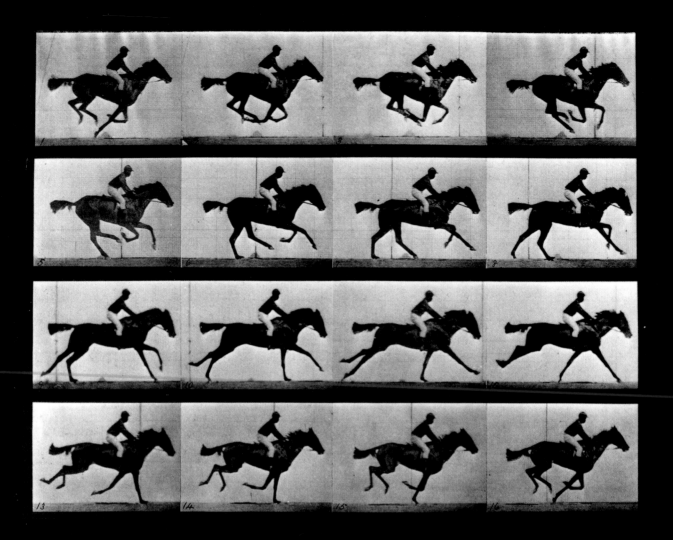

Eadweard Muybridge

(1830–1904)

Galloping Horse, Motion

Study—"Sallie Gardner,"

Owned by Leland Stanford

(Running at a 1.40 Gait over

the Palo Alto Track,

19th June, 1878)

International Museum of

Photography at George

Eastman House, Rochester,

New York

THE UNIMPEACH- ABLE WITNESS

Photography came into the world like a sign from on high, instantly converting all who came in contact with it into true believers. There was never any doubt that the photographic witness was exact. Buildings were said to draw their own pictures, or the sun itself was given credit, clear indication that the medium was thought to be totally objective and quite free of human error. Photography seemed to promise truth that no mere representation had ever given. In 1843 Lady Eastlake wrote, "Thus are the incidents of time, and the forms of space, simultaneously recorded; and every picture becomes an authentic chapter in the history of the world."[1]

This was a moment when philosophers, scientists, and technological and cultural shifts had elevated humanity's dependence on sight to a new pitch and magnified the authority of vision. "Show me an angel and I will paint one," said Gustave Courbet at mid-century; what could not be seen was not worth depicting. Photography bolstered the primacy of vision and affected the standards of visible proof. As a French journal remarked in 1854, comparing the credibility of photographs and drawings, "We can hardly accuse the *sun* of having an imagination."[2] The new medium was the ultimate eyewitness, unhampered by subjectivity, memory lapses, or flights of fancy. Its testimony could override almost any degree of disbelief.

In matters of influence, photography came endowed with multiple advantages, but chief among them was its skill at offering evidence and authentication. Even today, when a large audience supposedly "knows" that photographs lie, the most sophisticated observers instinctively believe the camera's report, at least for the brief pulse of time before the mind falls back on its education. And reason would add that photographs do not actually lie but only say precisely what the camera sees. If the subject is a deliberate falsehood—a dead man propped up to look alive, a wraithlike spirit inserted over an image of a seance—the photograph is still a meticulous witness of what was before the lens. As Lewis Hine said in 1909, "While photographs may not lie, liars may photograph."[3]

Photography rapidly established the expectation that evidence—in science, current affairs, exploration, crime—would be both more accurate and more accurately reproducible than before. For bearing witness is what photographs do best; the fact that what is represented on paper undeniably existed, if only for a moment, is the ultimate source of the medium's extraordinary powers of persuasion. The photograph, produced by a brief transaction between chemicals and light, is at once the most faithful and the most seductive of witnesses.

The first living-room war was not Vietnam but the American Civil War, which came into the front parlor in word and picture, even in photographs, as no war had before. The Civil War came home to civilians in a delayed and fragmentary manner that was nonetheless unprecedented, with a new breadth of reporting and images with a new stamp of authority. The power of photographic witness made vivid and inescapable many harsh sights of war that civilians had previously been spared and intensified the experience of conflict far from the battlefields.

Timing made this home delivery of war possible. By the late 1850s, circulation of the weekly magazines in America had risen as high as one hundred thousand a week, and by the time Fort Sumter was fired on, the stereograph and carte de visite were already staples of existence. In the early stages of the war, citizens of Washington had gone out to take the view and discovered it was dangerous. They fell back on the news.[4]

The news could be horrifying to an unaccustomed degree. Less than a year after the Civil War began, the journals began printing escaped prisoners' accounts of harsh treatment in Confederate prison camps, sometimes illustrated by sketch artists. Northerners were angry. Then, in the spring of 1864, a handful of photographs of starving Union prisoners provided proof that was merciless, shocking, and utterly irrefutable. It would not have taken much to convince this audience, but photography was so new and the images of human beings so unlike any ever seen before that the last vestiges of indifference were swept away. Public opinion was galvanized, Congress itself was stirred, and the pictures helped condemn a man to death.

In 1863 the press had reported that although the North fed and clothed its prisoners well, in the South, Yankee soldiers were freezing and starving. (Northern camps were, in fact, often little better than southern ones, except in Yankee minds.) Prisoner exchanges broke down several times in 1863; by the spring of 1864 the North called them off altogether because the South sent most of its black prisoners back to slavery or shot them, then swelled the ranks of the Confederate army with returned southern prisoners.[5]

The winter and spring of 1864 saw a crescendo of stories in the northern press on the brutalities of life in the southern camps. Reports were so horrifying that, once an exchange was finally arranged in April of that year, Congress began an investigation. News that "photographs of some of the half-starved heroes are to be taken, to accompany the report when printed" was mentioned on May 7 by the New York Times. And soon eight pictures of men from Libby, Andersonville, and other prisons, taken in the hospital when the men were exchanged, were widely published. (Andersonville, where over one hundred men died every day in the summer of 1864, had a particularly harrowing reputation.) These images of incredibly emaciated men, universally referred to as "living skeletons," jolted the people who saw them. They were medical studies, which people were not used to. (A photographic survey of Civil War wounded had been made for medical purposes, but not intended for the lay public.) The prisoners were photographed singly in sitting positions they could barely sustain; one was supported by a man who was probably a doctor. All but nude, and posed like specimens against blank backgrounds, the pale bodies are so utterly emaciated that the ordinary erotic response to nakedness is precluded. Indeed, these bodies are so removed from the norm of healthy manhood that they seem almost inhuman—ghosts before the fact. They are not yet dead, for their eyes still look at us—sad, resigned, passive—but their bodies waver on the way to the grave.

The congressional committee that investigated prison conditions in-

cluded these photographs with its report; they were seen by members of Congress and mentioned later on the floor. When the report was issued on May 9, it included numerous accounts of atrocities and eight engravings after photographs. The committee charged the South with deliberately killing Union prisoners. The Senate ordered twenty thousand additional copies of this report; these were "spread broadcast over the land." On June 18 both *Leslie's* and *Harper's* published engravings of the prisoner photographs. These reached enormous numbers of people, for by the end of the war *Leslie's* was printing up to half a million copies of an issue, with a readership of approximately two and a half million.[6]

Like all engravings after photographs in the nineteenth-century press, the reproductions do not even approach the concentrated conviction of the original photographs. These are so crudely drawn that it is hard to credit them with accuracy, much less emotional force. But they were all that most people had to go on, and *Leslie's* simple words "They are from photographs, and without exaggeration" sufficed to render them irrefragable. *Harper's* said: "They are not fancy sketches from description; they are photographs from life, or rather from death in life, and a thousand-fold more impressive than any description they tell the terrible truth. No evidence is like these pictures."[7]

The nineteenth century, so convinced of photography's truthfulness, often knew only these watered-down engraved versions. Photography surpassed the credibility of the printmakers but for years would still have to rely on those vanquished artists. *Harper's* bolstered the authenticity of their engravings by printing a doctor's estimate of the power of the originals. One corporal, he said, whose face was so shriveled it "looked like that of an ape. . . . had his picture taken; he asked me for one. I promised it to him, and inquired what he wanted it for. . . . 'To send home to my mother.' I rejoiced when I found that the picture was a failure, for the sight of that face in a picture, I really believe, might have killed the mother, or turned her brain."[8]

The terrible proof these photographs seemed to provide contemporary observers was not only that the prisoners were dying but that the South was intentionally killing them. This accusation is not encoded in the photographs but was hammered home by the press until the public believed that the pictures ratified it. Photographs are mute artifacts. They do not speak but can only be interpreted, and interpretation is a notoriously tricky game. Viewers bring their education, their preferences, their blind spots and expectations to bear on images. The denotation is generally exact: these are men, they are starving and weak. The connotation, however, is malleable and can be rearranged by information, belief, even wishful thinking. The viewer is outside the frame of the photograph but inside the frame of its meaning.

In September 1864 the United States Sanitary Commission, a private group that had conducted its own inquiry on the prisoners, published its report, repeating all the atrocity tales and printing eight colored pictures of the living skeletons. There was also a smaller edition with black-and-white reproductions, very poorly drawn. "The photographs of these diseased and emaciated men," said the report, "painful as they are, do not, in many respects, adequately represent the sufferers as they appeared. The best picture cannot convey the reality, nor create that startling and sickening sensation felt at the sight of a human skeleton. . . ."[9] All the eyewitness accounts stress that the reality was simply indescribable, that language could not handle it, that not even photographs could convey such misery.

In New York a fashionable and enterprising bookseller displayed one of these "most horrifying photographs" in a large format in his window for many

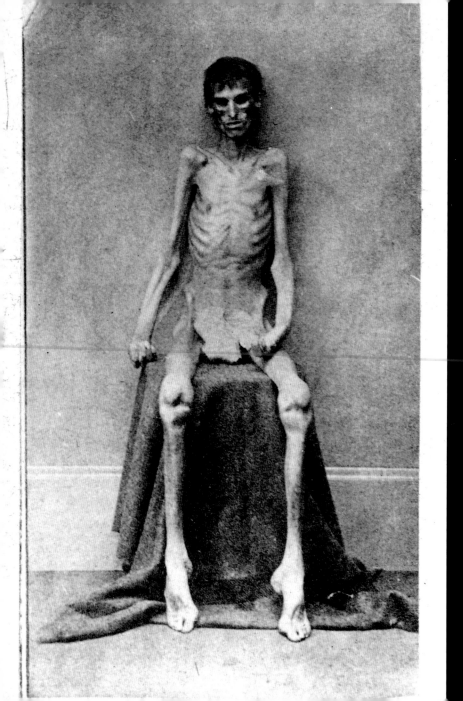

Released Federal Prisoner,

Richmond, Virginia—From

Belle Isle or Libbey ?, 1864

Library of Congress,

Washington, D.C.

FRANK LESLIE'S ILLUSTRATED NEWSPAPER

Entered according to the Act of Congress in the year 1864, by FRANK LESLIE, in the Clerk's Office of the District Court for the Southern District of New York.

No. 455—VOL. XVIII.] NEW YORK, JUNE 18, 1864. [PRICE 10 CENTS. $4 00 YEARLY. 13 WEEKS $1 00.

The Campaign — Grant and Sherman — Richmond and Atlanta.

ANOTHER week of signal and uninterrupted successes has been added to the glorious record of our advancing armies, East and West. Grant thundering at the gates of Richmond, and Sherman sweeping down with his irresistible columns upon Atlanta, are the great historical facts of the day. The heart of every Unionist rejoices, while the chiefs, organs and oracles of the rebellion are amazed and confounded.

These treacherous guides of a deluded people are now beginning to realise their folly, and to hint at their hopeless situation. Their hitherto unfailing devices of audacious falsehoods and brazen deceptions have failed to account, to the satisfaction of their credulous followers, for the presence of Gen. Grant in front of Richmond and of Gen. Sherman at Atlanta. And why? Because the popular credulity of the South had been flattered with the promises of a crushing campaign through Maryland and Pennsylvania by Gen. Lee, and a sweeping invasion of Ohio by Gen. Jo. Johnston with an army of veterans 100,000 strong.

These royal promises, contrasted with the sorry performances of both Lee and Johnston, have demanded an explanation beyond the inventive faculties of the rebel leaders to make. But they have, nevertheless, tried, by the boldest misrepresentations and effrontery, to make it appear that Lee and Johnston are doing wonders towards the achievement of Southern independence. Thus, when a few weeks ago the people of Virginia inquired why Gen. Lee, instead of moving across the Potomac, was on the road to Richmond, with Gen. Grant close upon his flanks, they were answered that Gen. Lee is drawing the Yankees away from Washington. He will still entice them on to Richmond with a small force, so disposed as to appear a large army, while, with the main body

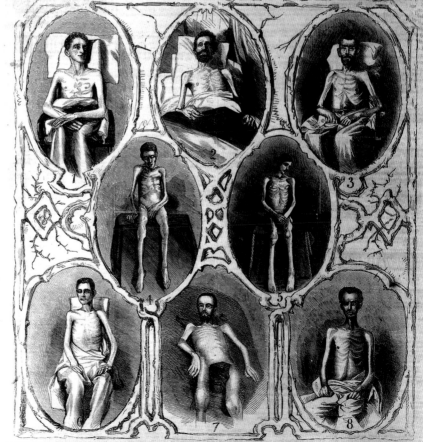

1. Private Lewis Klein, Co. A, 14th N. Y. Cav. 2. Private John Breinig, Co. G, 4th Ky. Cav. 3. Private George H. Wible, Co. F, 9th Md. 4. Private Francis W. Beedle, Co. M, 8th Mich. Cav. 5. Private John Q. Rose, Co. —, 8th Ky. 6. Private Charles R. Woodworth, Co. G, 8th Mich. Cav. 7. Private L. H. Parban, Co. B, 3d W. Tenn. Cav. 8. Private Edward Cunningham, Co. F, 7th Ohio Cav.

UNION SOLDIERS AS THEY APPEARED ON THEIR RELEASE FROM THE REBEL PRISONS.—FROM PHOTOGRAPHS MADE BY ORDER OF CONGRESS.—SEE PAGE 199.

Frank Leslie's Illustrated Newspaper, June 18, 1864

The New York Public Library, Astor, Lenox and Tilden Foundations, Central Research Division

months. A contemporary wrote that "his cadaverous presentment is put into the Broadway bookseller's window, to excite sentiments of hatred and vengeance against the wicked and cruel South," but the writer thought the subject might have been chosen because he was an extreme case, far worse off than other prisoners.[10] The South claimed, with some justice, that the pictures were being taken for use as propaganda. (The word *propaganda* means nothing more than dissemination of some doctrine, originally that of the Roman Catholic Church. The negative connotation has been added over time. If the doctrine is your own, disseminating it is good public relations; if someone else's, it's propaganda.)

For months in 1864 Congress debated whether to retaliate for the treatment of the prisoners. Some called for intentional starvation of southern prisoners; others cautioned against stooping so low. Congress put the photographs on the witness stand. January 25, 1865: "And lest there should be those who would not believe what is stated [in the report], it being almost too horrible to be credited, the portraits of men who were subjected to this treatment—not portraits painted from fancy, but photographs taken from life, taken of men in the agonies of death—are added to attest to the correctness of the fact that our prisoners were treated in the way I have described." January 26: "You cannot look with composure now upon the daguerreotypes of those men whose skeletons are before you and have been for more than a year; and yet you go coolly away and fold up your arms and do nothing!"[11] Congress did not legislate retaliation.

Less than a week after the war ended, Lincoln was shot and passions flared once more. Captain Henry Wirz, commander of the Andersonville camp, was arrested in May and tried at the end of the summer. The press had already condemned him. Just as Andersonville was the symbol of southern barbarity, so Wirz, a Swiss, became the focus of the public's hunger for revenge. General Norton Chipman, the army's prosecuting attorney, introduced four photographs of prisoners into evidence at the trial. Twice he showed photographs of the living skeletons to doctors who testified that they were true and fair pictures of conditions they had themselves witnessed; the first time the *New York Times* thought it important enough to mention. In his summation Chipman said that nothing—not language, science, art, or "the photographer [who] call[s] the elements to witness"—had succeeded in delineating the true horrors of Andersonville. Years later, when he wrote a book about the trial, he said that "numerous photographs of the returned prisoners were introduced and identified. . . . and so strong seemed the evidence of rebel cruelty, that the counsel for the prisoner sought in his examination to show that they were fancy sketches."[12]

Henry Wirz was hanged. He was the only prison official executed after the war.

One of the few guaranteed beneficiaries of war is the news business. (In 1935 a Time, Inc., editor, arguing in favor of founding *Life* magazine, observed that "a war, any sort of war, is going to be a natural promotion for a picture magazine.") During the Civil War northern newspaper and magazine circulations rose steadily. So did war coverage. In 1864 *Leslie's Weekly* said it had eighty artists in the field and had published nearly three thousand engraved pictures of the war. Photographers were slow at first to understand the opportunity, but eventually about three hundred were authorized to carry their cameras to the front.[13] Photographs went on exhibition within a month of battle and were distributed in quantity within another month, a time lapse that

seems ludicrous today but was then remarkable. The pace and nature of communications had clearly changed.

In 1872 one writer said that wars had ceased to be past history and become present-tense news: "No record of previous wars can surpass those of the years between 1861 and '71 [including the French Commune]. Anterior to these events we spoke of Napier, Thiers, Gibbon, Bancroft. They were compilers from old documents. Now we speak of the TRIBUNE, TIMES, WORLD, HERALD. They have been eye-witnesses."[14]

Photographs were an essential element of this radical shift in experience. Mathew Brady saw the possibilities for war photography before other photographers did. He applied for and received authorization from the government, but not employment. Brady decided the potential profit was worth the risk of paying his own way, and he was almost right. During the war he made as much as twelve thousand dollars a year from the sale of his pictures through Anthony and Company, a firm that specialized in stereo and carte pictures, and probably as much again on his own sales.[15] After the war he went bankrupt.

Few who were not soldiers knew what battle actually looked like, and photography could not yet teach them, but it could introduce them to war's aftermath. In the first half of the century the popular view of war had resembled a painting compounded of Théodore Géricault's bravura and Ernest Meissonier's pageantry. The camera in the 1860s could not directly contradict this mental picture; it was not fast enough to stop cavalry charges or human combat. Most pictures of the Civil War are of deserted fields and unprepossessing houses where battles had once raged, of soldiers in camps, of officers in formal poses. They are relatively dull now, but they were new then and the public studied them for insights into war.

Original illustration, rather than copies of photographs, predominated in the illustrated press, but illustrators were not trustworthy: *Vanity Fair*, in 1861, printed a cartoon of an artist sketching "on the spot" from toy soldiers, and a Cincinnati paper said many battle pictures were "little better than a substantial farce."[16] It was photography that would bring the real news home and give grim evidence never before seen by civilians: death on the battlefield.

The photographic turning point was Antietam. By nightfall on September 17, 1862 (the single bloodiest day in American history), the count lay at twenty-six thousand casualties, northern and southern, in a battle that decided nothing. Alexander Gardner and an assistant were photographing at Antietam within two days after the last shot rang out; Gardner took picture after picture of the dead on that grisly spot before burial was completed on the 21st. Until that time no American battlefield had been photographed before the fallen were properly placed in the earth.

(Gardner was employed by Brady, who took the lion's share of credit for all photographs taken by his employees. Until recently, Brady's name was attached to most of the important pictures of the Civil War. In fact, his eyesight was so poor by 1861 that some doubt he could have taken *any* of the pictures, although he went to the front several times. Gardner quit and founded his own studio a few months after Antietam, probably in part to put his own name on his images.[17])

In October the pictures went on view at Brady's New York gallery, on Broadway.[18] By November the pictures were available from Brady in albumcard size or stereograph views. At a time when many parlors displayed pictures of dead relatives posed as if napping, a harsher and more unmistakable death had come home.

There were mathematical rows of bodies laid out like animals in a slaughterhouse, lined up in trenches until earth should cover them over. There were men scattered helter-skelter beside a fence, exactly as they had been cut down, one with an arm reaching upward, frozen in position by rigor mortis. No melodrama here, and little explicit pathos—nothing but bodies, ordinary bodies, the casual by-products of war. The photographs of Antietam were implacably matter-of-fact.

Harper's Weekly published eight engravings labeled "from photographs by M. B. Brady" on October 18, so the images were immediately seen all over the North. The magazine noted that the men's features could be distinguished on close inspection of the photographs; the expression on many faces "is perfectly horrible, and shows through what tortures the poor victims must have passed before they were relieved from their suffering."

A *New York Times* reporter who saw the originals at Brady's gallery wrote about the impact of this new evidence: "Mr. Brady has done something to bring home to us the terrible reality and earnestness of war. If he has not brought bodies and laid them in our dooryards and along the streets, he has done something very like it. At the door of his gallery hangs a little placard, 'The Dead of Antietam.' Crowds of people are constantly going up the stairs. . . . Of all objects of horror one would think the battlefield should stand preeminent, that it should bear away the palm of repulsiveness. But on the contrary, there is a terrible fascination about it that draws one near these pictures, and makes him loth to leave them. You will see hushed, reverend groups standing around these weird copies of carnage, bending down to look in the pale faces of the dead, chained by the strange spell that dwells in dead men's eyes."[19]

Others also felt their terrible fascination. Oliver Wendell Holmes, who had been to Antietam shortly after the battle to nurse his wounded son, wrote of a set of these photographs: "Let him who wishes to know what war is like look at this series of illustrations. . . . It was so nearly like visiting the battlefield to look over these views, that all the emotions excited by the actual sight of the stained and sordid scene, strewed with rags and wrecks, came back to us, and we buried them in the recesses of our cabinet as we would have buried the mutilated remains of the dead they too vividly represented. Yet war and battles should have truth for their delineator."[20]

The new version of truth found a market. William Frassanito, an expert on Antietam, says that photographs of the battle seem to have sold at a steady pace throughout the war, and others have noted their frequent mention in photographic catalogs during the war and their frequent appearance in contemporary collections. Exactly how large their audience was and exactly how anyone but a couple of eastern writers responded is impossible to tell, but if so many suddenly witnessed death on the battlefield, a revised sense of war's consequences must have taken hold of the American mind.[21]

Even if human experience did not suggest that becoming a kind of eyewitness to war would have profound psychological effects, these pictures and others of the Civil War signal a shift in communications that would be meaningful for the future. Civil War views were sold mainly in stereographs and album-card formats. In the stereoscope, the sense of depth made the scene astoundingly present and at the same time reassuringly remote. Photography already was offering the news as a mediated reality: events that seemed present but were removed. It was still possible at that time to see a public hanging up close. With photographs, one stepped farther back, and others, sitting in their velvet-covered chairs in their overstuffed parlors, stepped back

Alexander Gardner

(1821–1882)

Dead of Stonewall Jackson's

Brigade by Rail Fence on the

Hagerstown Pike, Antietam,

Maryland, September 1862

Library of Congress,

Washington, D.C.

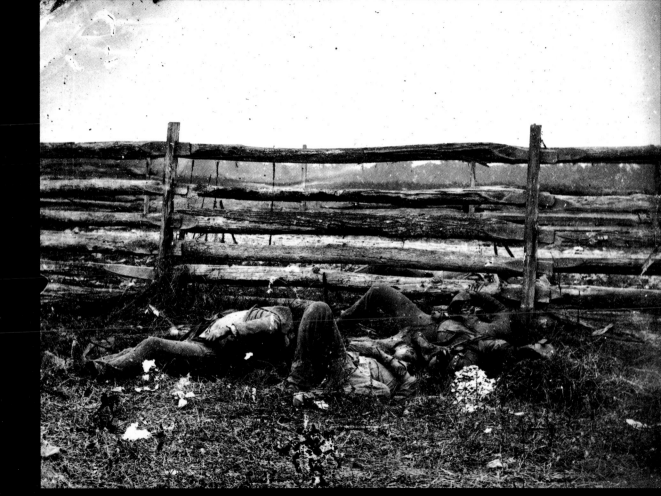

at the same moment. Here was the bare beginning of a phenomenon we take for granted today: simultaneous but separate experience of the same events.

Photographers continued to take and sell pictures of the Civil War dead. In 1863 Alexander Gardner went to Gettysburg with an employee, Timothy O'Sullivan, who snapped what later became the most famous of these pictures, *A Harvest of Death*. The bloated bodies, left on the battlefield through two days of rain, are in the center and more sharply in focus than the dim background. There is no attempt to gloss over the subject or make war more acceptable. Perhaps that is why this photograph has become so famous; it is closer to our expectations than it was to those of its time. It was not reproduced until 1865, two years after Gettysburg, in *Harper's Weekly*, and then it was redrawn, with material added to intensify the art and drama. (Artists could make war look more the way it was supposed to than photographers could.) Gardner published the photograph in his *Photographic Sketchbook of the Civil War* (1866). "Such a picture," he wrote, "conveys a useful moral: It shows the blank horror and reality of war, in opposition to the pageantry. Here are the dreadful details! Let them aid in preventing such another calamity falling upon the nation."[22] That is a hope photographers cherished at least through World War II, always to no avail.

Even the reality and dreadful details of these photographs were not necessarily as exact as viewers supposed. On July 9, 1864, *Harper's* wrote, "Of course it is impossible for photography to lie, and we may therefore regard these portraitures as faithful to the minutest detail." But Gardner choreographed the dead men in his pictures, often moving a body or bodies around to heighten the drama and changing the captions to cover his tracks. Because slow film and limited access continued to make news photographs difficult to obtain, events were staged with some regularity well into the nineteenth century, especially by the yellow press. During the Spanish-American War the battle in the harbor below San Juan Hill was re-created in a bathtub. It has been suggested that the idea that journalists were truthful and objective did not even arise until the early twentieth century,[23] but no one doubted the photographers in the Civil War era.

After the war Brady and Gardner both published expensive books of their photographs that failed miserably in the marketplace. Gardner then took his camera west to follow the progress of the railroad. Brady closed his business. In 1875, after he had gone bankrupt, Congress finally voted Brady twenty-five thousand dollars for his negatives. The man in charge of the collection, saying that the images belonged to the people, refused to let them be commercially exploited or published, so that "the people" were prevented from seeing them. Government employees handled the glass negatives so carelessly that within a decade three hundred were said to be broken or lost. Thousands of other negatives were sold to greenhouses as replacement glass; gradually the sun erased all record of the war. Some say those same glass negatives were used as face-plates in World War I gas masks.[24]

It is generally assumed, no doubt correctly, that once the war was over no one wanted to remember it any more (although many personal accounts of the war would be published and presumably found an audience). But perhaps interest also fell off because the photographs were no longer news. Once they had been objective signs of current events, signs that were potentially reusable while the war was going on. Each time the newspapers reported a new battle, the dry-goods merchant and the miller could have taken out the stereographs of Antietam once more, and, adjusting their viewers by firelight, tried to imagine their sons safe in their tents after the field was won. Images of

Negative by Timothy

O'Sullivan (1840–1882)

Original print by Alexander

Gardner (1821–1882)

A Harvest of Death,

Gettysburg, Pennsylvania,

July 1863

The New York Public Library,

Astor, Lenox and Tilden

Foundations, Rare Books

and Manuscript Division

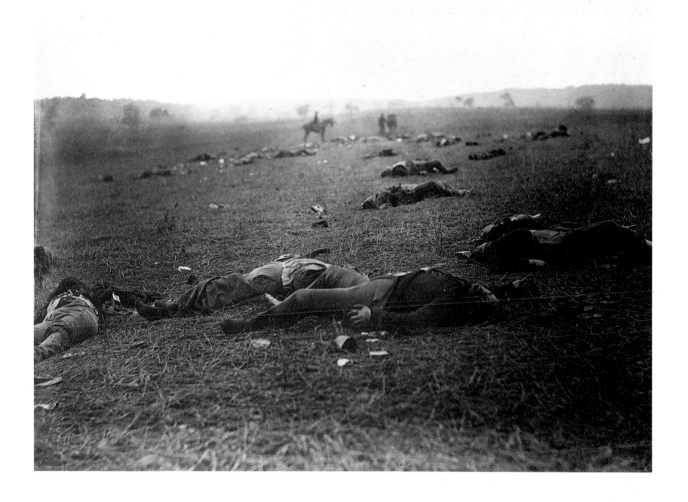

that kind used up their purpose once Lee surrendered and the last veterans limped home. Photographs, having brought far-off events into view, ensured that the world would always demand a fresh supply.

In the wink of an eye is not very fast. Photographic shutter speeds began to outrace human vision by the late 1850s, when stereoscopic cameras arrested the "fleeting effects" of passersby in cities. Oliver Wendell Holmes, physician and inventor of the stereoscopic viewer, was startled by the evidence of the new "instantaneous photographs." "No artist," he wrote, "would have dared to draw a walking figure in attitudes like some of these," and on the basis of the new data he criticized the design of an artificial leg for Civil War amputees.[25]

An era fixated on speed longed for a way to accelerate vision. By the third quarter of the century the camera obligingly provided one. In the 1870s Eadweard Muybridge settled one controversy and ignited another when he proved with a rapid shutter that a running horse habitually fools the eye.

For much of the nineteenth century, artists, scientists, and horse lovers had puzzled over the nature of the horse's movements. By tradition, the horse at full gallop was shown in the "flying-gallop" or "rocking-horse" position, with all four legs extended, but some claimed that horses never had all four legs off the ground. For painters this was a serious matter. Well into the fourth

quarter of a century that witnessed the introduction of Impressionism, Post-Impressionism, and Symbolism, academic painters assiduously pursued the most exacting degree of realism. Meissonier, the French painter known for his precise details, was so intent on portraying the horse correctly that the French government built him a miniature railroad beside a race track so he could travel at exactly the horse's speed while sketching it. For all his science, he never got it right.[26]

Eadweard Muybridge (born Edward Muggeridge), a celebrated land-scape photographer, took his first picture of a running horse at the request of Leland Stanford, former governor of California and an avid horse fancier. (Legend has it, probably incorrectly, that Stanford commissioned the photographs to settle a bet that a trotter did indeed have all four feet off the ground at once, and that Stanford won.) In 1872 Muybridge devised a spring-operated mechanism for tripping the shutter at 1/500 of a second. Earlier experiments had proved that the camera's capacity to stop motion far surpassed the human eye's, but the experimental design had been much more restricted. In 1851 Fox Talbot fastened a page of a newspaper to a rapidly spinning wheel in a darkened room and took a photograph by the light of an electric spark. This early forerunner of stroboscopic photography produced a picture of a page with distinct letters of type. Muybridge, out of doors and without lights, was up against higher odds.

In 1872 and 1873 Muybridge supposedly produced photographs of Stanford's favorite horse in full motion, but these were never published. He kept at it. In 1877 a wood engraving of the horse was published, but it was not the photograph itself, and not everyone believed it. The following year a group of reporters was invited to watch while Muybridge photographed and developed the negatives so there could be no question of retouching. His pictures showed the horse's gait in its successive stages.[27] As it turned out, the galloping horse never flew with its legs extended but jackknifed them under its belly. Muybridge exhibited his results in slides and lectures that were highly praised in photographic and scientific magazines.

Thousands of years of art had suddenly been proved mistaken. The influence on artists was immediate. In 1879 Thomas Eakins began his painting *The Fairman Rogers Four-in-Hand*, in which the horses' movements were directly based on Muybridge's revelations. Drawings from the sequential photographs were reproduced in a French magazine in 1878, and after Muybridge published a book of animal-motion studies in 1881 and traveled to Paris to lecture on the subject, European painters abandoned the fictive depictions they had been committed to for centuries. Meissonier, who had seen both Muybridge's photographs and those by the French physiologist Etienne-Jules Marey, who was working along similar lines, returned to a painting he had finished twenty years earlier and changed the position of the horses' legs.[28] The careers of the battle painters divide into pre-Muybridge "incorrect" paintings and post-Muybridge "correct."

Muybridge's photographs not only overturned the accepted conventions but shocked the eye. In 1882 the *Gazette des Beaux-Arts* remarked, "To the great surprise of photographers and of all those who saw these prints, the attitudes are, for the most part, not only disgraceful but of a false and impossible appearance." Although most people could not have articulated it, what was being learned was that perception depends heavily on representation. We see largely what we have seen before or what we have been taught to see. The camera was altering perception. In the 1930s Paul Valéry wrote about Muybridge that "thanks to photography, the eye grew accustomed to

anticipate what it should see and to see it; and it learned not to see nonexistent things which, hitherto, it had seen so clearly."[29]

Muybridge's influence on art continued. Edgar Degas executed a group of drawings directly after the plates in Muybridge's book. The photographer's direct or indirect influence extends into the twentieth century to the Futurists, Marcel Duchamp (his *Nude Descending a Staircase* was inspired by Marey's photographs, which in turn were influenced by Muybridge), Francis Bacon, and others.[30]

Muybridge's photographs raised a much larger issue in art than the question of where a horse in a hurry puts its legs. Although his contemporaries did not deny the veracity of the photographs, many did not approve. Because the eye had never seen, *could* never see the surprising positions caught by his shutter, the more rapid stages of the trot and gallop failed to convey any great sense of movement. The eye read them as sluggish or stationary, just as it read the precisely defined spokes of a wheel caught at $^1/_{500}$ of a second as perfectly still, because in actual experience a moving wheel always looks blurred. The old, incorrect manner of painting was more convincing. In 1880 the *Philadelphia North American* wrote, "There is no doubt of its truth in the photograph as a means of study, but there may well be grave misgivings as to the wisdom of its adoption in the finished picture."[31]

Where did the artist's obligation lie, in the truth as it was or as we perceived it? In 1882 Dr. J.D.B. Stillman wrote that the question involved an opposition between vision, which was limited, and human reason. Auguste Rodin came down squarely on the side of vision: "It is the artist who is truthful and it is photography which lies, for in reality time does not stop, and if the artist succeeds in producing the impression of a movement which takes sev-

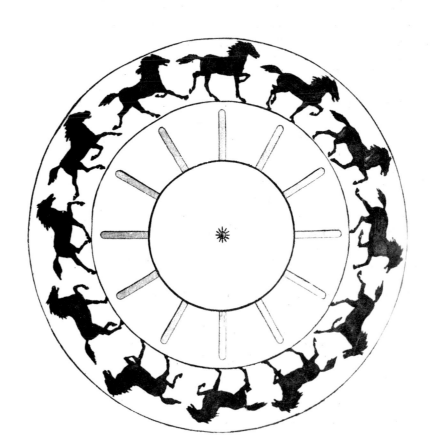

Eadweard Muybridge

(1830–1904)

Zoopraxiscope Disk, c. 1879

The Bettmann Archive,

New York

eral moments for accomplishment, his work is certainly much less conventional than the scientific image, where time is abruptly suspended."[32]

The question actually was: What constitutes realism? And after that: Where does the artist's allegiance lie? Photography, which had been invented partly to satisfy a desire for realistic depiction; which paralleled, reinforced, and perhaps influenced the nineteenth-century trend toward realism in both art and literature; which confirmed the century's increasing faith in and reliance on meticulous visual observation in the sciences and arts—photography had depicted facts so perfectly that realism no longer looked very real. This happened at the height of Impressionism's defiance of academic tradition and the beginning of Post-Impressionism's move away from the standards of purely retinal vision. From the truthful but ordinarily invisible evidence of Muybridge's photographs and their ultimate appeal to reason rather than to sight, it was not so great a leap to Pablo Picasso's "I paint forms as I think them, not as I see them,"[33] or to Cubist depictions of objects as they exist in space, from the front, the side, and the back, rather than as they look at any one moment.

Muybridge had another revelation in store for his audience. In 1878 he adapted his series photographs for mechanical projection in a machine he called the zoopraxiscope; it resembled the popular toy known as a zootrope, which, when spun around, animated consecutive drawings of a figure. His adaptation consisted of copying the photographs in drawings that elongated the horse's body to accommodate persistence of vision. The images were arranged consecutively on a disk, which, when rotated rapidly enough, seemed to show the horse cantering across the screen. The effect was rather like that of acrobats and dancers capering across the pages of flip books.

These were not true motion pictures, nor was the zoopraxiscope a movie projector. For that the world would have to wait for Thomas Edison's peepshow Kinetoscope in 1894 and Louis Lumière's Cinematographe projector the following year. Muybridge's primitive invention did, however, give the public its first taste of moving photographs; it was awed, and its expectations were raised. Here was the first clear indication that life's kinetic energy could be exactly reproduced and represented. The addition of motion to photography's repertoire, which would eventually lead to movies and television, would exponentially multiply the medium's influence. Never mind that Muybridge did not get much beyond pigs, oxen, and human beings docilely trotting across the screen. The first films that Lumière produced, although some were taken under less-controlled circumstances, had no greater narrative interest than these; they presented a crowd walking or a baby being fed. The wonder was that an ox or a baby could move at all and that reality could dance with time across a screen.

Photographic evidence is so powerful it can override willful denial and doubting Thomases. During World War II the U.S. Navy asked W. Eugene Smith to photograph what he called a "concentration camp" for Japanese POWs "so that *Life* would run a story about how wonderfully well we were treating those who surrendered to us. Then the Navy would drop the magazine on other islands, and on Japan itself, so that more people would surrender." He protested that the place was "a stinking hell-hole" and was told that reports indicated conditions were very good. Smith, furious (not an unusual circumstance in his case), went off to photograph. He later said that for once, the Navy censors "became angry at the pictures and not at me. They took it to higher authorities, and the concentration camp was completely turned

around. The officials were replaced. It never was a paradise, but at least they brought it up to the minimal standards of human decency."[34]

When Allied forces liberated the actual concentration camps in Nazi Germany, photographs conveyed the full extent of the horrors far more convincingly than words. Susan Sontag has written about her reactions to pictures of Bergen-Belsen and Dachau that she came upon by chance in the summer of 1945: "Nothing I have seen—in photographs or real life—ever cut me as sharply, deeply, instantaneously. Indeed, it seems plausible to me to divide my life into two parts, before I saw those photographs (I was twelve) and after, though it was several years before I understood fully what they were about."[35] Like the Holocaust they represented, the photographs mark a turning point in human consciousness; the world would never again seem quite the same.

It is a curious fact that in 1945 the first written accounts of the camps did not strike people as entirely truthful. When the original eyewitness reports reached the papers, before the photographs had come out of Germany, they were greeted with some suspicion. It wasn't until the newspapers published pictures of the camps, usually on the inside pages, that these images forced people to accept the enormity of Nazi war crimes.

In Great Britain, newspapers treated the photographs as a kind of necessary corroboration of the printed word. The *London Times* of April 19, 1945, printed one article with a note beneath it telling readers that "pictures . . .

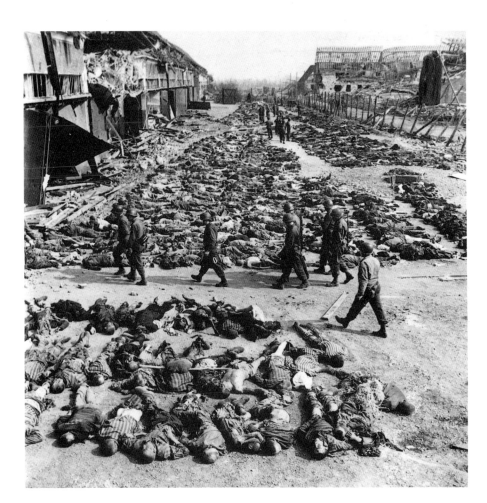

Johnny Florea (born 1916)

Long View of Bodies on the Ground Arranged for Burial, Nordhausen, 1945

Johnny Florea, *Life* magazine © 1945, 1973 Time Warner Inc.

which confirm the published accounts of German brutality appear on p. 6."
The next day a *Times* editorial made clear how tenuous words had been, how vital the photographs: "Supreme Headquarters did well to secure and to circulate the pictures, though they sicken the heart of all who see them, in order that the world may comprehend the exorbitance of evil gainst which the United Nations have been fighting. Terrible things have been told, during and before the war. . . . There have, however, always been some who for the honour of human nature have withheld complete belief from the reports, finding it easier to suppose that suffering has caused hallucination in the victims than to imagine a degradation of the soul that could descend so far below the animal level of cruelty. The photographs remove the last possibility of doubt, and show indeed that the slow horrors of torture, starvation, and induced disease, which have been the means of tens of thousands of murders in Buchenwald, Nordhausen, and Belsen, are more foul than the worst that has been told or suspected."

How could it be that eyewitness reports were not sufficient proof? The answer lies partly in the times, partly in the magnitude of the events. Distrust of reports in the press was widespread in the 1930s; American opinion polls late in the decade indicated that almost one out of three adults doubted the press was honest. The situation was much the same in Britain, where many thought it manifest that papers that kept repeating there would be no war were misrepresenting the news. By the late 1920s historians had proved what had long been suspected: the press had lied outright about the last war. Misleadingly optimistic accounts of the war's progress throughout World War I had been bad enough, but newspapers had also repeated the same lurid tales of German atrocities: raped and crucified nuns, babies with their hands cut off. The shocking stories were believed on the home front for a long while, but no one ever found the victims. There were no eyewitness reports. There were no photographs.

Popular trust in photographs increased as faith in the printed word declined. In the 1920s and increasingly during the 1930s, people began to expect information to arrive in visual form. "The image," as the publisher Jean Prouvost said in 1931, "has become the queen of our age. We are no longer content to know—we must see."[36] In fact, it became difficult for some to accept information without visual proof.

The decade of the 1930s was an era that put a high value on documentary, and its documentary ideal was the supposedly objective eye of the camera.[37] Journalists on the road gathering facts about America and novelists writing the new literature about the common man tried to be as sharply observant and as passively receptive as the shutter of a camera. John Dos Passos called one section of his *U.S.A.* trilogy "Camera Eye," another "Newsreel." Across the ocean Christopher Isherwood wrote a novel titled *I Am a Camera*.

Tabloid papers grew so popular in the 1920s that they forced most newspapers to increase their photographic coverage. The picture magazine, established in Europe by the end of the 1920s and in the United States in the mid-1930s (with *Life* and *Look*), made the photograph the chief purveyor of information. At the same time newsreels became a staple of urban existence. By 1938, according to one observer: "It was safe to say that the average citizen acquired most of his news through the medium of pictures. Over twenty million Americans go to the movies each day in the week and the newsreel is a regular part of every motion picture program."[38]

Nothing makes the dominance of the photograph and its favored place

in the general system of belief more evident than British and American reactions to the reports of the camps in 1945. The accounts were more surprising, and possibly more suspect, than they might have been because so little had been published about the concentration camp system before late 1944. Although eyewitness reports came out of Europe by 1942, American newspapers seldom released the information, radio rarely took up the topic, film and mass-circulation magazines almost never. Editors could remember the propaganda of World War I as well as anyone and were leery of being labeled sensationalist; many may have doubted the facts themselves. The Nazis claimed they were deporting people to labor centers to cover their labor shortfall, a program that would certainly have been more reasonable.[39]

When the news did come out, as in firsthand accounts of the Maidanek camp in August 1944, it still met resistance. A Gallup poll in January 1943 had found that close to 30 percent of those polled said the news that two million Jews had been killed was a rumor. By December 1944, 76 percent believed that many people had been murdered in the camps, but 27 percent thought the number was one hundred thousand or less.[40]

When the western camps were liberated in April 1945, the first articles were often printed on inside pages, as if the newspapers themselves were uncertain about the significance of news that scarcely seemed credible. One of the barriers to belief was that the facts were unthinkable, even unimaginable, and without pictures it was all the more difficult to slot them into the ordinary experience of the world. The mind hesitates to endorse what reason would prefer to deny. As early as 1942 three Jewish gravediggers had managed to escape from Chelmno; their account of the gas chambers had been smuggled to America. Although the source was most reliable, not even the editors of the Jewish press could believe the story; the September 1942 *Jewish Frontier* printed the account in small type in the back of one issue. Twenty-five years later one of the editors recalled that they had been "psychologically unschooled for the new era of mass carnage."[41]

In 1945 a populace that was less directly threatened than the Jews struggled with the same incredulity. Because of the public's unwillingness to believe written accounts in the press, the widespread reluctance to credit the full horror of the facts, and the general trust in photographs, the photographs of the camps acquired a stunning power. The *New York Times* of April 20, 1945, reported on the British reaction to the first pictures: "BRITISH ANGER DEEP AT ATROCITY PROOF / Publication of Photos Arouses the Nation." The *Baltimore Sun* of that date put it this way: "Atrocities? Americans, a sophisticated people, smiled at this idea. . . . When it came to atrocities, seeing, and seeing alone, would be believing, with most Americans." In May, *Editor and Publisher* recommended that newspapers give ample space to pictures of the atrocities in order to counter the American resistance to belief.[42]

The *New York Times* article on British reactions to the photographs reported that the London press had launched a campaign to reduce German prisoners' food rations, which were allegedly double the allowance for British civilians. The uproar over rations must have been intensified by the photographs of throngs of human skeletons, living and dead, in the German camps.

Films of the camps were released in Britain at the same time as the photographs, and they too were regarded as proof for people who would not otherwise believe. The *Daily Mirror*, according to the *New York Times* of April 21, 1945, said that "moviegoers, unable to stomach atrocity newsreels, tried to leave a Leicester Square theatre but were turned back by British and Allied soldiers who told them to return and see what other people had endured. . . .

'It's the only way to break the namby-pamby attitude toward the Germans,' the paper quoted a soldier as saying. 'Many people don't believe such things could be. These films are proof. It's everybody's duty to know.' "

The *London Daily Mail* of April 28, 1945—which announced that it would publish a book of all the photographs of the German camps, "lest we forget"—commented when the newsreels were released that "the view of those responsible is that the public should be able to see in their entirety the uncensored scenes that no one may in future doubt or ever forget the evidence of German brutality." The photographs were thus given two kinds of credit not accorded to the printed word: they were totally convincing and they would burn in memory forever.

A small number of people were never convinced, even by photographs. General Dwight D. Eisenhower, supreme commander of the Allied Forces, was aware of the depth of public resistance to the facts and fearful that not even eyewitness accounts and photographs would suffice. He invited groups of congressmen, members of Parliament, and editors to see the camps in person. Those who went said the sight beggared description. Representative John Kunkel of Pennsylvania said after visiting Buchenwald, "No one could visualize these horrors without seeing them." Joseph Pulitzer, editor of the *St. Louis Post-Dispatch*, said: "It is my grim duty to report that the descriptions of the horrors of [Buchenwald] have given less than the whole truth. They have been understatements."[43] The darkest inhumanity of the twentieth century could not be compassed in words. Photographs could lend it reality; the only thing more convincing was seeing it with one's own eyes.

When the Nazi war criminals were tried at Nuremberg, photographs and films were presented as evidence.

One photograph of the camps stands out in memory: Margaret Bourke-White's picture of inmates of Buchenwald staring out from behind a barbed-wire fence. For many people, particularly younger people, this is the image that springs to mind when they think of the camps. Yet so far as I can deter-

Margaret Bourke-White

(1904–1971)

Survivors behind Barbed

Wire, Buchenwald, 1945

Margaret Bourke-White, *Life*

magazine © 1960, 1988 Time

Warner Inc.

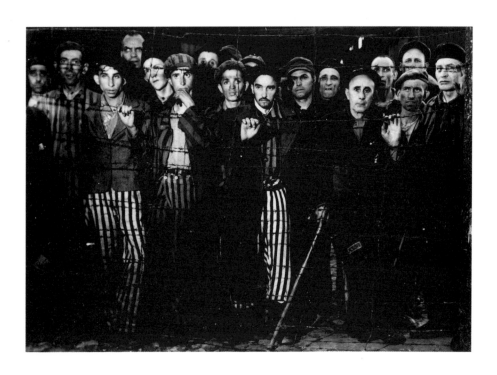

mine, this photograph was not published anywhere in 1945. It was widely reproduced in the 1950s and afterward, notably in *Life*'s twenty-fifth anniversary issue in 1960 and Bourke-White's best-selling autobiography in 1963. In recent years, as interest in her work has soared, this image has been more visible than most other images of the camps; it has come to represent the Holocaust even though it was not tied to the initial revelation.

Although in 1945 it was thought morally imperative to publish pictures of the camps, there was still a certain editorial reticence. Most newspapers relegated the pictures to inside pages. *Life* published one major, harrowing photoessay, then dropped the topic. Bourke-White's photograph may have become iconic partly because it suggests more horror than it depicts. She took many pictures of piles of dead bodies, many of men more skeletal, more obviously at death's door, more shocking than these. I suspect that this photograph has become a historical marker partly because it presents a level of pain that is just within the range of tolerance.

William Henry Jackson

(1843–1942)

Tower Falls, View from Base,

Wyoming, 1871

United States Geological

Survey, Denver

THE EYE OF DISCOVERY

At first the photograph was a bit like the proverbial talking dog—astonishing not because of the depth of its remarks but because it could talk at all. People were agog to see houses and bridges and barns reduced in size and color but otherwise apparently unchanged. They marveled at the detail in daguerreotypes; with a magnifying glass, the tiny shop signs in the background could be read, the bricks on a building could be counted one by one. In no time the camera was also reporting on distant lands and well-kept secrets, but the power to influence by surprise and disclosure was restricted for a while by photography's limitations, particularly its inability to register moving objects and the narrowness of its distribution.

Almost immediately, the camera's reach was extended by pairing it with other inventions. Fox Talbot took pictures through a solar microscope as early as 1839, the moon had its portrait successfully taken by daguerreotype in 1851, and in no time at all traveling cameramen set off across the continents for the view. These early entrepreneurs seldom saw anything that *someone* had not seen before; the camera was not yet a true explorer but a rider on a train or an adjunct of the microscope and telescope.

Daguerreotypes of moon craters and yeast particles in the 1840s, even the first star photographed in 1850, apparently had no measurable effects on science. They were not revelations, not discoveries, just the first photographs taken of the sights that astronomers and scientists sat down to look at each evening after dinner. Engravers had been picturing the moon and the particle for years. Not until after mid-century, when collodion prints replaced daguerreotypes, did photographs begin to take over the role that engravings had once played in scientific works.

In time, photography, having effected a shift in what was considered reliable evidence, began to influence the scientific view of the world. Study of the skies changed significantly when enlargements and gelatin dry plates came in. Astronomers used Henry Draper's 1863 enlargements of his photographs of the moon to correct the names given to lunar mountains; Draper would later photograph the sun and stellar spectra, laying the foundations for much of modern astronomy. In 1880 P.J.C. Janssen declared the camera a valuable scientific instrument with its own powers of revelation: "The sensitive photographic film is the true retina of the scientist," he said. "In the radiative spectrum it covers a range more than double that which the eye can perceive and soon perhaps will cover it all." And by the latter part of the century, after J. B. Dancer produced photomicrographs on glass with sufficiently fine defini-

tion to be useful to researchers, whole areas of science began to be opened up by the camera. One historian reports that " 'the unsuspected world'—as it was often called at the time—of histology, cytology, bacteriology and cristallography [sic], this whole invisible world acquired a new value now that it could be put on show and used to transmit knowledge."[1] The camera's power of discovery was the Siamese twin of its power to convince.

Even the visible world acquired new value in photographs, which began to amend the approved artistic version of the world. Essentially, human beings see as their culture's imaging systems have taught them to see. The Renaissance taught Western civilization to see in one-point perspective, the Cubists taught it to consider a shifting point of view. In Western, industrial societies in the nineteenth century, photography began to reveal that traditional imagery (and traditional ways of seeing the world) might be "wrong." Eugène Delacroix, who worked from nude models, was intrigued by photographs. In 1853 they convinced him that the bodies in Marcantonio Raimondi's highly regarded sixteenth-century prints were intolerably inaccurate. This had not occurred to him before; in fact, he had studied the models in his studio and seen them as Raimondi did before he was able to compare the engravings to photographs.[2]

Eventually, photographs would invent a revelation of their own: a photographic vision (or rather visions, for they changed over time). Photography created a world framed in rectangles, where life was stopped as it flowed by, where odd new relationships were formed by cuts and overlaps, where existence was shown to contain patterns and meanings revealed but not explained by such close scrutiny. In the early years photographers used many ploys to get around what seemed like the deficiencies of the new medium, but sometime in the third quarter of the century the unsettling elements began to seem more acceptable.

By that time photography had prepared the ground for a new appreciation of Japanese prints and the new art of the Impressionists—or perhaps the prints and the art of Edgar Degas, Claude Monet, and Gustave Caillebotte forced a reevaluation of photography. The Kodak and other hand cameras, which put photography into the hands of millions who were apt to make the "mistakes" photography invites because they did not know how to avoid them, made this vision familiar to millions; by the 1920s the 35mm camera placed it in a central position. Eventually, the dominance of photographs would not only instill an appreciation of the qualities photography had taught us to see but would also teach us to read photographic qualities back into the environment. Already in 1857 Degas wrote in an Italian sketchbook that he had seen a group of Franciscans "waiting for a funeral at the door of a church. It is impossible to render. It's not a photograph and yet it's posed to be taken"[3]—perhaps the earliest mention of a photo opportunity, the moment that looks like a photograph.

At later stages in its development the camera was taught to see farther and to focus better up close; it was programmed to see faster and made so small and clever it could sneak in any place. Sometimes it uncovered a secret where none was suspected. The classic movie instance occurred in *Rear Window*, when Jimmy Stewart realized that flowers in a garden had grown shorter in his recent photographs than in his earlier ones. Flowers had not been his subject, but these were in the frame and provided a clue that his eye alone would probably have missed.

Some revelations have resulted from major additions to photography's repertoire. In the 1840s Fox Talbot predicted that the camera would one day

see where human eyes perceived nothing but darkness. Infrared photography was not fully developed until the 1930s, but since then it has made numerous discoveries for doctors and geologists. When the Dead Sea Scrolls were found, some had turned utterly black from centuries of humidity; the human eye could not discern any trace of writing. Photographed on infrared plates, the scrolls miraculously yielded up their secrets. The camera has so jauntily, so ruthlessly explored the nooks and crannies of existence that there is now less of the world to reveal than there once was. Where once photographers expected discoveries around every bend in the road, now they find only other photographers, all of them desperately seeking some wonder that hasn't been staled by photography itself.

By revealing splendors that people might not otherwise see, the camera fed the romantic appetite for the past. Photography introduced Britons to their picturesque ruined abbeys, and it heightened the French national reverence for their country's Gothic heritage. Having turned everyone into armchair explorers, photographs gave a new grandeur to the idea of what people could expect, indeed were *entitled*, to see in their lifetimes.

After the Civil War, when the United States had a new identity, photographers introduced Americans to their own unknown land and their unexplored past: the West. The curiosity, admiration, and yearning aroused by these pictures and by the paintings of artists who often based their compositions on photographs magnified national pride at a time when the nation needed healing. The last spike in the transcontinental railway was driven in 1869; the West was no longer so remote. Images of it seemed to hold the door of opportunity wide open even as the frontier (which was officially declared closed in 1890) was slowly shutting down. Photographers such as William Henry Jackson, Eadweard Muybridge, Timothy O'Sullivan, Carleton Watkins, and others made records that were read as visual confirmation of the country's manifest destiny. These photographs probably had a twofold and contradictory effect. With their visions of abundant mineral wealth, lumber, grazing lands, and water, they helped to lure the settlers and entrepreneurs who would ultimately disrupt and dismantle vast tracts that had been essentially undisturbed for millennia. On the other hand, the photographs helped stay the onslaught of progress with their evidence that some of the land should remain inviolate forever.

Yosemite Valley, first seen by white men in 1833 and discovered again in 1851, remained almost unknown to the public until an article appeared in *Country Gentleman* in 1856. The news was soon being broadcast in the *New York Tribune* and the *Boston Evening Transcript*, and Americans began to speak of Yosemite as one of the great wonders of the world.[4] The place was still known primarily through written description and some artists' sketches; the rest was imagination.

The valley was first photographed in 1859 by Charles Leander Weed and Robert H. Vance. Their photographs were exhibited in Sacramento. Weed's were illustrated by engravings in a California magazine, and articles about Yosemite appeared in the press.[5] In 1861 Carleton Watkins photographed the valley on mammoth plates—sheets of glass approximately 18 by 22 inches, weighing about four pounds apiece, which had to be carried, along with his heavy cameras, a darkroom tent, and processing chemicals, across mountain and forest. His photographs and stereographs astonished viewers with their technical and aesthetic perfection. (In 1867 he would win an international award for landscape at the Paris Exposition.) Watkins conveyed a sense of

sublime immensity and preternatural stillness, bringing order to an extravagant landscape. With sweeping compositions that emphasized the majesty and timelessness of huge trees, rock forms, and water that turned to glass under the long exposures of his camera, he presented a landscape that seemed to provide a direct glimpse of eternity.

Oliver Wendell Holmes and Ralph Waldo Emerson saw these photographs in 1862, and Goupil's Art Gallery in New York put them in their window and on display. Holmes wrote about Watkins and brought the photographs to national attention in the *Atlantic Monthly* in 1863: "One of the most interesting accessions to our [stereograph] collection is a series of twelve views, on glass, of scenes and objects in California, sent us with unprovoked liberality by the artist, Mr. Watkins. As specimens of art, they are admirable, and some of the subjects are among the most interesting to be found in the whole realm of Nature."[6] These images, widely disseminated, helped establish in the public's mind the idea that Yosemite was unique.

Developers and settlers were already hatching plans to harvest Yosemite's riches. A few men, including Frederick Law Olmsted (best remembered as the designer of New York's Central and Prospect parks), moved to preserve it as it was. One advocate of preservation wrote to California

Senator John Conness in March 1864 asking that the land be protected and including a package of large photographs, most probably by Watkins. Conness introduced a bill on the floor of Congress that same month. His letter requesting a draft of a bill does not mention any pictures, and although it is usually reported that he showed the prints to his colleagues and that some hung them in their offices, that has never been substantiated.[7]

It is nonetheless highly likely that Watkins's photographs encouraged Conness, and presumably other senators, to back this legislation. The medium's power held its viewers in thrall. In 1866 the editor of the *Philadelphia Photographer*, writing about views of Yosemite, noted, "It has been said that 'the pen is mightier than the sword,' but who shall not say that in *this* instance, at least, *the camera is mightier than the pen?*"[8] Even if the influence of Watkins's pictures was more indirect and general, it indicates how early the combined forces of photography and the press succeeded in setting the agenda and determining the issues deemed important by the public.

The Yosemite bill did not establish a national park but a California state protected area. Even so, the idea behind it was new. In Europe hunting preserves and scenic areas were frequently accessible only to the wealthy or at their sufferance; there was no tradition of common use of the land. Since colonial days the American idea had been to put the land to economic advantage as soon as possible. But photography contributed to the idea of public lands, at precisely the right place and time. The prodigal natural formations of the West that explorers described and photographers depicted were quintessentially American; they were the monuments of the country's only antiquity.[9] By mid-century, industry and technology had so overrun the land that smoke from a passing railroad engine cast shadows over Thoreau's field at Walden Pond. The photographs of newly discovered scenes in the West renewed the promise of the land for a moment, and the idea of safeguarding natural splendors was a means of defending that promise while reaching a kind of compromise with progress.

In the late 1860s and '70s, the federal government sponsored extensive expeditions to explore the West, map it, and fathom its geological secrets. Photographers and artists trekked with them into the wilderness, and photographs almost immediately became an essential instrument of propaganda. Clarence King's Fortieth Parallel Expedition displayed Timothy O'Sullivan's photographs in Washington, D.C., in 1868 and distributed some of them to influential congressmen to help convince Congress to renew the appropriation. (They worked.) The Wheeler and Powell surveys at the beginning of the 1870s always had a photographer in their train.

Such expeditions became a training ground for several of the finest American landscape photographers. Their pictures, widely seen, provided a kind of vicarious adventure for urban stay-at-homes. They established in the popular mind the myth of the western wilderness, even as the basis of that myth was being eroded by the tourism and settlement these remarkable pictures were helping to promote.

In 1871 Ferdinand V. Hayden, director of the first official survey of the Yellowstone region in what is now Wyoming, took along five recording artists: three photographers, including William Henry Jackson, and two artists, one of whom was Thomas Moran, the well-known painter. Jackson and Moran worked side by side, with Moran scouting sites for Jackson and later using his photographs as models for paintings. Rumors about the Yellowstone region had been seeping out since the 1830s, but excitement really mounted around 1870, when expeditions began in earnest. Photographs of the region

Carleton Watkins

(1825–1916)

Vernal Falls—300 Feet,

Yosemite, 1861

The New York Public Library,

Astor, Lenox and Tilden

Foundations, Miriam and Ira

D. Wallach Division of Art,

Prints, and Photographs

43

were startling. *Everything* about Yellowstone was startling. One enthusiast, N. P. "National Park" Langford, published articles and lectured widely in the East. His hard-to-believe accounts, like all descriptions of the place, were full of marvels: explosive geysers, steaming fumaroles, bubbling mudpots. Hayden's report was eagerly awaited as a scientific confirmation of such fairy-tale phenomena.[10] As Hayden's various reports became popular reading, the accompanying photographs gave many Americans an introductory education on the subject of America's improbable glories.

In December 1871 bills were introduced in the House and Senate to make the region a national park. (Yellowstone was then in the Wyoming Territory, and it was feared that the kind of state control recently mandated at Yosemite would provoke a quarrel between Wyoming and Montana.) The bill had support from a number of interests: the Northern Pacific Railroad, which wanted to boost the tourist traffic; Jay Cooke and his banking firm (Cooke controlled the railroad); local people who stood to benefit financially if Yellowstone became a park; and government representatives who had idealistic, or not so idealistic, reasons to preserve it. A set of William Henry Jackson's photographs was sent to the president of the railroad during the congressional debate.[11]

Of the two other photographers on the Hayden expedition, one was from Montana and his photographs were seen only locally. The other, from Chicago, returned home just in time to see his negatives destroyed in the Chicago fire, which prompted Jackson to remark, "The fact that my pictures were the only ones to be published that year is something for which I have to thank Mrs. O'Leary's cow."[12] Jackson's pictures present an awed but bold vision of an eccentric corner of nature. The terraces of Mammoth Hot Springs became as elegant as an emperor's throne and as bizarre as the Arabian nights; craters and steaming geysers were like haunted lunar landscapes. These were tall tales Americans could be proud of.

Hayden arranged for the legislators a display of specimens of the mineral wealth and animal life of Yellowstone, plus Jackson's photographs and Moran's watercolors. He personally lobbied most of the congressmen. So did Langford, whose articles were distributed to every senator and representative, along with a copy of an earlier report. Jackson and his son later wrote that his photographs of Yellowstone were critical elements in the campaign for a national park, saying that every legislator received an album of Jackson's photographs, which were so convincing they turned the tide for the bill. No such albums have turned up, and it appears that the Jacksons exaggerated. However, individual photographs were freely distributed, some sets were apparently made up, and the pictures and specimens on display spoke at least as loudly as words.[13] The photographs did contribute, they were influential, but they were only one element among many. The bill was signed into law by President Grant on March 1, 1872, creating what was in effect the first national park in America—or anywhere in the world.

Jackson's photographs were revelation, confirmation, record, and persuasion all at once. They were extremely popular as stereographs, and Jackson undoubtedly had an eye on the private market when he composed them. But many other pictures from the various surveys were primarily scientific reports, as attractively made as possible, yet essentially no more than lucid accounts of rocks and barren plains. Time shifts the purpose and evaluation of photographs; these have been transmuted into art during our own times with the growth of the photography market.

Hayden's belief in the significance of illustrations, a belief he stressed in

William Henry Jackson

(1843–1942)

Crater of the Castle Geyser,

Wyoming, 1871

United States Geological

Survey, Denver

his reports, was shared by the government. The secretary of the interior had instructed him to "collect as ample material as possible for the illustration of your final reports, such as sketches, sections, photographs, etc." When Congress voted Hayden money for another survey in the spring of 1872, it included an additional ten thousand dollars for engravings to illustrate the expedition's publications. "Now," as one historian puts it, "even Congress had ratified the power of the visual." In 1875 the *New York Times* wrote about the survey, "While only a select few can appreciate the discoveries of the geologists or the exact measurements of the topographers, everyone can understand a picture."[14] Photographs were revelations that worked fast.

Not so long ago, photographs contributed even more directly to the creation of a national park: Kings Canyon, in the Sierra Nevada in California. Like all the parks, it had to be rescued from the march of development. At the turn of the century John Muir, finding sheep grazing on privately staked claims in what had been an untouched paradise, fought to have the area included in the national park system but died too soon. Lawmakers subsequently proposed bills to give it park status in 1918, 1921, 1923, 1928, 1929, and 1935. All were defeated. The Kings Canyon area was so rich in timber and in the potential for water storage, hydroelectric power, and grazing and hunting fees that local opposition was highly organized and powerful. In 1935, with a state highway under construction that would reach into the canyon, the stakes were raised.[15]

In 1936 the Sierra Club enlisted Ansel Adams in the cause. Adams had been photographing in the high reaches of the Sierra Nevada for over a decade, and in a way he would make it visible for his time, as Watkins had for his. Adams later said that he never took a photograph that amounted to much

for the sake of an environmental cause, but several he had taken for love of a place were used afterward to good advantage. He was, in a sense, the last of the great nineteenth-century landscape photographers. Not only did he profit from the aesthetic examples of photographers like Jackson and especially Watkins, but he seems to have shared their transcendentalism, their belief in the immanence of spirit in the landscape, their faith in the power of unspoiled nature—a faith that has receded elsewhere before the advance of development, pollution, even overuse of the national parks. Adams's photographs render the grandeur of his chosen landscapes with pellucid clarity, a rigorous sense of design and contrast, and exquisite technical control.

The Sierra Club sent Adams east to lobby for the Kings Canyon bill. He took his portfolio to conservation societies in New York to enlist their support. He spoke at a conference on the National Park Service in Washington, D.C., and set up his photographs on easels outside the conference room, then took the portfolio around to congressmen, cabinet officers, and other officials; but the Kings Canyon bill failed yet again.[16]

Another bill was proposed in 1938, and passionate campaigning resumed on both sides. That year Adams published a book, *The Sierra Nevada and the John Muir Trail*, with stunning pictures of the canyon. He sent a copy to Harold Ickes, secretary of the interior, whom he had met at the 1936 conference. A few days later a Park Service official wrote to request a second copy for Ickes: "Yesterday the Secretary took it to the White House and showed it to the President, who was so impressed with it that the Secretary gave it to him." Adams sent off a second copy. Ickes thanked him: "I hope that before this session of Congress adjourns the John Muir National Park in the Kings Canyon area will be a legal fact. Then we can be sure that your descendants and mine will be able to take as beautiful pictures as you have taken—that is, provided they have your skill and artistry."[17]

By 1938, when photographic revelations were in dwindling supply, the photograph as lobbyist had been converted from a single print or a stereograph to a book and from a scientific report to a work of art. The bill did not pass in 1939, but the Department of the Interior remained solidly behind it, and Ickes gave speeches in California and spoke on the radio on its behalf. The Sierra Club published "highly artistic" bulletins backing the park.[18]

At last, on March 4, 1940, lands were transferred from the Sequoia and Sierra National Forests to the Kings Canyon National Park. Arno Cammerer, the Park Service director, wrote to Adams: "A silent but most effective voice in the campaign was your own book, *Sierra Nevada: The John Muir Trail*. As long as that book is in existence, it will go on justifying the park."[19]

Today, as consciousness of the endangered environment grows, landscape photography still retains the power to perform an effective service on behalf of the land, despite the current deluge of calendar and magazine photographs, which might well have left the viewing audience sated and indifferent. Photographs seem to convey the sense of unspoiled land and of irretrievable loss with a directness and a sense of scale that nothing else quite matches. Robert Glenn Ketchum's photographs, for example, are credited with helping pass a 1990 bill to preserve the Tongass National Forest in Alaska, and photographs have helped foil a sufficient number of real estate projects to make developers wary of their power.[20]

One of the great discoveries of the physical sciences was also an unanticipated and highly specialized technical breakthrough in photography, and photographs spread the news with almost unprecedented rapidity. Wilhelm

Ansel Adams (1902–1984)

Mount Clarence King, Pool,

Kings Canyon National Park,

California, 1925

The Ansel Adams Publishing

Rights Trust, Carmel,

California

Conrad Röntgen, professor of physics at the University of Wurzburg, Germany, discovered X rays in 1895. He was doing research on cathode rays in a Hittorf-Crookes tube when he witnessed a phenomenon he had never seen before and could not explain. (A Crookes tube is an all-glass vacuum tube through which a stream of electrons is passed; as electrons were not then named or firmly established in scientific terms, emissions of electrons from the negative pole of an electrical circuit were known as cathode rays.) Röntgen worked in a darkened room with the tube covered by a black cardboard jacket so that no visible light of any known kind of ray could penetrate into the room from within the tube or from anywhere else. Yet a small piece of cardboard painted with barium platinocyanide, a fluorescent compound, glowed with a greenish light when discharges passed through the tube.

Röntgen, puzzled, proceeded to experiment. He held up various objects between the cardboard screen and the tube. A thin sheet of aluminum let the mysterious rays pass through, a sheet of lead did not. When he held up the sheet of lead, a startling sight appeared at its edge: the outline of his thumb and finger threw a shadow on the cardboard screen and within that shadow were darker shadows still—the bones inside his hand.

Röntgen tested his discovery on photographic plates. He photographed through the door of the dark room, he photographed the contents of a closed box. (As happens so often in the history of science, others had accidentally discovered X-ray photographs a few years before Röntgen but did not understand what they had, nor try to explain it. As Pasteur said, "In the fields of observation, chance favors only the mind that is prepared."[21]) One evening Röntgen asked his wife to place her hand on a photographic plate while he directed the rays from the tube at it for fifteen minutes. Her bones and ring showed up clearly on the print. Röntgen, looking at this simple, dramatic image of his wife's bones, saw the power of a ray previously unknown to science. Today, accustomed to the sight of anatomical X rays, you and I may be most struck by the historical detail of a ring worn on the second joint of the finger. Frau Röntgen, seeing her own skeleton for the first time, felt a vague premonition of death.

Röntgen realized instantly how immensely his discovery could benefit medical diagnosis and treatment. On December 28, less than two months after his initial observations, he delivered a manuscript on the new rays to the Wurzburg Physical Medical Society. The news raced across the world. The Vienna *Presse* published a front-page story on January 5, 1896; the *London Chronicle* followed soon after. Other newspapers leaped in, and Röntgen became the center of an international storm of excitement, praise, and censure. (He was awarded a Nobel Prize for physics in 1901, the year the prizes were instituted.) Medical journals in Britain, Europe, and America rushed into print with articles on the medical usefulness of the new rays.

Röntgen was a modest man who valued solitude and quiet for his research. He refused to call his find "Röntgen rays," as many urged, for he did not believe that the physical sciences belonged to individuals. He always referred to them as "X rays" to indicate their unknown character. His find occurred at a moment when discoveries in the physical sciences had apparently stalled, and scientists seem to have been spurred to greater activity by his breakthrough. Within little more than a decade the electron, the disintegration of the atom, radioactivity, and radium had all been confirmed.

It was the photographs even more than the significance of the discovery that created the great public stir about X rays. Without photographs, the announcement of a new kind of ray that could penetrate aluminum but not

lead would have been greeted as just another astonishing discovery in the physical sciences that no one could understand. But by the second half of the 1890s, when newspapers could reproduce photographs in halftone, this particular scientific breakthrough could almost literally be *embodied* and thus seen and understood by everyone. Röntgen himself was disturbed by the reaction to the pictures: "For me photography was the means to the end, but they made it the most important thing."[22]

X rays have made major changes in medical diagnosis and treatment, as well as in metallurgy and many branches of scientific investigation, such as crystallography and atomic studies. Having the veracity of photographs, they

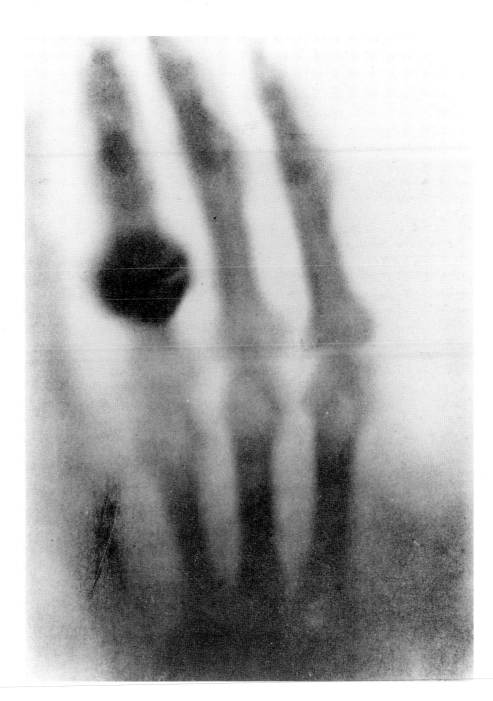

Wilhelm Conrad Röntgen

(1845–1923)

X Ray of Frau Röntgen's

Hand with Ring, c.1895–96

National Library of

Medicine, Washington, D.C.

were entered as evidence in court as early as March 1896. The dangers of too much exposure to X rays were also apparent very early: a man demonstrating the power of the new rays two or three hours a day at the Bloomingdale Brothers department store in New York noticed that his fingernails stopped growing and his skin began to scale. Not long after his skull was x-rayed, his vision was impaired and the hair of his temples, eyebrows, and lashes fell out. In the beginning, exposures ranged from twenty minutes to some hours; as early as 1896 better plates were devised and means were found to reduce exposures to a few seconds.

The idea of seeing through flesh was so stunning that some suggested the X ray would further the temperance cause by revealing to drunkards the steady deterioration of their own bodies. Others supposed the human soul might now be photographed. A New York newspaper reported that at the College of Physicians and Surgeons, X rays had been used to project anatomic diagrams directly on the brains of medical students to enhance the learning process. An assemblyman introduced a bill into the New Jersey legislature to prohibit the use of X rays in opera glasses inside theaters, but a London firm had already marketed a product that would make the bill unnecessary: "X ray–proof underclothing."

In March 1896, within months of the discovery, *Wilson's Photographic Magazine* regarded it as just another license for photographic intrusion into the individual's dwindling privacy: "It will add unspeakably to the horror with which the Kodak is regarded. It is bad enough even now, when one is in an undesirable or ludicrous attitude or situation, to hear the 'click' of that infernal machine and to realize that the attitude or situation has been perpetuated for one's future confusion, or it may be condemnation. How much worse will it be when the merciless instrument has the power of piercing not only one's clothing but the flesh as well, and reproducing, it may be, one's mental condition. How can we tell that one's very thought may not be laid open to this new power which passed through all fleshy disguises as easily as light does through glass."[23]

Sometimes objects are clearly seen but not recognized for what they are because the mind is unprepared or ill equipped to understand their significance—Poe's purloined letter, for instance, or the perfectly visible fortune hidden from all but philatelists in the guise of rare stamps on an envelope in the 1963 film *Charade*. Like other evidence, photographic proof may be bootless and photographic revelation remain mute if the eye is open but the mind is closed to its message. Readiness to believe must be added to evidence before it can carry weight. The X-ray diffraction photograph that proved key to Francis Crick and James Watson's theory of the double helix was taken by Rosalind Franklin, who decided that the helical theory was wrong shortly after taking the photograph that ultimately established its correctness. Seeing is believing, but only if established belief is not an impediment.

Before the invention of high-energy accelerators, cosmic rays (which had been discovered shortly after 1900) were photographically recorded in Wilson cloud chambers. Vapor condenses on the ions of rays passing through a super-saturated cloud chamber; the resultant trail of fog particles is visible on a photographic plate. (As it is impossible to know when a cosmic ray is in transit, huge numbers of photographs were taken that showed nothing whatever.) In 1931 Carl David Anderson, then aged twenty-seven, built a chamber at the California Institute of Technology with a stronger magnetic field than any previously employed in cosmic-ray studies. Magnetism curves and de-

flects the paths of charged electrical particles. Anderson placed a lead plate across the center of the chamber (the heavy horizontal in the photograph). This weakened the particle as it passed through, and since the path of a weaker particle curves differently from the path of a stronger one, it was possible to determine the direction of flight from the different degree of curvature above and below the plate.

In 1932 Anderson developed a photograph of a particle he was not looking for. It had not behaved like a proper particle. It had the mass of an electron but a positive charge, which amounted to a contradiction in terms. At that time electrons were known to be negatively charged. Robert A. Millikan, Anderson's teacher and the director of his research project, had won the Nobel Prize in 1923 for measuring the exact negative charge of the electron. And from 1919 on, once the existence of the proton, a positively charged particle, had been definitely established, the negative electron and positive proton were considered the two basic elements of electricity and the fundamental building blocks of the atom.

Anderson's photograph seemed to show a third particle, but there was no room for one in the accepted vision of the universe. He was well aware of this and tried to make the photograph behave better. He and a research colleague stayed up all night after this picture was taken, trying to figure out a way to fit it into the world as physicists understood it. They could not, and at last Anderson gave in to the evidence. He had discovered the positron, a new

Carl David Anderson

The Discovery of the Positive

Electron or "Positron," 1932

Science Museum Library,

London

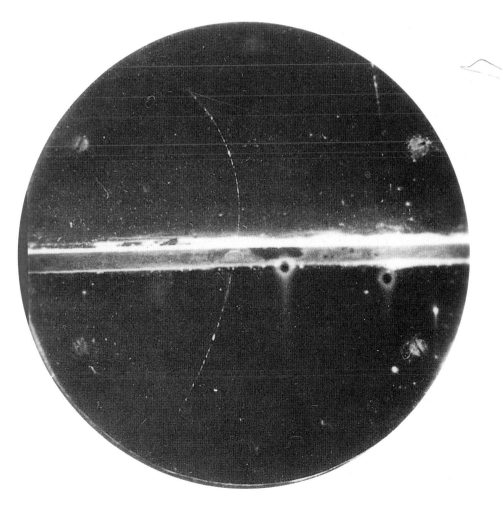

fundamental particle and the first evidence of antimatter. It was actually the first in a long line of new particles. Anderson himself would shortly discover another. He wrote that negative protons must also exist, a theory not experimentally confirmed until twenty-four years later. Anderson was awarded the Nobel Prize in 1936.

As it is rare for basic concepts of matter to be altered, Anderson's discovery rocked the world of physics. One scientist said the particle in this photograph was "probably the most famous individual corpuscle in the history of physics."[24] Five years before Anderson's discovery, the existence of a positive electron had been postulated by Paul A. M. Dirac in a brilliant mathematical treatise, but physicists, even though recognizing the elegance of Dirac's math, had not looked for physical evidence of such a particle because it violated their world view. Certainly Anderson was not attempting to confirm Dirac's theory; the discovery was entirely accidental. But other researchers had photographed the positron before Anderson did (in one case only months before), then failed to identify it because they had no theoretical structure that would make such a particle intelligible. Anderson's correct, courageous identification of the particle—Nils Bohr and Ernest Rutherford, the giants of physics in his day, were quite skeptical before they saw the visual proof—rested on his willingness to embrace evidence that ran counter to accepted belief.[25]

Often what is nearest is hardest of all to see—try asking a fish to define water. Distance opens a door to revelation. When the first great distances of space were conquered by technology, a camera altered the human perspective on the Earth as radically as Galileo did when he proved that the sun was the center of the universe. The ecology movement was born from a photographically altered consciousness.

In 1948 Fred Hoyle, the British cosmologist, predicted that a photograph from space would change humanity's relationship to the planet: "Once a photograph of the Earth, taken from outside, is available, we shall, in an emotional sense, acquire an additional dimension. . . . Once let the sheer isolation of the earth become plain to every man, whatever his nationality or creed, and a new idea as powerful as any in history will be let loose." In 1970, at the Apollo II Lunar Science Conference in Houston, Hoyle recalled his prediction:

Well, we now have such a photograph. . . . Has any new idea in fact been let loose? It certainly has. You will have noticed how quite suddenly everybody has become seriously concerned to protect the natural environment. Where has this idea come from? You could say from biologists, conservationists and ecologists. But they have been saying the same things as they're saying now for many years. Previously they never got on base. Something new has happened to create a world-wide awareness of our planet as a unique and precious place. It seems to me more than a coincidence that this awareness should have happened at exactly the moment man took his first step into space.[26]

Space was conquered by degrees. Late in 1957 the USSR sent *Sputnik* up to whirl around Earth. A month later a Russian dog spun into orbit and lived to place her paws on friendly ground once more. Technology moved fast. In 1958 the U.S. put a communications satellite into orbit; in 1961 Yuri Gagarin was the first man to make an orbit of Earth at the altitude of a passing meteor.

Then another Russian, then the American John Glenn in 1962—human beings were constructing their own small version of a geocentric universe, with satellite bodies revolving around our planet.

Space travel rapidly became a metaphor for worldwide interdependence. A manned satellite was a self-contained environment with all the necessities of life; if one element failed, then everything failed. Gradually, a few people began to think that our world might work the same way, that every place was somehow interconnected, that the polluted air of one nation could not be kept from invading another by a vigilant border patrol. When U.S. Ambassador Adlai E. Stevenson gave his final address to the United Nations Economic and Social Council in 1965, he said, "We travel together passengers on a little spaceship, dependent on its valuable reserves of air and soil; all committed for our safety to its security and peace; preserved from annihilation only by the care, the work, and I will say the love we give our fragile craft."[27] The idea of spaceship Earth was borrowed by others and became a catchword.

For several years, the press had been warning us that spaceship Earth was fragile indeed. The papers (especially in 1961) had been full of frightening stories about the chances of nuclear warfare and terrible destruction, about bomb shelters and radiation contamination of the food supply, even of human breast milk. In 1962 Rachel Carson's *Silent Spring* alerted the world to the dangers of pesticides. An idea was percolating: the globe could not support the life on its surface if some parts were malfunctioning.

At precisely this moment, photography made the beauty of the environment and the threat to it more visually available than ever before. The first of the Sierra Club's oversize and beautifully printed "exhibit format" books, illustrated by such photographers as Ansel Adams and Eliot Porter, came out in 1960; the series was hugely popular. T. H. Watkins, editor of *Wilderness* magazine, considers these books "the centerpiece around which the movement rotated. They gave visual power to the movement that it didn't have."[28] Later in the decade, when most calendars were still business promotions sent out by insurers or local merchants, the club began publishing its immensely successful calendars, which put rapturous color photographs of wilderness scenes on display day in, day out in kitchens and offices all over America.

As people saw more and more of the land's beauties and grew increasingly uneasy about its stability, acceptance of public responsibility for the environment began to surface. State legislatures in America initiated laws to regulate the use of pesticides. In 1963 the U.S. government passed a Clean Air Act; in 1965 federal emissions standards for automobiles were established. Still, the public is not stirred up all that easily. Ecology could not yet claim a movement, but it soon would.

On August 23, 1966, an automatic camera mounted in a satellite captured a picture of the earthrise from the vicinity of the moon, but it was not widely published or noticed.[29] In February of that year one man had a vision of Earth from a low roof in San Francisco and decided to lobby for the real thing. The man was Stewart Brand, who was not an astrophysicist, not an official of NASA, and probably not exactly rational when he first said he saw the actual curvature of Earth. With the help of one hundred micrograms of LSD, he suddenly realized that a color photograph of the planet from space would change the way everyone thought about it. The United States and the USSR had been sending all sorts of hardware aloft for ten years, but no one had ordered the cameras to look behind them. A slogan suggested itself: "Why haven't we seen a photograph of the Whole Earth yet?"

The next day Brand ordered several hundred buttons and posters with this message. He says he sent the buttons to "NASA officials, the members of Congress *and* their secretaries, Soviet scientists and diplomats, UN officials, Marshall McLuhan and Buckminster Fuller" and began to hawk them at the University of California in Berkeley for a quarter apiece. He was thrown off campus, the *San Francisco Chronicle* reported it, and his campaign was on its way to becoming a legend. He went on to sell buttons at Stanford, Columbia, Harvard, and MIT. " 'Who the hell's that?' asked an MIT dean, watching hordes of his students buying my buttons. 'That's my brother,' said my brother Pete, an MIT instructor."[30]

Brand says that an MIT astrophysicist bought one of his buttons, and an astronaut later told him they were visible on lapels around Washington and NASA. Buckminster Fuller wrote to say that it wasn't possible to see more than half the Earth at once anyway. Brand met him not long after; Fuller begged him to forget the letter, asked what he could do to help, then made the idea of a Whole Earth photograph part of a speech he was giving. Brand says, "I was tapping into a desire people didn't know they had."[31]

In August 1967, *Lunar Orbiter 5* took a nearly full-disk image of Earth, and that November an editorial in the *Saturday Review* suggested that the secretary general of the United Nations deliver an annual State of Mankind address about issues confronting all nations, so that all might see "the planet as a whole, just as the astronauts see the unity of the globe when they fly around it."[32] About this time Brand made a poster of a fairly crude, black-and-white photograph of the Whole Earth for an event he staged at San Francisco State College. In November an ATS satellite twenty-three thousand miles above South America made a kind of home movie of the planet, transmitting a color photograph every half hour via television until it had completed a twenty-four-hour sequence of the Earth's rotation. In the portion taken at noon, the diminutive disk of Earth, familiar from maps but breathtakingly foreign and wholly new, hung precariously in an enormous void. (It is surely fitting that ever since the mid-1960s, when a camera strap broke as an astronaut was taking a spacewalk and his Hasselblad whirled off into space, a lone camera has been orbiting Earth, perhaps its smallest satellite.[33])

Photographs are direct and immediate, but like ideas, their full import may take time to sink in. A few, a very few, act like matches and set instant fires. Most pile up like tinder with other pictures and events until they can generate a lot of heat. This photograph of our planet rendered suddenly small and precious and adrift without markers in space appeared in newspapers, but Brand says no one made a big fuss over it. He, at least, let it loose in the culture. The first *Whole Earth Catalogue*, which he founded, put it on both the front and back covers in the fall of 1968. On the back cover were the words "We can't put it together. It is together." The *Whole Earth Catalogue* offered the picture as a poster, but it was the *Catalogue*, which sold extremely well, that made it visible in so many places.

In small pockets here and there the ecology movement had begun to take shape in the 1960s. Still, the American presidential candidates spoke very little about ecology in 1968, and only late in the campaign. The movement had barely begun to gather political force. It embraced the concept of the biosphere, an environment of wholly interdependent parts, which had been popularized by the French priest and paleontologist Pierre Teilhard de Chardin and reinforced by the spaceship analogy. In 1968 UNESCO sponsored an international Biosphere Conference. That year at Christmastime, three American astronauts on the *Apollo 8* mission raced around the moon to see its dark

NASA ATS III 18Nov67 125656Z 13N

Earth, as Viewed from ATS

Satellite, November 1967

Color photograph

National Aeronautics and

Space Administration,

Washington, D.C.

side and put the Earth in its place. The moment was dramatic. There were fears that if they locked into orbit around the moon they would not be able to break free of its gravitational pull but would rotate there through eternity, a little metal satellite. All humanity seemed to watch as an old year ended and a new era began.

At midday the astronauts broadcast live on television to nations everywhere, sending back images of Earth that looked "like a sort of large misshapen basketball that kept bouncing around and sometimes off the screens back here."[34] Not much more than half of the hemisphere was visible; even so, it was startling to look at the only spot in the universe we could live on and see nothing but clouds and bare outlines of continents—no sign whatever that anyone was home. Poets and philosophers had told us for centuries that human beings were insignificant and transient, but no one had shown us so forcefully how tiny, how alone, how poignantly beautiful our planet was.

The next day the capsule beamed back pictures of a desolate moon-

scape, and Captain James A. Lovell, Jr., referred to Earth as a "grand oasis in the big vastness of space."[35] The day after Christmas the screen was filled with portraits of a three-quarter Earth. After *Apollo* came back from making rings around the moon, NASA released stills that had been taken on the journey, miraculous images that only gods and spirits could have seen before. Most heart-catching of all was a picture of the Earth rising over the moon's horizon—luminous and beckoning beyond the flat, exhausted plain of its constant companion.

On December 26, the day after the astronauts had read from Genesis over worldwide television and while they were still aloft, the poet Archibald MacLeish wrote, "Earth was no longer the World but a small, wet, spinning planet in the solar system of a minor star off at the edge of an inconsiderable galaxy in the immeasurable distances of space." The astronaut William Anders gave us his view from thousands of miles out: "I think that all of us subconsciously think that the Earth is flat, or at least almost infinite. Let me assure you that, rather than a massive giant, it should be thought of as [a] fragile Christmas-tree ball which we should handle with considerable care."[36]

The TV broadcast had beamed to sets in every major country except China. Stills from those broadcasts appeared on front pages across the globe, and the stills released on December 29, where Earth floated silently in space rather than bouncing awkwardly on a screen, appeared in newspapers, magazines—in early January, *Life* had page after page of magnified images—and soon on book covers, posters, ads, and postage stamps. For once language and culture made no difference. This was a new perspective

William Anders (born 1933)

Earthrise, December 24, 1968

Color photograph

National Aeronautics and

Space Administration,

Washington, D.C.

on everyone's birthright, everyone's life support, everyone's home.

Like a parent who no longer seems so big once we grow up, Earth had been deprived of its majestic size and power by the long view. We were stunned to finally realize that although it was all we had, it was every bit as *minor* as astronomers said it was. At the same time, that startling comparison to the moon made our planet seem stupendously alive, unique, and valuable. The *Last Whole Earth Catalogue* (1974) published on its inside front cover "the famous Apollo 8 picture of the Earthrise over the Moon that established our planetary facthood and beauty and rareness (dry moon, barren space) and began to bend human consciousness."

It had. People who had been clucking about pesticides and pollution for years were suddenly joining groups and donating money. What had begun in the isolated efforts of long-established conservation groups, of hippie communes, of outdoorsmen in Oregon worried about their dying forests and housewives in New Jersey concerned about their polluted water, began to spread and coalesce. Many who started out on the older ecological path, hoping to protect the fish in their own stream, found themselves fighting to preserve the entire planet. Essentially, though, ecology marched in with the youth movement and took most of its energy from college students. It grew from the bottom up: environmentalism was one of the few crusades of recent times to come from the people and spread to the leaders. A handful of images that touched the heart helped spark a true mass movement.

The photograph of Earth rising over the moon, together with the other *Apollo 8* photographs of the starved lunar landscape and the pulsating Earth, reinforced a new idea: Earth was alive. That idea had been born in the space program before there were photographs to support it. In 1965 or just before James Lovelock, an English scientist hired as a consultant to NASA in its search for life on Mars, decided that it was not necessary to travel to the red planet to decide it was dead. Analysis of its atmosphere was quite sufficient to convince him that nothing could crawl or lumber or swim over its angry surface. On the other hand, he wrote later, "The only feasible explanation of the Earth's highly improbable atmosphere was that it was being manipulated on a day-to-day basis from the surface, and that the manipulator was life itself."[37] Lovelock believed not just that life on Earth was a series of interdependencies but that Earth itself was a living being—he named it Gaia, for the ancient goddess of Earth—and that an atmosphere that could support life was constantly manufactured, maintained, and adjusted by the actions of every part of the organism, from rocks to oceans to air.

Lovelock launched the Gaia hypothesis in the late 1960s; he said it appealed to exactly two people, though it would later stir up a lot of controversy. But he credited the photographs of Earth with the power to change scientific attitudes: "This gift, this ability to see the Earth from afar, was so revealing that it forced the novel top-down approach to planetary biology."[38]

After 1968 Earth would never look the same. Then, in 1969, two Americans walked on the moon, and it was a new moon to us. We kept getting glimpses over the astronauts' padded shoulders, past the American flag impaled in lunar soil, beyond the rocky horizon of the moon, of Earth hanging there twinkling and gleaming. Twenty years later Lewis Thomas wrote in the *New York Times* that the most vivid impression of the moon walk was the picture of Earth. "As anyone could plainly see in the photograph, it was *alive*. . . . That photograph, all by itself, was the single most important event in the whole technical episode, and it hangs in the mind twenty years later, still exploding in meaning."[39]

SURRAT. BOOTH. HAROLD.

War Department, Washington, April 20, 1865,

 # $100,000 REWARD!

THE MURDERER

Of our late beloved President, Abraham Lincoln,

IS STILL AT LARGE.

$50,000 REWARD

Will be paid by this Department for his apprehension, in addition to any reward offered by Municipal Authorities or State Executives.

$25,000 REWARD

Will be paid for the apprehension of JOHN H. SURRATT, one of Booth's Accomplices.

$25,000 REWARD

Will be paid for the apprehension of David C. Harold, another of Booth's accomplices.

LIBERAL REWARDS will be paid for any information that shall conduce to the arrest of either of the above-named criminals, or their accomplices.

All persons harboring or secreting the said persons, or either of them, or aiding or assisting their concealment or escape, will be treated as accomplices in the murder of the President and the attempted assassination of the Secretary of State, and shall be subject to trial before a Military Commission and the punishment of DEATH.

Let the stain of innocent blood be removed from the land by the arrest and punishment of the murderers.

All good citizens are exhorted to aid public justice on this occasion. Every man should consider his own conscience charged with this solemn duty, and rest neither night nor day until it be accomplished.

EDWIN M. STANTON, Secretary of War.

DESCRIPTIONS.—BOOTH is Five Feet 7 or 8 inches high, slender build, high forehead, black hair, black eyes, and wears a heavy black moustache.

JOHN H. SURRAT is about 5 feet, 9 inches. Hair rather thin and dark; eyes rather light; no beard. Would weigh 145 or 150 pounds. Complexion rather pale and clear, with color in his cheeks. Wore light clothes of fine quality. Shoulders square; cheek bones rather prominent; chin narrow; ears projecting at the top; forehead rather low and square, but broad. Parts his hair on the right side; neck rather long. His lips are firmly set. A slim man.

DAVID C. HAROLD is five feet six inches high, hair dark, eyes dark, eyebrows rather heavy, full face, nose short, hand short and fleshy, feet small, instep high, round bodied, naturally quick and active, slightly closes his eyes when looking at a person.

NOTICE.—In addition to the above, State and other authorities have offered rewards amounting to almost one hundred thousand dollars, making an aggregate of about TWO HUNDRED THOUSAND DOLLARS.

"The Murderer," 1865

Poster

Library of Congress,

Washington, D.C.

SOMEONE IS WATCHING

It was obvious from the outset that photography would be a prize detective. By the mid-1840s Fox Talbot had suggested that photographs could identify stolen items; in 1854 the Swiss police identified a suspect by sending copies of a daguerreotype to all cantons; and in 1859, in California, the photograph of a signature proved that a disputed document had been forged, in the first American court case to admit photographs as evidence. The idea that a criminal's face could be the prime witness against him was taken up early. Police identification by mug shots commenced in 1839—the earliest surviving examples are some daguerreotypes from Belgium dated 1843—and soon thieves and cutthroats would sit for their portraits all over Europe. "The rogues," it was reported in 1841, "resort to contortions of the visage and horrible grimaces,"[1] and often they struggled violently to avoid being photographed.

Photography had come on the scene at the right moment to join forces with the police. The growth of urban centers and the acquisition of new wealth in the late eighteenth century had made older peacekeeping and property-protecting measures inadequate. The English parliament set up the Metropolitan Police Force in 1829 and extended it to counties and rural areas in 1856. The local watchman had not needed an extensive set of records; the Metropolitan Police Force did. The era's great interest in physiognomy and the widespread belief that character was implicit in facial features sustained several ventures into the definition of the criminal type, most notably Francis Galton's. Late in the century Galton made composite portraits of criminal types, taking fifty photographs of pickpockets or burglars, superimposing the pictures, and concluding that whichever features stayed clearest illustrated the generic type of the pickpocket or break-in artist.[2]

The police took a fancy to criminal portraits. In 1846 the matron of the women's prison at Sing Sing commissioned Mathew Brady to take portraits of the inmates of two New York State prisons to illustrate her edition of a book on crime that had first been published unillustrated. In the 1850s detectives and private agencies such as the Pinkertons embarked on criminal-portrait programs, and the inspector general of the French penal system announced a plan to photograph the most dangerous felons at seventeen prisons. "Wanted" posters with photographs appeared as early as the 1860s, when John Wilkes Booth and two accomplices were sought for killing President Lincoln. In 1870 the English mandated photographs of convicted prisoners in all county and borough prisons.[3] The government wanted portraits of felons almost as badly as upstanding citizens wanted portraits of themselves.

59

In the race to trap criminals by their features, the peculiar conviction arose in some quarters that the face of a murderer, the last image seen by his victim, would be fixed on the retina of the corpse for a few hours. According to one report from Italy, photographs were taken of a victim's eyes by Alinari (famous for photographs of works of art), with results that were not entirely conclusive but did the accused no good. In Russia a pair of such photographs allegedly showed even the insignia on the villains' uniforms and led to their instant apprehension.[4] An approximation of this odd and fleeting interlude in the history of photography turned up in 1990 on the television series "Twin Peaks." In an extreme close-up of Laura Palmer on videotape some time before she was killed, her boyfriend and his motorcycle were reflected in the pupil of her eye, putting the police on alert to look for a biker.

Not everyone was certain that photographs could catch criminals or even that they were wholly reliable evidence. A parliamentary report in 1873 stated that of 43,634 police photographs taken in England and Wales from 1870 to 1872, only 156 had been effective in cases of detection. In the 1873–74 Tichborne case in England, a man who claimed to be Roger Tichborne, lost at sea in 1854, sued the family for his inheritance and was convicted of fraud. At the trial his features and old photographs of Tichborne were compared by physiognomists, who offered differing opinions about his identity.[5] Perhaps photographic portraits were not so perfect an index to identity as they were generally thought to be.

The police continued to act as if they were. In 1876 Detective Phil Farley published an illustrated book titled *Criminals of America; or, Tales of the Lives of Thieves Enabling Everyone to Be His Own Detective*. Ten years later Thomas Byrnes, chief of detectives in New York City, published another, called *Professional Criminals of America*. Byrnes wrote that if the likenesses of criminals were within everyone's reach, "their vocation would soon become risky and unprofitable." He wished to correct the popular misapprehension that lawbreakers were lowbrowed and shifty-eyed by showing the public that they looked like everyone's neighbors.

One reviewer said that crooks had been upset by the publication of Byrnes's book, yet inclusion in it had become "a mark of standing among thieves," who referred to it as the Hall of Fame. The New York Police kept an up-to-date album of criminal photographs, popularly known as the Rogue's Gallery, at headquarters. It was a tourist attraction "more frequently heard of than the Cooper Institute or the Metropolitan Museum of Art," and "strangers from all parts of the country who never heard of these places came far to see it, and esteemed it a privilege to be permitted to do so."[6]

If photographs did not always succeed in identifying repeat offenders, that was partly because there was no standardized system of pose, lighting, and background to make them readily comparable, nor any efficient filing system for retrieval of an image when a man assumed another name. Alphonse Bertillon, who finally systematized police photography, had not meant to use it at all. What he had hoped to do was identify individuals by anthropometric description, a series of measurements of the body from full height to length of ears, fingers, toes. This was an attempt to prove that each individual differed from every other, hardly a universally accepted idea at the time. Bertillon was not satisfied that his system of measurements was practical, and in 1883 he decided to add photographs. (The Paris police had already set up the first studio exclusively for police use in 1874.) Bertillon was the first to insist that police photos be taken both full face and profile, and, aware of what powerful changes in appearance could be made by different

studio conditions, he set rules for background and lighting. "No one in the history of photography," according to a biographer, "did more to destroy the fallacy that the camera never lies."[7]

"The father of scientific detection" cut up these photographs to isolate individual features, which could then be more readily indexed and identified, and he devised a more efficient filing system. In 1888 Bertillon was installed as chief of the Service of Judicial Identity in France, and not long after, he instituted scene-of-the-crime photography. His system was widely copied, especially in the United States, until it was replaced in the second decade of this century by fingerprinting, which proved more accurate. The use of photographs persists, because it works. The television program "America's Most Wanted," which broadcasts pictures of criminals and reenactments of their crimes, led to the arrest of six major fugitives in the first ten weeks it was on the air in 1988.[8]

Just before and after the turn of the century, government institutions and academic disciplines increasingly depended on systematized collections of photographic examples, a proliferation of files that constitutes another landmark in the expansion of photographic influence. The police, the patent office, military intelligence, art historians, anthropologists, medical researchers, and other branches of work and knowledge made photographic files central to their operations.[9]

According to the critic John Tagg, photography's institutional centrality and its status as evidence and proof were made possible by a restructuring of the power relations between state and citizen in the nineteenth century. Institutions—including the hospital, the asylum, the school, the police force, and the prison—exerted a new and increasingly subtle form of dominance through ever more extensive observation. Photography, a medium of observation by its very nature, became a major element of the recording apparatus and enlarged jurisdiction that hospitals, guardian agencies, and bureaucracies acquired as the nineteenth century progressed. In effect, photography became another instrument in the arsenal of authority, an instrument of surveillance and control.[10] The nineteenth century laid the foundations for an information era, in which knowledge is power and photography a crucial form of knowledge.

The link between photography and institutionalized identification began to be forged around the middle of the nineteenth century. In 1851 a gentleman in France proposed putting photographic portraits on driver's licenses (and on cravats). That year it was also suggested that photographs should be affixed to passports, but the first such systematic application did not occur until ten years later in America, when the Chicago and Milwaukee Railway Company identified its season ticket holders by their portraits. In Vienna in 1864 it was recommended that all prostitutes be licensed and given sanitary certificates bearing their portraits.[11]

Hugh Welch Diamond, superintendent of the Surrey Country Lunatic Asylum in England, instituted photographic portraiture of the inmates in 1851, primarily to ensure identification of escapees but also to promote study of mental states. Medical records proliferated everywhere. The photographic report on Civil War casualties ran to six volumes. In 1867 the Paris Medico-Physiological Society met to discuss the application of photography to the study of mental illness. In 1873 the Hospital of San Clemente in Venice amassed thousands of pictures of its patients. The potential for control over the subjects of such records is abundantly clear today, when misuse of computerized information is so widely feared. It was clear then as well. By the

1880s, when an American organization called the Gerry Society photographed child beggars and vagrants before and after their arrest and transfer to asylums or protectories, the society officials themselves referred to the portraits as "like that of the Rogue's Gallery at Police Headquarters."[12]

At a time when photography was still technically difficult and expensive, it could be used to assert and embody authority. The Hampton Institute in Virginia took before-and-after pictures of Native American children it had "rescued." The children were pictured "before" on the floor wrapped in Indian blankets and "after" at a table with a checkerboard, dressed like white children. Although the photographs were meant to prove that the Indians were educable, they also served as a token of the children's submission to the institute and to the culture.[13]

Photography's position in the arsenal of domination is even more painfully evident in portraits of American slaves taken in 1850 by J. T. Zealy. The African-Americans in Zealy's picture pose almost as their masters did, looking straight at the camera. To our discomfort today, they seem to look straight at us. Their status as slaves is all too apparent, for men and women alike have been ordered to strip to the waist. Their nakedness made it obvious they had no control over their own likenesses; yet their humanity and dignity are manifest in their posture and unflinching gaze.[14]

The photographs were commissioned for study by Louis Agassiz, the well-known zoologist and geologist, whose theory that blacks were inherently inferior to whites was used to support slavery. Agassiz convinced not only southerners but also many northerners, even a number of abolitionists, that blacks could not measure up to whites. In these portraits the slaves were reduced to anatomical specimens, objects to be studied by their superiors; servitude and supposed inferiority were encoded in the pictures from the beginning.

In making portraiture universally available, photography gave a new significance to the individual's image and created a distinct advantage for anyone who controlled it. Those who cannot dictate the manner in which they present themselves or the way their portraits are used automatically cede a degree of authority to those who can, whether that be the photographer, the press, or the government.

In 1870 and '71 Prussia laid siege to Paris for four months, until the city capitulated at the end of January. Adolphe Thiers, head of a new government, signed a treaty allowing the Germans to occupy Paris for forty-eight hours in March, but Parisians who took this as a betrayal by their own government rose up in arms a few hours before the Prussians were to enter. The rebels held municipal elections and installed the world's first socialist government, the Paris Commune, which lasted all of seventy-two days. During that time, the Thiers government withdrew to Versailles and laid siege to the city yet again. Approximately twenty-five thousand civilians and a thousand French soldiers were killed. Shortly before surrendering, the Communards set fire to many of the capital's major public buildings. By the end of the insurrection, nearly a quarter of the city had been destroyed.

Most photographers left Paris as soon as hostilities began and returned soon after the final surrender to photograph the ruins, certain to be a highly marketable subject. A few remained throughout the battles, although the Commune never had an official photographer. Pictures were made of its troops and barricades, of war damage, of the Communards (often with bystanders), and of their leaders alone. A photographer named Auguste B.

Braquehais, about whom little is known, was particularly active throughout the uprising.[15]

During the insurrection the police in Le Havre asked the Versailles government for photographs of the leading Communards as an aid to surveillance of departing ships. Since many of these men had been prominent figures, it was simple enough to buy their portraits, and by the time the siege was lifted the police had paid for twenty-five hundred pictures. Once the insurrection was quashed, the government realized that photographs could easily be made to play informer. To identify the rebels the authorities collected group portraits that had been taken during the siege—pictures that had originally signified solidarity, pride, vanity. Copies were sent to the police at railroad stations, ports, frontier checkpoints, and suspected hiding places. Suspects were identified and captured on the basis of pictures made by photographers who did not work for the state and had probably never intended to put their images at its service. Citizens were imprisoned or put to death because once they had been proud to pose. This appears to be the first instance of organized state use of photographs for political repression.

As the historian Donald English points out, identification through photographs was not so simple. Beards, hair, clothing could be changed. Besides, citizens who had not fought with the Communards had sometimes posed with them; no doubt the government picked up some innocent people.[16]

The tradition of suborning photography for state use has continued and flourished. As recently as 1989 the Chinese government used photographs to identify participants in the student demonstrations in Tian An Men Square after soldiers had brought the demonstrations to a bloody end. All governments use photographs for surveillance; some are simply more thorough about it, or more repressive.

For years photojournalists in Central America, aware that security forces routinely scrutinize thousands of photographs, have exercised caution in photographing people—in the beginning Nicaraguan rebels wore masks for the camera. In 1989 the U.S. State Department's Graphics Service reportedly purchased dozens of photographs, supposedly for their publications, from New York photo agencies each week, then sent some of them back to the country of origin. One American photographer who covered El Salvador's civil war for several years discovered that up to twenty rolls of his photographs were being duplicated by the State Department every week. Anonymous government sources reported that many such photographs were routinely earmarked for intelligence purposes in American embassies abroad. Should the local police or army get hold of these photographs, the result could be imprisonment or death for the subjects.[17] Where identification is risky, the camera plays a malign role. As photography has proliferated, increasingly sophisticated and devious means have been found to channel the information it so abundantly provides.

The state holds no monopoly on surveillance. One of the first French newspapers consistently illustrated with photographs was L'Anti-juif illustré, founded in 1898 at the height of the Dreyfus affair. This periodical advocated a boycott of Jewish stores and published their names and addresses to warn its readers away. The editors went so far as to assign photographers to take pictures of customers at some of these shops, then exhibited the photographs to invite public scorn. In 1933 the Nazis took this technique one step further. In Berlin and other German cities there appeared on Jewish-owned shops and businesses stickers that read, "Jewish business! Whoever buys here will be photographed!" The Nazis did not yet have the highly organized apparatus

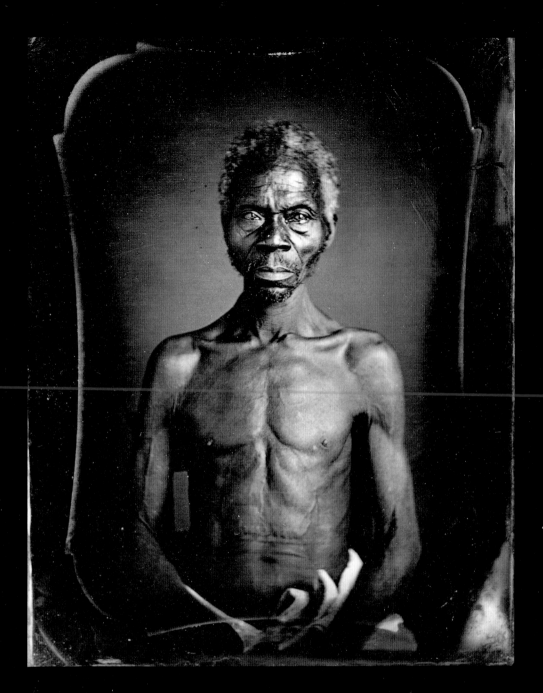

J. T. Zealy (active 1850s)

Daguerreotype Portrait of

Renty, Congo, B. F. Taylor,

Columbia, S.C., March 1850

Peabody Museum, Harvard

University, Cambridge,

Massachusetts

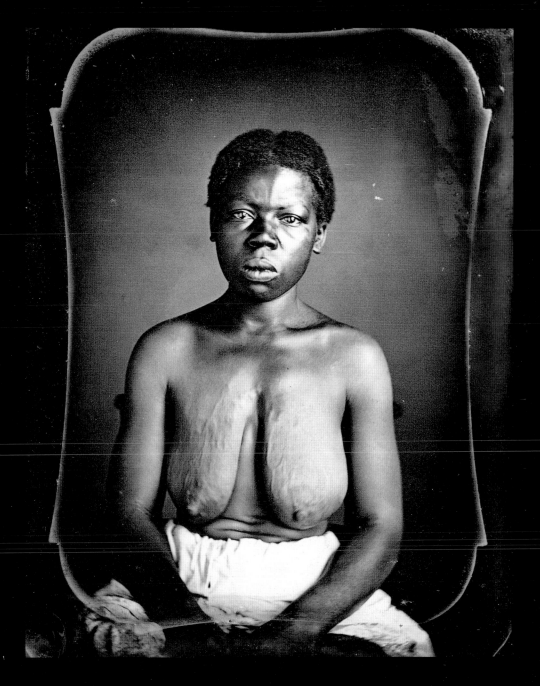

J. T. Zealy

Daguerreotype Portrait of

Drana, Country Born,

Daughter of Jack Guinea,

Plantation of B. F. Taylor,

Columbia, S.C., March 1850

Peabody Museum, Harvard

University, Cambridge,

Massachusetts

that would have been required to carry out their threat, so the signs were largely ignored . . . for a while.[18]

As the twentieth century grows more deeply involved with gathering, disseminating, and storing information, photographic images acquire heightened power, and control of them becomes critical. Simpler and cheaper technologies have made it more likely that people outside the zones of authority can effectively wield the camera as a weapon. In 1989 a riot erupted in Tompkins Square Park in New York City when the police moved to evict some homeless settlers. A man who was involved in the fracas videotaped the police using what is generally termed "excessive force"; the tape completely discredited police accounts of the incident. In 1991 a bystander videotaped five white Los Angeles policemen beating a black man named Rodney G. King after arresting him for speeding. The tape, repeatedly shown on television, contradicted the police version of the arrest, led to the indictment of several officers, and sparked nationwide reexamination of the issue of police brutality.

When eastern Europe broke its postwar bonds at the end of the 1980s, both governments and dissidents enlisted photography in their cause. In Czechoslovakia, for instance, only the official press agencies were permitted to photograph certain events, including arrests, but the photographers

Auguste B. Braquehais

(active 1850–1874)

Untitled (Paris Commune),

1871

Daniel Wolf, Inc., New York

stopped covering this kind of news when they realized that the police were examining their pictures to identify the participants. On the other hand, the authorities were themselves under surveillance in most countries, watched both by still cameras and a private army of video cameras. From basements, alleys, and second stories, dissidents filmed government agents breaking heads and hauling off demonstrators. The clandestine tapes were circulated as a kind of *samizdat* of videotapes; they were passed from hand to hand, city to city, even country to country, and they kept rebellion alive.[19]

Dissident movements are well aware of how kind the camera is to victims. As the South Africans, Israelis, and Chinese have recently discovered, repression of all kinds, especially armed repression of unarmed citizens, is splendid material for both still photographs and television. One of the difficulties for the authorities is that the photographic message is so simple: photographs narrate issues on a fairly primitive emotional level, eliminating political, economic, and historical circumstances. That is the weakness of photography, and that is its strength, a key to its capacity for influence. The image streamlines but cannot fully communicate complex matters. A photograph is not an explanation, and the authorities always have some explaining to do. Repressive governments will almost always look wrong to a camera, even at those moments when they have right on their side. The need of governments to control information, to control the *look* of events, has intensified as television has extended its reach and as citizens everywhere have acquired cameras and videocameras. The government that cannot control the record is in danger of losing control altogether.

The camera, which had been put to work to provide all manner of documents for the new record-keeping society, was soon set to watch over labor. As America became the industrial leader of the world during the last two decades of the nineteenth century, technical specialists stepped in to study and regulate the labor force, and one of them brought a camera with him. Photography was employed in the factory as an instrument of standardization, reeducation, and control. The kind of systematic analysis that was applied to manufacture in those years, an approach known as scientific management, aimed to organize and regulate every aspect of factory production (including the human aspect) to achieve true efficiency. As workers assembled watches or bolted beams together, the camera divided the processes up into individual units for study and codification.

Workers had first been studied with a stopwatch. Frederick Winslow Taylor, an engineer who began conducting time studies of labor in 1881, was the father of scientific management, which is often referred to simply as Taylorism. He timed the best workers at their tasks, then set a rate at which the job should be performed. Eleven years later Frank B. Gilbreth branched out from time study to motion study with a camera. Gilbreth, whose fame took on another dimension when two of his children wrote *Cheaper by the Dozen* about the Gilbreth family, began as a bricklayer and had his own contracting business by the 1890s. He devised a more efficient way to lay bricks and set speed records for putting up buildings. It occurred to him that he could teach laborers with pictures, and he originated a type of photography that would be adopted all over the world.[20]

Taylor's and Gilbreth's time-study and motion-study methods, often combined, rapidly spread through industrial economies. Books on Taylorism appeared in France in 1913 and 1917, one of Gilbreth's books in Czechoslovakia in 1923, and time and motion studies were essential to Russia's First Five

Frank B. Gilbreth

(1868–1924)

Chronocyclegraph of

Woman Staking Buttons,

1917

National Museum of

American History,

Smithsonian Institution,

Washington, D.C.

Year Plan (1928–33). Millions upon millions of workers' lives have been affected by the stopwatch and the camera, which still hold sway over industrial practice.

Gilbreth had a kind of high moral theory of efficiency, a firm belief that there was "One Best Way" to do anything and everything, a way that could be divined by close observation. He insisted it was not just speed that interested him but the easiest way of doing the job. He took a succession of pictures of the most skilled workers in the plant, analyzed the results, computed the times, added a fixed percentage of idle time or unavoidable delays, and came up with a standard for all workers. Sequences of photographs revealed the smoothest, most economical, least wasteful motions. These pictures were then used to teach apprentices and reeducate veteran workers who did not measure up. By 1906 Gilbreth was insisting that a minimum number of photographs be taken each week of each job.[21]

In 1911 Gilbreth acquired a movie camera, which captured even finer distinctions in a worker's movements than series photographs had. The hand-cranked motion-picture camera could vary in speed from single exposures to better than one hundred frames a second and could be played back in slow motion or stopped on one frame for the instruction of workers. Motion studies of the "high priced men" were sometimes given to them as gifts, with the idea that they could thus impress their families. Gilbreth's wife, Lillian, an industrial psychologist, wrote, "With the feeling that his work is recorded comes the feeling that the work is really worth while, for even if the work itself does not last, the records of it are such as can go on."[22] Here the means of surveillance

were turned into a reward so that laborers might take home evidence of their work skills for all to admire.

Frank Gilbreth knew Muybridge's photographs. He marked off the floor and background wall in grids, as Muybridge had done, and included a clock in the picture so time and motion could be charted more precisely. He contrived a means of recording tiny, successive motion on a single frame by attaching small electric lights to the hands or whatever part of the body was in motion while working. This "chronocyclegraph method," or "stereocycle chronograph," recorded a kind of dance of light on film.[23] Only later did Gilbreth discover that Etienne-Jules Marey's experiments had preceded his. Gilbreth even built three-dimensional models of the paths of light his film had traced, as a way of embodying the efficient course of action in its most condensed form.

Gilbreth had an unbounded faith in photography. He applied the motion-study system to musicians, baseball players, fencers, oyster shuckers, and surgeons; his wife wrote about applying it to household tasks as well. During World War I he used motion pictures to teach soldiers machine-gun assembly, proposed that motion studies could increase the effectiveness of bayonet thrusts, and introduced films of enemy atrocities into army education programs to keep fighting spirits high. After the war he applied his technique to men handicapped in battle and made a major contribution to the rehabilitation of wounded veterans.[24]

Not everyone on the other side of the camera shared his enthusiasm. Gilbreth wrote: "The worker is not always eager that he or his workplace should be photographed. This is even more true of management than of the men. Some managers are not willing to allow their work places to be photographed, when they realize that such photographs will live as 'before and after' records, in that they are accurate, detailed, unprejudiced, easily understood, easily preserved, and constantly available."[25]

Many workers felt threatened by such scrutiny. In 1913 the *Providence Labor Advocate* wrote of machinists at the New England Bolt Company: "Cameras to the front of them. Cameras to the rear of them. Cameras to the right of them. Cameras to the left of them. Pictures taken of every movement so as to eliminate 'false moves' and drive the worker into a stride that would be as mechanical as the machine he tends. If the 'Taylorisers' only had an apparatus that could tell what the mind of the worker was thinking, they would probably develop a greater 'efficiency' by making them 'cut out' all thoughts of being men." Aware that workers felt spied upon, Gilbreth invented a worker-activated apparatus to give back some measure of control.[26]

Workers had some reason to distrust scientific management, which rationalized the change from the traditional crafts to a manufacturing system broken down into discrete units of labor performed by specialists.[27] Time and motion studies attempted to reduce human beings to standard units turning out standard products, and this threatened workers' pay and unionism: it was easy to train and replace a man who did nothing but tighten a few bolts.

Although motion study supposedly was designed to make work easier, both motion and time studies usually resulted in a faster work tempo. The stopwatch, essential to Taylor but later opposed by the Gilbreths as less accurate than film, became the symbol of Taylorism around the world. Taylor's management technique was dubbed the "speed-up" system. In the second decade of this century French and American labor went on strike against the stopwatch, and in 1915 the United States Congress prohibited the use of time studies in government arsenals and navy yards.[28]

69

Many industries continued to be dominated by these techniques. Charles Bedaux, a French Taylorite whose ideas won wide acceptance during the Depression, advocated the substitution of motion study for time study because it was more accurate and did not rouse fear and anger, as the sight of a stopwatch did. General Electric and countless other corporations sent their employees to the movies at company expense to learn their trades. Today the results of time and motion study are so fully systematized that it is no longer necessary to use cameras and stopwatches; jobs are designed to detailed specifications before anyone is hired.[29]

Every so often a cry of pain is raised. Charlie Chaplin suffered from time and motion studies in *Modern Times* (1936). His job was simple enough: tightening nuts with a single set of motions. As the boss kept yelling "Speed 'er up!" and the conveyor belt moved faster and faster, Charlie became the machine he was trained to be. An addled machine, to be sure: pulled through the gears like a manufactured product, he was reduced to his one set of motions, trying to tighten a man's nose and the strategically placed buttons on a woman's dress. He finally achieved peace in an asylum, where no quotas had to be met. Lucille Ball lost a job in a candy factory because the chocolates marched faster and faster until her hands could not keep pace. "Racing with the Clock," a song in *The Pajama Game*, complained melodically that in the contest between clocks and workers the clocks had all the advantages. The perils of the speed-up system live on, but in the postindustrial era many of the operations will be performed by true machines, some of them robots designed after studying films of people who once performed the tasks.

Within recent memory, a set of aerial photographs nearly triggered the destruction of the world.

Frank B. Gilbreth

(1868–1924)

Woman Office Worker,

Motion Study, c. 1915

National Museum of

American History,

Smithsonian Institution,

Washington, D.C.

The first aerial photographs were taken from a balloon in 1858, and that same year it was suggested that the technique would be useful to the military. Some talked about using reconnaissance photography in the American Civil War, but there is no evidence that anyone ever did so, and not until the invention of the airplane did aerial photographs play a major role in battle. Reconnaissance photographs were vital to both sides in World War I; Edward Steichen, who had commanded the photographic section of the American Expeditionary Forces, later wrote that "at least two thirds of all military information is either obtained or verified by aerial photography."[30]

In 1918 a magazine asked whether the camera was a more deadly weapon than the machine gun and answered in the affirmative: "A bullet may kill a man, perhaps two; a round from a machine-gun bring down an enemy plane. But the influences of the aerophotograph are wider, more deadly." It is said that some twenty years later the German general Freiherr von Fritsch forecast that whichever side had the best photographic reconnaissance would win the next war.[31] After the next war the ante was raised by a staggering amount. During the Cuban crisis evidence obtained by photographic surveillance brought America and Russia perilously close to the brink of atomic warfare.

For over a year refugees from Cuba had been reporting nuclear installations, but the government had been misled by Cuban refugees in the past and had no way of determining whether they could distinguish an offensive from a defensive missile. The American government was willing to tolerate defensive weapons such as surface-to-air missiles in Cuba but repeatedly made it plain that it would not brook the installation of weaponry that threatened American territory. "Lacking photographic verification," as one historian puts it, "the intelligence community treated the [refugees'] information with reserve."[32]

In July 1962 the director of the CIA sent a memo to President John F. Kennedy saying that he believed the Soviets would deploy medium-range ballistic missiles on Cuba; exactly when was unclear. At the end of August and again in October, New York Senator Kenneth Keating announced in the Senate that Soviet missile installations appeared to be in place. Both times, the administration affirmed the presence of surface-to-air missiles in Cuba but denied that the Soviets had installed offensive weapons and vigorously warned against any such action. Over and over throughout September (and, indeed, until the end of the crisis), the USSR publicly disclaimed any intention of ever deploying nuclear weapons so close to America; as late as September 19 the U.S. Intelligence Board declared such a move unlikely.

But a buildup was evident, and on October 9 Kennedy approved reconnaissance flights over western Cuba from high-altitude U-2s. (Two years earlier, one of these high-flying planes had brought on another international crisis, when Francis Gary Powers was shot down over Soviet territory. Every government recognized the deadly nature of the aerial camera.) Hurricane Ella kept American planes on the ground until October 14; the pictures were read on the 15th; and on October 16 the CIA presented the president and his high-level advisers with proof (here a synonym for photographs) that the Soviets were installing offensive ballistic weapons within firing range of American cities.

For seven days, while the administration and the military agonized over America's options, the crisis remained a secret from the public. Allies had to be informed and persuaded to stand behind American policies; former Secretary of State Dean Acheson took detailed photographs with him and succeeded in convincing President Charles de Gaulle of France to support an

American quarantine of Cuba. De Gaulle told Acheson he did not need to see the photographs, as "a great government such as yours does not act without evidence."[33]

Then, on October 22, President Kennedy announced on radio and television that the United States had firm intelligence reports of offensive missile sites in Cuba and was imposing a blockade on the island. American forces were placed on alert around the world. Citizens in cities such as New York and Houston, within striking range of missiles on Cuban soil, hastily indulged old fantasies or gathered their families together in prayer. On October 23 the American embassy in London startled the administration by distributing copies of the incriminating photographs at a news briefing (the British had been skeptical). That evening the Defense Department decided to release pictures as well.

Surveillance continued. The Soviet buildup accelerated. On October 25 UN Ambassador Adlai E. Stevenson challenged the Soviet ambassador to the UN, Valerian A. Zorin, to deny the United States' charge that the Russians had installed offensive missile bases on Cuba. "In due course, sir, you will have your reply. Do not worry," the Russian replied. "I am prepared to wait until hell freezes over, if that's your decision," Stevenson said. "And I am also prepared to present the evidence in this room." Easels were wheeled in to display the photographs. In one sequence what had been peaceful countryside in August became a construction site for missile facilities in mid-October. Twenty-four hours later, there were unmistakable signs of missile installations. And still the confrontation inched forward toward nuclear war. At last, on October 28, Khrushchev backed down. The crisis that had been sparked by photographic evidence sputtered and died out.[34]

Three factors converged to make this evidence available. One was technology that had improved radically since World War II, with highly sensitive films and lenses that permitted photographs from forty thousand feet up that, under magnification, could show a man reading a newspaper in his backyard. A technique known as "peripheral photography" enabled planes to photograph the entire eighty-mile width of Cuba without flying over it.[35]

The second contributing factor was Soviet pride and inefficiency. At the Cambridge conference in 1987 the Soviets revealed that their experts had believed the missile installations could be kept secret from America by means of camouflage but had never asked Fidel Castro for assistance in disguising the work, so the sites remained naked to the camera's prying eye.[36]

The third decisive element was interpretation. The evidence was incontrovertible (although Zorin claimed it was faked), but aerial photographs are almost indecipherable to the untutored. As Steichen wrote in 1919: "The aerial photograph is itself harmless and valueless. It enters into the category of 'instrument of war' when it has disclosed the information written on the surface of the print." Robert F. Kennedy, JFK's attorney general, wrote about the CIA's explanation of the photographs at the first emergency meeting called by the president: "I, for one, had to take their word for it. I examined the pictures carefully, and what I saw appeared to be no more than the clearing of a field for a farm or the basement of a house. I was relieved to hear later that this was the same reaction of virtually everyone at the meeting, including President Kennedy. Even a few days later, when more work had taken place on the site, he remarked that it looked like a football field."[37]

Aerial and satellite photographs pick out cocaine-processing plants in the jungle and troop deployments along borders. A camera records Patty Hearst staging a bank robbery with the Symbionese Liberation Army; other

LAUNCH PADS U/C

CONTROL BUNKERS U/C

United States Air Force

Aerial Photograph, Cuba,

October 15, 1962

Department of Defense Still

Media Depository, U.S. Air Force

cameras strategically placed in casinos, department stores, and at grocery check-out counters document the activities of the guilty and the innocent with fine impartiality. In one district in Osaka, Japan, the police monitor the streets twenty-four hours a day via sixteen television cameras mounted on poles.[38] You and I and our activities are on record in more photographic archives than we would care to know about.

And while we are being watched in an organized fashion, our neighbors are casually keeping track as well. Amateur photographers busily record minor events that may in an instant become historic, or snap a crowd at a fire where the arsonist lurks in a corner. When Arnold Genthe, best known as a portrait photographer, photographed on the streets of San Francisco's Chinatown early in this century, the Chinese shied from his camera. It was long assumed that the Chinese were afraid that photography would steal their souls, but the truth was that many were illegal immigrants fearful of being identified and deported.[39] Big Brother has already been here for a long time. His eye is a camera, and in his hand he may hold the power of life and death.

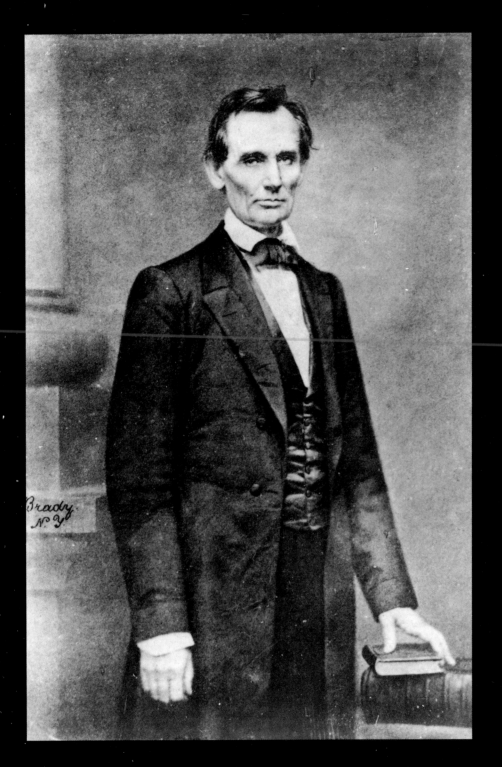

Mathew Brady (1823–1896)

Abraham Lincoln, 1860

Library of Congress,

Washington, D.C.

POLITICAL PERSUADERS & PHOTOGRAPHIC DECEITS

Photography and politicians proved to have a natural affinity, particularly in a democracy. First of all there was the question of identification, which photographs could answer handily. As late as 1864 the faces of public officials were so little known that after an act of Congress had made Ulysses S. Grant the highest ranking officer in the U.S. Army, only one member of the Washington press corps that met him at the station could identify him. That man had a faded photograph with a partial view of Grant's face.[1]

The immediacy and efficacy of photographic portraits had been metaphorically acknowledged in America as early as 1848, when one citizen wrote about Winfield Scott, "Somehow . . . Scott, although he has impressed the intellect, never has *daguerreotyped* himself, like Washington, Jackson, Harrison, and Taylor, upon the popular heart."[2] Today the electorate sees political figures primarily as photographic images rather than in the flesh. A favorite American pastime in the Reagan era was to have a portrait taken with a cutout photograph of the president, perhaps the ultimate photo opportunity. Photographs can become so closely identified with leaders that they are treated as their proxies, and because the medium is so patently in thrall to history, response to such images varies with the subjects' fortunes. When Nicolae Ceaucescu ruled Romania, his image in government offices stood for absolute power. When he was overthrown, the image too was thrown down. It became a symbol of hate that was attacked and slashed as fiercely as if it were the man himself.

The public image, a capsule impression that readily and indelibly lodges in the mind, is not a twentieth-century invention, although only this century has paid it such elaborate devotion. Whether it be slogan or reputation or appearance, the image is integral to electoral politics. Photography's verisimilitude made it the ideal carrier of this type of shorthand political judgment: this man is a statesman, that one a fighter, the other too crafty to trust. Certain British politicians in Lincoln's time refused to be photographed because they thought the results too realistic.[3]

At a time when there was no other way to see the man himself, photographs were all the more potent. In 1883 a Frenchman wrote that photographs were "the most certain means of propaganda, which . . . never failed to be effective in by-elections. . . . I have seen honest voters weep with joy at receiving one of these badly printed or clumsily colored portraits, and place them piously in their pocket books like precious objects." By the 1870s Frenchmen of every political persuasion understood the treacherous power of photographs to touch the heart. The prominent republican Léon Gambetta,

temporarily in eclipse after the Franco-Prussian War, told an interviewer that his enemies were making his life intolerable. "They torment me in every way they can think of. Can you imagine, they have forbidden photographers to take pictures of me! . . . Why? Because they say I use photography to gain publicity and that this makes me a danger! That's why. It is so stupid and ridiculous!"[4]

But it was neither stupid nor ridiculous. Prohibitions against photographs always indicate a healthy respect for their power. When the notorious General Georges Boulanger, who came close to overturning the French government, ran for election in Paris in 1889, a portrait photograph of him was sent to every voter in his district; after he won, the government outlawed all of his propaganda, and most specifically his portraits and photographs.[5] In our own time, when Nelson Mandela was in prison in South Africa it was illegal to take or publish his picture; the first reporter who saw him on his release was said to be uncertain who he was. Publicity and photographs both wield political influence; since they are often nearly synonymous, that makes the picture doubly dangerous.

The significance of photography for the democratic political system (with which television has made us all too familiar) was established by Lincoln's first election in 1860. In 1866 F. B. Carpenter, who had spent six months in the White House painting Lincoln's portrait, wrote that his friend Mathew Brady "insisted that his photograph of Mr. Lincoln, taken the morning of the day he made his Cooper Institute speech in New York . . . was the means of his election. That it helped largely to this end I do not doubt. The effect of such influences, tho' silent, is powerful. Freemont [John C. Frémont, the 1856 Republican presidential candidate] once said to me, that the villainous wood-cut published by the New York 'Tribune,' the next day after his nomination, lost him twenty-five votes in one township, to his certain knowledge." Brady himself later told an interviewer that Lincoln had once said, "Brady and the Cooper Institute made me President."[6]

Politics played a major role in American life at mid-century. When Lincoln debated Stephen Douglas in 1858 in Ottawa, Illinois, a town of six thousand citizens, ten thousand people came to hear the speeches. The populace in a democracy wanted to confront its candidates, to be, in some sense, intimate with them, yet the candidates were largely unavailable. Once Lincoln had spoken at Cooper and toured New England, he made no more campaign speeches; it was not customary to do so.[7] Recognition thus became a problem that photographs could solve.

When Lincoln went to New York in February 1860 to deliver the Cooper Institute speech, he was little known in the East, and his Republican colleagues were uncertain he would be an effective national candidate. He was taken to Brady's studio to be photographed. Six feet four and exceedingly awkward, with a long neck and dark skin creased with heavy lines, he wore a low collar, a tie that was just a black ribbon, and a badly cut, sorely rumpled, brand-new suit. One detractor wrote: "Mr. Lincoln stands six-feet-twelve in his socks, which he changes once every ten days. His anatomy is composed mostly of bones, and when walking he resembles the off-spring of a happy marriage between a derrick and a windmill. . . . His hands and feet are plenty large enough, and in society he has the air of having too many of them."[8]

Brady said later, "I had great trouble in making a natural picture. When I got him before the camera I asked him if I might not arrange his collar, and with that he began to pull it up. 'Ah,' said Lincoln, 'I see you want to shorten my

neck.' 'That's just it,' I answered, and we both laughed."[9] (Photographic flattery was, and remains, the standard product of portrait studios.) Brady's full-length portrait made Lincoln seem much more reasonably put together than he was and, with some retouching, it softened the harsh lines of his face, making him look dignified, wise, statesmanlike, and compassionate. He was, at last, presidential.

Lincoln's appearance was an issue in the 1860 campaign. Americans at the time fervently believed that the inner person was revealed in the face. One writer, convinced that wickedness would shine through no matter what adjustments were made to the outward appearance, said that the revelation of character in the face constituted "a valuable security for social order, insuring, as it does, that men shall ultimately be known for what they are."[10] Very few Americans knew what Lincoln looked like, but everyone had heard that he was ugly, which made his photograph all the more important.

The editor of the *Charleston Mercury*, after seeing a wood engraving of Brady's picture (which did not look so wise and statesmanlike to a southern Democrat), said Lincoln was "a horrid looking wretch . . . sooty and scoundrelly in aspect, a cross between the nutmeg dealer, the horse swapper, and the night man, a creature 'fit evidently for petty treason, small stratagems and all sorts of spoils.' " The *Houston Telegraph* said he had "most unwarrantably abused the privilege, which all politicians have, of being ugly," but added that he was a profound and concise reasoner.[11]

Representations of Lincoln were turned into political capital by both sides. A poem was written on "Lincoln's Picture," and the Democrats set it to music and sang it at campaign rallies. The last verse goes like this:

> *Any lie you tell we'll swallow—*
> *Swallow any kind of mixture;*
> *But oh! don't, we beg and pray you—*
> *Don't, for God's sake, show his picture.*[12]

On the day Brady took his photograph, Lincoln spoke at Cooper Institute. He did not ask that slavery itself be immediately eliminated but declared that a sense of duty forbade its extension to new regions in the West. The enormous audience was wildly enthusiastic. (A listener once remarked, "While I had thought Lincoln the homeliest man I ever saw, he was the handsomest man I ever listened to in a speech.") The *Tribune* reporter claimed that Lincoln was the greatest man since Saint Paul. The speech was reprinted in newspapers and pamphlets across the nation; millions read it before the election.[13] There was an immediate demand for Lincoln's portrait.

Brady, whose studio amounted to a gallery of his own work, would certainly have displayed this photograph as part of his ambitious project to photograph the illustrious Americans of his day. And New Yorkers would have flocked to see it, for, as *Harper's Weekly* put it, "The last new portrait at Brady's was a standard topic of conversation." The picture was reprinted in a smaller, inexpensive version. Some claim that one hundred thousand copies of it were distributed during the campaign, probably an exaggeration.[14] But it was in 1860 that the carte-de-visite-size photograph became popular in America, and it is precisely the marked increase in the distribution of images after mid-century that makes it possible to consider the influence of this photograph on the election. Family albums now displayed portraits of the president and his cabinet beside the requisite pictures of relatives.

The 1860 election saw the introduction of the photographic campaign

button, thanks to the newly popular cheap and durable tintype. Lincoln and his running mate, Hannibal Hamlin, reproduced from Brady's photograph—or sometimes from Alexander Hesler's—appeared on many a gentleman's lapel (as their opponents did on others'). There were daguerreotype medals of Lincoln as well, although many fewer.[15]

It was not technically possible to print photographs in papers or magazines in 1860, although woodcut copies of photographs were reproduced. In May 1860 *Harper's Weekly* reproduced Brady's portrait as a wood engraving with other candidates' pictures. On October 20 *Leslie's Weekly* ran the image full page. Currier and Ives reproduced it as a lithograph several times; in one version they colored the image, cropped it down to a bust portrait, fancied it up with a bit of drapery, and inscribed it within an oval. It didn't look much like Brady's full-length portrait, but they got the face nearly right. Their inexpensive prints, the smallest of which sold for as little as twenty cents, were available not just in book and art stores but in harness shops, general stores, and barrooms, from pushcart peddlers in New York, from the firm's representatives in rural communities, and by mail. Currier and Ives also used Brady's portrait for their lithographed political banner of Lincoln and Hamlin. (Nathaniel Currier liked to take credit for the invention of the political banner, an important campaign accessory from its first appearance in 1844.[16])

In one form or another, Lincoln's image was distributed to the voting populace. One of his lieutenants wrote him requesting a profile portrait for a medal: "Every little [bit] helps, and I am coming to believe that likenesses broad cast, are excellent means of electioneering." Sheet music bore Lincoln's lithographed portrait: there were Lincoln quick steps, Lincoln polkas, Lincoln grand marches, Lincoln schottisches. People in the streets and dining out wore brooches, pins, and studs with tintype reproductions of Lincoln or Douglas or other candidates. Lincoln's face appeared on broadsides plastered on tree trunks, fences, and walls, and in a multitude of cartoons. Most were based on photographs; in the drawings the head always seems to be at one angle and the expression unchanging, although the body was more freely drawn and more at ease.[17]

On the eve of the election it was remarked that "the country is *flooded* with pictures of Lincoln, in all conceivable shapes and sizes, and *cheap*. The newspapers have his likeness, it is in medal form; it is on envelopes; it is on badges; it is on cards; it is, indeed on every thing, and every where. And all for a *few cents*! . . . The most miserable likeness of Lincoln, with a plenty of *color*, if cheap, will go like buckwheat cakes."[18] Most of these images derived from photographs, and the actual photograph was the most highly valued reporter.

Lincoln himself had no photographs to distribute publicly and could not provide one to the Republicans who nominated him in May at the convention in Chicago. Lincoln was not there; his presence would have indicated unseemly ambition. Nor had he ever been seen in person by most of the delegates. His image was therefore all the more crucial. At the moment of his nomination, a shower of woodcut portraits, based on a photograph by E. H. Brown and rather crudely rendered, rained down on the delegates from the mezzanine. After his nomination, a portrait was carried into the hall in triumph and placed on the platform. It is not clear whether this was a painting or a photograph, and some said it was hideous, but it had to serve as the candidate's proxy, and it was greeted with roars and high enthusiasm. (Lincoln himself once remarked that he considered his campaign portraits "attempts upon his life."[19])

After his election Lincoln's portrait continued to be influential. Brady (or

FRANK LESLIE'S ILLUSTRATED NEWSPAPER. 547

ABRAHAM LINCOLN, OF ILLINOIS, THE PRESIDENTIAL CANDIDATE FOR THE REPUBLICAN PARTY.—Photographed by Brady.—Satm. .IN, BOSTON, MASS.

Frank Leslie's Illustrated Newspaper, October 20, 1860

The New York Public Library, Astor, Lenox and Tilden Foundations, Central Research Division

Currier and Ives *Portrait of Lincoln after Mathew Brady's Photograph*, 1860

Color lithograph

The Lincoln Museum, Fort Wayne, Indiana

Campaign button of Abraham Lincoln from the presidential election of 1860

Ferrotype, inserted into metal

The Lincoln Museum, Fort Wayne, Indiana

Anthony Berger

Abraham Lincoln, February

9, 1864

Library of Congress,

Washington, D.C.

Five-dollar bill

Fifteen-cent stamp, 1866

National Museum of

American History,

Smithsonian Institution,

Washington, D.C.

operators in his studio) photographed him thirty times more by 1864. Two of those portraits reached even larger audiences than the one taken in 1860. One was the model for the Lincoln penny. The other made its appearance in 1866 on a fifteen-cent stamp and again in 1920 on the three-cent stamp—and it sits in the middle of the five-dollar bill as well.

Once photographs took hold in politics, they would not let go. Early in this century a single image played a role in two successive California elections. The picture was locked in combat with overwhelming forces and had to engage the enemy twice to make a difference in the war.

The story begins with a man named Abraham Ruef, known as the "Curly Boss," who ran San Francisco early in the twentieth century. His unsavory practices were so notorious that both a local paper and a national magazine inveighed against his rule. In 1906 he went on trial for graft, which did not even slow him down. The second main character in the tale is the Southern Pacific Railroad; the main event is the 1906 gubernatorial election. The Southern Pacific ran state politics on the Republican side, rewarding its friends and never hesitating to punish its enemies.

At the Republican convention the railroad backed Congressman James Norris Gillett, who was on the American Federation of Labor's blacklist. Its machine traded judgeships for votes and bought Ruef's backing for $14,000, as the Curly Boss would later testify. When Gillett won the nomination overwhelmingly, the insiders decamped to a victory dinner. The celebration included Gillett, Ruef, a justice of the California Supreme Court, a congressman, the onetime chairman of the Republican State Central Committee, the head of the Southern Pacific machine in Southern California, and an assistant to the head of what was popularly known as the "Southern Pacific Political Bureau." A photographer snapped these men in a convivial moment, beaming at the camera—Ruef seated at the center, Gillett directly behind him with his hand on Ruef's shoulder. The *San Francisco Call* printed the picture, thereby making public the candidate's dependence on the Curly Boss and the railroad. Reform papers all over the state then published the photograph; newspapers supporting the Democratic candidate printed it and printed it yet again. The Southern Pacific steamed ahead, but not as fast: Gillett won by a

The Shame of California,

1906

Reproduced in *Everybody's*

Magazine, March 1912

Library of Congress,

Washington, D.C.

mere eight thousand votes, failing to muster a majority. One disgruntled Democratic voter remarked after the election that if he believed the voice of the people was the voice of God, he'd be an atheist.[20]

Ruef's trial ground on. In 1907 he confessed, implicating not only the officers of the Southern Pacific but other high-placed industrialists as well. The trial took a bizarre turn when the prosecutor was shot in open court; Ruef was convicted soon after and sentenced to fourteen years. Still, the railroad's dominance remained intact. In 1910, when Gillett declined to run again, the reform-minded Republican candidate ran mainly against the Southern Pacific in the primary. The photograph was once more pulled out of the files. By now known as "The Shame of California," it was circulated throughout the state yet again. The connections between Ruef, the railroad, and the party, connections the photograph made all too visible, finally proved too much for the voters, and the reform candidate was elected. *Everybody's Magazine* ran the picture two years later in a story about the railroads' corruption of the courts, thus keeping the shame of California alive in the nation's eyes.

In the political arena (and doubtless in some others), a photograph can convey a message so strong that it overrides the caption, text, and placement that would ordinarily interpret and modify it. The message may even override the reality. In 1959 and '60, an image of two world leaders came close to doing just that.

Vice President Richard M. Nixon flew to the USSR in July 1959 to open the first exhibition of American products and culture ever held in Moscow. While touring the exhibition, he and Soviet Chairman Nikita Khrushchev went inside a studio set up to demonstrate a new kind of color television and agreed to be recorded. This was not a direct broadcast; no one outside the studio would see the film for a couple of days. As the two leaders talked, Khrushchev systematically bullied Nixon and continually upstaged him. The Russian did most of the talking and all of the interrupting. He promised to overtake America and wave as Russia went by, he reeled off Russian proverbs, cracked jokes for his approving audience, laughed delightedly at his own performance, and adjusted his wide-brimmed hat for the camera. Nixon was polite and awkward. He wrote later that he realized after the encounter that he was now going to have to stand up to Khrushchev or the world would think America weak.[21]

At this point William Safire stepped in. The presidential speechwriter and *New York Times* columnist was then the press agent for the builder who had put up a model American house at the exhibition. As Safire tells it, he realized that the Nixon–Khrushchev tour had become thoroughly disorganized and called loudly to Nixon's military aide, "This way to the typical American house!" Nixon, Khrushchev, assorted Soviet and American officials, translators, aides, and a troupe of reporters piled in, followed by the crowd.

Safire was in the model kitchen when the two leaders arrived at the railing outside it. Harrison Salisbury, reporting for the *New York Times*, worked his way toward the kitchen but was barred by the Soviet guard. Safire got him in by telling the guard he was the refrigerator demonstrator. There were no television cameras at this unplanned meeting, and Safire tried to get the Associated Press photographer into the kitchen by claiming that he was the automatic-garbage-unit demonstrator, but that failed because there was no automatic garbage unit.

The AP man wanted a picture but was in back of his subjects. He threw his Speed Graphic over Nixon's and Khrushchev's heads to Safire, who snapped

a picture and threw it back. Anguished, the photographer yelled that Safire had put his hand over the lens and threw his camera back again. The two leaders kept talking while the camera flew overhead. This time Safire got a picture of Nixon talking and gesturing fairly forcefully, the side of one hand coming down on his other palm, while Khrushchev looked past him and listened.[22] Nixon was now talking back. At the kitchen rail he gave as good as he got, perhaps better. The diplomats were in despair that all the rules were being broken, but Khrushchev, a man who clearly loved an argument, seemed to enjoy the fray.

The photograph went out over the AP wire to the entire world. (It was treated like any pool photograph and credited to the Associated Press.) Photography should probably not be included among Safire's many talents, but this picture did the job, even getting into the frame a corner of the kitchen to identify the site and sell his employer's product. This is one of those news pictures that rides on its subject rather than its dramatic composition or its "decisive moment" quality, and it rode far, for the subject was big news and the world rushed to see the evidence.

The day after the argument that became famous as the "kitchen debate," this photograph had four columns at the top of front pages everywhere, and American newspapers generally acted impressed with Nixon's performance. By the second day, a Sunday, American commentators were convinced that Nixon had gained politically. (European reactions were mixed.) The front page of the *New York Times* reported, "There was agreement in Washington today that Vice-President Richard M. Nixon had thus far in his visit to the Soviet Union immeasurably advanced his Presidential prospects for next year." It added, "One expert on United States elections said that as long as the Vice President could maintain the image of an American who came out well in tilts against the Russian leaders, he would profit politically at home." The *Times's News of the Week* reprinted the photograph on the front page of the section and also printed a cartoon showing Nelson Rockefeller, Nixon's chief rival for the Republican nomination, questioned by a man called *Politics*: "How d'ya expect to get the nomination? You ain't talked to Khrushchev! You ain't even picked a public fight with Mikoyan, Kozlov, or Gromyko!"[23]

That night the three television networks received the TV film from the USSR, and after delaying for several hours because of Soviet reluctance, finally broadcast it simultaneously. The audience was enormous. On Tuesday the photograph appeared in the *Times* yet again, now labeled "The Conference in the Kitchen." This time it was featured in a full-page ad for Macy's. "This could be your kitchen," the ad announced (although it did not promise such high-level visitors) and showed Russians lined up to get inside the house that Macy's had furnished at the State Department's request.[24]

A few days later other pictures of the confrontation appeared in the national magazines. *Newsweek* ran stills of the television dialogue. *Life* ran several pages of "That Famous [kitchen] Debate in Close-Up Pictures." On facing pages were a photograph by *Life*'s Howard Sochurek of a shouting Khrushchev shaking his fist at Nixon and one by the Magnum Agency's Elliott Erwitt of a shouting Nixon shaking his fist at Khrushchev—both close-up, as advertised, both blurred in the center where the fists were moving. *Time* published pictures of both debates, including a livelier version of the Safire view and an even more telling frame by Erwitt, with Nixon poking a finger at Khrushchev's chest. This last picture had a vivid afterlife.[25]

After the debates Nixon toured the Russian provinces and Poland. The crowds were huge and enthusiastic, and the Western press covered every

moment favorably. The trip had no impact on foreign affairs—President Eisenhower undercut any potential gain by announcing while Nixon was still abroad that Khrushchev would visit the U.S. for a summit conference—but Nixon continued to reap political benefits. The Republican right was understandably gratified. On his return Nixon had letters of congratulations from Eisenhower, FBI director J. Edgar Hoover, and the actor Ronald Reagan, who praised him for "the great step you took in starting us back to the uncompromising position of leadership which is our heritage and responsibility."[26]

But the imagination of a larger public had been fired by the image of Nixon standing up to Khrushchev in an American kitchen in Moscow. He had previously won a reputation as a fearless fighter against communism by courageously facing down hostile and dangerous crowds in Latin America; now that reputation was galvanized with the assistance of a photograph. In politics, photographs, which have little to do with logic and only limited powers of explanation, become a shorthand means of spreading ideas and encapsulating issues. The image functions as a slogan: "This man stands tough against Communism." In February 1959 Nixon had been leading Rockefeller in the polls by 52 percent to 28 percent; by August, after the Russian trip, he was leading 72 percent to 21 percent. Against the Democrats, Nixon had regularly trailed John F. Kennedy in nationwide polls, but in November he pulled ahead by 53 to 47 percent.[27]

The kitchen debate, Safire wrote, "was instructive about public opinion formation too. When the story of the kitchen conference was reported in the States, accompanied by still pictures showing Nixon dominant, the impression was created that Nixon 'won.' Later, when the television tape of the color-studio debate was played—the first debate, which Nixon 'lost'—the impression did not change. People viewed the TV debate with the mental set that the American Vice President 'stood up to the Russians' and the sight of him kowtowing did not cause them to waver." Nixon himself recalled the TV

The Great Debate, 1959

AP/Wide World Photos,

New York

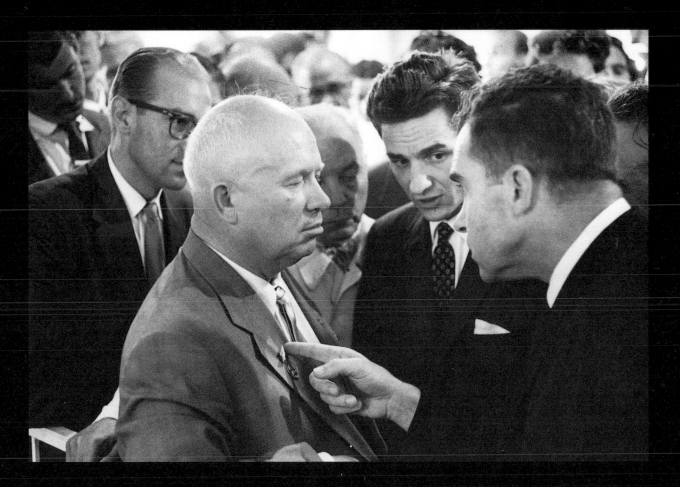

Elliott Erwitt (born 1928)

The Kitchen Debate, 1959

Magnum Photos Inc.

episode as one where his restraint in the face of Khrushchev's rudeness had met with public approval. A spot-check taken by the *New York Times* immediately after the broadcast, obviously not very scientific, showed divided reactions in Boston, New York, and San Francisco, and quite favorable responses in Chicago, Little Rock, Houston, and New Orleans.[28] Huge numbers of people, having been primed by reporters and a photographer to think Nixon had argued well, evidently continued to believe it.

Television was by no means dominant in 1959, but its future was clear, and Safire concluded that the press would continue to be important because it could influence people's interpretations of what they saw on the home screen. The reception of most media information—written, photographic, televised—is influenced by the viewer's prior beliefs and opinions. For the most part, televised campaign speeches and debates tend to be viewed differently by people in different parts of the political spectrum; such communications are more likely to confirm opinions than to change them.

In 1959, before satellite relay, newspapers still had the advantage of prior revelation, a situation that has since been reversed. But even today the media do not act alone. Newspapers, television, magazines, and radio reinforce, confirm, and sometimes recast each other's reports. In the case of the kitchen debate, the newspaper photograph came first and remained primary in part because it showed what people wanted to see, in part because it produced the more dramatic exchanges and images.

Although the AP photograph had worldwide publication, Erwitt's photograph of Nixon poking his finger at Khrushchev is the picture that is still remembered. Nixon himself arranged this. His reputation as a man who could stand up to communism was a central element in the 1960 presidential campaign against Kennedy. A photograph could carry the message effectively, even subliminally, and his campaign unerringly picked the sharpest image, another frame of the *Time* magazine picture, probably taken a second before or after that picture as Erwitt kept shooting.

After the AP picture was published, the Russians insisted that all negatives be developed in Russia so the censors could "make sure they are objective." Safire says he had to smuggle Erwitt's negatives out in his socks the next day. Erwitt says his memory is unclear but he's doubtful, because he took so many pictures Safire would have had to have enormous socks.[29]

However it got out, that photograph was ultimately seen by millions upon millions of voters in the 1960 campaign. A free pamphlet reprinting the text of a speech Nixon made in March was published by Nixon Volunteers with three photographs of Nixon. Erwitt's picture was on the inside with the caption, "As I said to Mr. Krushchev [*sic*] . . . in Moscow . . . 'The United States has, from the distribution of wealth, come closest to the ideals of prosperity for all in a classless society.'" The photograph, with the same caption, also appeared as the back cover of a large folder of material for the press, called "Become Better Acquainted with Richard Nixon," which included his voting record and positions on a number of issues.[30]

This photograph also turned up on television commercials for Nixon, although it was never the star of the program. It was used in at least one California primary spot and again on a half-hour national program called "Meet Mr. Nixon," and it reportedly appeared in print ads as well. It drove home the message. Illegally, as it happened: the campaign had not requested permission from the agency, which Erwitt says he would have refused, as he was no fan of Nixon's. The agency and the Republicans eventually came to a settlement. (So much for a photographer's control over his images.[31])

These two images point a moral about photographic influence. The AP photograph is not a very strong picture by most aesthetic or dramatic criteria, but it had the inestimable advantage of being the only picture available when it was published. And if it did not say what it had to say brilliantly, it said it well enough. Photographs are inseparable from the information they contain; in news photographs the subject may well be more vital than the aesthetics. An important subject seldom rescues a bad painting from the swamp of the gladly forgotten, but it can magnify what might otherwise be judged a weak photograph.

Erwitt's picture, on the other hand, has all the power of the perfectly captured moment. The composition is forceful and concentrated; it eliminates every extraneous detail; it delivers a simple message with great urgency. The AP picture could not match the power of persuasion that made the other perfect for a political campaign. Erwitt's picture became so symbolic of the kitchen debate that when Nixon wrote his memoirs in 1978 he recalled that the debate "was widely reported—with a dramatic photograph showing me prodding my finger in Khrushchev's chest for emphasis."[32] Later the picture gained yet another audience as photography received wider attention and Erwitt's reputation as an "art photographer" grew.

In 1960 the public image of Nixon as "the man who stood up to Khrushchev" was so strong that Kennedy felt he had to match it by opening their first televised debate with a brief, hard-hitting attack on the Soviet leader. Both photographs had helped Nixon maintain this vote-getting posture, and although he lost the election, he lost by a mere thirteen thousand votes out of more than thirty-four million cast.

Ironically, his defeat is usually attributed to another visual image, this one on television—the first time that television had a marked effect on an American election. Nixon came to the first debate after losing twenty pounds in a hospital bout with an infection. His shirt collar was too big; he was pale; he had imprudently refused all makeup but a little "beard-stick" powder that could not cover his heavy five o'clock shadow; he sweated; he seemed stiff and uncomfortable. In the next three debates he recovered much of the ground he had lost, but the audience was never again nearly so large, and the image of him as a weak candidate, sweating and uncomfortable, had lodged in too many minds.

A political photograph can be so strong and its force so sly that it continues to broadcast its message even in enemy territory. An odd disjunction then results, with the picture whispering one thing and the text proclaiming another. Funny how the whisper persists and sinks into consciousness . . .

This disjunction operates in other areas but is particularly obvious in politics. In the 1930s, when photography, newsreels, and radio shifted the focus of news and communications, Stephen Early turned these basic changes in the information system to the president's advantage. As Franklin D. Roosevelt's press secretary, Early offered photographers easy access to FDR with their new 35mm "candid cameras" if they stayed within bounds. Principally that meant they were not to show that Roosevelt was as disabled as he was. It was a more polite and private time, and the press was willing enough to cooperate. The public did not see the president carried onto the dais to give a speech or assisted across difficult terrain.

Early did not permit important speeches to be filmed live, but knowing how useful the footage would be, he arranged for the president to reenact some of his meetings and fireside chats, and there were plenty of oppor-

tunities for stills of FDR and those around him. Photographers, who wanted their pictures published and found their way smoothed to the most newsworthy of subjects, generally took flattering or at least friendly pictures of the president, his family, and his aides. With nothing else to print, editors published these genial, approving images in papers and magazines that consistently opposed Roosevelt; the photographs subtly undercut the text.[33]

By the 1960s the image business was more sophisticated. President Lyndon Johnson appointed the first White House staff photographer to ensure that a favorable record would be made. One of his aides wrote him a memo in 1964 about the power of photographs to counteract partisan attacks: *"A good, strong, happy family image is the best counterattack on political smears: i.e., to offset any image of you as 'one of the boys in the back room.' For this purpose, pictures are worth thousands of words."* The aide recommended photographs of Johnson and his wife alone, strolling in the White House garden hand in hand, or of the president and his daughter bowling by themselves in the Executive Office Building bowling alleys.[34]

With Ronald Reagan the disjunction between image and content was not only wide but carefully built into the presidency. Reagan looked so consistently cheerful that it was difficult to find an unhappy photograph of him, and if the sound was turned off when he was delivering a televised speech on evil empires or nuclear weapons, the impression that remained was of an amiable after-dinner speaker. (Oliver Sacks wrote about a group of severely aphasic patients who were incapable of following the logic of speech but uncannily adept at reading facial expression and body language and at distinguishing the authentic from the inauthentic. He was startled to hear them roar with laughter one evening as Reagan began to speak on TV.[35])

The president's assistants had determined that for ordinary people visual imagery could undermine any kind of damaging commentary. Leslie Stahl, the CBS television reporter, says that when disasters like the bombing of the marine barracks in Lebanon occurred, the president would quickly disappear to California, so there was no opportunity to take a picture of him that would become identified with the calamity. During the 1984 campaign Stahl did a five-and-a-half-minute report on Reagan (most TV news items last at most a minute and a half). "The piece," she said,

was very tough and very negative. Basically it said that Reagan was trying to create amnesia about policies of his that had become unpopular. So we'd show him standing in front of a nursing home cutting the ribbon and I'd say, but he tried to cut the budget for nursing home construction. Then you'd see him at the Olympics for the handicapped and I'd say, but he tried to cut the budget for the handicapped . . .

The piece ran and my phone rang—it was a senior White House official. And he said: "great piece." I said, wait a minute, that's probably one of the most negative pieces that's ever been done on Ronald Reagan. And he said: "You guys haven't figured it out yet, but when you run five minutes of pictures of Ronald Reagan looking energetic, patriotic, smiling and sweet, the public doesn't care about what you're saying. If your message is negative but the pictures are positive, the positive will totally override the message and cancel it out."[36]

People took Reagan's affable image to heart, and in such matters the eye and heart overrule the mind. We learn at an early age to believe our eyes rather than our ears. A parent who says "Yes, that's very nice" with an

unconvincing facial expression, a friend who says "I'm fine" but whose body language denies it, teach us to trust the evidence of our eyes. In the media age image makers can manipulate this trust. The polls kept showing great popular support for Reagan even when the voters disagreed with his policies.

In other realms than the political, the process may be slow, but the disjunctive image still makes itself heard above the din of text. During the Korean War there were pictures in the national magazines that were far more grim than the articles they accompanied, and images of the Vietnam War on television preached an antiwar doctrine for some time before the broadcasters and the press in general stopped accepting the government line. These pictures had an influence, but it went underground and was experienced as a small and nameless discomfort until well into Vietnam, when it was allowed to have a name. In August 1990, when President Saddam Hussein of Iraq appeared on television with the families of Western hostages to tousle a boy's hair and prove what a friendly and peace-loving fellow he was, none of his verbal messages or overt gestures could overcome the impression made by the boy's all too visible fear.

The power of photographs to establish an image was no sooner understood than it was exploited. Photographs are easily manipulated; a nose can be straightened by retouching, a companion spliced in by collage or montage. Fake photographs were enlisted early to destroy reputations. A nineteenth-century photograph of the pope wearing the insignia of a Freemason created a scandal before people realized it was impossible. In 1861 the head of the exiled queen of Naples was tacked onto someone else's majestically unclad body in images that purported to show her having a rousing time with Zouaves, cardinals, His Holiness himself, and certain unmentionables: "The Queen of Naples is nude and bathing in a round bathtub in which there were objects of unmistakable form floating." Fakes could be equally useful for enhancing or preserving reputations. In 1879 the young head of the Bonaparte dynasty in exile, fighting with a British battery in South Africa, died at the hands of Zulu attackers. He received at least seventeen spear wounds, his corpse was stripped, his saber carried off. Yet the photograph of his dead body showed him in uniform, unblemished, with a saber still in his lifeless hand—a life portrait with its eyes artfully closed by the retoucher.[37] The martyred leader maintained his imperial glory with the aid of a little photographic chicanery.

The photographic lie succeeds because photographs appear to be so truthful. The fake disrupts two dearly held expectations: that photographs report what was actually there, and that seeing is believing—for photography amounts to a surrogate for personal observation. Fake photographs are an obvious choice for propagandists and are difficult to counter. L'Anti-juif illustré, the anti-Dreyfusard paper, printed so many composite pictures purporting to show people in damaging alliances that the Dreyfusard paper printed a special supplement called "Les Mensonges de la photographie" (The Lies of Photography) to expose its opponent's lies.[38]

Photographic lies and innuendoes are fairly plentiful in the annals of political propaganda. A French photographer named Eugène Appert made a veritable industry out of discrediting the Communards with cleverly faked pictures once the uprising had been put down and anti-Communard feeling ran high. Appert reconstructed historical scenes he could not have witnessed by posing models, adding portrait heads of Communards or their victims, then rephotographing these collaged pictures so that they would appear

seamless. They were subtle enough to be just believable. A faked picture of Archbishop Darboy in his cell (he was imprisoned and later executed by the Commune) showed him suitably calm, with the bars on the door and windows of his cell forming crosses—the perfect portrait of a martyr. Two generals who were in reality separately butchered by frenzied crowds were shown by Appert bravely and imperturbably facing a firing squad together.[39]

As photographs are primary historical documents, tampering with them can amount to tampering with history itself and in fact has proved an expeditious way to rewrite the past. The primary method here is excision, as when the Soviet Union cropped Leon Trotsky out of pictures with V. I. Lenin—sometimes Trotsky's elbow stayed uncomfortably behind—or cut out Lev Borisovich Kamenev, or others who had fallen from grace. Eastern European countries and China have been equally adept at political elimination by adroit use of scissors, which makes history obligingly elastic. But dictatorships have no monopoly on the attempt to control the political record. After Lincoln was assassinated, a law was passed prohibiting the sale of photographs of John Wilkes Booth, so that his name should not be perpetuated.[40]

Motion pictures are as easily suborned as stills. When the March of Time began making newsreels in 1935, events no camera had seen were routinely reenacted. Presumably the public was not fooled. During Upton Sinclair's unsuccessful campaign for governor of California in 1934, however, the Motion Picture Industry Association made trumped-up newsreels, one of which featured a foreigner with the look of a revolutionary and a supposedly Russian accent declaring that he would vote for Sinclair: "Vell, his system vorked well in Russia, vy can't it vork here?" What made these films—political commercials, to be more precise—particularly insidious is that they were often run in movie theaters in California as actual news footage. The notorious jig that Hitler performed on film in June of 1940 when the French surrendered, a jig that made him look like a gleeful demon dancing on the grave of his enemies, was in fact a single stamp of excitement repeated in a loop by a filmmaker.[41]

The best-known fake in American political history was a still photograph.

Early in 1950 Senator Joseph McCarthy, Republican of Wisconsin, announced in a soon-to-be-famous speech that he had a list of 205 State Department employees known to the department to be members of the Communist party. After changing the number several times, McCarthy spoke in the Senate about "active Communists at State"; alarmed senators asked the Foreign Relations Committee to conduct a full investigation. The Democrats named Millard Tydings of Maryland, chairman of the Armed Services Committee and member of the Foreign Relations Committee, to chair the five-man investigating subcommittee. In four months of hearings McCarthy came up with a mere ten names; only four of these were still at the State Department, and they had already been cleared.

The subcommittee reported that "a fraud and a hoax [have been] perpetrated on the Senate of the United States and the American people." Tydings, accused by Republicans of whitewashing State Department sins, spoke against McCarthy for two hours in the Senate, saying the Wisconsin senator had been "whitewashing with mud, whitewashing with filth," and conducting "the most nefarious campaign of half truths in the history of this republic." The senator from Wisconsin was reportedly so angry about the Tydings report that he could scarcely sleep.[42] Nineteen fifty was an election year, and McCarthy went after several of his enemies. He gave Tydings a good deal of

Hitler Does a Victory Jig after

Signing the Peace Treaty with

France in 1940—Compiègne,

France, 1940

The Bettmann Archive,

New York

personal attention. With almost 70 percent of Maryland voters registered Democrats, Tydings was considered a sure thing. A conservative, he had already been elected to four terms in a row, staving off an attempt by President Roosevelt to unseat him in 1938. McCarthy and his staff planned and raised funds for the campaign of an unknown Republican lawyer named John Marshall Butler, who spent most of his speeches inveighing against the Tydings committee "whitewash" of the State Department.

Early on, McCarthy enlisted the assistance of Mrs. Ruth "Bazy" McCormick Miller, niece of the conservative Chicago newspaper baron, Colonel Robert R. McCormick, and editor of the McCormick-owned *Washington Times-Herald*. The senator wanted her help in compiling and printing half a million copies of a tabloid attacking Tydings. She obliged him for far less than cost. Her chief editorial writer, Frank M. Smith (who became Butler's assistant after the election), put the paper together, chiefly from material supplied by McCarthy's office. Her assistant managing editor, Garvin E. Tankersley (who later married her), directed the composition of the front-page photograph.[43]

The tabloid, rather deftly titled *From the Record*, was so obviously composed of lies and half-truths that one Butler campaign volunteer said he burned or sold for scrap about one hundred fifty thousand copies. The rest were sent to Maryland voters a few days before the election and played a key role in the campaign. On the front page was a photograph of Senator Tydings having a pleasant chat with Earl Browder, former head of the American

Communist party. The caption read: "Communist leader Earl Browder, shown at left in this composite picture, was the star witness at the Tydings Committee hearings, and was cajoled into saying Owen Lattimore and others accused of disloyalty were not Communists. Tydings (right) answered, 'Oh, thank you, sir.' Browder testified in the best interests of those accused, naturally."[44]

The conversation had never occurred, the photograph had never been taken. In fact, it was composed of a cutout of Browder from one photograph and a cutout of Tydings from another. The two figures were pasted into place and rephotographed, creating a seamless visual lie. Who would doubt a photograph? The McCarthy people were well aware that most readers would skim past the word *composite* or would have no idea what it signified in relation to a photograph.

Tydings lost to Butler by forty thousand votes. It wasn't the photograph alone that defeated him, or the effectiveness of the tabloid, or even McCarthy himself; Tydings's conservatism, sudden reversals in the Korean War, resentment against the Democrats, and a much larger Republican campaign chest all contributed significantly to his loss. But McCarthy's fellow senators read the election as a warning that anyone he opposed was doomed.[45]

In early 1951 Tydings appeared before a Senate subcommittee and

Earl Browder and Senator

Millard Tydings in the

composite picture originally

published in *From the*

Record, 1950

Reproduced in the *New York*

Post, September 19, 1951

State Historical Society of

Wisconsin

ONE-MAN MOB—NO. 14:
The Man McCarthy 'Got'

Continue from Page 2

strategy was to try to defeat Tydings rather than to stress Butler. At McCarthy's instigation, they began a whispering campaign with the theme that Tydings was disloyal or if not disloyal, at least should be defeated because for unexplained reasons he was protecting Communists in the government.

The Senate report: "The 'back street' campaign conducted by non-Maryland outsiders was of a form and pattern designed to undermine and destroy the public faith and confidence in the basic American loyalty of a well-known figure.")

McCarthy and Jonkel realized that it would be impossible to convince the majority of people of such nonsense. However, they calculated that perhaps 20 or 25 per cent of the voters were in doubt; if this many people could be reached by a whispering campaign which said: why be in doubt? play safe and vote for Butler—then Tydings was doomed.

(The Senate report: "It might be an exaggeration to call this 'back street' campaign a 'big lie' campaign. But it certainly is no exaggeration to call it a 'big doubt' campaign.")

Butler was sent on tour making general speeches along customary Republican lines. The really heavy cannonading against Tydings' loyalty and patriotism was done by Senator McCarthy who stumped the state, by radio commentator Fulton Lewis Jr., who has five stations in Maryland, and by the Washington Times-Herald which has an extensive Maryland circulation.

FOUR WEEKS BEFORE THE end of the campaign, McCarthy decided that something more was needed as a knockout punch. He proposed publishing a four-page tabloid summing up all the charges against Tydings, partic-

would have run such a picture in his own newspaper, Tankersley conceded that it is "not the usual illustration that you will use in a newspaper."

Mundy, who was Butler's nominal campaign manager, denounced the photograph later as "stupid, puerile, and in bad taste." Tankersley and the other members of the McCarthy cabal, however, defend it stoutly. McCarthy himself describes it as "a very effective job."

In addition to publication of the tabloid, the Butler campaign wound up with mailing half a million postcards containing last-minute personal messages to the voters written in pen and ink supposedly by Butler himself. The postcards were actually filled in by campaign workers in accord-

eyes looked like they were going to pop out of his head. I said that he was working himself up over nothing . . . I'm tired and I want to go home. (This was about 1 a.m.)

"Surine reached out and jerked me back by the coat. He said, 'Listen, I want that letter back.' I said, 'What letter?' He said, 'The guarantee letter you got from Butler.'

"I told him that he wasn't going to get that letter. He told me if I didn't give him the letter, they would fix me up and put me through a McCarthy investigation. He bragged about being good at that sort of thing. I told him that I couldn't give him the letter even if I wanted to—that this letter was in my attorney's office.

postcards' was not the only purpose of their mission.")

McCarthy's employes did their best to shield the boss when they testified. Moore said he operated under direct orders from George Greeley, McCarthy's administrative assistant, in dealing with Fedder. Moore said his job was to specialize on Senator Tydings' attitude toward Communism. He provided this information to anybody who wanted it, he said, under specific instructions.

"Who gave those instructions?" he was asked.

"I don't remember," said Moore, whose memory had been excellent up to that point.

RAY KIERMAS, McCARTHY'S office manager, had similar difficulty in recapturing the past

Herald, and was attended by, among others, Sen. Owen Brewster (R-Me.), chairman of the GOP Senatorial Campaign Committee and the regular intermediary between Sen. Taft and the McCarthy bloc.

As a result of this conference, Butler filed five days later a supplemental report with the Secretary of the Senate listing $27,100 in previously "overlooked" campaign contributions.

To make this move seem regular, Jonkel wrote a letter to Mundy saying that in the campaign he had been "so busy (that) accurate records were not kept in all instances."

Mundy, however, refused to sign the supplemental statement. Jonkel was left to take the rap alone.

THE FINANCIAL HOCUS-PO- cus does not end there. The check from Bentley, the Detroiter, which McCarthy himself personally solicited was not turned over to Mundy. McCarthy gave it to Robert Lee, a McCarthy friend who has a job as minority clerk of the Senate appropriations committee. Lee passed the check to his wife who used it to open a personal account in her own name at the National Capital Bank and then drew on it for campaign activities. Why this circuitous method was followed and for what campaign purposes Mrs. Lee spent the money has never been explained.

(The Senate report: "The financial irregularities uncovered by this investigation of the Butler campaign were of a substantial nature, involved large sums of money and were engineered by the candidate's own manager. We are impressed with the fact we are not considering actions by enthusiastic supporters of his candidacy operating from a base foreign to the candidate's per-

THIS IS THE FAKE—"Composite Picture" of Earl Browder and Sen. Tydings
Associated Press Wirephoto
"Not the usual illustration that you will use in a newspaper."

Non-Composite Campaign Picture

Herblock

Non-Composite Campaign

Picture, 1951

Pen and ink on paper

© 1951 by Herblock in the

Washington Post

charged that Butler had won by lying about him. He was particularly incensed about the photograph. The Senate investigated the election and the matter of the photograph at length. Frank Smith testified that it was "not a fake . . . not a fraud." Garvin Tankersley said they'd done nothing wrong: "We wanted to show that Mr. Tydings did treat Mr. Browder with kid gloves and conveyed that in the caption." Jean Kerr, McCarthy's research assistant (later his wife), said the picture was "the type of literature that should go out in a campaign. The voters should be told what is going on and this certainly did it."[46]

The subcommittee did not see matters quite that way. Their report, unanimously signed by the Democrats and the Republicans on the committee, referred to the "infamous composite picture" and charged the managers of Butler's campaign with illegal and irregular conduct. Still, they made no attempt to unseat Butler. The infamous picture was mocked by Herblock in the *Washington Post* in a cartoon of a safe with an overflowing garbage can on top of it and a ballot box on top of that. A newsman whose coat says "Investigation of Maryland Senatorial Election" is photographing this combination. The caption reads: "Non-Composite Campaign Picture."[47]

The damage that fake photographs could do had been made so abundantly clear that in Wisconsin, McCarthy's home state, two bills to outlaw composite photographs were introduced in the state legislature that year.[48] But a little more than a month after a Senate investigation had been proposed to determine whether McCarthy should be expelled, he won an overwhelming victory in the Wisconsin primary.

McCarthy got away with endless numbers of verbal lies. Although he was caught at it many a time, he merely lied again and yet again; there was always

a crowd who believed his words. He also kept using fake photographs, but those he could not recycle. Fake photographs were more easily and convincingly disproved than most verbal lies, and once disproved they could not simply be repeated or even adjusted a bit, as his accusations were.

In 1950, when yellow journalism seemed like ancient history and 35mm "candid cameras" had made photojournalists known for a sometimes wicked truthfulness, news photographs were deemed so reliable that it might never have occurred to a reader, even a reader suspicious of the text surrounding the Tydings photograph, that the picture was a fake. When events as unlike one another as bank robbery and wins-by-a-nose could be proved by photographs, a chat between public figures was not likely to be questioned. The picture in itself resembles thousands of other newspaper photographs and on the surface is innocuous enough. As Roland Barthes points out, what makes the Browder and Tydings conversation "the sign of a reprehensible familiarity is the tetchy anti-Communism of the American electorate"; what poisons the scene is not what is ostensibly pictured but the historical context.[49]

Senator McCarthy's staff tried the cropping gambit too. On the fourth day of the 1954 Army–McCarthy hearings—which pitted the senator against the secretary of the Army, Robert T. Stevens, and in the end discredited McCarthy—Ray H. Jenkins, special counsel for the Senate subcommittee,

William J. Smith (1906–1986)

The Focus of Attention, 1954

AP/Wide World Photos,

New York

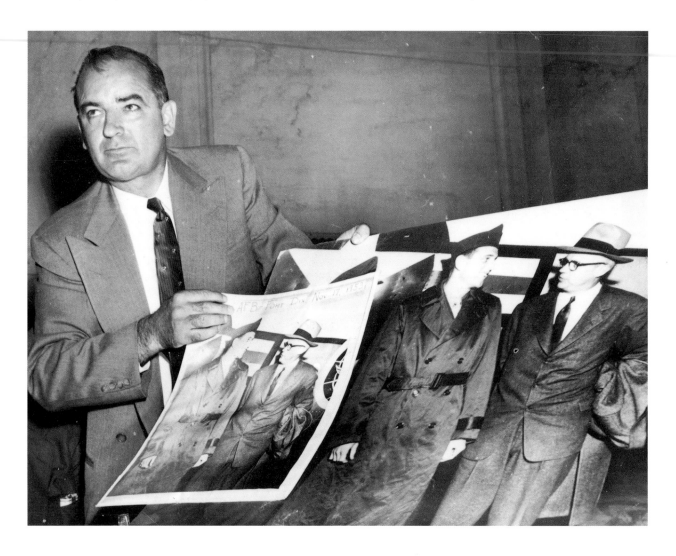

showed Stevens a photograph of him with Private G. David Schine. Stevens appeared to be smiling at the younger man. Prior to the hearings McCarthy had been investigating the military and had put Stevens under intense pressure. Now it was alleged that McCarthy or his counsel had requested preferential treatment for Schine. Jenkins used the photograph to drive the point home. Jenkins to Stevens: "Isn't it a fact that you were being especially nice and considerate and tender of this boy, Schine—wait, wait, wait, wait—in order to dissuade the Senator from continuing his investigation of one of your departments?" Stevens had already tried to interrupt to say, "Positively and completely not."[50]

The next day Joseph N. Welch, special counsel for the Army, produced the original photograph. Schine was not alone with Stevens but was standing in between him and Colonel Jack Bradley, the real recipient of Stevens's smile. Bradley had been cropped out of the picture shown the day before. McCarthy subsequently said the photograph wasn't doctored and wasn't a group picture, as Welch said it was; only Colonel Bradley had been left out.[51] But the cropped photo made McCarthy's duplicity obvious to many who had not previously understood it so clearly and reminded viewers of the composite picture he had made infamous four years earlier.

The televising of the Army–McCarthy hearings can be regarded as an early stage in the transition from the dominance of the still photograph as a carrier of information to the dominance of television. It is ironic that the dark power of photographic deceit should have been so dramatically displayed on TV just as television was gathering power. The hearings were further proof of the public's desire for visual news—the news coded in pictures. At this point TV may have been strengthening photography's hand by bolstering the public's expectation of seeing an event, complete with fumbles and bumbles, the instant it occurred. *Life* reported that the "news photographer, with the added impetus recently of spot-news TV, has come from the sidelines to the spotlight. No longer need a photographer covering a Congressional hearing necessarily wait outside. . . . Today he is not only inside for the whole shebang, as in the current McCarthy investigation . . . but senators may even write him plaintive messages, like the one the junior senator from Wisconsin himself sent last week saying, 'Could I have time off from cameras for ten seconds to use a handkerchief?' "[52]

Collage, montage, retouching, and cropping all interfere with the information in the photograph itself, but even intact and entirely truthful photographs can still tell lies. The culprit in such cases is either text or context, for photographs are captives of circumstances that can realign their meanings. Most photographers know the damage that captions can do and are aware that photography's fidelity to fact and purity of witness are easily undermined by editors, caption writers, and means of distribution.

During World War I the Germans published pictures of their kindly occupying troops giving food to French children and of other generous German soldiers distributing food to Belgian youngsters. Oddly enough, the same children appeared in both pictures. The story was told in World War II that the German occupying army in France once gathered the residents of one district with the promise of bread and asked everyone who wanted a loaf to raise his or her right hand. A picture was snapped; when it appeared in the paper the next day, the caption described it as a group of French citizens saluting Hitler. Even the photographer's intentions may be subverted by editorial interference. In 1936 when Robert Capa took a photograph of Alsatian

women giving a leftist salute, the French magazine *Vu* printed the picture on the cover but cropped it down to a close-up of a single face, eliminated the gesture, titled it "The True Face of Alsace," and followed it with an article that implied Alsace leaned to the right.[53]

That same year an American photographer's intentions were also misinterpreted by the press—his photographs, guilty of nothing more than aesthetic experiment, caused a political uproar. Early in 1935 the U.S. government had established the Resettlement Administration (later incorporated into the Farm Security Administration), under the directorship of Rexford Guy Tugwell, to improve the lot of farmers and to resettle those working unproductive land. To counter anticipated hostility to socialistic aspects of the program, Tugwell created a Historical Section to document in photographs the nature of rural life, the necessity for assistance, and, ultimately, the results of RA policies. Tugwell appointed Roy Stryker, an economist, to head this section; Stryker then hired outstanding photographers—including Walker Evans, Dorothea Lange, Ben Shahn, and Arthur Rothstein—and compiled the most comprehensive visual record of rural America in the 1930s.

Almost immediately, a controversy over Rothstein's photographs of a steer skull threatened the credibility of the RA and damaged its effectiveness. As Rothstein told it, he was driving through the Badlands of South Dakota in May 1936 when he spotted a steer skull lying on an alkali flat. The subject was so good—a still life arranged by nature herself, a composition with an instant echo of the Old West and a little shiver of death—that Rothstein "started playing around—you know, like an artist photographer would. And I took pictures of the skull with the light this way and the shadows this way. And I dragged it about ten feet to a clump of cactus and took it with the cactus, and so forth." He made five exposures and sent them to Washington, D.C. Stryker was so impressed with them that he wrote Rothstein a congratulatory letter.[54]

That summer the drought came on, parching the land across the plains. In July, as conditions grew severe, an Associated Press editor who had never been out west went through the RA photographic files and decided that one of Rothstein's skull pictures was the perfect symbol of the drought that had turned the country's farms to dust. He captioned it "skull of a drought-stricken steer" and syndicated the photograph nationwide.[55] Back in May, when the photograph was taken, there hadn't been any drought. Besides, alkali flats exist all year round, drought or no drought, and no farmer in his right mind would have worked the Badlands. But the picture looked the part, and its inherent symbolic quality established it as a ready-made emblem of nature's terrifying power.

Documents may become emblems easily enough, but an emblem is not necessarily a document. Rothstein's photograph, actually a document with an aesthetic turn of mind, was misrepresented, and its privileged position as objective witness was compromised. All photographs, including documentary photographs, are open to interpretation—perhaps one should say *vulnerable* to interpretation—when text or context is changed. This one might have passed had it not been an election year.

As the drought wore on, President Roosevelt sent a delegation of farm experts, led by Tugwell, on a fact-finding tour of five states to map out a relief program. The committee was scheduled to meet up with the president and report its findings when FDR's reelection campaign train stopped in Bismarck, North Dakota, at the end of August. The drought was a big issue in the papers that summer. North Dakota and neighboring states in the Republican camp felt they were being singled out for political reasons, though the drought had

Arthur Rothstein (1915–1990)

Two versions of *Steer Skull*,

1936

Library of Congress,

Washington, D.C.

A Diet Coke can had been removed from the table in the foreground; the computer filled in the empty space with elements duplicated from the same photograph's background. Not much, merely a soda can, but it worried someone other than the company that lost a free ad. If a can of soda can be banished by editorial edict, why not a gun? (A gun and holster actually were erased from a photograph of Don Johnson for the March 18, 1985, cover of *Rolling Stone.* The fact that a gun belonging to the star of "Miami Vice" is essentially a fiction does not change the issue.) Why not cut out a hundred-dollar bill? Another person in the picture? Photojournalists no longer claim pure neutrality and objectivity—everyone's too post-Freudian and post-Barthesian for that—but the photographers and their audience have inherited the tacit assumption that the news will not be willfully tampered with. The question now is, who will guard that assumption—and how are we to judge the truth of the photograph in the future?[62] It is a question that will surely change the nature of our relation to photography.

André-Adolphe-Eugène

Disdéri (1819–1890)

Carte de Visite

of Napoleon III

International Museum of

Photography at George

Eastman House, Rochester,

New York

FAME & CELEBRITY

Fame has been with us for quite some time, but the celebrity was a nineteenth-century invention. Fame is, or was, essentially a reputation earned by achievement; a celebrity is someone who is famous for being famous. It took the combined efforts of the press, the graphic revolution, and photography to make reputation more important than skill.

The word *celebrity* had for some time indicated the state or condition of being famous, or perhaps of being notorious—"They had celebrity," Matthew Arnold said, "Spinoza has fame"—but not until 1849 did people and their fame become synonymous. That year Ralph Waldo Emerson spoke of "one of the celebrities of wealth and fashion"—and after that the condition and the person were united in the word.[1]

Celebrities were put on pedestals partly to replace the idols that had fallen off: saints that were diminished in a secularizing age, kings and aristocrats whose positions had lost their luster. The photograph was one means of making the new objects of veneration portable and affordable, much as engravings and woodcuts on paper had disseminated the holy images in the fifteenth and sixteenth centuries. Even family Bibles had spaces for cartes de visite, presumably of family members, and some albums were manufactured to resemble prayer books.[2] G. K. Chesterton said that when people stop believing in God the trouble is not that they believe in nothing but that they will believe in anything. In liberal regimes and democracies, in countries where literacy had spread and travel was easier, citizens yearned to know and touch their new leaders and heroes. The bourgeoisie may not have wanted to be ruled, but they still needed someone to rule their fantasies. Someone, by then, just a bit more like themselves.

The new information systems created just such models and brought them to everyone's door. As each new means of communication came forward, and as every shift in the distribution of news and entertainment swelled the store of available data, the fame of the famous grew and the number of celebrities grew with it. The new media at length became indispensable to fame. First lithographs and wood engravings made pictures of George Washington and the Empress Eugènie more affordable, then the penny papers ran gossip columns and needed to fill them with names, then the picture press found out that famous names sold magazines—and then there was the photograph. For those who could not personally know their heroes, photography offered the next best option: ownership of their images.

Photographs of the famous were sold singly or in readymade collections. Mathew Brady's *Gallery of Illustrious Americans* was issued as a set of

lithographs after daguerreotypes in 1850. Once multiple photographs became easy to produce, Mayer Brothers and Pierson's Paris studio immortalized the faces of illustrious Europeans in albums of deputies and ambassadors, and other notables appeared in publications like the eight volumes of the *Galerie contemporaine*. As information of all sorts gradually piled up, celebrities would come to substitute for events or political or cultural movements, an economical way to handle so much data. The leaders of the Bonaparte dynasty in exile stood for the return of monarchy to France, Gustave Courbet stood for realism in art, any number of actresses signified glamour, some of it agreeably spicy.

Photography and its potential influences change, sometimes radically, in response to changing technology. Such was the case with the carte de visite, patented by the portrait photographer André-Adolphe-Eugène Disdéri in 1854. The idea of mounting a portrait on a card the size of a visiting card came up in 1851 but not until three years later did Disdéri make the portrait calling card a technical and economic reality by dividing a single collodion-coated glass plate into ten (or occasionally twelve) rectangles that could be exposed simultaneously or serially, then cut apart. He thus instituted true industrial-era efficiency, conserving labor and drastically cutting the unit price. Major changes in social custom followed close behind.

Cartomania, a craze for collecting portraits of public figures and family members, began with the desire of cats to look at kings. The photographer Nadar said that Napoleon III stopped at Disdéri's studio while leading his troops to Italy in 1859 and thereby began a fashion, but Elizabeth Anne McCauley has proved that Napoleon's troops never marched down Disdéri's street.[3] Nonetheless, Disdéri did take Napoleon III's portrait and, perhaps more important, his family's portraits, and cartes de visite did leap to popularity in 1859.

The craze reached its height in the 1860s and persisted into the twentieth century, although by the later 1860s the slightly larger cabinet card partially replaced the carte. Albums were marketed by at least 1860, when collecting took on international dimensions. Carte sizes were uniform; albums could accommodate photographs from anywhere in the world. Cartes were also cheap: in the early 1860s in America, they sold for two to three dollars a dozen.[4] The invention of the carte, though it started among the highborn, brought about a true democratization of imagery and access to it.

In England the carte craze began in 1860, when J. E. Mayall published his "Royal Album" of fourteen carte portraits of Victoria and her family; at least sixty thousand sets are said to have been sold in Great Britain and the colonies. In the week after Prince Albert died, seventy thousand copies of his picture were bought by a fond public.[5] By posing *en famille*, Napoleon and Victoria turned themselves into ideal bourgeois models, no longer distant and godlike in the manner of earlier royalty but rulers who lived domestic lives resembling their subjects'. The men and women who bought their pictures could imagine a kind of intimacy and identification with their sovereigns.

At first the carte de visite was a plaything of aristocrats, who, after all, had a use for calling cards, but gradually its popularity filtered down. Cartes were usually full-length portraits, an aristocratic form; in painting, these cost more money. So, while royalty and aristocracy tried out middle-class family scenes, the bourgeoisie assumed an aristocratic stance. Needless to say, the middle class did not gain the advantages of nobility any more than aristocracy relinquished them; all that either class actually did was to assume the look of the other. Beginning with the French Revolution, the nineteenth century

perfected the art of making changes in social conventions seem like satisfactory substitutes for actual social improvement. Now the camera, by reassuring the merchant that he looked like a nobleman, helped buy him off and keep him in his place.

Cartes also helped promote a new aristocracy of achievement. No longer did high birth alone confer fame, nor even military prowess or political success; now artists, writers, clergymen, scientists, composers, actors, the talented, successful, and famous rose to a new level of social esteem. Cartes of such figures were widely available. They were sold in bookstores, galleries, and magazine shops, anywhere there was a lot of street traffic. The expansion of the definition of fame and the craze for collecting the portraits of those now included could have occurred only in an era convinced that character was expressed in a person's features. Once the pictures of the newly famous were put into circulation and collected, they, too, seemed more approachable and familiar. In the early to mid-1860s, Anthony and Company in America produced up to thirty-six hundred cartes of celebrities every day. Carte photographers regarded celebrity portraits as such a dependable source of sales they referred to them as "sure cards."[6] Today, baseball cards are probably the closest equivalent.

The culture was so eager for heroes and so caught up in the communications revolution that brought more news faster that the visage of a man who figured in a major news event could become an instant collector's item. For nearly two months after Fort Sumter was bombarded and Major Robert Anderson was forced to surrender it to southern forces at the start of the American Civil War, the firm of E. and A. Anthony produced a thousand copies of his portrait for sale every day.[7]

The carte de visite had an effect on families as well, endowing them with visible histories and genealogies. The traditional family was changing under the pressure of the industrial revolution and the consolidation of bourgeois society, which moved the center of labor outside the home. Emigrations from Europe to the New World, the westward migration in America, colonial wars and the American Civil War—all of which transplanted relatives to remote areas, sometimes forever—further altered the family structure. The album offered families a cohesion that reality did not necessarily provide; the dream of the perfect family slumbered within its covers.

Perhaps, too, the central importance of family and carte albums in so many nineteenth-century parlors speaks of the incipient breakdown of community brought on by rapid changes at mid-century. Existence was so thoroughly altered and speeded up that by the last quarter of the century complaints were heard about the loss of face-to-face communication.[8] Some personal contact had been replaced with disembodied messages and sounds relayed over wires; some faces had given way to photographs.

In professions that depended on an audience, sales of a person's portrait could indirectly bolster his or her income, but it was usually the photographer, not the subject, who was the chief beneficiary. In one early instance, however, portrait sales provided the subject's only income: Sojourner Truth supported herself by selling her picture. Truth was an illiterate slave who was emancipated in 1827 and afterward worked as a paid domestic. In 1843 she had a call from God instructing her to change her name to Sojourner (Truth came a little later) and preach his word, which she did until her death in 1883. She was the first black woman to speak out against slavery in public—mainly to white northern audiences—and she spoke up as well for women's rights, homeless

Sojourner Truth Seated with

Knitting, 1864

Sophia Smith Collection,

Smith College Archives,

Northampton, Massachusetts

freemen, and the temperance cause. During the Civil War she traveled to the White House to meet Lincoln.

In 1850 a friend and benefactor wrote the story of her life for her and arranged to have it published. For years Sojourner Truth sold this book when she preached and earned a living from it. Then, in 1863, when she had been ill for some time and her stock of autobiographies had run low, it occurred to her that photographs might be easier to sell than books, and she had her portrait taken. "I'll sell the Shadow to support the Substance," she said, and

this became her motto. Her pragmatic shift from the sale of books (which she could not read) to photographs (which she could "read" as well as anyone) is an appropriate metaphor for the growth of the image culture and its gradual displacement of text. First she sent her portrait to the *Anti-Slavery Standard* in New York, which printed an announcement that "a card photograph of that noble woman, Sojourner Truth" was available. (She sold both cartes and the slightly larger cabinet card portraits.) Other newspaper accounts sometimes took note of her photograph and her need. A Falls River, Massachusetts, paper wrote: "Sojourner Truth—the colored American Sibyl—is spending a few days in our city. . . . Give her a call, and enjoy a half hour with a ripe understanding, and don't forget to purchase her photograph."[9]

Purchases of her portrait amounted to donations to support her and her causes, but because donors received a memento in exchange for their contributions, she must have felt that she was not merely begging. And those who bought the photograph of this woman with a burning religious vocation and a high moral mission bought an image that in some respects resembled a pilgrimage souvenir—those inexpensive prints of miraculous statues or icons that pilgrims brought home with them as holy talismans and as proof that they had made the journey. Contributing to Truth's support by possessing her image presumably carried some small weight of moral satisfaction above and beyond the common thrill of "owning" a celebrity. The donations for her book and portrait eventually enabled her to buy a small home in Michigan. By the time of her death Sojourner Truth had become a legend, and her face was known throughout the northeastern quarter of the United States.

Actresses were especially eager to be recognized, and photography rushed to their assistance. When Mlle Rachel, the French actress once referred to as "the tragedienne of all Europe," was photographed by Charles Nègre in 1853, the photograph reportedly sold more than five hundred copies, unheard of at the time. When Jenny Lind, "the Swedish Nightingale," came to America in 1850–52 on a tour managed by P. T. Barnum, her photographic portrait so ravished her audience that a poem was published "On Seeing Mr. Anthony's Portrait of Jenny Lind"; it began " 'Tis true to life!" Lola Montez—the dancer whose necklines were low, whose skirts were short, and whose motto was "Courage! And shuffle the cards"—understood how a photograph might enhance her risqué reputation: on her American trip in 1856, Southworth and Hawes portrayed her smoking a cigarette.[10]

Rachel, Lind, and Montez all earned their reputations before the carte de visite was invented or before it gained a foothold in America. They were photographed often enough, but most of their portraits were lithographs or other prints. The magic that thousands of photographs could work was still waiting in the wings. The woman whose career began at the right moment to take advantage of that magic and who was clever enough to do so was Adah Isaacs Menken. She made her acting debut in New York in 1859, the year the carte was introduced to America. That year she had her portrait taken for the first of hundreds of times.

Menken's talents consisted chiefly of courage, seduction, and a keen appreciation of the uses of publicity. She was dogged by scandals and created several of her own. At the start of her career, when she was married to a boxer, she appeared alone at dinner one night with a bruise on the back of her hand. A reporter who sought out her husband found him nursing a black eye. Asked how he got it, he replied, "My wife hit me"—which made her an instant celebrity. The following year she remarried and was sued by the boxer

for bigamy, which did not improve her reputation but spread it far and wide.[11]

Menken's acting fame commenced in earnest in 1861 when she first played the title role, a man's part, in *Mazeppa*. The dramatic high point occurred when the hero was stripped, lashed to the back of a wild horse, and sent off to die. This scene was ordinarily played by a live horse and a male dummy, but Menken managed not only the daring canter offstage tied to a horse, but she did so stripped to pink silk tights that covered her from neck to ankle but made her look nude. She was a sensation, although one reviewer wrote, "So far as the person called in the bills 'Mazeppa,' she is the best *on* the mare, and the worst *off* that I have seen or expect to see."[12]

Menken toured America, then went to England in 1864 and France in 1866. At every stop she sought out new photographers and had pictures taken of herself in one role or another. She regarded photographs seriously and would send samples of portraits to friends for their opinions. Thousands of cartes of her were made during the nine years she was on stage, and she is said to have been the most photographed woman in the world.

When Anthony Comstock, who valiantly protected the public from cleavage and curse words, cried: "Why is it that every public play must have a naked woman? It is disgusting, and pernicious to the young," it was already five years after Menken's death, but the truthful answer to his question would have been that Menken had set the style. It was constantly bruited about that she appeared entirely nude in *Mazeppa*. In New York, Horace Greeley wrote in an editorial, "An actress who uses her naked body to entice audiences into the theater should be barred, by legislation, from the stage." Naturally such fulmination enticed a still larger audience. Photographs and drawings both fueled Menken's notoriety. Sometimes she played Mazeppa in a shoulder-

Napoléon Sarony

(1821–1896)

Carte de Visite of Adah Isaacs

Menken as Mazeppa, 1866

International Museum of

Photography at George

Eastman House, Rochester,

New York

Alphonse Liébert (active 1860s)

Carte de Visite of Adah

Isaacs Menken on the Lap of

Alexandre Dumas, Père, 1867

Harvard Theatre Collection,

Harvard College Library,

Cambridge, Massachusetts

Carte de Visite of Adah Isaacs

Menken and Algernon Swinburne,

December 1867 or January 1868

Harvard Theatre Collection,

Harvard College Library,

Cambridge, Massachusetts

baring blouse and a pair of shorts—more flesh than men and women had ever seen on stage (some had not seen so much at home)—and lithographed posters showed her so attired. In London the poster showed a drawing of a naked man in a loincloth, because naked men were acceptable, and the implication was that whoever rode that horse would be in the same state of undress. It appears that she even had herself photographed naked save for a tactful bit of gauze, although certainly not for her public. With photograph after photograph Menken created the demand for publicity and built a career on a foundation of little else. In Paris her celebrity was so great that shop windows were full of her pictures, and gentlemen who shaved from mugs adorned with her image wore Menken hats, coats, collars, cravats, scarf pins, even Menken pantaloons.[13] Her fame and photography got tangled in a manner that set tongues wagging across that sophisticated city.

After one of her performances Alexandre Dumas *père*, author of *The Three Musketeers* and *The Count of Monte Cristo*, went backstage to meet Menken. There soon ensued an affair of the heart and perhaps of the other kind as well, although people who knew Dumas thought the old roué no longer in good enough trim. He was then in his mid-sixties, still famous but no longer lionized, decidedly rotund, none too healthy, and entirely broke. Menken and Dumas had their portraits taken together: Dumas posed in his shirt-sleeves, with Menken on his lap. In another picture he had his arm about her waist while she pressed close to him and laid her hand on his chest. And there were more.

The photographer, Alphonse Liébert, was competent but evidently not much better, one of a slew of portraitists of moderate talent who flocked to the profession as the demand accelerated. His portraits of Menken and Dumas are not distinguished, but both the subjects were; the story was all in the

content and not in the telling. At least Liébert knew the uses of publicity. He put the pictures in his window and offered them for sale. Those little pieces of paper ignited the hottest scandal in Paris in years.

Paris in 1867 was not Victorian England, but it did have its rules and proprieties. Gentlemen did not ordinarily appear in public in their shirt-sleeves with ladies they were not related to. Not even a couple in a long-established marriage would have been likely to put themselves on record in such sexually suggestive postures as Menken and Dumas assumed—in some places, they would not even have held hands—and certainly such photographs would have remained private. Menken and Dumas, of course, were not married. In Parisian society a man was entitled to have a lover, even a woman might be entitled to a lover, but not, definitely not, in a shop window.

It is not entirely clear how the actress and the author came to be in Liébert's window. Apparently Dumas owed the photographer some money and, having none to spare, paid him off with permission to publish. Menken, whose reputation was badly damaged, wrote to Dumas about how unhappy she was with him. They broke off for a while, but ultimately she forgave him. In the meantime, every photographer in Paris rushed to copy Liébert's portraits and sell them as their own. Newsstands displayed them, newsboys hawked them on the street. Soon photographers were turning out faked portraits that were openly obscene, and many believed the lovers had posed for those too. People made collections that consisted solely of portraits of the famous pair. London and American papers furiously outbid each other for the rights to publish. In a reference to one picture in which Dumas seemed to smirk, Queen Victoria told members of her court that his smile made her ill.[14]

The journals carried on gleefully about the photographs, largely at Dumas's expense. *Le Figaro* wrote: "There are to be seen just now in the shop windows a series of astonishing cartes-de-visites of Miss Menken and Alexandre Dumas joined together in *poses plastiques*. Can M. Dumas be her father? In one of the series he is in his shirt sleeves. Oh, for shame!" *La Vogue parisienne* was so offensive that Dumas sent his seconds to offer a duel, and Dumas *fils* had to intervene to prevent it.[15]

George Sand wrote to the younger Dumas (who no longer spoke to his father): "How this business of the photograph must have annoyed you! The consequences of a Bohemian life make a sad spectacle in old age. What a pity it all is." Paul Verlaine dealt the unkindest cut of all, with a jingle that began: "L'Oncle Tom avec Miss Ada, / C'est un spectacle dont on rêve" (Uncle Tom with Miss Ada is a spectacle one dreams of)—perhaps a reference to Dumas *père*'s part-African heritage. It went on to rhyme the lady's name with *dada*, which means both rocking horse and the astride position during intercourse. It seemed that *le tout Paris* had the jingle by heart; children chanted it in the streets.[16]

Dumas kept the scandal alive by claiming that Liébert had no permission and taking him to court. The author lost, having had to admit that he himself had authorized the sale. He appealed, ensuring that gossip would run on. When at last he won an injunction against the distribution of the photographs, Menken had already gone elsewhere to play another role.

Only photographs could have caused such a scandal. Drawings might have caused talk but, presumably created without the consent of the subjects, they would have been too easy to doubt or too scurrilous. In the photographs the lovers, carefully posed and looking at the camera, clearly wished to be seen as they were. Menken's and Dumas's fame counted heavily: lesser folk might have seemed naughty but not all that interesting, but these two had been

photographed so often they were as recognizable as any other monument. And then the pictures broke all the rules. The man was thought too old for such shenanigans, the woman beneath his dignity, the costumes and poses improper, and the public display of what should be kept private a severe breach of etiquette.

Only an audience with this shared social code would have been scandalized. Certainly photographs cut across cultures more easily than words, but they are a most imperfect lingua franca. Like words, they depend on conventions, common memories, value systems. Had Brazilian planters or Javanese farmers who did not know Menken or Dumas and did not share Parisian mores glanced at these pictures, boredom rather than scandal would have been the upshot. If photographs do speak a universal language, it is the language that one Native American mother reported when she said that yes, her baby did speak, but she did not understand him yet. Photography is a universal language only in a limited universe.

These photographs transgressed the mores of the moment as well as the place. Had Arthur Miller been photographed in his shirtsleeves with Marilyn Monroe on his lap before they married, society might have lifted an eyebrow but definitely would not have gasped. When Gary Hart, running for the Democratic presidential nomination in 1984, was photographed on a yacht with a bikini-clad young woman on his lap, the electorate would not have been shocked had he not been married. From the vantage point of our day, Liébert's pictures are faintly amusing but hardly scandalous.

These pictures, however, had yet another sizable effect on their particular world. After subjecting Dumas to barbs and lampoons, they rescued him from unhappy obscurity and returned him to prominence in society for a while. His newfound notoriety piqued the interest of theatrical producers, who revived several of his early plays. None lasted long, and neither did he, for within two years he was dead. But the actress and the photographs put him in the spotlight once again.[17]

Menken not only had an instinct for the publicity value of photographs but also a less-fortunate knack for falling into pictorial scandal. Barely a year after the Dumas episode, a photograph of her with Algernon Swinburne set tongues wagging in Britain. Her romance with the poet, this time a few years younger than herself, was much talked about, but the stiff English libel laws had kept it out of the press. The nature of the affair has never been clear. It was said that Dante Gabriel Rossetti was concerned about the twenty-nine-year-old Swinburne, who liked to be whipped but had never had any other kind of sexual encounter with a woman. Rossetti supposedly gave Menken ten pounds to seduce his friend and later told a confidante that she'd given it back, saying she'd been unable to bring Swinburne "up to scratch." But as she was then the world's highest paid actress, earning one hundred pounds a week as *Mazeppa*, the money part of the story, at least, is unlikely.[18]

Menken was certainly fond of Swinburne, who apparently boasted to friends of his conquest in order to counteract the persistent rumors of his homosexuality. They posed together in late 1867 or early 1868 and sent prints to their friends. It is rather a silly and tedious portrait save for whom it represents. This time she did not sit on her lover's lap but sat down while he stood, for Swinburne was a tiny man, and she towered several inches above him. The photograph, not so inherently scandalous as the pictures with Dumas, had the lure of a celebrity romance and was put on display in shop windows all over London. It was proof enough of a liaison to give the journals free rein, which they promptly took. Swinburne wrote to a friend: "There has been a *damned*

row about the photographs, paper after paper has flung pellets at me, reissuing or asserting the falsehood that its publication and sale all over London were things authorized by the sitters; whereas, of course, it was a private affair to be shown to friends only. The circulation has, of course, been stopped as far as possible, but not without irritating worry."[19] He refused to see Menken and within the month she returned to Paris. Later that year she died—probably of poor health rather than blighted love or the harm her photographic escapades had inflicted on her reputation.

By Menken's time photographs had become essential to renown, and so they would remain. But her career proved photography a two-edged sword. It could build up reputations—her portraits had helped make Menken the world's most highly paid actress—and it could damage them as well—photographs had caused her no end of grief. The matter of fine-tuning one's public appearance was delicate. Sarah Bernhardt, who brought the celebrity photograph to a high pitch—she claimed that if all the pictures of her were stacked atop one another, they would be as high as the Eiffel Tower—tried to control her image. She had been photographed in white silk trousers and satin blouse, and although the costume included a lace neck ruche and a huge tie of white tulle, it was considered scandalously mannish, and postcards of the white-suited Sarah sold at a feverish pace.[20]

In 1880 Bernhardt allowed a photographer to photograph her in the satin-lined coffin in which she was said to receive her lovers. (It was known as the "sepulchre built for two.") Directing her own publicity, she stipulated that he could not sell the picture until after her death, which she promised would take place in a year. After a year she was not only still breathing but still performing, and he wrote to say her contract had been broken. "Patience," she wired back. The poor man would have had to have *that* in abundance, for Bernhardt lived on until 1923. She had managed her publicity so well that Dumas *fils* said he had been present at the deathbed of an elderly man-about-town whose last words were, "I depart this life willingly, for I shall hear no more about Sarah Bernhardt."[21]

But by that time a reaction to the excesses of publicity had set in. In 1884 Mrs. Madge Kendal, a much-admired English actress, denounced the "mania" for publicity in the theater and condemned photography as a degrading component of this unfortunate trend. By that time, too, celebrities had realized that their faces, which were reaping good profits for photographers, could also ease their own fortunes. When Charles Dickens made his second lecture tour of America in 1867–68, he refused to sit for his portrait until the photographer paid him a fee. Up to that time the idea of publicity had been so new and performers so eager to get it that they had freely given the photographer permission to sell their images (unless they were meant to be private). After Dickens all that changed. Bernhardt got a fee of fifteen hundred dollars to pose for Napoléon Sarony, one of the foremost theatrical photographers of his day, and Lillie Langtry, some years later, demanded five thousand dollars.[22] Once photography had helped establish the cult of personality, appearance became as salable as talent itself.

Late in the last century, as the rotary press sped up output, newspaper circulation spiraled upward once again, building a new audience in America among poor and immigrant populations. The *New York Tribune*'s high-speed press, installed in the 1870s, could print eighteen thousand newspapers an hour. By 1909 a magazine editor regarded the press as "the highest agent of our modern civilization. . . . at present the chief work of the common schools,

consciously or unconsciously, has come to be that of making a nation of people who read newspapers and periodicals."[23]

Not everyone in the era of yellow journalism thought the press so high an agent. Newspapers competed for readership by escalating the degree of sensationalism. The gossip column was by now a staple of journalism. "Gossip," as the *Harvard Law Review* opined in 1890, "is no longer the resource of the idle and of the vicious, but has become a trade, which is pursued with industry as well as effrontery." Human interest stories edged closer to gossip and gossip closer to exposé. High society found itself first scrutinized, then uncomfortable, then constrained; American extravagance looked so dreadful in the papers that for a while the conspicuous consumers slowed down and muted their voices. The camera's prying eye was hard to avoid. Already in 1880 President Garfield had prohibited photographs of his family and children as the only way to ensure their privacy.[24]

Photography was a major ally of the new, invasive journalism. The medium that had contributed so much to the establishment and dissemination of celebrity now proved itself quite capable of conferring fame on some who would rather not have it. Once more technology had bestowed a new power. The dry plate and roll film, faster lenses, smaller hand-held cameras, and flash powder combined in cagey new instruments. In the 1880s cameras for the general public were designed to be so inconspicuous that they were advertised as "detective cameras." Some were even disguised as pistols (although it is hard to imagine getting a candid "shot" of people by casually aiming what looked like a pistol in their direction); others were cleverly hidden in waistcoats, cravats, and gentlemen's hats. No one was safe from being caught unawares and permanently put on record.

This state of affairs, which had no historical precedent, inspired general indignation, yet neither law nor custom had any means of dealing with it. Delicious as it might be to see your neighbor caught in an awkward situation, there was always the chance that you would be the one caught tomorrow—incapable of preventing it and without recourse if the image was ill used. This was not yet the age of truly "candid photography," when 35mm cameras without tripod or flash or elaborate preparation readily captured a fleeting expression or the high point of a leap, but the camera was already adept at mischief. In a 1913 film called *Bobby's Camera*, a little boy gets a camera for his birthday and photographs his mother filching money from his napping father, the cook giving a kiss to a policeman, and his father trying to steal one from his secretary. In the end the father destroys the villainous instrument.

Just after the turn of the century, a photograph misused on a larger scale finally proved too much to put up with, and the public insisted on taking back control. The photograph that sparked the revolt against the camera's intrusiveness was quite a nice portrait of an attractive young woman. She never complained that it showed her to disadvantage. Indeed, one of the problems was that she was so easily recognizable. Her name was Abigail Roberson, but her lawsuit was so pivotal that lawyers fondly and simply refer to her as "Abigail." The case was Roberson v. Rochester Folding Box, the year 1902.

Someone took Miss Roberson's picture on the street, apparently without her knowledge and certainly without her permission. The Franklin Mills Company, liking the young woman's looks, printed her portrait twenty-five thousand times on advertisements for their chief product without bothering to ask if she minded. Above her portrait were the words "Flour of the Family"; below, in large type, "Franklin Mills Flour," and in smaller type in the corner the name of the box company.

These posters were then displayed in stores, warehouses, saloons, and other public places, and there they were seen by Miss Roberson's friends and acquaintances. Subjected to scoffs and jeers, her good name attacked, she endured such distress and humiliation that, as the legal complaint would put it: "She was made sick and suffered a severe nervous shock, was confined to her bed and compelled to employ a physician. . . . She had been caused to suffer mental distress where others would have appreciated the compliment to their beauty implied in the selection of the picture for such purposes." Miss Roberson sued for damages.

This photograph would have done Miss Roberson no harm whatever in a frame in her own home or her aunt's home or an art museum. Whatever meaning a photograph has is bound up in its context and its uses. Photographs are also known by the company that keeps them: a picture of an unidentified flying object released by NASA would attract a different response than the same photograph would if it originated in a tabloid paper. Photographs are peculiarly unstable documents, with peculiarly ambiguous meanings. This one made Miss Roberson pretty, but its placement made her a huckster.

The lower court ruled that she had a good cause of action because her "right to privacy" had been violated. But as that court noted, and as the higher court insisted, there was no right to privacy in the annals of law. In America the possibility that people had such a right had not even been broached until 1890, when Samuel Warren and Louis Brandeis wrote an article proposing its existence in the *Harvard Law Review*. The two learned lawyers cited several English decisions in which it was agreed that a man had property rights to his own thoughts and words, which therefore could not be published by others without his permission. Warren and Brandeis argued that these decisions actually rested on the principle of "an inviolate personality" rather than on property. An inviolate personality had a right to be let alone.

But the New York court trying Roberson v. Rochester Folding Box, although finding Warren and Brandeis's presentation attractive and able, repeated that there was no precedent for a right to privacy either in prior cases or in the great commentators on the law before 1890. There had been a pertinent American case in 1892, in which the court permitted the publication of a picture of one Mr. Corliss (Corliss v. E. W. Walker Co.) because he was "a public character," and that court also expressed the opinion that "a private individual has the right to be protected from the publication of his portrait in any form."

The judge in the Roberson case was not happy with this line of reasoning. "Is the right of privacy," he asked, "the possession of mediocrity alone, which a person forfeits by giving rein to his ability, spurs to his industry or grandeur to his character? A lady may pass her life in domestic privacy when, by some act of heroism or self-sacrifice, her name and fame fill the public ear. Is she to forfeit by her good deed the right of privacy she previously possessed?" (In subsequent years she was indeed to forfeit that right by such a deed. In general, a person involved in a newsworthy event—a bystander photographed during a gangland slaying, for example—or even in a newsworthy accident, has no legal right to prevent the press from printing her picture.)

The court was fearful that if it allowed the principle of privacy the judicial system would be flooded with lawsuits, many of them absurd. The decision went against Miss Roberson. The court decided that neither she nor anyone else had a right to privacy and therefore she had no right to sue. The opinion did say that lawmakers could change this: "The legislative body could very

well interfere and arbitrarily provide that no one should be permitted for his own selfish purpose to use the picture or the name of another for advertising purposes without his consent." Miss Roberson was sent home to suffer.

There was, however, a dissenting opinion by a judge who recognized that law, morality, and philosophy almost always lag behind technology but still must accommodate to a changing world. He said: "Instantaneous photography is a modern invention and affords the means of securing a portraiture of an individual's face and form, *in invitum* their owner. While, so far forth as it merely does that, although a species of aggression, I concede it to be an irremediable and irrepressible feature of the social evolution. But, if it is to be permitted that the portraiture may be put to commercial, or other, uses for gain, by the publication of prints therefrom, then an act of invasion of the individual's privacy results, possibly more formidable and more painful in its consequences, than an actual bodily assault might be. . . . In the existing state of society, new conditions affecting the relations of persons demand the broader extension of those legal principles, which underlie the immunity of one's person from attack."[25]

The principle outlined by this dissenting jurist was eventually established in law. People in public places are, generally speaking, fair game for photographers, but their pictures cannot be used for commercial purposes without their written permission. (Reporting the news is not considered commercial use; the public has a right to know.)

Miss Roberson's case was denied, but the public was not appeased. (Ironically, no copies of the ad seem to have survived, and so Miss Roberson's privacy has been restored.) On August 23, 1902, the *New York Times* came out against the judge's opinion, saying it caused as much amazement among lawyers and jurists as among the lay public. The paper took angry note of how mercilessly the populace was being victimized by photographers.

The present President of the United States has been so much annoyed by photographers who have attended his down-sitting and his uprising and spied out all his ways, for the purpose of making permanent pictorial record of the same, that it is reported that only his respect for the dignity of his office has upon one or two occasions prevented him from subjecting the impertinent offender to the appropriate remedy, which is all that the Court of Appeals has left, of personal chastisement.

Mr. J. Pierpont Morgan, we read, was so beset by "Kodakers" lying in wait to catch his emergence from his office on the day of his return from Europe that he was actually held a prisoner for some time.

These men were "public characters"; when such as they "revolt from the continuing ordeal of the camera, it is shown that there is something very irritating to normal nerves in chronic 'exposure.' But take the case of the young woman whose portrait was flaunted in all the illustrated newspapers for no other reason than that she had at one time been betrothed to a young gentleman who committed suicide in circumstances necessarily very painful and horrible to her, and rendered far more so by this wanton invasion of her privacy and her grief."

The dismal state of privacy today, when the families of murder and accident victims are staked out like prey by television crews, obviously has a long history. It is almost as if the invention of the camera made human feelings somehow irrelevant. Some years ago Woody Allen satirized the sacrifice of privacy to the news in *Bananas,* a film that opened with sports announcer

Howard Cosell covering an assassination and interviewing a Latin American dictator moments after the shooting. The dictator, bleeding and breathing his last, kept answering with something that sounded roughly like "Argghh" as Cosell pressed on with the interview.

When the *Times* came out against the Roberson opinion, it denounced photographic invasions of privacy as "outrages" and declared that if a judge could say there was no law against them, the people would arrange to have one enacted. One of the judges who had denied Miss Roberson's suit later wrote that there was a certain irony in a newspaper championing the right to privacy. He noted that the New York Senate had recently passed a bill prohibiting the use of pictures and photographs without the subject's permission; the bill was subsequently defeated by the opposition of the press.[26]

Still, fired by public outrage over the Roberson decision and the *Times*'s championship of the case, the New York state legislature passed a first, limited law of privacy in 1903, prohibiting unauthorized use of either names or photographs. In Georgia the following year, in a case regarding the unauthorized use of a man's portrait in a newspaper advertisement, the court ruled that the man's right of privacy had been violated.[27] In the courts and legislatures America established a right of privacy where none had existed before, and it did so because photographs had made the issue urgent and the right imperative.

Today, photographers, sometimes with concealed cameras or telephoto lenses; tabloid papers; and television still try to whittle away at their subjects' privacy, but the law has at least given citizens a forum to complain in. When Jacqueline Onassis sued the "paparazzo" photographer Ron Galella to keep him and his camera at a distance from her children and herself, she claimed that their privacy had been invaded because he had so exhaustively pursued them, by boat and helicopter and on foot, and had frightened them by leaping out from hiding places. Because her right to privacy had been so "relentlessly invaded," the court ordered Galella to remain a couple of hundred feet away (the distance was later reduced). He counterclaimed freedom of the press and said she was depriving him of the right to earn a living. His suit was dismissed.[28]

That case turned on harassment, but for the most part the courts still do not acknowledge a general right to privacy. The law in New York that Miss Roberson's photograph prompted is construed very narrowly as guaranteeing only the right not to have one's name or image used commercially without permission. On December 13, 1978, the *New York Times Magazine* published a cover story on the black middle class, saying that many successful blacks were preoccupied with material goods and status and no longer felt much in common with "their black street brothers." On the cover was a photograph of a well-groomed black man in business suit and tie, obviously middle-class, standing on a New York City street. A young financial analyst, the man was never named. He had not been asked for permission to publish and was not even aware that someone meant to use his picture. He sued.

He sued the *Times* and brought a separate suit against the photographer, the agency, and the head of the agency who sold the photograph to the paper, claiming that he and others who knew him found the article "insulting, degrading, distorting and disparaging," and that because he had been associated with it, and because some people assumed he was working at least part time as a model, he had been subjected to "public scorn and ridicule." The lower court acknowledged the public's resentment of photographic prying. "In obeisance to what it sensed was an emerging 'right to be let alone,

sometimes referred to as [a] constitutional right of privacy,' " that court made some concessions to the plaintiff.

The appellate court, however, declared several times, much as it had in 1902, that there is no common-law right to privacy in New York State and cited the Roberson case to support this. The judge remained unpersuaded by the plaintiff's "perfectly understandable preference that his photograph not have been employed in this manner and in this connection." He declared that "an inability to vindicate a personal predilection for greater privacy may be part of the price every person must pay for a society in which information and opinion flow freely." The suit against the *Times* was dismissed because publication of a photograph in an article on a matter of public interest is not considered commercial use. (The other defendants had sold a photograph and published nothing; they were ordered to pay minor court costs.[29])

Photography so threatened privacy that it occasioned a change in the laws, yet privacy remains elusive and often unprotected from the camera. It is possible to say "No comment" to an interviewer without losing all credibility, but covering one's face from an advancing photographer practically guarantees that the resulting photograph will be the perfect image of a crook.

Every change in communications has altered the scope of publicity. As small cameras and fast presses made fame a major commercial enterprise, another technological shift—the invention of the movies in 1895—made stars out of celebrities. In the public mind stars exemplify something larger and more enduring than themselves: power, innocence, tragedy, evil, sex, leadership, greatness. The real person can seldom be distinguished from the role. (If Boris Karloff was a tender man, his film roles have effectively erased the evidence.) Prior to film, the popular press had concentrated mostly on business and political leaders, but the cinema changed that. The change was symptomatic of larger shifts. In the first half of the century the growth of stardom, especially movie stardom and eventually the stardom of wealth and privilege, mirrored a shift in the culture from production to consumption. Earlier heroes— generals and inventors, presidents and scientists—had been people who fashioned the world that others lived in. The new heroes were just as likely to be those who reaped the benefits of a society built by others: stars were people who enjoyed the good life the public yearned for.[30]

While the movies were building their audience, they had no stars whatsoever. For the first decade of this century, producers never listed the players in their films. Audiences had their preferences nonetheless and soon wanted to know when their favorites were playing. One major contribution to the manufacture of stardom was the invention of the close-up sometime around 1905, probably by Edwin S. Porter, and its development by D. W. Griffith (who is often given the credit). The close-up seemed to thrust the spectator into an intimate relationship with the actor, who suddenly became *known* on some emotional level that the ordinary pirate or damsel in distress on the screen had not achieved. In 1910 a few independent producers, striking a blow against the major studios, gave their actors screen credits and reaped such economic benefits that others followed suit. Carl Laemmle is said to have created the first "name" actor when he planted a story in the *St. Louis Post-Dispatch* that Florence Lawrence, previously known only as "the Biograph Girl," had been killed by a trolley car, and the next day took out an ad in the trade publications denouncing his own plant as a vicious lie.[31]

The marketing potential of stardom outstripped even the filmmakers' imagination. The first fan magazine, appropriately enough called *Photoplay*,

appeared early in the second decade, with a gossip column subtitled "Facts and Near-Facts about the Great and Near-Great of Filmland." By 1916, when Charlie Chaplin traveled east to sign an $820,000 contract for twelve films to be made in just over a year, the railroad telegraphers wired ahead to each stop to say he was aboard, and crowds gathered at every station. One New York newspaper headline said simply, "HE'S HERE."[32]

As *Photoplay* proved, the new medium remained partially dependent on the older medium of still photography to consolidate its empire. In the succeeding years, still and motion pictures maintained a constant interplay, illuminating, boosting, and capitalizing on one another. In a multimedia society, no visual medium operates in isolation.

In the second decade of this century cinema created a star system vaster than anything the world had known before. If the carte de visite had helped set in motion the rise of celebrity and had launched the craze for collecting photographs of entertainers like Adah Isaacs Menken and Sarah Bernhardt, the movie star system explosively accelerated the advance of popular culture and of fame itself across national boundaries.

Photographs played an integral part in the presentation of the new pantheon of idols to a mass of devotees. Graven images of film immortals could be lifted intact from their film roles or show the star in an ideal incarnation, a distillation of some lifetime pose: Lana Turner as sex goddess, Douglas Fairbanks as debonair boulevardier. In the 1920s and '30s Hollywood publicity portraits became in effect a new kind of portraiture that took its cues on lighting, pose, and degree of artifice from film itself.

By that time the unprecedented advertising power of cinema and its stars had been recognized, and manufacturers had learned to exploit their newfound access to the consumer with a blitz of still photographs. Clark Gable's bare-chested confrontation with Claudette Colbert in *It Happened One Night* was an oddly potent and unintentionally negative example of advertising that nearly ruined an American industry without even trying.

It Happened One Night (1934) was Gable's first straight comedy. MGM had lent him to Columbia for the film as a disciplinary measure after he'd been obstreperous. Gable, nervous about playing a comic role, was reluctant at first to take the part—but the movie catapulted him to stardom and won him an Oscar, the only one he ever got. (It took four other awards as well: best actress, picture, director, and screenplay.) In the famous motel scene pictured here, Colbert the heiress and Gable the reporter get stuck sharing a room for the night, and, the era being more delicate, modestly partition the room with a curtain. Then comes the drama: both of them stubbornly insist they want the same side of the curtain. Independent-minded Colbert will not budge, so Gable decides to teach her a thing or two. He gives her an impromptu lesson in the way men undress. First, he says (demonstrating), a man takes off his jacket, then his tie. He proceeds to remove his shirt, his shoes, his socks—not all men bother with the socks, he instructs her, but he's the kind of guy who does. When he's down to nothing but his trousers and shows no sign of stopping, she beats a hasty retreat to the other side of the curtain.

Gable wasn't wearing an undershirt (audible gasp from the balcony). Not that his bare chest was shocking, but his lack of an undershirt was big news. Men wore them then. At least until this movie. Women apparently went crazy over Gable after this film—it's said that when he made a cross-country trip soon after its release, women rioted in every city he appeared in. So naturally men copied him, slavishly. Millions adopted a moustache, previously unpopular among young American men. If Gable didn't wear an under-

shirt, then undershirts must not be truly masculine. (In fact, he went without one only because no way could be found to take one off gracefully.[33])

After *It Happened One Night*, undershirt sales reportedly plunged by 75 percent. Within a year a group of men's underwear manufacturers complained to the film industry that they had been bankrupted, a complaint hard to ignore in the Depression. Hollywood heeded their pleas and put an undershirt back on its star. In *Idiot's Delight* (1939), Gable went shirtless in one scene opposite a fully clothed Norma Shearer, but now he was wearing what was undeniably an undershirt. The still from this scene was widely reproduced; *Life* printed it in an article on the film shortly after its release.[34] But *Idiot's Delight* was not so big a hit as *It Happened One Night*, and it probably came too late to recoup all the losses the manufacturers had already suffered.

In *It Happened One Night* and its attendant still photographs, Gable set several fashions for men, all of them better for the economy than bare chests: the Norfolk jacket, the V-neck sweater, the snap-brim hat, and the trench coat worn with its belt tied rather than buckled. Gable, a disaster for the underwear industry, was the best thing that ever happened to men's fashion. By 1939, when he played Rhett Butler in *Gone with the Wind*, a *Detroit Times* reporter could write, "One of the big reasons why 80% of male fashion creations are now spread by Hollywood is Clark Gable."[35]

Hollywood's influence on consumer habits had been apparent long before Clark Gable proved his charm on screen. Early in the second decade of the century English and German manufacturers had begun to complain to their governments that a decline in demand for domestically produced items and a rise in American imports had occurred because American movies made audiences want American goods, from sewing machines to shoes. In the second and third decades fan magazines and studio publicity photos spread California sportswear styles to small towns across the country. Women's slacks for streetwear, a Southern California invention, were ignored by retailers outside Los Angeles until the manufacturers began sending the press photographs of stars—especially Marlene Dietrich and Katharine Hepburn—wearing pants. By the 1930s the Associated Apparel Manufacturers routinely distributed thousands of photographs of stars sporting the latest styles at Hollywood receptions, the racetrack, and the Rose Bowl. The photographs, complete with text, were sent without charge to news services, and because the stars were so popular and the price was right, the pictures were widely published. One of the pressbooks for *It Happened One Night* included fashion photographs of Colbert that would soon be used in nationwide tie-ins with the Modern Merchandising Bureau.[36]

The stars who had been given what amounted to free advertising when newspapers reproduced their photographs endorsed cosmetics, silverware, appliances, and coffee in ads in national magazines—often under contractual arrangements that provided products free to film producers in return for the publicity. Cinema and its stars, which saturate the culture with a mutually reinforcing mix of moving and still images, were the most persuasive salesmen of all time—at least until television expanded the territory.

Cinema still sells the goods today (close-up on the beer bottle label, lingering shot on the billboard), and movie stars play at being models in fashion magazines. But television has moved in on the world market and made people in less successful economies envious of the Western democracies. It's easy to measure their material success. Just tune in, courtesy of satellite, on the house where JR lives, the clothes Bill Cosby's TV family wears, the cars "Miami Vice" so casually wrecks during every episode.

Clark Gable and Claudette

Colbert in *It Happened One*

Night, 1934

Clark Gable and Norma

Shearer in *Idiot's Delight*,

1939

"The previous champ's record of launching a thousand ships and burning the topless towers of Ilium is pretty piffling compared to the record set by Miss Betty Grable, the enchantress of the present conflict—or, to use her press agent's phrase for it, the Pin-Up Girl. Fifty thousand servicemen a month write for her photograph." So said the *New Yorker's* "Talk of the Town" on June 26, 1943. The photograph of Grable in a white bathing suit was more sought after than Rita Hayworth in a nightgown or Dorothy Lamour in a sarong[37] and is probably more famous than any World War II photograph except the raising of the flag on Iwo Jima. In bathing suit, high heels, ankle bracelet, and an upswept hairdo, Grable looks back over her shoulder with a big come-hither smile; the pose was just unusual enough to set her pinup apart. Retouched to Hollywood standards of perfection, she fairly floats in an unmarked space, a sex symbol waiting for the viewer's fantasy to give her a context.

Grable herself was the favorite of servicemen everywhere. In 1944 *Time* said a poll by their "far-flung" correspondents found that "in direct ratio to their remoteness from civilization, soldiers prefer Betty Grable to all other women." It was alleged at the time (quite possibly by the studio publicity department) that one of every fifteen men in the Armed Forces belonged to a unit that had elected her their mascot, dream-girl, honorary commander, or whatever.[38] The pinup made the star more famous, and in the round-robin of entertainment publicity, her photograph and her films endlessly chased one another up the popularity ladder. In 1944 Twentieth-Century Fox used the photograph as an excuse to make a film called *Pin-Up Girl* featuring the eponymous star. The credits rolled over her photograph, which appeared repeatedly in the movie and again behind the written words, THE END.

The military had already made the photograph its own. A fighter plane called *Pin-Up Girl* had the picture pasted to its fuselage. Later one reporter would write that "pilots even pasted it near their control panels, and claimed that it exerted a stronger pull than radar." The Air Force made it official by blowing the photograph up large, marking it off in sections, and using it to teach fliers how to read aerial maps. The original photograph was even said to have been found on captured German and Japanese soldiers.[39]

Pinups had been popular in the 1930s, but during World War II they took on a kind of inspirational power for lonely servicemen, rather like the lady's scarf a knight wore into battle. When the Postmaster General banned the scantily clad drawings of women in *Esquire* from the mails in 1944, three servicemen were moved to write: "You won't find one barracks overseas that hasn't got an Esquire Pin-Up Girl. I, for one, have close to fifteen of them, and none of them seems to demoralize me in the least. Those pictures are very much on the clean and healthy side and it gives us guys a good idea of what we're fighting for." Grable herself took this notion seriously. " 'You do not need to laugh at pin-up girls,' Miss Grable chided us [the *New Yorker*] unnecessarily. 'A lot of these kids don't have any woman in their lives to fight for, and I guess what you would call us girls is kind of their inspiration. It is a grave responsibility.' "[40]

Indeed it was. Grable's picture became associated with the war effort. *Modern Screen* promoted its October 1943 issue by advertising a story about a soldier who died clutching Grable's photo. One of her biographers reports that veterans and their families continued to pay their respects to her long after the war for helping them make it through. One vet is alleged to have said: "There we were, in those damn dirty trenches. Machine guns firing. Bombs dropping all around us. We would be exhausted, frightened, confused and sometimes hopeless about our situation, when suddenly someone would

Frank Powolney

Betty Grable, early 1940s

pull your picture out of his wallet. Or we'd see a decal of you on a plane and then we'd *know* what we were fighting for."[41]

And Grable was, in a way, what they were fighting for. An editorial in an army publication in the Pacific theater said, "We are not only fighting for the Four Freedoms, we are fighting for the priceless privilege of making love to American women." Betty Grable was the American woman *par excellence*. She became a prime sex symbol when George Raft, a matinee idol with gangster connections, and Harry James, leader of the nation's hottest swing band, had a fistfight over her in a nightclub, but she was also wholesome and innocent. Her small-town, college coed image replaced the smoldering and more threatening sexuality of stars like Jean Harlow, Bette Davis, Greta Garbo, and Joan Crawford. Her marriage to Harry James in 1943 only increased her popularity with young servicemen who doted on swing (and with young women yearning for marriage), and when she had a child the following year, soldiers sent gifts to the baby and the Betty Grable Fan Club changed its name to the James Family Fan Club.[42]

Columnists and reporters harped on her clean, domestic image, but the way she looked in a bathing suit was seldom far from view. Many stories have been told about how Frank Powolney, a Fox still photographer, hit on this pose. The most likely is the photographer's unexceptional statement that she looked back at him as she was walking away from a shoot, he liked it and suggested they try it out. Whatever the impulse, the pose emphasized the legs she was so famous for, the legs that were in a sense her identifying attribute. Her nylons were auctioned in 1943 for forty thousand dollars in war bonds, her legs soon after imprinted in the pavement at Grauman's Chinese. The *New Yorker* once defined entertainment as "Mickey Mouse's adventures and Betty Grable's legs." Legs were the focus of sexual attention at the time, as is clear in the majority of well-known pinups. (*The Outlaw*, featuring Jane Russell's heaving bosom in 1943, signaled a shift that would not be completed until after the war.) A 1942 beauty manual advised young women that men were more interested in a woman's legs than any other female feature.[43]

The great secret of Betty Grable's popularity was her appeal to the working classes. Critics never liked her movies much; only the public did. In 1943 she became the number-one box-office draw in Hollywood, the first woman ever to reach that pinnacle, outdoing Bob Hope and Abbott and Costello. Two years earlier the *Harvard Lampoon* had called her movies "the most consistently bad performance in 1941." The star responded that she didn't care what Harvard boys thought because the approval of servicemen was more important to her. She said she was "strictly an enlisted man's girl. I do not mean that I do not like officers or that officers do not like me. But I am a truck-driver's daughter"—it's more likely that her father was a fairly successful stockbroker, at least until 1929—"and so I have got to be an enlisted man's girl, just like this has got to be an enlisted man's war."[44]

Grable had a head start on pinup popularity. In the late 1930s, when she specialized in coed roles, she got more fan mail from college boys than any other star, and photographs of her hung in many a dormitory. But a photograph does not necessarily achieve the status of an emblem through the mere force of its imagery. The untold story of this picture is that its popularity was largely manufactured by Twentieth-Century Fox's publicity department. During the war, publicity always emphasized Grable's popularity with the Armed Forces. The studio publicity department staged pinup contests around several of her movies, got news of the contests placed in the press so they didn't look like studio promotions, and sent press clips to first-run theaters. The theaters

then staged their own contests; whenever a Grable film opened, the press and the audience both concentrated on her as a pinup girl. Patrons of one of her films could leave a soldier's name and address at the theater and the theater would send him a free pinup.[45] The bathing suit image was so widely known and so enduring that it illustrated many of her obituaries in 1973.

(Studios went to great lengths to promote their stars. The famous Bob Landry photograph of Rita Hayworth in a nightgown, probably the second most popular pinup of the war, was slyly pasted on the Bikini Atoll test bomb by the Columbia Pictures publicity department, which engineered the stunt to promote Hayworth as an explosive bombshell in *Gilda*.)

An emblematic image may lose some of its force and meaning, especially when removed from its context, and still remain iconic. But its meaning may well change in the process. The Eiffel Tower does not speak to Frenchmen or tourists today as an engineering wonder and sign of a new technological era as it did when it was erected in 1889 but has come to stand for Paris itself. The great Christian images still grip the spirit even of those who no longer go to church, but their spiritual magnetism has weakened, so that much of their power now rests on their artistic brilliance. And so on down the scale to Betty Grable, who may be recalled in the context of World War II but no longer represents to most people what we were fighting for. This photograph has become again what it was in the beginning, a mere sex symbol. In 1980 Olivia Newton John posed for the September 9 issue of *Us* magazine à la Betty Grable, and the *Chicago Sun-Times* of November 18 reprinted the famous pinup to illustrate a story on "Cheesecake and Other Sexy Desserts." The queen is dead; long live the queen—Grable the star has been subsumed by her photograph, which concentrates her fame in a single image and has managed to outlive its own significance.

The leggy image of Grable in a bathing suit was eventually replaced by the leggy image of Marilyn Monroe, her skirt billowing up around her thighs as she stood on a subway grating. Monroe was naughtier than Grable, for she gave spectators a good look at what skirts ordinarily covered, yet if she was indelicate, she was not indecent. One famous photograph is a publicity still from *The Seven Year Itch*, a film about a married Milquetoast and a voluptuous blonde. The year was 1955, and adultery was not permitted in movies, but the significance of Monroe standing on the grating—the night was hot, and the rush of the train cooled her off—could not be missed.

Monroe's overt sexiness and vulnerability replaced Grable's wholesome, forthright, girl-next-door appeal just as sexual mores gave hints of loosening a notch. (*Playboy* magazine was founded in 1953.) Here Monroe manages to be both narcissistically self-involved and joyously abandoned, almost as delighted with her own charms as with the rush of air up her legs. She is a voyeur's dream: a woman far gone in pleasure all by herself and deliciously happy to have a man watch.

What was dramatically new for a star's image, and what accounts for the preeminence and durability of this photograph among hundreds of images of Monroe, is that it showed a woman as sexually turned on as any man could wish. Men at that time were not accustomed to such frankness. Sex goddesses had always promised them a good time but made no vows to have one themselves, and good girls were brought up to be guarded. In the 1950s women were expected to be virgins when they married—Doris Day made a career of it—but men, whose desires were presumably too strong to be contained so long, were expected to sow some wild oats. Well into the sexual revolution of the following decades, many women reportedly had trouble

Matthew Zimmerman

(1909–1965)

Marilyn Monroe

during the

filming of *The Seven-Year*

Itch, 1954

AP/Wide World Photos,

New York

achieving orgasm. Monroe's photograph assured men (and women) that it did not have to be like that. Her sad life and suicide merely enhanced her aura and added a forlorn undertone to this unrivaled image of sexual glee.

In 1922 D. W. Griffith, remarking that the United States was impressed primarily by material progress, suggested that possibly in half a century "America will awaken to an appreciation of art" and make a hero of an artist. "Perhaps motion pictures will do more to stimulate this than any other force," he added, no doubt thinking that creative individuals like movie directors

rather than mere performers would be the nation's stars.[46]

Griffith was right on several counts. America did make heroes of artists, and film contributed to the process, especially films like *Lust for Life*, with Kirk Douglas as van Gogh and Anthony Quinn as Gauguin, or *The Agony and the Ecstasy*, with Charlton Heston playing Michelangelo. These films not only drew audiences far beyond those of the books they were based on, they also turned their protagonists into titanic, romantic personalities identified in many minds with the over-life-size stars who had played the parts. What Griffith could not have foreseen was the way a combination of still photographs and film would help shape the legend of the first American artist ever to achieve mythic stature: Jackson Pollock.

The first superstar artist of the twentieth century was Picasso. His reputation was bolstered but not created by photographs, which helped keep him before the public eye chiefly in the years after World War II, when his myth was already firmly established. By that time New York City had begun to replace Paris as the center of the art world, and postwar affluence, GI Bill education, increased travel and sophistication all contributed to a broad new interest in art in the United States, even, to some extent, interest in avant-garde art. The artist that the art world was most interested in, although the public had not yet heard of him, was Pollock. In 1948 the critic Clement Greenberg predicted that Pollock could become "the greatest American painter of the twentieth century."[47]

That year, as this kind of critical praise continued and Abstract Expressionism became a term to be reckoned with, *Life* published a symposium on modern art. The participants' opinions of Pollock's *Cathedral* ranged from Greenberg's serious approval to Aldous Huxley's remark that it looked like a wallpaper panel and a Yale professor of philosophy's dismissal of the painting as "a pleasant design for a necktie."[48] This was the first time most Americans had seen Pollock's name.

On August 8, 1949, after museums had taken some interest in Pollock and he was scheduled to show in Paris, *Life* put him on the map with an article titled "Jackson Pollock: Is He the Greatest Living Painter in the United States?" *Life* wrote that "a formidably high-browed New York critic" had allotted Pollock this position, although others thought his work decorative, degenerate, or "as unpalatable as yesterday's macaroni." The article opened with a photograph by Arnold Newman of Pollock leaning against a narrow, eighteen-foot-long painting that ran across the top of two pages.

The picture and the article put Pollock in position to become a symbol. Newman portrayed a moody and defiant artist, cigarette dangling from the corner of his mouth, arms folded across his chest. Dressed like a cowboy in jeans and a jeans jacket, he had a kind of rugged good looks. (Pollock made much of his Wyoming background.) He was isolated, almost suspended, in a space without a floor line, as if alone with his painting. That long canvas defied people's expectations of paintings and, according to the caption, stopped where it did only because Pollock's studio wasn't much longer. On another page another photographer watched him "drool" paint on canvas and add sand for texture. (In fact, Pollock was not painting in these photographs. Massively uncomfortable before the camera, he would agree only to imitate his own technique.[49]) There was something macho about the man in the picture and something very American—the kind of tough independence and individuality that would soon be glorified in Marlboro ads.

The pictures of Pollock at work revealed means that were clearly unorthodox, but his intense concentration fit the romantic concept of artists worth

JACKSON POLLOCK

Is he the greatest living painter in the United States?

JACKSON POLLOCK, 37, stands moodily next to his most extensive painting, which is called *Number Nine*. The picture is only 3 feet high, but it is 18 feet long and sells for $1,800, or $100 a foot. Critics have wondered why Pollock happened to stop this painting where he did. The answer: his studio is only 22 feet long.

Recently a formidably high-brow New York critic hailed the brooding, puzzled-looking man shown above as a major artist of our time and a fine candidate to become "the greatest American painter of the 20th Century." Others believe that Jackson Pollock produces nothing more than interesting, if inexplicable, decorations. Still others condemn his pictures as degenerate and find them as unpalatable as yesterday's macaroni. Even so, Pollock, at the age of 37, has burst forth as the shining new phenomenon of American art.

Pollock was virtually unknown in 1944. Now his paintings hang in five U.S. museums and 40 private collections. Exhibiting in New York last winter, he sold 12 out of 18 pictures. Moreover his work has stirred up a fuss in Italy, and this autumn he is slated for a one-man show in avant-garde Paris, where he is fast becoming the most talked of and controversial U.S. painter. He has also won a following among his own neighbors in the village of Springs, N.Y., who amuse themselves by trying to decide what his paintings are about. His grocer bought one which he identifies for bewildered visiting salesmen as an aerial view of Siberia. For Pollock's own explanation of why he paints as he does, turn the page.

"NUMBER TWELVE" reveals Pollock's liking for aluminum paint, which he applies freely straight out of the can. He feels that by using it with ordinary oil paint he gets an exciting textural contrast.

"NUMBER SEVENTEEN" was painted a year ago in several sessions of work which took place weeks apart so Pollock could appraise what he was doing and "get acquainted with the picture." He numbers his paintings instead of naming them, so his public will not look at them with any preconceived notion of what they are.

CONTINUED ON NEXT PAGE

Life's attention (and ridicule). In the long run, eccentricity and inventiveness would also be useful components of an artistic myth. Thus, even *Life*'s disparagement contributed to Pollock's aura, and the impact of the picture magazine being what it was, the implied craziness of the art and the painter's isolation and cockiness were the impressions most likely to stay with readers.

Both painting and process struck those readers as ridiculous, but suddenly Pollock, who had not yet sold much, was "a household bête noire," as one critic put it, a name everyone knew, a personality, a character to be admired or despised as actors were, in a way that artists had not been before because the popular press had not chosen to make them so. The article was the most controversial *Life* ran that year. Five hundred thirty-two letters poured into the magazine; only twenty supported Pollock or approved of *Life*'s publishing an article on him. On the other hand, fan letters from home and abroad flooded in to Pollock.[50]

Not only the vast public but the art world, too, plied Pollock with a new kind of attention. People sought him out; some even bought his paintings. Pollock caught the scent of fame. The sculptor Tony Smith said Pollock asked him if he'd read the article and wanted to know if he should now have a better car than his old Model A Ford. (He bought a secondhand Cadillac convertible.[51]) It's said that he would go into a restaurant and announce that he was the greatest American artist, then half expect he wouldn't have to pay.

The *New Yorker* and *Time* both wrote about Pollock in 1950. *Time*, in a piece called "Chaos, Damn It!" illustrated with one of the *Life* photographs of

Arnold Newman (born 1918)

Jackson Pollock, printed in

Life, August 8, 1949

© Arnold Newman; *Life*

magazine page reprinted

with permission

Pollock painting, reprinted excerpts from an Italian critique of Pollock's canvases at the Venice Biennale the previous summer, saying that what was easy to detect in all his work was chaos, and once more chaos. "Each one of his pictures is part of himself. But what kind of man is he?" the critic asked. "Damn it, if I must judge a painting by the artist it is no longer the painting that I am interested in." This signaled the beginning of a shift from a focus on the art to a focus on the artist that was significant for Pollock and for contemporary art in general. (Pollock cabled *Time*: "NO CHAOS DAMN IT, DAMNED BUSY PAINTING.") The next year *Vogue* printed a Cecil Beaton fashion essay with models posed before Pollock's paintings, a clue to their approved status.[52]

In the summer of 1950 Pollock had met the photographer Hans Namuth in Easthampton, New York, where both men lived. Namuth wanted to photograph him working, and at the urging of Lee Krasner, Pollock's wife, he agreed. These photographs present an artistic drama: the artist's choreographed movements and total immersion in his work, the tension between the confined space he stands in and his freedom of gesture, the calligraphic energy lacing across floor and walls and through the artist as he too becomes a configuration in motion. The photographs were almost as new in art history as Pollock's technique itself. Although photographers had made artists' portraits since the nineteenth century, sometimes posing them at their easels or next to one of their works, it was another matter to capture the actual process of creation. In Pollock's case, the photographs explained a technique that even artists did not understand well.

It was assumed that Pollock dripped paint onto canvas—*Time* later referred to him as "Jack the Dripper"—but the photographs show him flinging paint from a stick or sometimes a brush, or trailing paint across the surface from above in a liquid line. The pictures make the process look athletic and fast; many times the artist's hand or head blurs in motion, and the few pictures of him meditating seemed so much less new and exciting that they were seldom published. The blurs, which turn Pollock's process into an impetuous adventure (although it has been described as fairly slow and measured), were caused by a defect in one of the cameras and by slow shutter speeds. Thus a technical problem increased the drama and made Pollock entirely an "action painter," an image that clung to him.[53]

Pollock had talked to Namuth about being "in" his canvas while he worked; Namuth thought he could convey this best in film. Surprisingly, Pollock liked the idea and consented. A short black-and-white film proved unsatisfactory, so Namuth teamed up with the film editor Paul Falkenburg to make a color film during which Pollock would paint on glass while Namuth photographed him from below.[54]

The film is even more intimate and immediate than the photographs. It opens with Pollock apparently writing his name across the sky, for only the sky is visible through the glass. Then, in a more standard presentation, he paints a canvas spread on the ground outdoors. In an abrupt switch Pollock is seen upside down through the glass and begins to paint. As the surface grows denser, the artist behind it dims and becomes less visible. Dissatisfied, he wipes this painting away and starts another, with string, wire mesh, and small colored objects that he arranges and incorporates into the painting. Painting on glass was an experiment for Pollock and for the filmmakers and startling for the spectators. The glass is equivalent to the surface of the screen; he flings paint at the spectators' plane of vision. With large, sure, and graceful gestures, he paints with a drive and confidence that belie the notion that his painting depended on accident.

The art historian Barbara Rose has written at length about the effect of Namuth's photographs and film. Alleging that the American public needed heroes to replace those of the wartime years, she writes, "Through Namuth's unique documentary record of the artist in action, the public was to fabricate a new conception of the artist that fulfilled the need for a culture hero." These images, she goes on, showed the artist in the thrall of his own inner drives and unveiled the mysteries of creativity to the public, thus providing "the material necessary for the creation of a culture myth of the artist as an inspired shaman." Pollock's paintings were known to most people chiefly in reproduction, which necessarily diminished their power, but these photographs and the film retained their full force on page and screen, so that the artist's personality took on greater vividness, immediacy, and dimension than his work.[55] The Italian critic had already sought the artist's psyche in his paintings; now the photographs exalted the persona at the expense of the work.

Rose's observations are slightly exaggerated but penetrating. Without question, photographs and film played a large role in the creation of the myth of this first American artist-hero. However, that myth had two distinct audiences, the art world and the general public, and two time frames, before Pollock's death and after. The primary source of Pollock's fame among the general public was the *Life* article of 1949 and to a lesser extent *Time*'s of 1950. Although they introduced Pollock to millions who were not ordinarily preoccupied with art, those articles scarcely left their audience awed. It was probably only after his death in August 1956 that he became a hero to the public at large—and even then, less a shaman than a tragic, romantic figure.

Pollock died in a car crash at the age of forty-four. He was driving; the

Hans Namuth (1915–1990)

Jackson Pollock, 1950

© Hans Namuth 1990, Hans

Namuth Ltd., New York

woman with him—his wife was away—was badly injured; her friend in the back seat was killed. Stories circulated about his fast driving and drinking. The semisuicidal nature of his death was itself enough to ensure his fame in a culture that cherishes the myth of the accursed artist. *Life* ran a story titled "Rebel Artist's Tragic Ending," repeating the Newman picture of 1949 and acknowledging that his style had "stirred a whole generation of young American painters."[56] His obituary appeared on front pages across the world.

Up to this point Namuth's photographs had played no part in establishing Pollock with the wider public. Not even the obituaries reproduced them, although occasionally they used a late portrait by Namuth of Pollock sporting a beard and looking ravaged. The photographs had a much greater impact on the art world of the 1950s. Pollock's reputation soared in the first half of the decade as Abstract Expressionism became the leading style. Namuth's photographs fed the legends of his technique and personality. In 1951 some of the pictures were published in *Portfolio*, a magazine with a very limited circulation, and in *Artnews*. In 1952 the critic Harold Rosenberg wrote an unillustrated, widely read, and controversial article, "The American Action Painters," which set new terms for Abstract Expressionism. Without mentioning Namuth's pictures, Rosenberg thrust them to the forefront. "At a certain moment," he wrote, "the canvas began to appear to one American painter after another as an arena in which to act. . . . A painting that is an act is inseparable from the biography of the artist. . . . The new painting has broken down every distinction between art and life. . . . [The American painter] gesticulated upon the canvas and watched for what each novelty would declare him and his art to be." Pollock always believed that he was the inspiration for this article; Rose believes that the real inspiration came from Namuth's photographs.[57]

In fact, the film had a far greater influence on artists than the stills, partly because it received wider distribution early on. It was first screened at the Museum of Modern Art in June 1951, then in August at Woodstock, New York. For $7.50 it was available for rental to colleges and art schools, which were not much interested until 1952, when Namuth says "it took off." Not many good films on contemporary artists existed then. There was one on Calder, and a film about Picasso that ended with his painting on Plexiglas had been produced in 1950, but it was not released in America for a couple of years; the Modern did not acquire it until 1954. One Pollock scholar recalls that every art history department had two or three films that were brought out when lecturers ran dry, and that Namuth's film on Pollock was one of them.[58]

Thousands of undergraduate and graduate art students saw Namuth's film in the years before and after Pollock's death. Between Rosenberg's article and this film, a generation of young artists modeled themselves and, for a while, their painting styles, after Pollock. The painter, who craved but was uncomfortable with the signs of stardom, may have felt his privacy would be threatened by the movie. The night Namuth finished filming, Pollock got drunk for the first time in two years and soon slid into a creative decline that would last until his death.[59]

After Pollock's death his myth lost much of its power in the art world, just as a mass audience took him up. Namuth's photographs now found a somewhat wider public. *Evergreen Review* published some in 1957, *Life* in 1959, and a book about Pollock in 1960 had a number of them. By the 1960s they were known as far away as India. By then they had become canonical and would appear in subsequent monographs and biographies, culminating in the book of Namuth's photographs edited by Rose in 1980. In 1967, when the

Museum of Modern Art in New York mounted a retrospective of Pollock's work, Namuth's pictures were blown up larger than life on the walls. That year they were also published in the museum's publications, the *New York Times Magazine*, the American Society of Magazine Photographers Annual, and other publications.[60]

The film and the paintings together strongly influenced the Happenings of the 1960s. In a 1958 article, "The Legacy of Jackson Pollock," the Happenings impresario Allan Kaprow wrote that to understand Pollock's impact correctly one had to be something of an acrobat, identifying with the hands and body that flung the paint—an identification more likely to arise from images of him working than from the work itself. Kaprow felt that Pollock's mural-scale paintings, which seem to go in every direction rather than being bound by the frame, were not so much paintings as environments and that they invited us to give up the single painting and make art of "the vastness of Forty-second Street. . . . sight, sound, movements, people, odors, touch." In a 1966 book by Kaprow, Namuth's pictures are paired with pictures of Kaprow and Claes Oldenburg in environments they acted in, and in 1967 Kaprow wrote about Pollock: "A film of the artist at work indicated the close bond between his body movements and the track left by them on the surface of the canvas. Then Harold Rosenberg's article . . . completed the growing idea: Why not separate the *action* from the *painting*? First make a *real* environment, then encourage appropriate actions."[61]

Late in the 1960s art by such artists as Carl Andre, Barry Le Va, and Robert Morris, who arranged objects on the floor, was traced to the influence of Pollock's techniques. Rose thinks this art came directly from the oversize Namuth photographs at the 1967 retrospective, which frequently made the paint look like objects flung on the floor, but it seems to me it could also have been inspired by the film, in which Pollock swiftly sets out small, disparate objects and only afterward unites them with paint. A 1970 article in *Life* on several artists who worked this way was headed by a photograph of Pollock stepping into a painting and pouring his paint.[62]

Pollock rose to mythic heights on the wings of the popular press and photography. What began with him reached its apogee with Andy Warhol: painter as personality, personality as creature of the media, media as tool of the artist. And if Namuth's photographs did have a larger influence than the actual paintings, that situation was acknowledged in the 1970s and '80s by a group of artists and photographers known as appropriators, who worked with reproduced images of art and photography. Richard Prince, an early adherent, pinned the issue squarely on Pollock in his book *Why I Go to the Movies Alone:*

They were always impressed by photographs of Jackson Pollack [sic], but didn't particularly think much about his painting, since painting was something they associated with a way to put things together that seemed to them pretty much taken care of.

They hung the photographs of Pollack right next to these new 'personality' posters they just bought. . . .

The photographs of Pollack were what they thought Pollack was about. And this kind of take wasn't as much a position as an attitude, a feeling that an abstract expressionist, a TV star, a Hollywood celebrity, a president of a country, a baseball great could easily mix and associate together . . . and whatever measurements or speculations that used to separate their value, could now be done away with.[63]

Photography has mandated new kinds of behavior. Nineteenth-century men and women learned to sit very still and stare fixedly, often with their heads clamped in a headstand, in order to behold their own likenesses. After the Kodak, family occasions took on a new ritual: the group portrait, with everyone assuming a prolonged expression of joy. In the twentieth century, one last vestige of politeness in frayed urban environments is the hesitation to cross the space between a camera and the subject it is aimed at. Conversations may be guiltlessly interrupted and personal space violated, but no one wants to ruin a photograph. The visual image rules.

The camera is a particularly exacting taskmaster of the famous. Fame, which most of the world seems ferociously eager to enjoy, has high maintenance costs. Behavior and appearance must be reportable and camera-worthy at all times, for any slip in standards can be immortalized in one fiftieth of a second. For years there were rumors, evidently true, of a photograph neither Carmen Miranda nor her studio wanted released. Frank Powolney, the photographer who took the Betty Grable pinup, took stills of Miranda dancing with Cesar Romero for *Springtime in the Rockies* (1942). The session took place on a hot day in July, before air-conditioning. Miranda wore the usual platter of succulent fruit on her head and a skirt slit to just below the navel. When the photographs were developed, they created an uproar in the studio. In one, with Romero holding her in midair, Miranda was quite obviously wearing no underpants.[64]

To prevent a private gaffe from becoming public and to keep their images burnished, celebrities in the last few years have begun to demand complete control of their images. If their names are commanding enough, some will not consent to interviews unless given the final say over the text and the photographs to be published. Entertainers and movie stars were in the vanguard on this matter, but as American culture made financiers into idols in the 1980s, they too insisted on control of any images.

If you are thinking of celebrity, it would be wise to live prospectively, in case fame should come to visit in the future. The past is particularly hard to erase if it has been recorded on film. Vanessa Williams, the first black woman to win the Miss America contest, found this out when a photographer cashed in on her new celebrity by selling nude photographs he'd taken of her some years ago. At first she claimed they were "artistic" poses but that didn't work because it wasn't true—she had been photographed nude with a white woman in sexually charged positions. She was forced to give up her title.

Photographs sign cruel pacts with youth and beauty and publicity. Lainie Kazan, the singer and actress, told a television interviewer in 1986 that she did not go out of the house for seven years because she could not live up to her airbrushed and retouched portraits. "I went to bed in 1969 and didn't get up until 1976. . . . I would not come out until I looked like my photograph."[65]

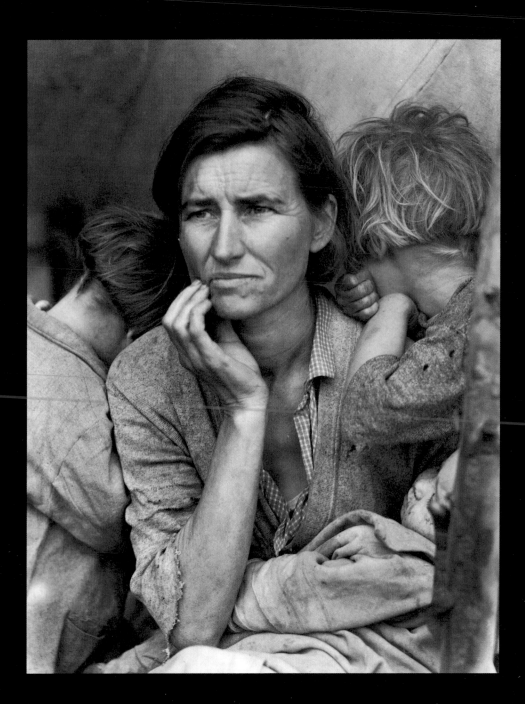

Dorothea Lange

(1895–1965)

Migrant Mother, Nipoma,

California, 1936

Library of Congress,

Washington, D.C.

ICONS

The photograph is a highly efficient means of cultural communication; it has the advantages of credibility, easy mass distribution, and instant convertibility into a symbol. Since visual imagery is more readily abstracted than sensations of touch, smell, sound, or taste, the mind is accustomed to using images as ideas (which is apparently what happens in dreams).[1] People cherish photographs, and the culture relies ever more heavily on them, in part because they are so readily converted.

Civilization uses, even requires, visual symbols—the cross, the swastika—for shorthand communication of complex groups of ideas. As international trade, easy travel, instant worldwide transmission of visual data, and vast movements of people from country to country have complicated the problems of spoken communication, visual signs have taken over: there are corporate logos everywhere and simplified figures that indicate men's room, women's room, deer crossing, no smoking, poison. Photographs are not so simple as stick figures or the symbols for Mercedes-Benz and Japan Airlines, but they can cross language barriers almost as easily. With their enormous capacity to contain, compress, and symbolize events or ideologies, photographs become the signs and signposts of modern society.

The Greek word *eikōn* originally meant a portrait or representation, sometimes carrying a memorial connotation. In Christianity it became a sacred painting or sculpture. Today the word extends to secular images with so strong a hold on the emotions or the imagination that they have come to serve as archetypes. I take secular icons to be representations that inspire some degree of awe—perhaps mixed with dread, compassion, or aspiration—and that stand for an epoch or a system of beliefs. Although photographs easily acquire symbolic significance, they are not *merely* symbolic, they do not *merely* allude to something outside themselves—as a red cross does, or a hammer and sickle—for photographs intensely and specifically represent their subjects. But the images I think of as icons almost instantly acquired symbolic overtones and larger frames of reference that endowed them with national or even worldwide significance. They concentrate the hopes and fears of millions and provide an instant and effortless connection to some deeply meaningful moment in history. They seem to summarize such complex phenomena as the powers of the human spirit or of universal destruction.

Photographs have come to occupy this position more and more often, partially displacing the public monument. Where generals once rode bronze

135

horses in public squares, Douglas MacArthur now wades ashore on the pages of a news magazine. Where once only a poem was more lasting than bronze, now the palm goes to a halftone reproduction on glossy paper. The photograph's unbreakable tie to the reality it represents nominates it to the position of history's proxy; it stands for people as if they were present and for events as if they were still occurring. We who are so totally at the mercy of time's progress have succeeded at last in stopping it; that alone is a little miracle worthy of our obeisance.

President Roosevelt established the Resettlement Administration (later known as the Farm Security Administration) in 1935 to assist marginal farmers with low-cost loans and land-renewal projects. While Roy Stryker was organizing the RA's Historical Section, he saw reports on migrants in California, illustrated with photographs by Dorothea Lange, that struck him as exemplars of the kind of work his division should do.[2] He hired Lange in August 1935. The next year she made *Migrant Mother*, by far the most famous of the quarter of a million negatives taken by the agency's photographers during its seven-year existence.

Soon after Lange took this picture it became the canonical image of the Depression, and so it has remained—one of those rare photographs that seem to personify the salient facts of a lengthy history and that trigger a complicated set of emotional responses. *Migrant Mother* is iconic in the commonly held sense of that term: a representative image of profound significance to a nation or other large group. Even a secular culture finds something sacred in the bond between mother and child, so basic to all human experience, so charged with the potential for tenderness and compassion.

No doubt much of the power of this photograph lies in its echoes of the Madonna and Child, an image that resonates throughout Western culture and crowds the mind with memories of some of the greatest triumphs of Western art. Photographs often depict subjects known to us from art; the familiarity that results must be comforting. An image (or a fact) that is already known in outline or already accepted can be more easily slotted into the mind. When the image is a photograph, the impression of life imitating art adds a touch of wonder and perhaps a sense of satisfaction that things should turn out as humans had envisioned them.

One commentator referred to this photograph as "a sort of anti-Madonna and Child. . . . the mother, who, we feel without reservation, wants to love and cherish her children, is severed from them by her anxiety even as they lean on her." The figures are compressed within the frame, the children literally dependent on their mother. Two of them turn their faces away, emphasizing the intense concentration of the woman's expression. The emotional force of this monumental composition was recognized immediately. Stryker later recalled: "To me, it was *the* picture of Farm Security. The others were marvelous, but that was special. . . . So many times I'd ask myself what is she thinking? She has all the suffering of mankind in her but all the perseverance too. A restraint and a strange courage. You can see anything you want to in her. She is immortal."[3] Perseverance in the face of suffering was exactly what Stryker and people across the country hoped to see in the attitudes of Americans burdened by the Depression. Apparently it is what we still wish to see.

Lange had not wanted to stop for this picture. She was speeding home from a lonely month-long stint photographing migrant workers when she saw a sign that said "PEA-PICKERS CAMP." She kept driving for another twenty miles

and then, as if despite herself, turned around and headed back to the camp. Instantly drawn to the mother and her children, she asked enough questions to find out that the pea crop had frozen, everyone was out of work, and the family had been subsisting on frozen vegetables from the fields and birds the children had killed. The mother had just sold the car tires to pay for food. Lange took six exposures, moving closer each time; this image is the last. She left as soon as she had finished, not bothering to photograph anyone else, certain she had what she wanted.[4]

She had carefully calculated this picture. As Lange herself noted, the mother, who was thirty-two, had seven children. Four were there at the moment, one of them a teenager. This girl appears in the first picture in a rocking chair in front of the family's tent, but she is not included in the subsequent photographs; Lange must have realized that her age raised questions about how old her mother had been when she was born. The progression of the negatives makes it clear that Lange was looking for something. She took one picture of the mother and baby alone and two middle-distance shots of the mother and one child facing us. These were good pictures, but the landscape was a bit distracting, the mother's expression not quite telling enough. Only when Lange moved in tight and put both children into the picture with their heads turned away, only when the mother made her expressive gesture, did all the elements coalesce in a highly concentrated message, a symbolic image of family and poverty.

If Lange recalled the shoot as a moment of destiny almost beyond her control, she was entirely pragmatic about the photographs. As soon as she had printed the pictures, she took them to an editor she knew at the *San Francisco News* and told him the pea pickers were starving. He alerted the United Press, UP contacted the relief authorities, and food was dispatched to the camp. On March 10 the *News* carried a front-page article headlined "FOOD RUSHED TO STARVING FARM COLONY" and printed two of Lange's pictures of the family (but not the one that would become so famous). The paper's lead editorial gave the photographer full credit without ever mentioning her name: "Ragged, ill, emaciated by hunger, 2,500 men, women, and children are rescued after weeks of suffering by the chance visit of a Government photographer." The editor wrote Lange a most appreciative letter.[5]

RA and FSA photographs rarely had such immediate and concrete effects. The instant influence of these photographs owed something to Lange's acquaintance with an editor and to her sharp sense of the uses of publicity. The RA and FSA were essentially propaganda arms of the government, intent on reinforcing New Deal policies in the face of a generally hostile press and Congress. Photographs were made available to editors everywhere, and as they were free of charge, magazines and newspapers picked them up, but the office was not organized like a public relations firm to get the news out fast where it would have the greatest impact. The goals were long-term goals, and in the long term Stryker would say, "We succeeded in doing exactly what Rex Tugwell said we should do: *we introduced Americans to America.*"[6]

Migrant Mother rapidly became a classic and was exhibited at the Museum of Modern Art in 1941 when its photography department was founded. It had been published in *Survey Graphic* in 1936 and was included in *U.S. Camera*'s exhibition of the year's outstanding pictures, which toured the U.S. and Europe; it was then printed in the *U.S. Camera Annual*. Archibald MacLeish reprinted it in *Land of the Free* (1938), a book of texts and photographs that included thirty-two other photographs by Lange. The image was reproduced so often that Lange later complained about it, saying she was not a

one-picture photographer but people thought she was. "The woman in this picture," she said, "has become a symbol to many people, until now it is her picture, not mine."[7]

This photograph was so telling and so well known that an artist who borrowed from it, even if fundamentally changing it, could count on the extra authority of an iconic image. As early as 1939 a lithograph called *Spanish Mother, The Terror of 1938* used Lange's composition to comment on the horrors of the Spanish Civil War. In 1964 the cover of *Bohemia venezolana*, a Latin American magazine, turned *Migrant Mother* into an emblem of oppressed Hispanics; and in 1973 the back page of *Black Panthers' Newspaper* converted the group's racial type and captioned it: "POVERTY IS A CRIME, AND OUR PEOPLE ARE THE VICTIMS." Lange's authorship was not acknowledged by those who borrowed her composition. In the 1930s photographers were seldom credited, and by the time the photograph became an icon, it could be appropriated by anyone who understood its emotional force and knew how to refocus it.

The subject, never identified by Lange, was named Florence Thompson. In 1978 she complained to the AP that she couldn't get a penny out of the photograph's fame; she tried, and failed, to have it suppressed. In 1983, when

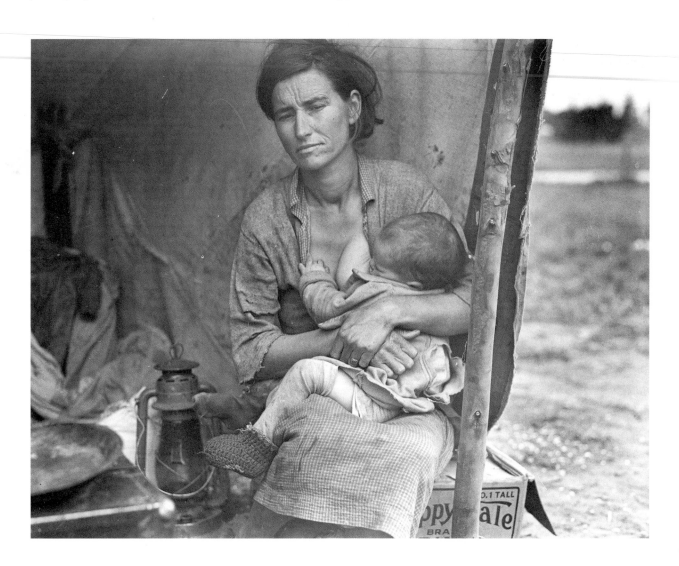

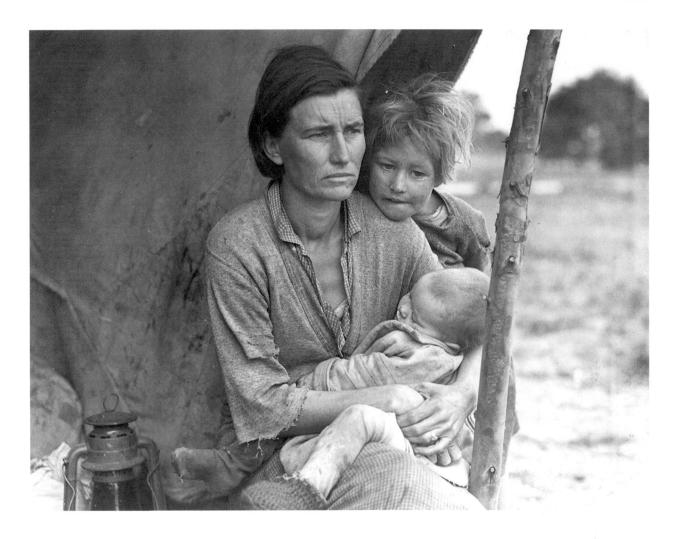

Dorothea Lange

(1895–1965)

Two alternative versions of

Migrant Mother, 1936

Library of Congress,

Washington, D.C.

Thompson was very ill, the nation still remembered her image. The *New York Times* of August 24 reprinted the picture with a small, recent photograph of Thompson under the headline "AN APPEAL FOR A FACE FROM THE DEPRESSION": "Decades after her careworn, resolute face became a symbol of the grinding poverty of the Depression, Florence Thompson's children are asking for help to save their mother's ebbing life." A fund was set up, and by the time she died, less than a month after the first article, more than fifteen thousand dollars had been donated, and many had written letters saying that her photograph had touched them deeply.[8] Lange's photograph of this woman, which had raised funds in 1936, still had the power to do so nearly half a century later.

The success of Lange's photographs in eliciting aid confirmed a feeling that prevailed during the New Deal: those who saw the afflicted would be moved to assist them. In more recent times some have questioned whether photography has not overexposed suffering, so that its audience has begun to grow defensive, even immune. But in the 1930s, when the Depression itself remained largely invisible for several years and a large daily dose of photographs was still a relatively new regimen, the eye and mind, and perhaps the heart, were more receptive. Poverty was not thought to be the fault of the poor nor the Depression irremediable. The official line, clung to by millions, was

139

that American know-how and willpower, a sympathetic population, and New Deal policies would ameliorate the kind of misery Lange's photographs portrayed. The pictures carried with them the expectation that they might rouse people to action. In 1940 a journalist writing about the FSA photographs said they were "important to everyone who believes that democracy can succeed in a gigantic country like ours only when people are informed about the trouble of their fellow Americans and thus are impelled to do something to help them out."[9]

The Historical Section's mandate was to convince the country that government assistance was essential and FDR's policies the best course. The precise influence of the photographs is difficult to measure, but it is possible to point to the broad distribution of these pictures and to suggest that they had a cumulative force and helped raise the level of awareness about many problems in the agricultural sector that might otherwise have gone unseen by most. By the end of the RA's second year, Stryker had placed photographs in four national magazines and had organized twenty-three exhibitions, including one at the Museum of Modern Art, one at the 1936 Democratic National Convention, and one at the Texas Centennial Exposition in Dallas. Libraries and state fairs had loan exhibitions supplied by the agency; the pictures toured internationally; and Harvard, Columbia, Princeton, and the universities of Wisconsin and Oklahoma taught economics and sociology classes with sets of FSA photographs. Between 1938 and 1940 approximately 175 newspapers and magazines, "from the *Saturday Evening Post* to the Walnut Ridge [Arkansas] *Times-Dispatch*," reproduced the agency's free photographs.[10] So did *Collier's, Current History, Life, Literary Digest, Look, McCall's, Nation's Business, Newsweek, Survey Graphic,* and *Time.*

Several popular books, such as *Land of the Free* and Lange and Taylor's *American Exodus*, made the FSA pictures even more widely available. When *U.S. Camera* printed thirty-two pages of them in its 1938 annual, Stryker sent copies to top officials. That year two of Lange's photographs appeared on the cover (and several more inside) of a pamphlet called *Their Blood Is Strong*, a collection of articles by John Steinbeck about the migrants' problems. The book had a large readership and went into four printings.

Lange's work allegedly was requested for reprint from the RA and FSA more often than any other photographer's. From 1935 to 1939 her pictures of migrant workers in the West were a major source of information about refugees from the Dust Bowl. The RA's regional office arranged public displays of her photographs when lecturers spoke about migrant problems at men's and women's clubs, schools, churches, trade unions, and so on. In 1941 the documentary filmmaker Pare Lorentz wrote, "If there are transient camps, and better working conditions, and a permanent agency seeking to help migratory workers, Lange, with her still pictures that have been reproduced in thousands of newspapers, and in magazines and Sunday supplements, and Steinbeck, with two novels, a play, and a motion picture, have done more for these tragic nomads than all the politicians of the country."[11]

For the truth of the matter is that John Steinbeck's *Grapes of Wrath* focused the nation's attention and sympathy on the migrant workers as the FSA had never been able to do. The book was published in 1939 and immediately became a best-seller. Three months after publication eighty-three thousand copies had been sold; only *Gone with the Wind* outsold it. In 1940 the film opened to even bigger audiences. Steinbeck's mission of concentrating the nation's mind on the problem had been helped by the FSA (and by Lange in particular), by his own earlier writings on the workers, and by other

BELOW

Diana Thorne

Spanish Mother: The Terror of 1938, 1939

Lithograph, printed in black, composition, 11 x 7¼ in.

The Museum of Modern Art, New York; Study Collection of the Department of Photography

140

ABOVE, LEFT

Bohemia venezolana,1964

The New York Public Library,

Astor, Lenox and Tilden

Foundations, Central

Research Division

ABOVE, RIGHT

Malik

Page of *Black Panthers'*

Newspaper, 1973

The Oakland Museum;

Dorothea Lange Collection

accounts, all of which had brought the populace to a level of consciousness that could accept the brutal tales he told.[12] But both the novel and the film were influenced to an unusual degree by still photographs.

Steinbeck had firsthand experience of the camps. He had traveled through them for the *San Francisco News* in 1936; and in 1937, in order to gather material, he worked as a migrant for a few weeks with an FSA staff member. Still, he depended heavily on photographs. He traveled back to the camps five or six times in 1938 with Horace Bristol, who had been photographing migrants under Lange's guidance, to do a story for *Life* that the magazine never printed.[13]

Steinbeck admired Bristol's photographs, which *Life* finally published on June 5, 1939, after the book came out, with captions comparing some portraits to Steinbeck's descriptions of Ma and Tom Joad. Steinbeck also knew Lange's work, which had illustrated his 1938 pamphlet and which he would have seen in the FSA files. Stryker, who remembered him spending a couple of days looking through the files, thought the author had been inspired by the "tragic, beautiful faces" he saw there. Others have tied descriptions in Steinbeck's book to specific pictures by Lange and other FSA photographers.[14]

Once the film had reached millions and been condemned by some, *Life* reprinted Bristol's photographs next to film stills to prove how realistic the movie actually was. The most striking comparison is a portrait of a middle-aged woman by Bristol next to a picture of Jane Darwell as Ma Joad, but other pairs are close enough to suggest that John Ford, the director, looked hard at photographs before his cameras rolled. "Never before," *Life* said,

141

"had the facts behind a great work of fiction been so carefully researched by the news camera."[15]

Life notwithstanding, earlier filmmakers had looked to photographs for authenticity and inspiration. Ford's film appears to have Lange's stamp on it as well as Bristol's, just as Steinbeck's book did. Ford even hired an FSA staff member as a consultant to his film—Tom Collins, the man who had traveled and worked with Steinbeck in the camps.[16] The book and the film that finally woke an enormous audience to the problem, as Lange and the FSA had been trying to do since 1935, was built on a foundation of photographs. Transposing those still images into words and motion, The Grapes of Wrath kept their purpose and sometimes the look of the photographs alive as well, while it spread their influence across the land.

The little island of Iwo Jima is five miles long, two miles wide, and six hundred seventy-five miles from Tokyo. Allied forces wanted control of it as a staging ground for bombing raids on Japan. Twelve days after U.S. marines landed on Iwo's shores in 1945, the Japanese commander there was quoted by Tokyo radio as saying, "This island is the front line that defends our mainland, and I am going to die here." The Japanese had tunneled deep into volcanic rock; the commander and over 20,000 of his men did die there, many of them inside the island, but they took 6,821 Americans with them and wounded more than 18,000 in less than a month, causing greater losses than any battle in the history of the marines to that date.[17]

On March 5, before the fighting was over, Time magazine announced that the name of that tiny speck of land had already entered history: "By week's end there were other great events: the flag-raising on Corregidor, the renewed air blows at Tokyo, and the battering push toward the plain of Cologne. But Iwo held top place in the minds and hearts of Americans. Henceforth, Iwo would be a place name in U.S. history to rank with Valley Forge, Gettysburg, and Tarawa. Few in this generation would ever forget Iwo's shifting black sands, or the mind's images of charging marines, or the sculptured picture of Old Glory rising atop Mt. Suribachi."[18] In fact, the shifting sands and charging marines have dimmed in most minds, but the raising of the flag remains because a photograph immortalized it.

The Associated Press photographer Joe Rosenthal's picture of five marines and a navy hospital corpsman raising the emblem of America over Japanese territory reached mythic status almost instantly. One newspaper said these six men had "achieved a recorded, historic splendor which the camera's eye has never before granted fighting men and their flag," and a photo editor wrote that "in a sense, in that moment, Rosenthal's camera recorded the soul of a nation." A month after the photograph was first published, Life reported that "schoolboys wrote essays about it, newspapers played it for full pages and business firms had blow-ups placed in their show windows. There have been numerous suggestions that it be struck on coins and used as a model for city park statues"; some talked of installing a two-hundred-foot reproduction in Times Square.[19] (In 1954 the Marine Corps War Memorial Foundation commissioned a sixty-four-foot bronze sculpture of the image, which stands at an entrance to Arlington National Cemetery.)

The photograph has the diagonal drive of the most dramatic Baroque paintings. The marines, the flag, the wind have all cooperated to produce an image of impending victory. The pole bisects the space, leaving a huge empty triangle at the right waiting to be filled. The foremost marine strains to plant the base of the pole in the earth, the last man has just lost his grip as the pole

Joe Rosenthal (born 1911)

Iwo Jima—"Old Glory goes

up on Mt. Suribachi,"

February 23, 1945

AP/World Wide Photos, New

York/International Museum

of Photography, George

Eastman House, Rochester,

New York

rises, the flag begins to take on air and swell with the promise of unfurling. The instantaneous camera had rarely captured a news event so charged with the potential for its own fulfillment. In an instant the flag will be vertical, the position of victory, the position human beings doubtless have associated with triumph ever since they rose off all fours in defiance of gravity.

This may be the most widely reproduced and re-created photograph in history: 3,500,000 posters of the image were printed for the Seventh War Loan drive, 15,000 outdoor panels and 175,000 car cards were published, and the photograph was reproduced on an issue of three-cent stamps. In 1955 the photographer said: "It has been done in oils, water colors, pastels, chalk and match sticks. A float based on it won a prize in a Rose Bowl parade, and the flag-raising has been re-enacted by children, by gymnasts . . . and as a part of the Orange Bowl pageant in Miami. It has been sculptured in ice and in hamburger." (It was also reenacted in the 1949 film *Sands of Iwo Jima*.) A

143

marine photographer took film of the flag raising that was shown at the time in newsreels, but it was the still photograph that took up residence in the mind.[20]

From the beginning the photograph was dogged by rumors that it was posed and therefore, in a way, a fake; they have not died out. The rumor was partially due to a misunderstanding, partially to the fact that the picture was too good, too perfect to be true—reality was hardly expected to accommodate a photographer with a scene of such artistic finesse. If Muybridge's photographs of the running horse had raised the issue of the truth's being unconvincing when it fails to match what we see, Rosenthal's picture raises a similar issue by matching too well what we might have imagined. This seldom happens in photography. Ordinarily, even if the event does not look the way we thought it would—the mourners seem more bewildered than sad, the man on fire too calm—we greet it with what amounts to a sigh of recognition: "So *that*'s the way it is." We expect photography to teach us the world. Once Rosenthal's picture was reported to be posed, the marvel of life's closely imitating art became less marvelous.

As Rosenthal himself told it, he went up Mount Suribachi with a marine still photographer and a marine movie cameraman, apparently a bit behind the detail that carried the flag and pole. On the way up Rosenthal passed a Marine Corps photographer going down, who told him that he was too late, the flag was already flying. He went up anyway, and there was the flag, a small one measuring 54 by 28 inches. Rosenthal discovered that the second detail had arrived with a flag eight feet by four feet eight inches, a flag that would be visible over the entire island, even from the ships standing offshore. At the summit of Suribachi the marines were getting ready to raise the new flag. Rosenthal scraped together a makeshift platform to get a good view, saw some movement out of the corner of his eye, and turned to take a picture as the pole was being raised. Uncertain he had got it, he took another, and when it was over, he asked the marines to pose around the flagpole. Three photographs were all he took.

Since the negatives were sent off Iwo for processing, Rosenthal did not see the results. When a wire came from Guam saying his flag picture was very good, he thought it must be the picture taken after the flag raising and when asked if it was posed, he said it was. A radio announcer in the States reported that it had been posed but later retracted the statement. If this were a staged shot, the photographer would have done a bad job. Not one face is visible, even though readers back home wanted desperately to see their sons and husbands. Rosenthal later wrote that had he posed this picture he'd have had fewer men in it—there are six, so crowded together that nothing is visible of one but his hands. It was so difficult to distinguish them that as late as 1947 the Marine Corps was still reidentifying the men in the photograph on the basis of troop movement reports.[21]

At the time *Life* was so convinced that Rosenthal had restaged the event that the editors decided not to print the picture. (It was precisely this kind of cautiousness and allegiance to high standards of photographic truthfulness that had helped maintain the public's confidence in photographs.) Three weeks later *Life*, aware that millions believed in the photograph, felt compelled to publish it at last, saying the image had become a symbol of heroism to the marines and the nation. The photograph was already a symbol of American history; *Life* paired it with *Washington Crossing the Delaware*.[22]

Rosenthal's photograph arrived on front pages at a psychologically opportune moment. Headlines had been crowded with news of Iwo Jima for days; everyone knew how fierce that battle was. In Europe the noose was

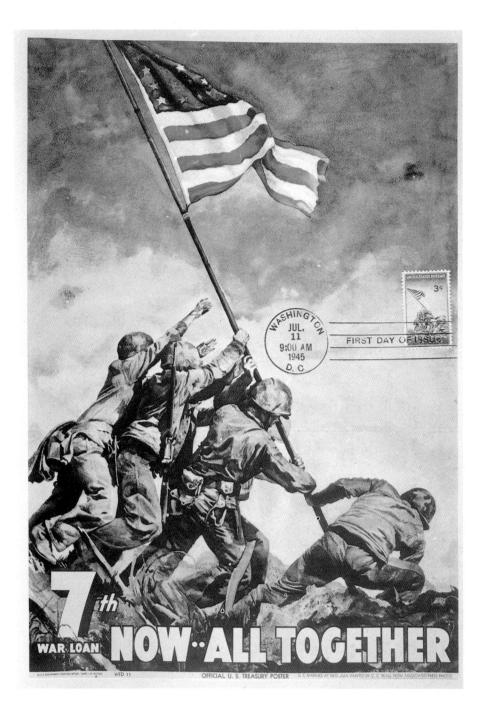

C. C. Beall

7th War Loan: Now—All

Together, 1945

Color poster from

Associated Press photo by

Joe Rosenthal

slowly tightening around Germany, while the Pacific was being savagely contested inch by inch on tiny islands with unpronounceable names. The raising of the flag—traditional symbol of victory—over an island within striking distance of Japan was like a promise that war would finally end.

The marines, their faces invisible, fight as a group against gravity's downward pull on the heavy pole, much as they teamed together in battle against the Japanese. The writer Paul Fussell believes that the elements of anonymity and group effort account for the immense power of the image:

THE SPIRIT OF JEANS.

"Because the war was a common cause, no ordinary person in it has a right to appear as anything but anonymous. . . . 'Stars' are not wanted." (Ironically, the papers revealed the identities of these anonymous men [though not always correctly] because they were the subjects of this photograph. Three of them later died on Iwo.) Fussell calls Rosenthal's photograph a successful "emblem of the common will triumphant" and says that it brings to a climax the New Deal myth of community.[23]

The picture, which won a Pulitzer Prize, has endured as an icon of American patriotism. In 1989, when the Supreme Court found that flag burning was protected by the Constitution, Representative Ron Marlenee of Montana said the decision was a "shot in the back" of the marines who raised the country's banner over Iwo Jima, and President George Bush gave journalists a photo opportunity by speaking against "desecration" of the flag at Arlington, with an intact flag beside him and the bronze replica of Rosenthal's picture in the background.

Rosenthal's photograph is so instantly and universally recognizable that it has become a model to be played with and punned upon. During the Vietnam era a peace poster was blazoned with a group that was struggling to raise a flower. In 1984 *Granta*, the British literary magazine, published on its cover a picture of young Americans raising a flag that said "McDonald's."[24] In 1990, when Rosenthal's photograph was forty-five years old, a clothing manufacturer staged a reenactment of the flag raising in a blue jeans ad. The models were too young to remember the war but not to recall the photograph. Like the altered images of *Migrant Mother*, these less serious versions of Rosenthal's *Iwo Jima* rely on a certain reverence for the original. Parody doesn't work unless everyone gets the joke, and a mythic image like *Iwo Jima* can take a little teasing without losing its essential dignity.

OPPOSITE, TOP

Peace poster based on

Rosenthal's *Iwo Jima*

OPPOSITE, BOTTOM

Advertisement for h.i.s.

jeans, 1990

h.i.s. Men's Jeans

The news came out in the papers on August 7. From the first announcement that an atomic bomb had been dropped on Japan, it was clear the world would never be the same again; one of the *New York Times*'s headlines began: "NEW AGE USHERED." In some respects the news was so immense it was hard to grasp. When President Truman's press secretary first briefed the press, not one reporter broke and ran for a phone, and several had difficulty making their news desks understand how important the announcement was.[25]

No photographs of the bomb, the cloud, or the destruction were released that day, so in a way the news remained oddly abstract. Some papers published officially approved pictures of a plant where the bomb was manufactured or portraits of the scientists and engineers, but the visual effects of the equivalent of twenty thousand tons of TNT were largely left to the imagination. News of the July 16 Trinity test at Alamogordo, New Mexico, was released the same day, but no photographs of the test were released either. However, the cloud at Alamogordo was described: "[F]irst in the form of a ball, then changed into a long trailing chimney-shaped cloud, and finally . . . sent in several directions by the wind"—not yet a mushroom cloud.[26]

The next day, eyewitnesses of the Hiroshima blast reported what they had seen: "a tremendous flash like a ball of fire or a setting sun shone in the distance"; a black cloud that "looked like boiling dust." Paul Tibbetts, pilot of the *Enola Gay*, the plane that carried the bomb, was the only one who spoke about a mushroom cloud: "I could see a mushroom of boiling dust— apparently with some debris in it—up to 20,000 feet."[27]

Nagasaki was bombed on August 9. Japan accepted the Allied terms of surrender the following day, and the end of World War II was announced on

August 11. That day, photographs of the Hiroshima and Nagasaki bomb missions were released.

As Vincent Leo has pointed out, the timing of their publication turned these photographs into pictures of victory; had they been published earlier, they would have been primarily pictures of destructive force or scientific achievement. Rarely has an audience been so thoroughly prepared and so predisposed to find photographs awesome. Yet the victory news and the delayed release made the pictures secondary in newspaper layouts; no American paper or periodical published them on the front page or the cover.[28] (The *New York Times*, for instance, placed them at the top of page 28.) Not until August 20 were the pictures played large, in *Life* magazine. When *Life* put the Hiroshima and Nagasaki cloud photographs, nearly full page, on facing pages, many saw the mushroom cloud for the first time; others had the first glimpse of its magnitude.

The two images of a phenomenon never seen before gave the imagination a visual sign to work with at last, and the power to kill eighty thousand people in one instant finally seemed horrifyingly real. Not that the reports had not been believed—belief was never in question. But a photograph can make a phenomenon visible in a distilled and symbolic form, contained within the field of vision, easily recalled, like a key that unlocks a roomful of ideas. *Life* underlined the import of the photographs with aerial views of the city before and after the bombing. In an attempt to correlate the two sets of pictures—awesome clouds, distant destruction—the magazine began the article with an artist's rendering of what the city might have looked like from above as the bomb exploded.

From the beginning, military officials had exercised complete control over all information relating to the atom bomb. Not long after Hiroshima and Nagasaki were destroyed, Japanese film crews began documenting the effects. American authorities commandeered the film, shipped it to Washington, D.C., and classified it secret. It was not seen until 1970. The mushroom cloud was, in effect, chosen by the military to represent the new weapon. In the first second after detonation of an atomic bomb, a steadily expanding fireball forms, and only then does the cloud begin to rise. On August 17, 1945, *Time* published a series of eight photographs of the Alamogordo test: all were images of the fireball. When the test pictures had been shown to the fliers who were going to drop the bomb on Japan, the projector failed and a diagram was drawn—of the mushroom shape. The crew was watching for the mushroom cloud before it formed.[29]

The outline of a mushroom is more unusual and graphically distinct than a fireball; the choice was an effective one. It was also largely symbolic. The cloud pictures reveal no damage, yet they *represent* previously unimaginable levels of destruction. The emblematic character of the photographs was reinforced by a disturbing touch of aesthetic grace in those sinuous pillars of smoke—the kind of oddly inappropriate beauty that creeps into many war pictures of artillery bursts and nighttime explosions.

It has never been made clear why the military delayed release of the pictures. The day the bombing of Hiroshima was announced, Lowell Thomas had said, "As for the actual havoc wrought by that first atomic bomb, one earlier report was that the photographic planes on the job shortly after the cataclysmic blast at Hiroshima had been unable to penetrate the cloud of smoke and dust that hung over the devastated area." It was true that the city was not visible in the pictures, but there were photographs of the cloud. The two lead planes on the bombing mission had been equipped with stationary

George R. Caron

Atomic Bombing of

Hiroshima, August 6, 1945

UPI/Bettmann, New York

K-17 aerial cameras set to record the strike. Sergeant George R. Caron, tail gunner of the *Enola Gay*, had a hand-held K-20; immediately after the explosion he began photographing and did not stop until the roll was finished. When the film was processed, the negatives from the stationary cameras showed nothing but sky and odd patches of ground outside the target area. To escape the violent drafts of the explosion, the planes had instantly taken evasive action, throwing the fixed cameras off target. Caron had the images, and the only images, that were released to the papers.[30]

The mushroom cloud instantly became a universal symbol, an icon for the age. Observers of the Trinity test had referred to the cloud as a mushroom but

also as a "parasol," a "geyser," a "convoluting brain." In 1946 the Bikini Atoll test was described as a "cauliflower cloud," but "mushroom" became the standard reference. (The more perfect mushroom shape of the Bikini bomb cloud and movie footage of its roiling formation partially supplanted the original images in the public mind.) As one observer pointed out, mushrooms are associated with rot and death, but also with nourishment and magic; and besides, it is "hard to imagine people feeling the same awe for a 'cauliflower cloud.' "[31]

The mushroom symbol itself was soon simplified. (Even the language was abbreviated: "Atom bomb" became "A-bomb," then simply "the Bomb.") The cloud was regularized and abstracted in simple drawings that depended less on the original photographs than on the *idea* of a mushroom. Powerful and well-known visual images, if they can be converted to easily recognized graphic shapes, are sometimes reduced to logos, symbols of symbols, losing much of their force while retaining their meaning. The word *atomic* and the hallucinatory cloud were tamed for everyday use by being reduced to cartoon levels. The Bikini Atoll test in 1946 was celebrated with a cake shaped like an icing-covered mushroom cloud. There was the Atomic Cab Company, the Atomic Cocktail, and the atomic hairdo, arranged on a wire form. By 1947

Jacobus

Bikini Atoll Cake Celebration

November 6, 1946

Historical Pictures Service,

Chicago; Harris & Ewing

Collection

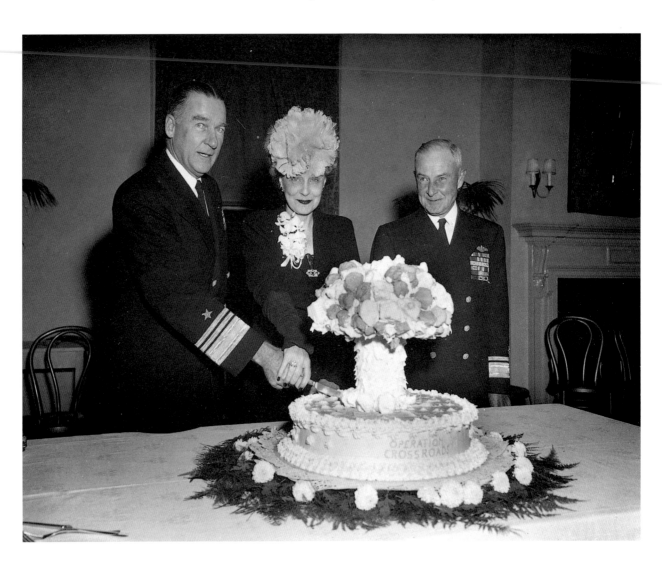

Don English (born 1926)

Miss Atomic Bomb,

May 1957

Las Vegas News Bureau

there were forty-five companies in the Manhattan phone book with the word *atomic* in their titles, including the Atomic Undergarment Company, and many had a sweet, puffy little mushroom cloud as their logo. The museum at the University of Nevada, Las Vegas, displays a photograph of Miss Atomic Bomb from 1957: a young woman who wears little but a smile and a big mushroom-shaped appliqué of cotton.[32]

Not even such careful domestication could diminish the force of the mushroom cloud's hold on the mind. The symbol has consistently stood for extreme opposites. Almost from the moment of the first reports, atomic fission was seen both as evil incarnate and as a possible force for good. The end of the world was foreseen by many, and the United States, sole possessor of a weapon that could destroy any enemy, envisioned itself as a potential victim. "In that terrible flash 10,000 miles away," James Reston wrote in the *New York Times* on August 12, 1945, "men here have seen not only the fate of Japan, but

have glimpsed the future of America." Millennial religions then and now regarded the bomb as proof of the Bible's predictions of the end of the world.

On the other hand, on August 7, the day of the first announcement, both the *St. Louis Post-Dispatch* and the *New York Herald Tribune* wrote that atomic power would turn out to be a blessing for mankind. *Time* made President Harry Truman Man of the Year in 1945; the cover pictured him beneath a fist holding a brace of lightning bolts before a mushroom cloud. *Collier's*, in 1947, hailed the healing powers of the atom by picturing a paraplegic walking out of a mushroom cloud and leaving his wheelchair behind.[33] In a world where religions and philosophies are largely predicated on the dichotomy between good and evil, only the most powerful of symbols can stand for both. One of the few truly momentous events in world history will forever be marked by the shape of an image in a photograph.

In the Western world there is more than a little dismay that the electoral process has come to rely so heavily on the creation and selling of images rather than on issues. Photography and its offspring, television, take much of the blame here, and critics who note their damaging effects also point out how perfectly suited photography is to the advancement of capitalism, how readily it lends itself to the sale of consumer goods and the promotion of the underlying political agendas of corporate sponsors of advertising and commercials. Certainly capitalist enterprise is fueled by advertising, which depends on images, and images apparently have a direct link to desire. Evidently the Communist world is breaking up in part because it could not deliver the good life its citizens saw in the press and on TV. In 1989 the *New York Times* reported that residents of one Siberian city who used to think they had "the best of everything—cheap food, good, free medicine" now realize that is not so: "Things also seem worse now because the more open press has shown them pictures of life in the West."[34]

But capitalism obviously has no monopoly on photography, and totalitarianism has often enlisted the camera to advance its cause. Photography is a splendid instrument for both sales and propaganda, which after all have a great deal in common. Capitalist enterprises have been extremely resourceful in making idols and icons of entertainers, public figures, and politicians with the assistance of photography—think of Elvis Presley, Brigitte Bardot, John Lennon and Yoko Ono, Princess Di, Ronald Reagan—but totalitarian governments have gone them one better by manufacturing gods. At least the Chinese did so when they constructed the image of Mao Tse-tung. It was not predominantly a visual image. Mao's thought, reduced to aphorisms and compared to "a spiritual atom bomb," was central to his cult, but photographs played an enormous part in his elevation to a unique position on high.

A personality cult began to be erected around Mao as early as the end of the 1930s, partly as a consequence of the revolution. In wartime, leaders seem larger than life, and Mao was no exception. In 1949, just before he entered Beijing in triumph, he himself supposedly suggested that the party forbid the naming of streets, cities, or places for any individual.[35] In the future he would not be so hesitant about accepting the signs of adulation.

The heroization of Mao continued, interrupted by de-Stalinization in 1956 but taken up again in 1959. When the Cultural Revolution began in 1965, Mao was already an outsize figure; in the following years he would be, in effect, deified. His ascension was carefully orchestrated and his portrait instrumental.

This portrait, blown up to an enormous size, hung on the fifteenth-century

Red Guard badges with photos of Mao, 1960s Collection of Michael Gasster

Mao Tse-tung

UPI/Bettmann, New York

Gate of Heavenly Peace in Tian An Men Square for the rally at dawn on August 18, 1966, that signaled the full force of the Cultural Revolution; it hangs there still. In 1966 portraits of Karl Marx, Friedrich Engels, and Sun Yat Sen hung on the other sides of the enclosure. More than a million young Chinese thronged into the square that morning, most of them wearing khaki with crimson arm bands saying "Red Guard." They came bearing symbolic images of Mao. As the *Peking Review* described it: "The great mass of Red Guards and revolutionary teachers and students, militant and alert and with red flags and portraits of Chairman Mao held high . . . each carrying a copy of the bright red-covered *Quotations of Chairman Mao*" converged on the site. As the sun rose behind him, Mao himself, wearing a simple soldier's uniform, appeared on the upper gallery of the Tian An Men gate, above his mammoth portrait. The crowd went wild, waving their flags, their portraits, and their books, screaming his name, weeping, leaping into the air. Photographs of the occasion were widely distributed, and a film of the rally, some of it staged, was shown throughout China and much of the world.[36]

Both the occasion and the placement of Mao's portrait had resonance for the Chinese. The Gate of Heavenly Peace was the entrance to the imperial palace in the Forbidden City. For five hundred years of imperial rule, this gate had been barred to commoners. On that very spot, on October 1, 1949, Mao proclaimed the People's Republic of China. Tian An Men Square, enlarged by the Communists, thus stood for the revolution itself, and Mao's huge portrait guarded the imperial gate he had won for the people.[37]

As the Cultural Revolution wore on, the country was flooded with symbolic representations of Mao, and important messages were coded in them. One former Red Guard later related that the students at his secondary school had been particularly inspired by a photograph of Mao wearing a Red Guard arm band. More clearly than words this image assured the students they were free to form a Red Guard unit in their school.[38]

By 1964 and '65 giant portraits of Mao hung in the streets and busts of him could be found in every house; Mao's own residence seemed to be the only home that did not have his image. By 1966 he was named more often in the papers than Stalin had ever been in the USSR, and a photograph of Mao would be given the whole front page of the *People's Daily*, whereas Stalin had usually been content with a quarter of a page. Shrines were set up in barracks and factories to display statues or pictures of Mao. Shops sold icons with his picture in the center—sometimes graced with a golden halo, often surrounded by the sun's rays—which took the traditional place of the ancestral tablet in the Chinese home. His picture appeared in buses, trolleys, and cabs, at the entrance to every house and office, in shop windows and public squares. Movie theaters showed nothing but close-ups of Mao against a sea of Red Guards. Peasants went to till their fields carrying pictures of Mao; sometimes their fields were fenced off with the chairman's pictures. On holidays in the provinces peasants might place a picture of their leader in the center of the village and genuflect before it.[39]

Red Guards and soldiers marching in rank upon rank carried portraits of Mao at chest height. Occasionally they carried two, one in their hands and one suspended from the neck. The Guards and others also wore badges and buttons with Mao's image. Some, to show their loyalty, pinned the buttons to their skin. By 1969 an average family would start its day by bowing before Mao's portrait, singing "The East Is Red," and chanting quotations from his book. Pupils entering school bowed three times before a picture or bust of Mao; brides and grooms did the same at their wedding ceremony and often received portraits of Mao as presents. And while the sayings of the chairman produced the greatest number and variety of miracles, his portrait also brought cancer victims back to health and patients in comas back to consciousness. It inspired astounding devotion. In 1967 Peking Radio broadcast this message: "With Chairman Mao's portrait hung in the warship, our way will not be lost despite giant waves; with Chairman Mao's portrait hung in the submarine, a ray of sun shines under the sea."[40] In the time of the Roman empire, the portrait of the emperor was revered in the colonies like the emperor himself. Mao's portrait, too, became the emperor.

There was not one portrait, there were many. There were several particularly famous photographs of Mao, and the picture in Tian An Men Square was often reproduced in official literature. But the point was to see, wear, revere not the canonical image of the chairman but an image of the canonical chairman. China has a tradition of godlike rulers and of the emperor as "mother and father of the people," but no tradition of pictures of the emperor visible and cherished everywhere. No doubt that idea was borrowed from Stalinism, the prime example of the heroization that totalitarian regimes have built with the aid of modern communications. In Western Europe and America, which have been less devoted to images of rulers in this century than the nineteenth century was, an artist who was tuned in to the communications revolution took up the image: Andy Warhol's several versions of Mao's portrait are probably better known in some circles than the original portrait.

Having long ago developed the art of conveying important information

indirectly, the Chinese have a sophisticated sense of how messages can be encoded in photographs. Not only have they deftly rewritten history by erasing disgraced functionaries from photographs, they may have faked the famous picture of Mao's head above water in his first appearance after what was rumored to have been a serious illness. The summer before Lin Piao, Mao's defense minister and designated successor, was killed, allegedly in an airplane crash, Mao's wife distributed a group of photographs that she had supposedly taken; in one of them Lin appeared hatless and almost completely bald. Since Lin was known to be hypersensitive about his baldness and always covered his head, the photographs were an indication that he had fallen out of favor.[41]

After the Cultural Revolution, Mao's portraits no longer appeared on every arm band and field and entranceway. Since his death in 1976, and most particularly since 1981, when the party declared that he had been mistaken about certain things late in his life, his reputation has been somewhat in decline. His pictures and statues have largely disappeared. Yet his portrait still dominates Tian An Men Square, although Marx and Engels, Lenin and Stalin are no longer present, and Sun Yat Sen is brought out only for special occasions associated with his part in the revolution. The Deng government

Shunsuke Akatsuka

Demonstrators in Tian An

Men Square, May 23, 1989

Reuters/Bettmann, New York

needs Mao's authority, the imprimatur of the conqueror and liberator, to give the Communist regime legitimacy. In March 1989 an architect suggested that the Tian An Men portrait be removed and the square restored to its original historical condition. Officials made it clear this was unlikely.[42]

Then in May, when students occupied the square, a teacher and two accomplices splattered Mao's portrait on the Gate of Heavenly Peace with paint. The symbolic weight of that portrait is so great that defacing it implied denying the governing regime and communism itself. The portrait was replaced with an unsullied copy during the night. The student demonstrators, who had always denied any intent to overturn communism, reported the offenders to the authorities. Not long after the demonstrations were suppressed, the three who defaced Mao's portrait went on trial. One was sentenced to three years, one to six, and the leader to life in prison.[43]

Alberto Korda (born 1928)

Che Guevara, March 5, 1960

Alberto Korda

Mao Tse-tung's image was conceived and deployed as an icon to bolster Mao's authority while he was in power. Che Guevara became an icon only after his death. He was a hero during his lifetime, but a martyr's death made him a legend.

The most famous photograph of Che—it has been called the most famous photograph in the world—was taken by the Cuban photographer Alberto Korda on March 5, 1960, while Fidel Castro was delivering a speech commemorating the victims of a French ship sabotaged in Havana's harbor. Che, Castro's minister of economics, appeared next to Fidel for a few moments, and Korda, who had been photographing the event, snapped a picture. When he developed the negatives, he was struck by the intense image of Che gazing upward; he cropped out everything else and printed the image of Che's face. It was not published.[44]

Five years later Che disappeared. Having helped win the revolution and then served in a position of power, he became a guerrilla once more and took a small band into Bolivia to expand the revolution. On October 9, 1967, Bolivian forces killed him. The night that Fidel spoke in the Plaza de la Revolución to announce Che's murder, Korda's portrait covered the ten-story Ministry of the Interior in the plaza, and there it has remained.[45]

In no time Korda's portrait and related images flooded Latin America and washed across the world. The export of Che's portrait began soon after his death when Feltrinelli, the Italian publisher, marketed posters based on the photograph. Che's life, ideals, and death seemed to be concentrated within this image of the handsome, heroic revolutionary, with his eyes fixed in the upward gaze that has signified spiritual aspiration at least since Roman portraiture of the second century A.D. The revolution he had hoped to begin in Bolivia was quickly squelched, but after his death his influence and image were widely broadcast, and he was at last successful in exporting his ideas.

Che was already perceived as a moral exemplar, for he had given up power to fight for the beliefs he espoused, then sacrificed his life at an early age. He had written about the creation of a man for the next century, saying, "We ourselves will be such men." To many, he seemed to have fulfilled his own ideal. To Jean-Paul Sartre, Che was "the most complete man of his age; he lived his words, spoke his own actions, and his story and that of the world ran parallel." Once he was gone, Fidel held him up as the guide to the new world, "If we wish to express what we want the men of future generations to be, we must say: 'Let them be like Che,'" and children in Cuban classrooms adopted the chant, "We will be like Che."[46]

In death Che was transfigured, becoming the equivalent of a saint, the

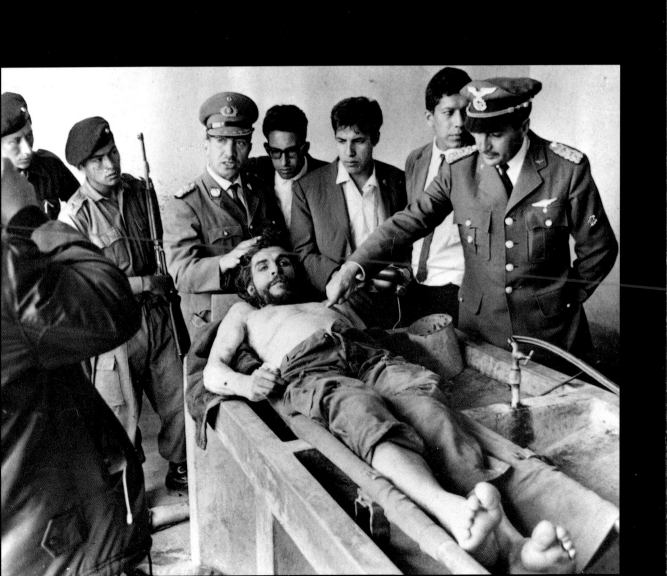

first saint Marxism has produced.[47] In parts of Latin America, his martyr's death cast him in a sacred light; he is often linked with Christ. Dedicated to the poor of the earth, Che was willing to die for their sake. The handsome young man in the photograph, bearded like Christ, wears a beret that bears a bright star and forms a partial halo around his head. The famous picture of his corpse being displayed resembles the foreshortened figure in Andrea Mantegna's *Dead Christ*, c. 1480, in the Brera.

In Che's image, the religious connotation of the word *icon* returns. Bolivian peasants commonly believe that those who die tragically are empowered to perform miracles. In less than two weeks after his death, sixty-seven hundred photographs of Che were sold at the weekly regional fairs in the province where he died. Peasants came from remote villages and lined up to buy his picture, which they then took to church to have blessed. The miracles he performed were soon the stuff of legend, and his portrait appeared in huts next to pictures of Christ, the Virgin, and the more standard roster of saints.[48]

This holy association spread across Latin America and beyond. Cuban homes frequently display a picture of Che next to one of Christ. Father González Ruiz, the rebel priest in Madrid, was reported to keep a photograph of Che next to the Crucifixion on his desk. Folk artists in Central and South America have been known to combine the two figures in one work of art. One Cuban artist gave Che a halo; at a village fair in Central America another composed a head that was half Che and half Christ, with sayings by each written on their respective sides of the painting.[49]

Che's portrait, whether religious in aspect or not, is ubiquitous in Cuba. Korda's photograph is permanently installed in the Plaza de la Revolución and pinned on the walls of most homes. (Castro, who has discouraged any cult of personality, is pictured far less often than Che.) Brilliant posters display Che's face in every city; as the cities are gray and dreary, the posters stand out with particular force. His face gazes from offices and shops, from postage stamps, from books and periodicals. The anniversary of his death each year calls forth still more representations.[50]

Susan Meiselas (born 1948)

Havana's Plaza de la

Revolución, with Che

Guevara's Image in the

Background, January 1, 1979

Magnum Photos Inc.

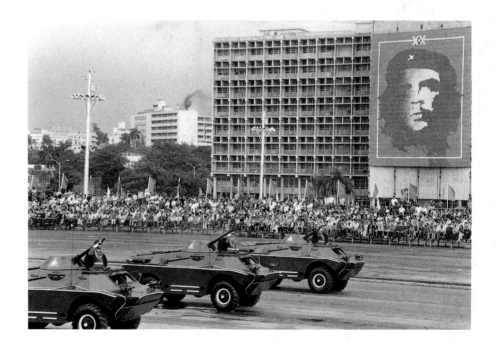

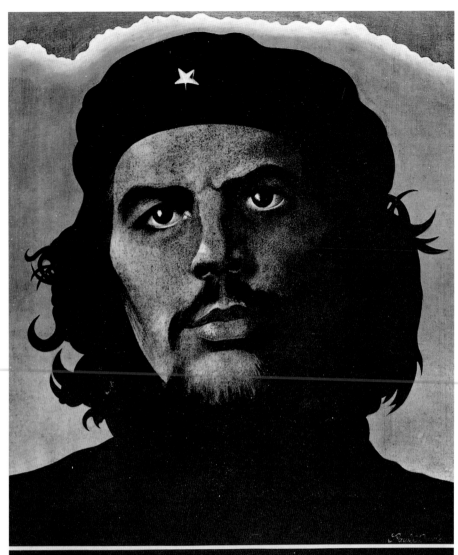

Paul Davis (born 1938)

"Che Guevara"—Poster

Advertisement for

"Evergreen" Magazine,

February 1968

Acrylic on board

The heroic image also turns up everywhere in Latin America. Shortly after Che's death it was applied to lampposts in Puerto Rico. A high school in Mexico City has a large mural based on the Korda photograph. By the early 1970s T-shirts with the image were being sold on the streets of Peru, Chile, and Mexico. Even socks have been embroidered with his picture. Che became the model for student revolutionaries and antiwar demonstrators from Liverpool to Berkeley. Students who identified with the revolutionary stance of a man born into a bourgeois family adopted his hair, his beard, and his picture. The 1968 student demonstrations in France were partially inspired by Che's death, as were student and other uprisings elsewhere. Che posters decorated dormitory walls everywhere. American antiwar demonstrators wore his image on their backs; it appeared on banners, fixed to street posts, and in the hands of demonstrators in countries throughout Europe, Asia, and the Americas, in Caracas, Berlin, Hanoi. When students at the University of California went on strike in 1970, their poster bore Che's image. His face is embroidered in the center of the flag of a guerrilla army in Guatemala.[51]

Che's image became an icon, and his ideas took on an iconic significance for a generation of the downtrodden and rebellious. The image itself became the symbolic center of his martyrdom. Its religious references and the idiosyncratic features that allow it to be so easily abstracted rendered the portrait instantly translatable for any audience. For illiterate and peasant populations, the portrait substituted a person for an ideology: here was revolution, socialism, Marxism in easily comprehensible form.

As with Mao, there is a primary portrait of Che—Korda's photograph—and many secondary images, principally stylized versions of Che's face derived from the photograph for posters. His skin has been darkened or his face reduced to his gaze, his beard, his beret and star, and still he is the heroic Che.

When photography was invented, people had to make room in their minds for the idea that the dead would always be visible. This has to have been a jolt to the feelings. With a true-to-life image of the dead always available, the bitter or sweet reactions to the person in life and after are easily and vividly renewed. In the case of Mao, a photograph that represented his authority in life has been preserved by his successors to legitimate their rule, as portraits of rulers have done for centuries. With Che, a photograph spread not only his fame but his ideals after his death. As symbols will, as representations can, a portrait of Che accomplished more for his cause than the man himself accomplished in his lifetime.

E.E.J.M.

Home for Working & Destitute Lads.

No. 27.—ONCE A LITTLE VAGRANT.
(The same lad as on card No. 28.)

E.E.J.M.

Home for Working & Destitute Lads.

No. 28.—NOW A LITTLE WORKMAN.
(The same lad as on card No. 27.)

Dr. Thomas John Barnardo

(1845–1905)

Before-and-After

Photographs of a Young Boy,

c. 1875

Barnardo Photographic

Archive, Ilford, England

SOCIAL REFORM

Photography can be indentured to many employers for many purposes. One service it has performed brilliantly has been to render powerful assistance to social reformers, but it did not begin to do so until forty or fifty years after the medium's invention, when technology and organized reform converged. Before that, although it was apparent that the high reality quotient of photographs would make them useful for fund-raising, photography had made only sporadic forays into the fields of charity.

In America the fight against slavery and the consequences of war created a sense of community and obligation, and the new, easily reproducible methods of photography were called in to assist. During and after the Civil War cartes were published with appeals for funds for wounded soldiers, orphans, and "needy victims." Cartes of one town burned by the Confederate Army were sold to raise funds for the inhabitants. As the North took control of certain southern areas, antislavery societies published a series of cartes of emancipated children and sold them to raise funds for the children's education. The imagery was carefully slanted to appeal to the audience. The children were well dressed, to show that they were better off than slave children, and most had light skins and Caucasian features. The idea was to solicit money by skirting prejudices, as many northerners believed the black race was inferior.[1]

"Before-and-after" pictures had already proved useful to money-raising missions. Oliver Wendell Holmes remarked in 1863 that "charitable institutions have learned that their strongest appeal lies in the request, 'Look on this picture, and on that,'—the lawless boy at his entrance, and the decent youth at his dismissal." Sometimes the fund raisers went a bit too far with their photographs. In England, Dr. Thomas John Barnardo established houses for street children, and around 1870 he began commissioning before-and-after pictures to show how proper care had improved their situation. Some were reproduced in pamphlets that related the stories of individual rescues and told how happy and productive the children were in their new residence; some were issued in pairs of cards, one with the child in the tatters he arrived in, the other looking spruce and healthy. The photographs were used in annual reports sent to subscribers and potential donors, sold in packs of twelve, or pasted on collection boxes that were carried through the streets.[2]

Barnardo had numerous quarrels with opponents and authorities, and after several years he was brought before a court of arbitration on several charges, including misappropriating funds and falsifying the "before" pic-

tures. The accusation charged that he was not satisfied with taking the children "as they really are, but he tears their clothes, so as to make them appear worse than they really are. They are also taken in purely fictitious positions"—selling papers or matches in the street when they had never done such a thing. The doctor said they might have, considering their circumstances, but the tribunal declared that photographs implied actuality and that these had therefore been deceptive. After 1877 he stopped taking the before-and-after series or selling the photographs; from then on, his pictures, supposedly intended only to identify the children, were more restrained.[3] The public had called the medium to account and obliged it to stick to the facts and uphold its own reputation.

For a brief moment in the mid-nineteenth century, it was thought that photography might ameliorate the lot of a small and special group: the mentally ill. In England, Dr. Hugh Welch Diamond had portraits of psychiatric patients made to ensure the return of escapees and as a means of differentiating the various forms of madness. He also believed that photographs of patients assisted in their cure, especially when they were amused or horrified by portraits of themselves at their most mad. Diamond did not use photographs as treatments for very long; they seemed to work only while they remained a novelty.[4] Yet photographs are still used in some psychiatric treatments, and alcoholics, when sober, have been shown films of themselves in far-gone drunken states.

M. H. Kimball

Carte de Visite of

Emancipated Slaves Brought

from Louisiana by Colonel

George H. Hanks, 1863

The New-York Historical

Society

Technology and social circumstances eventually established a context in which documentary photographs could make a difference on a larger scale. Just before 1890 the halftone process made it possible to put photographs on printed pages around the world. At the same time, in America, a combination of a liberal trend of thought, the growth of the progressive reform movement, and the pressures created by overcrowded cities produced an audience for a new kind of subject matter. Poverty became a pressing matter, and picturing it took on a new importance.

For centuries it had been assumed that poverty was the inevitable lot of much of humankind and not worth worrying about (unless you were poor). By the middle of the nineteenth century, with revolutions in Europe and the rise of industrial economies, the poor came to the attention of the middle classes, although not yet as a matter of general concern. Authors like Charles Dickens wrote about them, painters like Honoré Daumier and Gustave Courbet looked at a few of them closely, photographers like Charles Nègre took genre pictures of waifs and street vendors for the enjoyment of those who could afford to find them charming.

The reform movement, which gathered strength about mid-century, made some use of photography. Henry Mayhew's *London Labor and the London Poor* (1851), a serious study of the problem, was illustrated with woodcuts after daguerreotypes by Richard Beard. As usual, the method of reproduction sapped the force of the photographs. The first book about the lower classes to combine text and photographs, Adolphe Smith's *Street Life in London* (1877), was illustrated by John Thomson. The pictures were reproduced by woodburytype, the finest of several excellent, but expensive, forms of mechanical reproduction that vastly increased the use of photographs in the 1870s. Thomson's pictures, however, still dwelt on quaintness.

In America there was no tradition of reform photography and only a limited tradition of reform. The poor were held responsible for having brought on their poverty by indolence and immorality; a society that believed in progress and endless opportunity placed most of the blame for losing out on the losers themselves. Then, during the last quarter of the century, American society, and urban society in particular, underwent profound changes. An enormous influx of immigrants had swelled slum populations to untenable proportions and generated fears that the very fabric of the republic might be rent by the destructive forces of vice, crime, and the diseases spread by overcrowding. (After the 1870s, when Louis Pasteur and Robert Koch proved that specific bacteria caused specific diseases, scientific advances spurred a widespread public-health movement.) In the 1890s the country endured recurrent economic crises that focused attention on the menacing lower classes.[5]

The charitable-organization movement and the reformers had slowly been gathering strength. They believed an enlightened electorate would actively combat social ills that were brought to its attention, a belief that gave photography at least a potential part to play. Poverty began to be blamed less on defective character than on circumstances, and on the slum environment in particular. Still, when illustrated articles on reform appeared, they usually amounted to sentimental melodramas, with drawings that sanitized their subjects.[6] Yet the elements were in place for real reform, and social and technical factors prepared the ground for photography to play a major role. It did play that role—because the right man came along at the right moment.

The man was Jacob A. Riis. He came to the United States from Denmark in 1870, when he was turning twenty-one. Unable for seven years to find steady employment, he was acquainted with poverty at first hand, having

slept in a police lodging house and nearly starved more than once before finding his calling as a reporter in 1873. Four years later he took on the police beat, and his reforming instincts came to the fore. Riis repeatedly wrote articles exposing the conditions of life in the slums and the unwholesome police lodging houses that packed in the homeless at night. "It was upon my midnight trips [to the slums] with the sanitary police," he wrote, "that the wish kept cropping up in me that there were some way of putting before the people what I saw there. A drawing might have done it, but I cannot draw, never could. But anyway, a drawing would not have been evidence of the kind I wanted." He added that he wrote articles in his paper, "but it seemed to make no impression." Then one morning in 1887 he read in the paper that a German had discovered how to make photographs by flashlight, and he knew he had the answer.[7]

Flashlight then was magnesium powder set off with a match; it went up with a roar and an explosion, and was more than a little dangerous. Riis set his own house on fire twice and ignited himself once; only his spectacles saved him from blindness. At first he convinced two gifted amateurs to take the photographs, and when they got bored, a professional. Early in 1888, when he realized the professional was cheating him, he learned to use a camera himself. Riis always claimed he was not much of a photographer, and he gave it up in 1898; only a little over half the photographs usually credited to him are actually by Jacob Riis.[8]

166

OPPOSITE, LEFT

Jacob A. Riis (1849–1914)

Baxter Street Alley, Rag

Picker's Row, 1888

Photograph

Museum of the City of New

York; Jacob A. Riis

Collection

OPPOSITE, RIGHT

New York Sun,

February 12, 1888

Wood engraving of Riis's

Baxter Street Alley photograph

The New York Public Library,

Astor, Lenox and Tilden

Foundations, Central

Research Division

At first his photographs were printed as woodcut copies in the *New York Sun*. The first halftone in a newspaper is generally thought to have appeared in 1880, but one scholar has pushed the date back to 1873. Prior to this time it was not possible to print pictures and text simultaneously; separate printings were obviously slower and more expensive. Regular use of halftones had to wait for faster and better presses. The *New York Tribune* began using half-tones on a regular basis in 1897, but for several more years most newspapers printed them side by side with linecuts.[9] The importance of the halftone process cannot be overestimated. The halftone exploded the potential for photographic reproduction, and we are living in the fallout today. The image culture of the twentieth century springs directly from the fecund union of the rotary press and the photograph.

Riis could not rouse any interest in his pictures from magazine editors, so he made glass lantern slides and lectured about the slums in New York churches. There he was so convincing that a *Scribner's* editor asked him for an article on the subject, and the article brought him an invitation to write the book *How the Other Half Lives*. It came out in 1890 with seventeen halftone reproductions of photographs and nineteen wood engravings and was so successful that it went through eleven printings in five years.[10] It is a milestone—the first book so extensively illustrated with halftones.

These halftones are poor and slightly fuzzy, with nothing like the vigor of Riis's prints or slides. But even in these inferior renditions they carry a far greater sense of reality and conviction than the wood engravings in the book. They made an enormous impression. Riis knew his material inside out, and his sturdy, energetic prose style, studded with anecdotes that were brought to life by the photographs, reinforced the eyewitness quality of all his accounts. His pictures were harrowing to his contemporaries, who had never seen the poor at such close range or in such grimy and frightening detail.

Depictions of the poor had always been coyly "improved" because the reality was considered vulgar and repellent. Photography itself was considered slightly declassé: until quite recently the more literary magazines and highbrow newspapers defended their reputations by printing drawings to the exclusion of photographs or by strictly limiting their photographs, and the combination of photography and lower-class subjects was considered an affront in some quarters. A contemporary of Riis's wrote about seeing such material in newspapers: "Is it proper to sully the pages with rioting in the slums? . . . Is it in the interest of purity that society should hang its morally stained linens upon its lines to be stared at?" Riis suggested that his photographs were a safe way of viewing these terrors: "The beauty of looking into these places without actually being present there is that the excursionist is spared the vulgar sounds and odious scents and repulsive exhibitions attendant upon such a personal examination."[11]

Riis's straightforward style would indirectly influence documentary photography in years to come. Some of his photographs were posed; others were appallingly spontaneous, for he would burst into a room at night firing a flashlight that looked like a pistol, and the terrified poor would leap out of windows after being caught by his camera. The flash technique itself imbued his pictures with the great drama of strong contrasts; a slight underexposure that gave many scenes a dirty, vaguely ominous cast; and a sharply detailed description of every spot and stain, every worn and irregular surface, every tear in a jacket and crack in a wall.

The hand-held camera and dry plates of the 1870s and '80s had made it possible for an amateur like Riis to take indoor and outdoor pictures easily

enough. His claim that he was a poor photographer was his way of excusing the cropping in some of his pictures, where arms, legs, and the backs of heads intruded abruptly at the edges. Sometimes, too, his pictures tilt at odd angles. All of these elements went against the artistic rules, but for that very reason they made his pictures seem that much more like the unvarnished truth. Riis, in fact, evolved a style that approximated the conditions he was photographing: rough and ragged; crowded, cluttered, and disordered; claustrophobic, fragmented, and off-balance. At times his subjects were isolated or sunk so far into hopelessness they seemed beyond human contact.

The halftone process was one major element in Riis's reform campaign. Teddy Roosevelt was another. When the Tammany Hall machine was ousted, Roosevelt became head of the police board of New York City. Soon after reading *How the Other Half Lives*, he came to the newspaper to meet the author, who was out. Roosevelt left his card with a note saying he had read the book and come to help. And so he did. Roosevelt helped close down the infamous police lodging houses that Riis had photographed and continued to lend his weight to Riis's causes.[12]

One of his causes was Mulberry Bend, perhaps the worst part of the worst slum in America—already spoken of with a shudder by Dickens in 1842. Riis attacked it for years in lectures and articles and photographs. Once, he said, he went there at night with the sanitary police and found fiercely overcrowded lodges, where people slept for five cents a spot. "When the report was submitted to the Health Board the next day, it did not make much of an impression—these things rarely do, put in mere words—until my negatives, still dripping from the dark-room, came to reinforce them. From them there was no appeal. It was not the only instance of the kind by a good many. Neither the landlord's protests nor the tenant's plea 'went' in the face of the camera's evidence, and I was satisfied." In 1897 the Bend was torn down and a park opened on the site of some of its darkest tenements. Riis believed strongly in parks and playgrounds, and his efforts helped put playgrounds into public-school designs for the first time.[13]

The New York Tenement House Law, first passed in 1867 but seldom enforced, was rewritten in 1901 largely because of Riis's relentless exposure of how airless, overcrowded, filthy, and likely to breed disease the tenements were. By no means was enough done, but at least a start was made. In 1903 Lincoln Steffens, the muckraking reporter, wrote that *How the Other Half Lives* "awakened public conscience and was responsible for the appointment of investigating commissions and ten years of constructive fighting to improve the condition of the poor."[14]

In the last decade of the century Riis was the country's most effective reformer. His chief pride was that with his photographs he averted a cholera epidemic in 1891. Having noted that the report on water from the Croton reservoir in New York indicated sewage contamination, he wrote a warning in the paper, then spent a week photographing in the Croton watershed, following streams to their sources and photographing evidence that sewage from towns in the watershed emptied directly into the New York City reservoir. His story and pictures convinced the health inspectors to inspect Croton themselves. They found it worse than he had said, and the city had to spend millions to purchase enough acreage to protect its water supply.[15]

No photograph acts in a vacuum, and Riis's photographs were supported by a confluence of historical circumstances as well as by his own energy and talent. The reform movement, the health movement, middle-class fears of the immigrant populace, the novelty of his subject matter, and the arrival of

Teddy Roosevelt in city government all contributed to the effectiveness of his pictures. So did the magnesium flash, the hand-held camera, and the halftone process. So did Riis's position on a widely read paper, his crusading fervor and dedication, and his skill as a journalist. He had the public's ear before he caught its eye, and he knew how to use both the press and his pictures.[16]

Although *How the Other Half Lives* was not only the first book illustrated with so many halftone photographs but a highly influential publication, scholars have pointed out that Riis's photographs had an even greater influence as lantern slides. Riis began his reform campaign in lectures and was soon in constant demand all over the country. He made his first extensive speaking tour of the Midwest in 1893, his first trip to the West Coast in 1900. Until 1913, the year before his death, he gave scores of illustrated lectures every year, but the motion picture doubtless cut into his popularity.[17]

The magic lantern was a highly popular form of public entertainment in the nineteenth century, widely used by magicians to conjure up spirits, by schools to educate students, and for adult entertainment and edification. Late in the century Muybridge's zoopraxiscope added a sense of motion to slide projections, and magic lanterns sometimes dramatized sermons in church. Before radio, television, and film, the slide lecture was a thrilling form of entertainment. With his lectures Riis reached precisely the educated community he sought, and if they did indeed have a greater influence than his book and newspaper articles, that indicates how small the community that could effect change really was.

It is also an indication of how photography exerts different influences in different guises and circumstances. It stands to reason that no matter how startling the reproductions in *How the Other Half Lives*, they could not match the impact of large and brilliant slide projections that seemed to put the audience right at the doorway of a foul tenement house. Riis played his lectures for every possible ounce of drama. He spoke for two hours running, in a dark auditorium with a spotlight on himself. He showed up to one hundred slides, piling horror upon horror. His up-to-the-minute equipment projected the photographs in stereo vision for added depth and realism, and a dissolve mechanism made one slide slip into the next as if slowly moving. A lecture he gave in Washington, D.C., was preceded by readings from scripture, prayer, and gospel music; in another lecture, when a picture of a boy sleeping out in the street appeared on the screen, a cornet duo in the wings played "Where Is My Wandering Boy Tonite?" Sometimes a lecture closed on a slide of a painting of Jesus, with Riis intoning, "In as much as ye have done it to one of the least of these, my brethren, ye have done it unto Me."[18]

The appalling novelty of the subject, and of *photographs* of the subject, was thus enveloped in a highly charged, emotional atmosphere. Facing pictures such as they had never seen, people sometimes cried, or talked to the screen, or fainted.[19] This was a peak moment for photography, when it still had revelations to impart. Seldom would it achieve such raw power over an audience again.

The fact that Riis was a photographer faded from view when he gave it up in 1898. None of his obituaries mentioned it. His photographs were not resurrected until Alexander Alland, Sr., rediscovered his negatives in 1947, at a time when documentary photography was highly regarded. (Eight years earlier, Alland himself, on assignment to promote tourism in the Virgin Islands, had taken pictures of housing conditions as wretched as any Riis had photographed. The photographs were published in the newspaper *PM* in 1940, and Congress subsequently doubled the housing appropriation for the

Virgin Islands.) Lewis Hine, the great documentary photographer who came shortly after Riis, never mentioned him publicly, although he could not have avoided knowing his work.[20]

Hine, like every documentary photographer and every reformer in the succeeding decades, owed a basic debt to Riis's crusading images: the conviction that photographic investigation and documentation were central to the reform enterprise. From the Farm Security Administration and the Photo League of the 1930s to reports on Bangladesh, the Sudan, and homeless Americans in the 1970s and '80s, photography has raised pleas for relief and reform because Riis proved it a successful advocate.

The critic John Tagg has documented a British campaign against unsanitary housing that was also waged with photographs, at the exact same moment as Riis's efforts, but with a wholly different approach. The Quarry Hill area of Leeds, a fearsome slum, suffered an outbreak of typhus in 1890, when improved sanitary conditions had almost eliminated the disease elsewhere in the country. A campaign to raze the area commenced in Parliament; it was still being debated six years later when typhus struck again.[21]

Once Parliament confirmed orders to purchase sixteen acres of the area in 1896, Dr. James Spottiswoode Cameron, the medical officer of health, pressed for an additional fifty acres as a safety measure. He appeared several times before Parliamentary Select Committees on behalf of the proj-

Quarry Hill, Leeds,

England—Insanitary Housing

Conditions, c. 1901

Two views

Brotherton Library, University

of Leeds, England

ect and made photographs central to his testimony. Packets of photographs were bound together and presented to Parliament with the requisite maps and estimates, in impressively complete reports. The approach was designed to convey an aura of technical expertise, thoroughness, and authority, and to place the photographs on the same level as maps and numbers in the hierarchy of evidence.

These photographs were just as new to the English audience as Riis's had been to Americans. They showed the Quarry Hill slums not as Riis had shown overpopulated Mulberry Bend but as narrow, unclean places devoid of street life or the human experience of living in such spaces. Whereas Riis appealed to an identification with human misery, Cameron appealed to a more theoretical sense of the proper hygienic conditions for living. Whereas Riis, convinced that educated citizens would take action to improve an unjust system, went directly to the public with an emotional plea, Cameron went directly to Parliament with facts, details, and supporting arguments based on his professional authority. And whereas Riis took advantage of his novel subject by encasing his pictures in a dramatic framework, Cameron took advantage of the novelty of photographs as evidence by imposing his own interpretations on the images.

Members of Parliament were accustomed to arguing political matters on the basis of economics and partisan interests; they were not accustomed to judging the veracity of photographs. Evidently no one questioned whether these representations were accurate or fully representative. In his testimony Cameron emphasized the narrow spaces and lack of air the pictures were meant to show; so far as possible, he did not allow the observers to see anything else in the images. The landlords and the laissez-faire politicians who opposed the purchase of so much land had no experience refuting the testimony of pictures and fell back on remarks about "very good photographs" of well-built buildings. (A lawyer in court generally knows a case is

going well when the opposition is reduced to commenting on the technical excellence of the evidence.) Cameron, better prepared than his opponents, responded by pointing out yet again how tightly these buildings were crammed against their neighbors. He insistently interpreted the contents and directed the viewers' perception of the photographs.

Cameron was, at least tacitly, making a dual argument for photographs. He introduced them as perfect prima facie evidence, being proof themselves of the facts; and at the same time, he used them as witnesses that could be directed to produce only the desired view of reality. The courts, at least in America, had long been clear that photographic evidence was no more reliable than any other. In 1881 New York's highest court had judged that photographic portraits could be admitted into testimony: "The signs of the portrait and the photograph, if authenticated by other testimony, may give truthful representations. When shown by such testimony to be correct resemblances of a person, we see not why they may not be shown to the triers of facts, not as conclusive, but as aids in determining the matter in issue, still being open like proofs of identity or similar matter, to rebuttal or doubt."[22] Members of Parliament had probably not seen such evidence before, and Parliament was not a court—or perhaps Dr. Cameron was just a better lawyer than his opponents.

Although Cameron carried the day, winning is not always enough in matters of reform. The last of the condemned houses in Quarry Hill was not razed until 1933. According to Tagg, the photographs that once stood witness against the slum in Parliament came back to life later as tourist promotions for picturesque "Old Leeds." Photographs are chameleon documents; they change color with their setting.

As the progressive movement spread and reform organizations multiplied in America, the protection of children became a popular cause. A rapidly declining birthrate raised alarm about the country's future and the need for a good start in life; at the same time, new ideas about child development intensified the scrutiny turned on the very young. Riis's campaign against the tenements had made much of the plight of children. His success in instituting playgrounds in schools had been aided by a movement that pressed for progressive education and the creation of courts specifically for juveniles.[23]

Child labor was widespread at the turn of the century. The issue had hung over American life for many years, but concern about it was fitful. In 1813 Connecticut passed the first law requiring manufacturers to educate children in their work force. The law said nothing about working conditions or hours and, like subsequent laws passed later in the century, it was poorly enforced. The 1870 census, the first to differentiate children from adults, reported 793,000 children between the ages of ten and fifteen in the labor force. (The younger children were not even counted.) By 1900 there were almost a million more. Many worked from early morning until after nightfall in unhealthy conditions, in mines and mills and canneries, earning so little that they were guaranteed lives of continuing misery. By this time the problem was so apparent and so outrageous that the national magazines began to write about it. Four articles appeared between 1896 and 1901; sixty-nine were published in the next four years alone.[24]

The South, where mill owners reasoned that employing children would save their families from starvation and keep the young ones with their mothers, had fewer child workers than the North but a higher proportion. By 1900 one quarter of all southern mill workers were between ten and sixteen

years old. It was here that reform was first organized. In 1901 a minister named Edgar Gardner Murphy helped found the Alabama Child Labor Committee, the first of its kind in America, and started to write a series of pamphlets that were very effective in educating people about the problem. Hoping to reach people who did not take the time to read, Murphy secretly photographed children in the mills and put out a twelve-page leaflet with ten of his images. *Pictures from Life: Mill Children in Alabama* was one of the most effective publications in the early history of child-labor reform.[25] The photographs, "from life," caught the attention and tugged at the heart as words and statistics had not.

Murphy was no more a professional photographer than Riis was, but once Kodak made it easy to handle a camera and transferred the difficult processes of developing and printing to a professional laboratory, amateur photographers could have as marked an effect on the course of events as professionals could. The trend continues. Today, television newscasts increasingly show us images taken by bystanders with videocams rather than by journalists.

In 1904 Murphy was one of the founders of the National Child Labor Committee, a private organization that would be the primary force in this field for years. The NCLC not only believed in publicity but knew how to produce it. In its first year it cranked out nearly two million pages of print and generated extensive material for newspapers. The next year it did more.[26] Considering Murphy's earlier success, it is not surprising that the committee thought photography could help their cause. In 1907 Lewis Hine took some photographs for the NCLC and in 1908 went to work for them full-time.

Hine was trained as a sociologist and had a deep regard for individuals at the wrong end of society. He had been teaching at the Ethical Culture School in Manhattan and photographing immigrants arriving at Ellis Island. He was hired by the NCLC as an investigator who could provide valuable photographic evidence. As he put it, "In the early days of my child labor activities I was an investigator with a camera attachment . . . but the emphasis became reversed until the camera stole the whole show."[27] Hine's photographs became the primary elements of the committee's propaganda effort and remained intrinsic to its accomplishments.

Riis was a journalist who harnessed photography to print and discovered that the new reproductive processes could carry his crusade to a large public. Hine was a sociologist who placed his camera at the service of a highly organized movement and helped make photography a protean instrument of publicity. Riis set the agenda and Hine set the style. Hine's straightforward, undramatic, just-plain-facts style, with pictures generally taken from a middle distance and subjects often posing frontally for the camera, established the tone of documentary photography for decades. Riis's style was raw, primitive, and abrupt; Hine's was simple, respectful, and sympathetic. The Farm Security Administration photographers of the 1930s, whose report on rural America during the Depression was the first photographic account to surpass Hine's in extent and thoroughness, owed more to his matter-of-fact sociological observation than to Riis's more sensational, journalistic approach.

Hine compiled a massive and unprecedented document of child workers in the southern textile mills. The mill owners were not often eager to have a photographer on the premises. To gain entrance Hine would sometimes claim to be a fire inspector, an industrial photographer, an insurance salesman; at times he was in real danger. He kept a notebook in his pocket and would take notes on a child's age and height with a concealed hand, having measured

the young worker against one of his jacket buttons. From his training he knew how essential statistics and background information were, and from experience he knew that words and photographs lent each other energy.

Hine faced more than the usual opponents. The yellow press's highly inventive approach to photographic documentation had inspired widespread distrust of the camera. Because Hine had to use deceit to get many of his pictures, those who did not want to credit them accused him of fakery. That was one reason he was so careful with his written data, noting time of day, place, height, age, and any other statistics he could obtain about the children he photographed. He was determined that his documents would be trustworthy. "Not long ago," he said in 1909, "a leader in social work who had previously told me that photographs had been faked so much they were of no use to the work, assured [the] Editor . . . that the photographs of child labor in the Carolinas would stand as evidence in any court of law. Moral: Despise not the camera, even though yellow photography does exist."[28]

The serious, raggedy little girl in Hine's *Child in Carolina Cotton Mill* is smaller than the row of spindles, less well cared for, isolated—the dim figure of a girl in the back is too distant for companionship—confined in a narrow space, and intent on her work at a time when she should have been in school. The very quality of the sunlight pouring in the windows makes the mechanical setting all the more inappropriate for a child by suggesting she should be playing outside. Hine said of this picture:

Take the photograph of a tiny spinner in a Carolina cotton mill. As it is, it makes an appeal. Reinforce it with one of those social pen-pictures of Hugo's in which he says, "The ideal of oppression was realized by this dismal servitude. When they find themselves in such condition at the dawn of existence—so young, so feeble, struggling among men—what passes in these souls fresh from God? While they are children they escape because they are little. The smallest hole saves them. When they are men, the millstone of our social system comes in contact with them and grinds them."

With a picture thus sympathetically interpreted, what a lever we have for the social uplift.[29]

Pictures and text. Riis had understood their synergy; Hine found new ways to combine them, new means to distribute the package. His pictures illustrated his own reports. They were used by newspapers and magazines (he remarked that photographs were a great help when it came to getting pieces published); in NCLC publications (including its annual report and the magazine it founded); on posters; in exhibitions that traveled across the country; in every kind of publicity; and in slide sets that accompanied lectures by NCLC officials. By 1909 Hine himself was preparing and designing the committee's exhibitions and laying out brochures; he not only provided the pictorial material but ensured it a forceful presentation.[30]

Hine's pictures began as documents and ended as persuasion and publicity. A movement that believed that people who knew the facts would act appropriately needed to get the facts out. The documents had to be trustworthy, and they had to serve as effective publicity for the cause. At the conference where Hine told social workers to despise not the camera, another speaker said, "The rule of right publicity in public health work, as I see it, is essentially the same as the rule for commercial advertising: as striking as you can make it." (He added that yellow journalism would do if that was the only way to convey the information to the public.[31]) Hine's photographs were

Lewis Hine (1864–1940)

Child in Carolina Cotton Mill, 1908

Print made by Hine

Foundation of The Photo League

Gelatin silver print on Masonite, 10½ x 13½ in.

Collection, The Museum of Modern Art, New York;

Purchase

arranged to tell stories in articles or collaged onto posters that would preach a simple moral instantly.

It is difficult to point to a single photograph by Hine that stirred the public to action; his work for the NCLC underlines the fact that photographs most often achieve their force by addition or multiplication. A single photograph may be powerful but it seldom does the job alone. Pictorial influence tends to be cumulative, like the Chinese water-drop torture: image after image of tenements, of child labor, of civil-rights outrages load down the mind until it snaps under a particularly sharp assault. Time and repetition are photography's greatest allies in the battle for influence.

It was the mass and weight of Hine's evidence that was so convincing. His photographs repeated over and over that, although the locations, the labor, the children were different, all the situations were unhealthy and unfit for the young. But so many pictures of newsboys smoking and sooty-faced kids in mines, of children with fingers missing from factory accidents and eight-year-olds shucking oysters came from his camera that before the end of the decade the novelty that had been such an important component of Riis's effectiveness had worn off. Already some thought that the public could grow immune to the appeal of reform images. ''Perhaps you are weary of child labor pictures,''

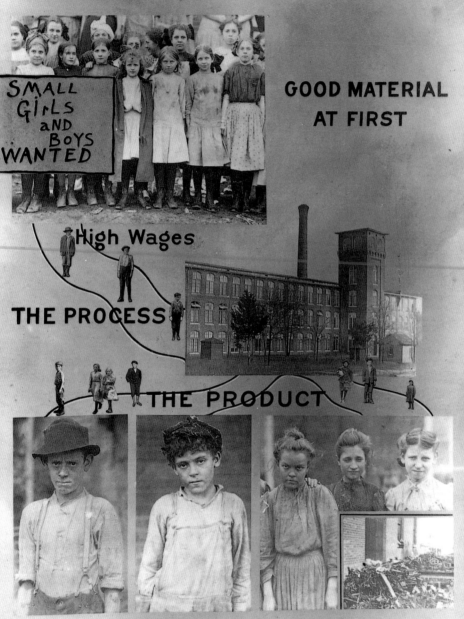

MAKING HUMAN JUNK

SMALL
GiRLS
aND
BOYS
WANTED

GOOD MATERIAL
AT FIRST

High Wages

THE PROCESS

THE PRODUCT

No future and low wages "Junk"

SHALL INDUSTRY BE ALLOWED TO PUT
THIS COST ON SOCIETY?

Hine told an audience of reformers in 1909. "Well, so are the rest of us, but we propose to make you and the whole country so sick and tired of the whole business that when the time for action comes, child-labor pictures will be records of the past."[32]

As Dr. Diamond had realized when treating the mad, the novelty of photographs wears off fast. It recurs only when enough time has passed for nostalgia to set in. The force of novelty in appeals for reform is increasingly difficult to sustain now that the proliferation of photographs has sapped the vitality of so many images. Susan Sontag (and many others) argues that "concerned" photography, although it has wakened conscience at some points, has also dulled the moral sense through a surfeit of images.[33]

It is true that after too many pictures of the poor and hungry, the viewer's system tries to immunize itself against excessive pain. But conscience is not so readily deadened. Photographic stories about orphans in Romania and starvation in Eritrea, whether in the press or on TV, still prompt astonishing responses. In fact, it may have become easier to respond to the image than to the actuality. The world is so threatening that it seems safer to react to an image that has been verified by a news organization than to place a coin in the hands of a beggar on the street. As Riis himself suggested, it is reassuring to be able to stare at the face of desperation in privacy without having to confront such need in person. Photographs mediate the tough realities for us. If they have forced us to grow thick hides, they have also found the way to pierce them.

By the time Hine thought that people might be growing weary of child-labor pictures, his photographs were already making a difference. He wrote to a friend in 1910: "I am sure I am right in my choice of work. My child labor photos have already set the authorities to work to see 'if such things can be possible.'" In 1911 a reporter for a Birmingham, Alabama, newspaper wrote: "There has been no more convincing proof of the absolute necessity of the child labor laws and the immediate need of such an enforcement than by these pictures, showing the suffering, the degradation, the immoral influences, the utter lack of anything that is wholesome in the lives of these poor little wage earners. They speak far more eloquently than any work—and depict a state of affairs which is terrible in its reality—terrible to encounter, terrible to admit that such things exist in civilized communities." The NCLC chairman later remarked: "The work Hine did for this reform was more responsible than all other efforts in bringing the need to public attention. The evils were intellectually but not emotionally recognized until his skill, vision and artistic finesse focussed the camera intelligently on these social problems."[34]

And what exactly was accomplished? In 1906 a bill for a national child-labor law was introduced in Congress; it was voted down. Between 1904, when the NCLC was founded, and 1912, thirty-four states enacted new child-labor laws or amended old ones, and every southern state at last had some law on the books. Unfortunately, these laws were weak and rarely enforced. Improvement was slight. The 1910 census reported that two million children between the ages of ten and fifteen, or 18.4 percent of the age group, were employed. In 1900 the figure had been 18.2 percent.[35] The battle was slow and long and had to be fought against apathy, disbelief, factory owners, and states-righters who were opposed to government interference. But the apathy was wearing away, and laws were at least being passed. The biggest breakthrough the NCLC contributed to was the establishment of the United States Children's Bureau in 1912. By 1912, thanks in good part to the education provided by the NCLC and Hine's photographs, much of the public had come

Lewis Hine (1874–1940)

Making Human Junk, c. 1915

Poster

Library of Congress,

Washington, D.C.

177

to believe that the federal government should be actively concerned with children's welfare, and the government had responded.

Still there was no national labor law. The NCLC had not backed such a law, had even opposed one because Edgar Gardner Murphy and other southern members opposed federal regulation, and the committee had decided to concentrate on establishing a children's bureau. In 1912 the NCLC threw its weight behind a national measure, and in 1916 Congress made it law. Two years later it was declared unconstitutional. In 1919 another law was passed, then it too was found unconstitutional. An amendment to the constitution was proposed and allowed to die. Photographs had made the public aware, but the progressives may have overestimated the will and power of an enlightened citizenry. At last, in 1938, during a decade of violent labor turmoil, Franklin Delano Roosevelt signed the Fair Labor Standards Act, which included federal provisions regulating child employment.[36] More than half a century later the New York Times was still publishing articles about the evil conditions of child labor.

Lewis Hine took another body of photographs that had evident, if equally hard to measure, effects. In 1907 he worked for several months for the Pittsburgh Survey, the first comprehensive report on an American working-class community in an industrial setting. Part of the survey was published in three issues of the magazine Charities and the Commons in 1909, then it was released in its entirety in six volumes that reproduced many of Hine's photographs. Speeches, press releases, and articles in the popular press followed, and the survey was studied across the nation. The noted social worker Jane Addams attributed to it "the veritable zeal for reform" that shook the country between 1909 and 1914. The American public's new awareness of the hard life of the working classes laid the groundwork for widespread sympathy and outrage when steelworkers struck in 1909 and 1910. In 1912 the Senate Committee on Labor and Education denounced U.S. Steel's "brutal system of industrial slavery." State governments, spurred by the public's anger, also moved against unfair industrial practices; U.S. Steel subsequently instituted safety reforms and ended the seven-day work week.[37] In this case the survey, and Hine's photographs, had enlightened and alerted the public exactly as the progressives believed they should.

During the winter of 1934–35, as American farmland in the Midwest and the plains states dried to powder and scattered on the wind, tens of thousands of farm families streamed out of the Dust Bowl into California looking for work. In January the Division of Rural Rehabilitation of the [California] State Emergency Relief Administration in San Francisco, aware that a crisis was brewing, asked Paul Schuster Taylor for help in determining what kind of program would most effectively aid the migrants. Taylor, an associate professor of economics at the University of California at Berkeley, had already done research on Mexican migrant workers. He knew how to obtain the necessary data, and he had decided opinions on how reports could be made sufficiently convincing to produce action.

Taylor believed that photographs were far more persuasive than facts or written documents. "I'd like the people in the relief administration, who will read my reports, and evaluate them and make the decisions to be able to see what the rural conditions are like. My words won't be enough to show the conditions visually and accurately."[38] On the whole, social scientists (other than anthropologists) were suspicious of photographs at the time. Photographs weren't thought to be emotionally neutral enough to meet the criteria

of scientific objectivity. But it is at almost precisely this moment that admiration for the camera's potential for objective reporting and its power of persuasion achieved a kind of critical mass with the public.

Photographs had been gathering force in the press and in advertising for over a decade; people increasingly paid attention to pictures and respected the apparent accuracy of the photographic report. In early 1935 the monthly March of Time newsreels targeted a growing nationwide dependence on visual news, and the Resettlement Administration (RA), a federal agency, created its Historical Section to document conditions in rural America and attract support to New Deal programs. Then, late in 1936, the publication of *Life* magazine set the seal on the photograph as the preeminent carrier of information to a large portion of the populace. (*Look* began a few months later, and a slew of picture magazines soon tried to cut into *Life*'s phenomenal popularity.) *Life* and the RA (later called the FSA) were the two most comprehensive photodocumentary enterprises in America in the 1930s.

Taylor's belief in photographs was timely. A practical social scientist, he seems to have been less concerned with the theoretical objectivity of photographs than with their value as persuasive instruments. Taylor knew that federal aid would be required for the vast numbers of migrant workers; to convince the federal government, he would need a fully documented report. For his staff he requested field workers, some office help, and a photographer. No one had ever heard of a photographer on such a project before; the program director was skeptical. Taylor finally got Dorothea Lange onto the payroll on a one-month trial basis by listing her as a typist. Before the month was up, the two of them had produced a report recommending that camps be built for migrant workers.[39]

Lange took a hand in the report's presentation. She had seen the new spiral bindings and thought they'd do the trick. Fifty-seven of her photographs were bound into the report, with fifteen pages of Taylor's text, and sent to Washington, D.C., with a request for money for camps. While waiting for an answer, Taylor and Lange kept up their campaign. They showed the report to an editor of the *San Francisco News*, who wrote an editorial in support of their program. The social scientist and the photographer then went after federal backing directly. They took the regional adviser of the Federal Emergency Relief Administration into the field so he could see for himself the extent of the migrant problem. When he asked for a supplementary report, they produced one with three pages of text and thirty-nine photographs.

Taylor later wrote that "when the members of the California Relief Administration were sitting around a table, my skeptical director [the one who had doubted the need for a photographer] . . . tore out five or six sheets that had Dorothea's photographs on them and passed them around the table. The Commission voted him $20,000 to set up sanitary camps for migrant laborers." (In fact, Washington had allotted $20,000 for a California project that had been dropped. The adviser wired headquarters to recommend that the money be reallocated for two camps to be set up on an emergency basis, and the reply from Washington was positive.) "So after that," Taylor said, "no question was raised about why I wanted a photographer. It worked."[40]

It did work. Photographs could say, did say, what social science reports could not, and more dramatically. Lange was an especially skillful and compassionate photographer with a knack for finding not so much the decisive moment as the convincing emotional expression. In this case her photographs worked in good part because Taylor and Lange supplied an extensive support system, using every weapon in their arsenal of persuasion. A camp was

Dorothea Lange

(1895–1965)

Migrant Workers, 1935

Library of Congress,

Washington, D.C.

built at Marysville that summer, another at Arvin. Public housing had been constructed in the United States prior to this, but only by cities and states. These two camps were the first federally funded housing in the country.

Despite this breakthrough, the program of camps for migrant workers remained limited. The big agricultural interests, afraid that permanent camps for migrant workers would become centers of worker organizations and communist activity, fiercely opposed all plans. Congress scaled back proposals for a network of worker camps. By 1940 only three mobile camps and fifteen more permanent ones had been built or were under construction.[41]

In the 1950s and early 1960s, when *Life* dominated the print media in the United States, photography had enormous authority, and magazines gave it the perfect rostrum for crusading campaigns or charitable appeals. W. Eugene Smith's "Nurse-Midwife" of 1951 demonstrated the power of the medium. Smith's photojournalism had already become the standard by which other photographers judged the genre. He had made a lasting reputation with his World War II photographs in the Pacific and went on to establish high levels of aesthetics, compassion, and uncompromising professional integrity in the field of photojournalism. "Country Doctor," in *Life* in 1948, reset the course of the photoessay toward a greater emphasis on character and inner feelings and an easier, more natural development of a photographic narrative. "Spanish Village" of 1951, again in *Life*, is still cited by many as the finest photoessay ever published. "Nurse-Midwife," later that same year, was another of Smith's most brilliant stories. The dramas of birth and death are subsumed in a story of dedication and hard work, with pictures of endless waiting patiently endured, of slogging through mud, make-do medical arrangements, sympathy, and weariness.

Maude Callen was one of nine trained nurse-midwives in South Carolina and three hundred in the nation. She traveled thirty-six thousand miles a year over back roads to bring the only medical care many poor blacks were likely to receive. Smith makes it clear that she is a heroine. She is central not just to the story but to most of his thirty pictures spread over twelve pages. The photographer celebrates her caring, her boundless empathy, her persistence against the odds of poverty and inadequate facilities. His camera stays quite close to its subject and focuses on her a wonderfully rich and subtly theatrical play of light.

The story opens with a full-page photograph of Callen waiting at the bedside of a woman who dozes between labor pains in a difficult birth. There are three more pages about this birth; Callen delivers the baby safely. On the following pages she brings dresses to two delighted little girls, places a sympathetic hand on the head of a disabled man who weeps to see her again, races a desperately ill baby to the hospital but cannot save her, runs one clinic for typhoid vaccinations and patches together another in a church, and teaches a class of midwives. (In one photograph the dying baby is receiving a transfusion. The caption did not reveal that it was the photographer who donated the blood—or that the white nurses in the hospital disapproved of a white man's giving blood to a black baby.[42])

Callen turned an old church into a makeshift clinic by hanging up bedsheets as partitions, further evidence of the neediness of her patients, the limited means at her disposal, her resourcefulness, her devotion to her work. The caption said, "She dreams of having a well-supplied clinic but has small hope of getting the $7,000 it might cost."

Three weeks later *Life*'s letters column announced that readers had al-

W. Eugene Smith

(1918–1978)

"Inside a church . . . Maude

Callen checks a patient in a

clinic," 1951

From the Life essay "Nurse-

Midwife," December 3, 1951

Center for Creative

Photography, University of

Arizona, Tucson/Black Star;

W. Eugene Smith, Life

magazine © 1951, 1979

Time Warner Inc.

ready donated $3,689.03, plus a pair of rubber boots for the muddy paths she walked on, a sewing machine, a portable incubator, a wristwatch, and many boxes of clothing. The author Vicki Baum had sent a check. So had a woman who had been saving for a rug that no longer seemed so important to her. So had a man who said that this year all his family and friends would get a note at Christmas explaining what Maude Callen did and telling them that a donation had been made to her on their behalf. One hundred employees of a Los Angeles dress company were donating one day's work to make pajamas and dresses for her patients.[43]

In January 1952 Life used a picture from this story—the mother seeing her new baby for the first time—in a full-page self-promotion inside the magazine. In April 1953 the magazine ran a one-page article, "Maude Gets Her Clinic," with Smith's photographs. By then $18,500 had been donated. The Maude Callen Clinic, a cinderblock structure in Pineville, S.C., was fifty-seven feet by thirty-two feet; Callen said, "It looks like the Empire State Building to me." The appeal of the story would not die. There were always some people who kept their copies of Life, or at least the issues that interested them. For whatever reason, money was still coming in to Maude Callen three years after the public first learned about her. When a Life editor telephoned her in 1954, she said that ten thousand dollars more had come in, and the mail had not stopped. In 1980 the seven-room clinic was converted to a nutrition center. In 1986 Callen, by then eighty-eight years old, had switched to a volunteer status but still put in a full day's work at the clinic built with contributions from people moved by an essay about her.[44]

Smith himself believed the story had yet another effect. He thought Maude Callen the greatest person he had ever known and hoped his story about her would help undermine prejudice. "I built a story like a play," he noted, "with ingredients, a cast . . . that had meaning beyond the people

involved. I wanted to do something with sincerity that would take away the guns of the bigoted." Just before he began photographing her, Smith heard with pleasure that the state health department, which was not eager to have a South Carolina black woman represented in a national magazine as both educated and accomplished, was none too happy with his choice. He later told an interviewer that "Nurse-Midwife" was the first major essay about an African-American ever run in a white magazine. "This essay, in a way," he said, "changed the course of history. It was the first story in which many Negroes felt it made them proud of seeing their race in a national magazine because they were always athletes or freaks or Holy Rollers. She came through as being so wonderful a person that almost no one could attack her on racial issues." Smith added that in response to this story *Life* got fewer letters protesting a story about a black than they had ever had to date.[45]

The photoessay is a sum that is larger than its parts. No single picture was likely to have had the effect Smith described, and if *Life* had published only the picture of Callen in her makeshift clinic, she might never have had the cinderblock structure with her name on it. Smith's photographs told a remarkable tale of selfless devotion so movingly that readers across America were stirred. The editors deserve a large part of the credit for this. Smith was famous—and at *Life*, infamous—for demanding control over the layout, for he knew his message could easily be distorted by a heavy editorial hand. Ultimately, however, with whatever assistance, the art director made the choices and arrangement. This story moves from an individual to a larger community, from birth to death and back to the preparation for birth. It stays physically close to Callen and concentrates on the long hours and the *dailiness* of compassionate care. There is a convincing, three-dimensional sense of reality about this woman's life that is emphasized by the story's rhythm. The essay was of necessity a cooperative venture.

The visual culture that engulfs us is always allied to text, which is sometimes subordinate to the image, sometimes not. Silent movies had captions to advance the story, the most pictorial ad has a logo to identify the product, and television news consists largely of talking heads—more talk than pictures. Seldom do photographs prove effective without words to explain and amplify and propel them forward. The text for Smith's article, brief as it was, was vital. The story did not ask for money directly, but speaking about Callen's dream was almost as good. The caption gave readers a place to put the emotions stirred up by the photographs.

More than the influence of a photoessay, or even of Smith's pictures, powerful as they are, the story of readers giving Maude Callen a clinic illustrates the power of *Life* magazine. The picture magazines, beginning in Europe in the late 1920s and in America with *Life* and *Look* in the mid-1930s, had brought the influence of photographs to a high pitch. Although the extent, details, and comparative influence of the various media are still largely matters of speculation, the weekly *Life* was undeniably a force in American social history. Other magazines and newspapers had authority and a capacity to arouse sympathy and could elicit spontaneous contributions, but in 1951 *Life* had the edge over most other publications in its large-scale national circulation, generous format, comparatively good reproduction, and first-class photographers. Its stunning popularity from the first day of publication in 1936 meant that it fulfilled some need for a mass audience, and the need seemed to be for pictures. *Life*, the closest thing to a national newspaper America had ever had, gave photography the largest forum in its history.

Almost from the beginning the magazine boasted, with some justification,

of its impact on its readers. By 1950, when the magazine's average net paid circulation was 5,340,300, a survey estimated that over half the population of America saw one or more issues of *Life* in any three-month period, a total audience of some 62 million people. That year the magazine ran a series of ads about its influence on the nation's life styles and the magazine's contribution to the country's "enlightenment." In the mid-1950s *Life* ran testimonials from men and women of accomplishment like the opera singer Phyllis Curtin, who said that after *Life* did a story on her Salomé, her bookings immediately tripled. "Literally," she went on, "my *Life* story short-cut my way to fame by several years."[46]

This was an advertisement for itself, of course, but there was truth in *Life*'s advertising. Photographs gave *Life* its power, but *Life* knew how to use them. The magazine was a kind of national forum, and photographs had the floor. Through the pages of *Life* Smith's humane and forceful essay on Maude Callen reached the wide audience it was meant for and had an influence it could not have had in any other setting.

In 1961 *Life* ran a series on Latin America, beginning with "The Menacing Push of Castroism." Gordon Parks was sent to Brazil to photograph a poor family that would stand for desperate millions. He found twelve-year-old Flavio da Silva in a *favela*, a grim slum in the hills around Rio de Janeiro. Flavio's father earned about twenty dollars a month selling kerosene; his mother, pregnant for the ninth time, washed clothes for an additional five dollars. The boy, who took care of the seven younger children, suffered from malnutrition and severe bronchial asthma. A doctor told Parks that Flavio had two years to live, at most.[47]

Parks spent several weeks with the family and developed a strong emotional attachment to Flavio. But the magazine hesitated to present such hopeless poverty to its readers. At last the editors decided to use one picture, a poignant image of Flavio in bed, taken from the foot of the bed looking down on the boy. Flavio's expression is worried, his arms are extended diagonally slightly away from his body, his face and chest are picked out by light. The picture faintly echoes paintings of the dead Christ. The preliminary layout gave this photograph a full page—opposite a glamorous portrait of a Brazilian socialite. Seeing his story travestied, Parks handed in his resignation.

That was Friday. On Sunday the *New York Times* reported that the secretary of state had declared the United States must give massive aid to the poor of Latin America to forestall the possibility of communist exploitation and takeover. Parks's story had a new relevance. Now *Life* laid out ten pages of his pictures, plus excerpts from his Rio diary, and called it "Freedom's Fearful Foe: Poverty." Quietly, Parks tore up his letter of resignation.[48]

In 1961 black-and-white film still dominated the picture magazines. Parks's photographs were brooding and dark, as if the da Silvas lived most of their lives in shadow. The quiet, almost romantic drama of the play of light in darkness no doubt reflected the living conditions but was also a kind of convention, easily understood at the time, of serious, humanitarian photojournalism. There were pictures of the children crying, the filthy slum, the parents and six children in one bed. "In the family," the text said, "the spark of hope and warmth and care which keeps life going comes from the boy Flavio." He can neither read nor write, "but at 12 he is already old with worry. . . . Wasted by bronchial asthma and malnutrition he is fighting another losing battle—against death." The final pictures were a full-page photograph of a neighbor's dead body laid out on a bed awaiting burial, and

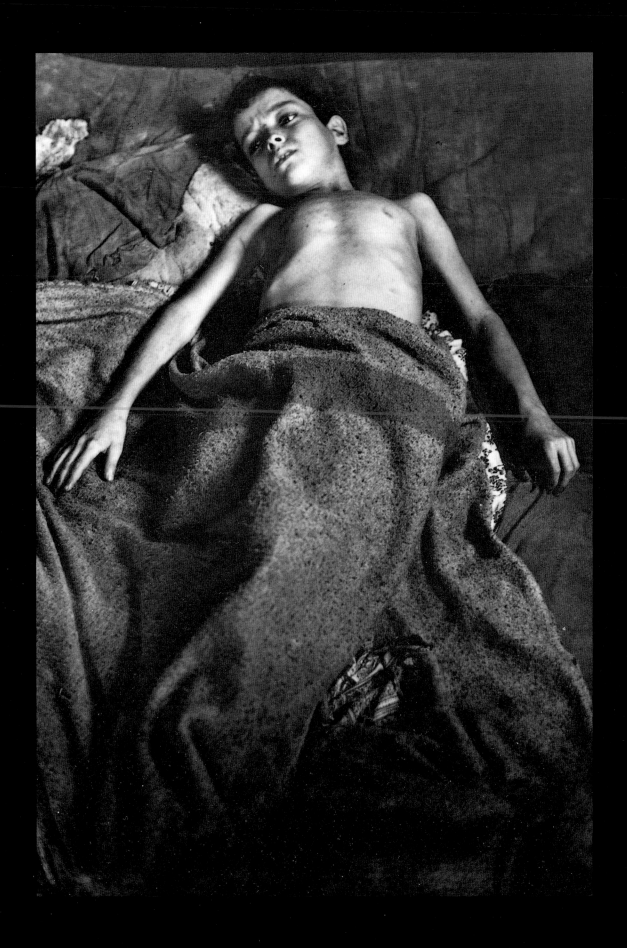

facing it, the eloquent photograph of Flavio in bed. " 'I am not afraid of death,' [Flavio] explained earnestly to Parks. 'But what will they do after?' "

Parks's diary followed. He wrote about taking Flavio to the beach—it was only ten minutes away, but he had never been there before. The photographer wrote: "Maybe one trip outside will give him the added incentive to some day get out of this. I may create a longing impossible to fulfill, but I think it is worth the gamble."

One picture, like the photograph of Flavio on the bed, may stand out in a photoessay, but it is the narrative and dramatic drive of the picture story and its interpretation by the text that give the essay its force. This story outlined a life that made despair inevitable and ended by suggesting that death was the only possible conclusion. Parks photographed close-in at unguarded moments, with intimacy and sympathy. The reliability of his reporting was tacitly enhanced by the family's obvious trust in him; they let him see everything.

The essay evoked an unprecedented response. Letters from readers flooded the magazine, many with money, some with offers to adopt Flavio. Life set up a Flavio Fund to handle contributions. The magazine gave over one of its letters columns to the response. A widow with two small children wrote that she could send a small sum each month. A junior high school class wanted to contribute; some younger children had already raised twenty-seven dollars in a sale. The Children's Asthma Research Institute and Hospital in Denver, a philanthropic center, offered to take Flavio as an emergency patient free of charge. The offer was accepted.[49]

Almost thirty thousand dollars was contributed, and the magazine topped off the sum. The story had not asked for donations, but a history of photographs with direct appeals had conditioned people to offer material aid. This was early in John F. Kennedy's presidency, when the Peace Corps was new. Americans were highly motivated to help those less fortunate and highly optimistic about their power to effect change, especially far from home. Life asked its readers for advice on how the fund should be spent, and they decided it should be divided equally between Flavio, his family, and the favela. The family was moved to a modest house with running water and a toilet.[50] The children would go to school for the first time.

Flavio's story also had an effect in Brazil. A Brazilian magazine called O Cruzeiro rushed a photographer to New York to take pictures of a Puerto Rican family. The story showed one child asleep with cockroaches crawling over his face and another crying from hunger. O Cruzeiro accused Life of making up its story and said Parks had bought a coffin and posed a live woman in it. (There was no coffin in Parks's picture.) Time investigated their story and printed an exposé, saying the photographer had caught cockroaches and pasted them on the child's face, then, to provoke tears, threatened to throw the other child out the window.[51]

Five weeks after Flavio first touched American readers, he appeared on Life's cover smiling from a hospital bed. The story, "Flavio's Rescue," began by reprinting the Christ-like photograph of the boy in bed in the favela, this time contrasted with a picture of him smiling on a swing. Flavio's story, the magazine wrote, "can be a catalyst, can make people understand how desperate the need is—and bring on the massive help and change required to give some measure of well-being and dignity to the many who so desperately need it."[52] That would take a miracle. When Parks had returned to take Flavio to America, a woman grabbed him and said, "What about us? All the rest of us stay here to die."

But in a way, the miracle did happen. The Flavio Fund gave the rest

Gordon Parks (born 1912)

Flavio, 1961

Gordon Parks

something—ten thousand dollars for the *favela*, nowhere near enough, but local businessmen, clubs, and civic groups offered supplies at cost, free labor was contributed, doctors and social workers offered their services. The *favelados* formed an association, elected officers, drew up estimates and plans. A community center was built, telephone and power lines brought in, paving begun on the mud paths. The association became a self-help group, unheard-of in Brazilian slums, and worked to organize hygiene projects and women's handicrafts. Sargent Shriver, head of the Peace Corps, visited to see what lessons might be applied elsewhere.[53]

Flavio stayed at the hospital for two years. His asthma, an especially severe variety, improved greatly. Of course there were difficulties. He had trouble adjusting to the extreme change in his circumstances. He withdrew, he was a fractious pupil, he stole from the other children. Improvements were made in every area, but he did not want to go back to Brazil, although the agreement had stipulated he do so. He was placed in a Brazilian boarding school but soon expelled. His prospects were lower than the expectations he had formed in America.

His family had nearly destroyed their new home. The furniture and faucets were broken, the door was off the refrigerator, the house was filthy. Flavio's father had bought a truck to start a delivery business, then wrecked it. When Flavio was twenty-one and holding down two jobs, as mechanic's helper and waiter, he was given the forty-five hundred dollars remaining in his account with *Life*. He married, and his in-laws gave him a small house. Six years later Parks, on assignment in Brazil, flew to Rio to see the boy he'd last seen fifteen years before. Flavio had two children by then, a neat, clean house with a stove, sink, toilet, and bidet, and a night job guarding a wealthy man's child for one hundred sixty dollars a month. Parks made some inquiries and learned that he'd spent the *Life* money in three months flat and that it was thought he'd shot himself in the leg with the gun he carried on his job.

Flavio wanted desperately to go back to America and asked Parks for help. "I feel like an animal in a trap here," he said. He was convinced that America was his only chance to do well. Parks was not so sure. The boy's survival was a major achievement, but it seemed he had reached the limits of his potential, only to be tormented by dreams of more.

Parks later wrote about the tug of war that occurs between professional objectivity on assignment and the emotional demands that intrude when a photographer gets involved with a story. On another assignment that changed its subjects' lives, he recalled digging ever deeper into the family's privacy, "hoping, I realize now, to reshape their destinies into something much better. Unconsciously, I was perhaps playing God." The power of the photograph to change events is randomly bestowed and does not include the power to control them. "In hindsight," Parks wrote, "I sometimes wonder if it might not have been wiser to have left those lives untouched, to have let them grind out their time as fate intended."[54]

Parks ended with the thought that the real benefits might be reserved for Flavio's son. When *Life* revisited Flavio in 1986 on its fiftieth anniversary, he had three children and was working as a night watchman at a sewer plant and on construction jobs during the day. "The *Life* article," he said, "gave me the health to give my children a better chance than I have had."[55]

Photojournalist Mary Ellen Mark, who has done her share of stories that brought money and opportunities to their subjects, believes that photographs cannot change people because "the person who can escape their environment is rare. You have to know how to change your life to be able to change

it." When she photographed a homeless family living in a car for *Life* in 1987, ten thousand dollars in donations poured in. Even before the story was published, *Life* had arranged for the family to live in an apartment. When Mark called them to see how it was going, they already had "call-waiting" phone service. Someone donated a second-hand car; they left the key inside and the car was stolen. They spent the ten thousand and lost the apartment.

Earlier Mark had photographed street children in Seattle for *Life* (the story was the basis for the film *Street Wise*). She became very attached to one of the girls, a fourteen-year-old street hustler. "Adopt me, adopt me," the girl said to her once. Mark says she thought about it seriously. "You'd have to go back to school," she said. "You couldn't hang out on the street." "Forget it," the girl shot back. After the film, this child had an offer to read for a movie, but she hadn't the discipline to stay off drugs, go to bed early, report to work on time. As of this writing, she is twenty years old, with a third child.

No longer do photographers trust their pictures will change the world, as most did at least through World War II. The only influence Mark sees is on the audience, which may reach a deeper and wider awareness of circumstances they do not know firsthand.[56]

Sam Shere (born 1904)

Explosion of the Hindenburg,

May 6, 1937

The Bettmann Archive,

New York

NEWS PHOTOGRAPHS AS CATALYSTS

THE MAGAZINE ERA

In the late 1920s the news photograph spread out to claim yet more territory as its own. Photojournalism reached the acme of its influence during the great era of the photo magazine and the picture paper, lasting roughly from the late 1920s to the late 1960s. As improvements to the printing press made possible cheaper and better reproduction, hundreds of thousands of copies of stories illustrated by photographs hit the newsstands. The 35mm camera, first marketed in the mid-1920s and popular among photographers from the early 1930s, combined with faster film and flashbulbs to introduce new subjects and a cheeky familiarity with people from all walks of life, who now could be easily caught off-guard.

As technical factors made the picture press possible, cultural change made it desirable. In the first two decades after World War I, shorter work weeks, better transportation, and work-saving devices added hours to people's leisure just at the moment they began to feel pressured by a lack of time and intent upon shortcuts. Lunch counters, plane travel, the *Reader's Digest*, and the tabloids all promised to streamline daily existence. When the *New York Daily News* was founded in 1919 as the *Illustrated Daily News*, the editors assured readers that to save them trouble no story would be continued to another page.[1] In terms of information the biggest time-saver of all was the photograph, which told the story far faster and more efficiently than words.

Tabloid papers quickly put people in the habit of taking their news with a dose of pictures, and by now photographs took up so much space that text shriveled in response. After a while more traditional newspapers felt obliged to add some photographic coverage in order to compete. At the end of the 1920s German papers like the *Berliner Illustrierte Zeitung* and the *Münchener Illustrierte Presse*, followed soon by magazines like the French *Vu*, changed the terms, putting more of the world on display at one time than the press had done before. They printed groups of photographs on a single subject, pictures that told stories and illuminated events from a variety of angles. Thus the picture essay and the picture magazine were born.

They grew to giant proportions in no time at all. In the 1930s *Picture Post* in England, *Paris-Match* in France, and *Life* and *Look* in America marked the weeks off for millions. People hung on these magazines, anticipating that the news they had glimpsed in the papers or heard on the radio would be amplified and explained in detail before their very eyes. When they finished looking at the pictures they flocked en masse to the movies, where newsreels sent more picture stories flashing by.

It was already becoming clear that news consisted principally of what could be shown—a foretaste of the world we know today. The privilege of vicariously experiencing events came to be accepted as everyone's natural right. Henry Luce put it rather grandly in the 1936 prospectus for *Life:* "To see life; to see the world; to eyewitness great events; to see strange things . . . to see and to take pleasure in seeing; to see and be amazed; to see and be instructed; Thus to see, and to be shown, is now the will and new expectancy of half mankind."[2] People had long since become addicted to photographs; now the general dependency was rationalized by the idea that seeing the news was one of the prerogatives of modern life.

With the growth of the picture magazines the picture culture triumphantly took over, without so much as a battle. Society, long since infiltrated, happily surrendered. In 1948 Wilson Hicks, *Life*'s director of photography, proclaimed the new kingdom: "World War II was a Photographer's War," he said. "This is a Photographer's World."[3]

All I could think of was that the ship had fallen out of the sky. They were not supposed to touch land, they were tethered to tall towers, they were sky creatures; and this one had fallen in flames to the ground. I could not get the picture of that out of my mind.

E. L. Doctorow, *World's Fair*, 1985

There were real pictures, too, that were hard to get out of the mind. When the ship docked at its mooring mast in Lakehurst, New Jersey, on May 6, 1937, it was almost twelve hours late because of bad weather. The flight was routine, the eleventh North Atlantic round-trip for the big German dirigible. It was the first landing of the year, and twenty-two photographers, several reporters and newsreel men, plus a radio announcer were on hand. Moments after it landed, the great airship exploded with a burst of brilliant flame. The tail, hovering in air and burning fast, broke apart and sank to earth. Bodies fell from the air like cinders. One newsreel man, who had been photographing the ground crew hauling on the landing ropes, was so stupefied he never shifted his camera until his crew chief shouted at him, "For God's sake! Turn it up!" One of the still photographers cried "Oh my God! Oh my God!" over and over as he loaded and shot his camera like an automaton. There were ninety-seven passengers and crew aboard that flight; thirty-five of them died.[4]

The day the *Hindenburg* went down was one of the first times a mass audience achieved the immediate shared experience of the news and the proximity to disaster that have since become components of contemporary life. The camera made people direct spectators of the *Hindenburg* explosion no matter where they were when it happened, and technology put them on the scene within hours of the event. By 1937 there were numerous picture newspapers eager to tell a story in photographs: the *New York World Telegram* printed twenty-one pictures of the dirigible; the *New York Post*, seven *pages* of pictures; the *New York Daily Mirror*, nine. New York had theaters that played nothing but newsreels, and theaters everywhere included them on their programs. Film of the explosion was being shown on Broadway by noon the following day, and late that afternoon prints were rushed to theaters across the country. Audiences were not accustomed to witnessing horror and death as they happened: screams frequently rang out across the theater.[5]

Radio, which had just become a truly mass medium earlier in the 1930s, brought the stunning news of the dirigible's crash directly into millions of homes. Herbert Morrison, an announcer for a Chicago station, had gone to

Front page of the

Washington Post the day

after the Hindenburg

disaster, May 7, 1937

© The Washington Post

192

Sunday
THE PARADE OF YOUTH
A Magazine for Children
WITH THE SUNDAY POST

The Washington Post

The Weather
Today and tomorrow—Fair,
slightly warmer tomorrow.
Yesterday's high, 74; low, 58.
Details on Page 25.

NO. 22,240 — Entered as Second-Class Matter, Postoffice, Washington, D. C. — WASHINGTON: FRIDAY, MAY 7, 1937 — XX ★★★★ — Copyright, 1937, By The Washington Post. — THREE CENTS

Hindenburg Explodes With 97 Aboard;
D. C. Man Escapes, 33 Die at Lakehurst

F. L. Belin, Jr., Leaps From Blazing Ship

Relatives Here Term His Jump to Safety a 'Miracle.'

Change in Orders Keeps Two Naval Officers From Flight.

The hand of fate intervened to save Washington from representation on the Hindenburg death list, it developed last night.

Ferdinand Lammot Belin, Jr., 24-year-old son of Mr. and Mrs. Ferdinand Lammot Belin, 1623 Twenty-eighth street northwest, and only District resident aboard the ill-fated ship, was among the few survivors.

When word of the youth's safety reached Dr. and Mrs. D. W. Mears, 2934 Edgevale terrace northwest, an uncle and aunt, Mrs. Mears said:

"It is a miracle."

Soon after reaching New York from the disaster scene, young Belin telephoned a description of his escape to the Yale News at New Haven, Conn., according to dispatches.

With two stewards, the young man said, he leaped from a cabin window while the airship was 80 feet from the ground. He landed on a pile of sand and was unhurt.

He and his companions, Belin said, ran for some distance before looking back to see the great ship a mass of flames. Fifteen minutes later, Belin succeeded in finding his parents in the sobbing, hysterical crowd of spectators.

Assignments Changed.

And the Belins were kind to two naval officers—Lieut. Comdr. Francis W. Reichelderfer and Lieut. Richard N. Antrim (j.g.), both well known in Washington.

Both were scheduled to ride as observers aboard the Hindenburg on its flight from Germany, but a last-minute change switched their assignments to the return crossing in Paris.

Lieut. Comdr. Reichelderfer was stationed here in 1930 as an aerologist at the Navy Department. Lieut. Antrim, on duty here several years ago, was sent to Lakehurst last June.

When early reports listed Belin as among those killed, Dr. and Mrs. Mears waited anxiously at their telephone for word from his parents, who had gone to Lakehurst to meet him.

Their first knowledge of his safety came from a Post reporter. Later, a telegram from Belin's father, in New York, confirmed reports that Ferdinand, known to his friends as Peter, had been saved.

Father Minister to Poland.

Her voice choked with emotion, Mrs. Mears called The Post to tell the news. She said the Belins would return here today.

Ferdinand is the Belins' only child. His father, former Minister to Poland under President Hoover, has a distinguished record in the diplomatic service. His son was returning from a course of diplomatic studies in Paris.

Following his graduation from Yale last June, Belin went to Paris in October. He returned home for a brief vacation before continuing his studies.

Mr. and Mrs. Belin, it was reported last night, witnessed the air tragedy as they stood in the Lakehurst crowd waiting for the huge airship to land.

Hitler, Stunned, Refuses Comment On Airship's Loss

Berlin, (Friday), May 7 (U.P.)—Reichsfuehrer Adolf Hitler was called from his bed early today to receive news of the worst disaster in German air transportation in history—the loss of the proud dirigible Hindenburg.

The dictator apparently was stunned by the news. He refused formal comment.

A report of the catastrophe was telephoned to the chancellor and Propaganda Minister Joseph Goebbels.

The official news agency—DNB—announced German Zeppelin traffic across the North Atlantic will continue "unabated."

Today's Index

	Pages
Amusements	16, 17
Books	17
Classified Advertisements	28, 29, 30
Comics	31
Crossword Puzzle	28
Death Notices	28
Editorials	8
Financial News	26, 27
Radio	17
Night Clubs	17
Sugar's Column	9
Society	13, 14, 15
Sports	19, 20, 21, 22, 23
Theaters	16, 17
Society News	23, 24, 25
Vital Statistics	28
This Is a New Yorker	11

Copyright by News Syndicate Co.
Remarkable photo (above) shows the actual explosion of the giant Zeppelin as the gas let go with a terrific roar when the ship approached its mooring mast. Balls of flame are seen spurting from the descending bag. Lower photo shows part of the enormous ship hitting the ground as the land crew tries to avoid disaster.

Capt. Lehmann, Pruss Are Among Survivors

By the Associated Press.

Lakehurst, N. J., May 6—Capt. Ernest Lehmann, veteran Zeppelin commander, and Capt. Max Pruss, the new commander, were listed in official sources tonight as among the survivors of the Hindenburg disaster. A Capt. Stumpf of the crew also was said to have survived.

Other survivors were Herbert O'Laughlin and Nelson Morris, of Chicago, a radio officer named Schweinhardt, and three children of Mr. and Mrs. Doehner, of Mexico City.

Mrs. Doehner and two of her sons were taken to a Point Pleasant hospital, where their injuries were reported as not serious.

The following were in Paul Kimball Hospital, Lakewood:

Capt. Lehmann.

Philip Mangone, 145 West Fifty-eighth street, New York, suffering shock and burns.

George Hirschfeld, of Bremen and New York.

And the following unidentified as to whether passengers or crew members:

Albert Summit.
William Steit.
Theodore Ritter.
Frank Herzog, condition critical.
William Luthenberg.
Hans Hugo.
Adolf Fisher.
Ray Fields Stahler.
Joseph Lebrecht.
Hans Teinhold.
Leonard Jacobson, of Lakewood, also at the Lakewood hospital, was believed to have been either a member of the ground crew or a spectator.

The following survivors were taken to Royal Pines Hotel and Clinic, Pinewald:
Mrs. Mary Kleenmen, 51, Frankfort-on-Main, Germany.
Hans Hund, 31, same address.
Alfred Groelinger, 20, same address.
George Grant, 63, London, England.

Seven were at Fitkin Memorial Hospital in Neptune. One, a man, was unconscious and was not identified. The others:

Richard Kalmer, machinist member of crew.
Ergis Brentele, also a machinist.
Phillp Lentz, Frankfort-on-Main.
Herbert Dowe, wireless operator.
Ernest Klockner, Ceglenloda, Germany.

Also at Paul Kimball Hospital were the following:

Irene Doehner, daughter of Mr. and Mrs. Herman Doehner.
Otto C. Ernst.
August Deutchoier.
Clifford Osbun, 904 Vine avenue, Park Ridge, Ill.

Continued on Page 6, Column 6.

Others Near Death Given Last Rites

Last Rites Administered Capt. Lehmann; Blast Called 'Strange' by Air Official of New Jersey.

Inside The Post—

Pictures, Pages 6, 16, 22, 28.
Disaster Stories, Pages 3, 6, 7, 22, 28.

By the Associated Press.

Lakehurst, N. J., May 6.—Her silvery bulk shattered by a terrific explosion, the German airliner Hindenburg plunged in flames at the United States naval air station tonight.

Exactly how many died was still in dispute as the flames licked clean the twisted, telescoped skeleton of the airship that put out from Germany 76 hours before on its opening trip of the 1937 passenger season.

The American Zeppelin Company, through its press representative, Harry Bruno, placed the death toll at 33 of the 97 aboard. The company listed 20 of the 36 passengers and 44 of the 61-man crew as the disaster's survivors.

These figures were at slight variance with unofficial estimates of the number of dead.

Some Survivors Gravely Burned.

In the crowded hospitals in the communities neighboring this hamlet in the pine-covered New Jersey coastal plain, many of the survivors were in critical condition, a number suffering from excruciating burns. Some were so gravely injured, among them Capt. Ernst Lehmann, that the last rites of the Roman Catholic Church were administered to them. Lehmann, skipper of the ship's 1936 flights, made the ill-fated flight as an observer. Capt. Max Pruss, the commander, was listed among the injured survivors.

An explosion of the No. 2 gas cell toward the stern of the ship was named as the cause of the disaster by State Aviation Commissioner Gill Robb Wilson, who called the blast "strange." The highly inflammable hydrogen gas billowed into fierce flame as the explosion plummeted the ship to the airfield. Ground spectators said crew members in the stern of the ship "never had a chance" to escape.

The disaster struck without the least warning. The ship had angled her blunt nose toward the mooring mast, the spider-like landing lines had been snaked down and the ground crew had grasped the ropes from the nose, when the explosion roared out, scattering ground crew and spectators like frightened sheep.

Passengers Stunned.

The passengers, who were waving gaily a minute before, from the observation windows, were so stunned they could not describe later what happened. Some jumped to the sandy landing field along with members of the crew. Others seemed to have been pitched from the careening sky liner as it made its death plunge.

The heat drove back would-be rescuers, so it could not be determined for how many the Hindenburg made a burning tomb. Fire departments from nearby communities converged on the field and soon had streams of water playing on the broken airliner. The flames still enveloped the outline of the ship, apparently feeding on the fuel oil supply which the Hindenburg carried for her Diesel motors.

Somewhere in the glowing furnace were the two dogs, 340 pounds of mail and the baggage which she had aboard.

Wilson said there was "a hydrogen explosion in number two cell from the rear."

"There was something very strange about the explosion," he said. "The Hindenburg had stopped completely and was preparing to hitch when flames broke out from the rear.

"The only persons possibly saved were those who were in the engine gondolas.

"Those in the belly of the ship absolutely had no chance.

"In all my 21 years of flying experience I have seen crackups, explosions, flaming airplanes but nothing measures up to the explosion of the Hindenburg.

"I cannot be too loud in my praise of those Navy boys who dove into the flames like dogs after rabbits in their rescue.

"There will be investigations by the Federal Bureau of Air Commerce and the State of New Jersey.

"I repeat there was something strange that caused the tragedy."

Spectators shrieked and screamed as the explosion, apparently in the stern of the envelope, shattered the ship and she collapsed.

The ground crew of sailors, which had been standing by to help land the ship, scattered before the blinding flare of the explosion. One sailor later said he saw three bodies removed from the stern of the ship, all horribly burned beyond recognition.

Even after the first stunning explosion sent the ship crashing, additional blasts continued to rend the Hindenburg's silvery bulk as the spectators sobbed hysterically.

Continued on Page 6, Column 1.

Berry Is Appointed Tennessee Senator

Nashville, Tenn., May 6 (U.P.)—Gov. Gordon Browning appointed Maj. George L. Berry, Federal industrial coordinator, to the United States Senate to succeed the late Nathan L. Bachman, of Chattanooga.

Associated Press WIREPHOTO

record the landing for his regular program. He intoned, in true radio reporter fashion, "The vast motors are just holding it, just enough to keep it from . . ." Suddenly he broke off, then came in quickly in an anguished voice: "It's broken into flames! It's flashing—flashing! It's flashing terrible!" He continued his report but at length burst out sobbing. "I'm going to have to stop for a moment because I've lost my voice. This is the worst thing I've ever witnessed!"[6] The recording was nationally broadcast the next day at 4:30; by then, most people had seen photographs and had an image in their minds. (The on-the-spot immediacy of this account, broadcast so soon after the explosion, was eclipsed a year later when Edward R. Murrow began broadcasting directly from Europe about the lengthening shadows of war.)

What the reporting of the *Hindenburg* disaster did was to change the nature of the news and the public's expectations of it. Previously, firsthand reports of disaster had depended on verbal accounts by survivors; now it was possible to see the catastrophe itself, to hear about it as it unfolded. Occasional events of great magnitude had been photographed ever since the camera became fast enough: burning mills in Oswego, New York, in 1855; the attempted assassination of Mayor Gaynor in New York in 1910; the execution of Ruth Snyder in 1928, photographed with a concealed camera and printed on the front page of the *Daily News*. But disaster usually doesn't wait around for a photographer, who seldom has a chance to depict anything but the aftermath. Even Arnold Genthe, who lived through the San Francisco earthquake, took pictures of the city burning afterward.

Now the nation and the world were witnesses to an accident in a small town in New Jersey. The picture magazine, the wire service, and the newsreel had widened the dominion of photographs over the mind, and, with the collaboration of radio, established the reign of instant news that addressed both the eye and the ear. The way was prepared for the entry of television.

The immediate reports in three media on the *Hindenburg* explosion depended first on a fluke and second on technology. The fluke was that representatives of all the media were present at the disaster because they expected to cover the landing. Had the explosion occurred a mile away, the event would have taken on an entirely different character. News was becoming not only whatever could be photographed, but more specifically, what could be photographed dramatically.

Technological advances moved the accounts across the nation and the world with unprecedented speed. Photographs had begun to travel by wire in the first decade of the century and had a limited national distribution by the mid-1920s; in January 1935 the Associated Press Wirephoto network was inaugurated. (The first photograph sent by wire across the Atlantic, in 1935, was a view of a plane crash.) Not only did the pictures move faster, but tabloid papers made them available to enormous audiences. Most news photographs before the 1930s had a fairly limited circulation. The advent of the picture magazine in mid-decade provided huge numbers of people with the same visual experiences but made them wait a couple of weeks: the *World Telegram* gave the *Hindenburg* extensive coverage on May 7, the day after the explosion; *Life's* appeared ten days later.

Between photographs, newsreels, and radio, a far-flung public was *there*, and everyone received just about the same account. At least since the 1920s—with syndicated news articles, wide-circulation magazines, and nationwide broadcasting—the media had been in the process of homogenizing experience within nations and to some extent across the world. The reporting of the *Hindenburg* explosion unified the culture in a nearly simultaneous

observation of disaster. The world was rapidly filling in the outlines of Marshall McLuhan's global village.

It is often assumed that the explosion of the *Hindenburg*, and the photographs that fixed it so starkly and irrevocably in memory, spelled the end of commercial dirigible travel. There is some truth to this, but less than first appears. Dirigible crashes in the 1920s and early 1930s had already made the public wary. After a British airship crashed in 1930—killing the secretary of state for air, the director of airship development, and six officials of the Royal Airship Works—Britain gave up developing rigid dirigibles. Americans had their own crashes, but Dr. Hugo Eckener, head of the German Zeppelin Transport Company, wooed American industrialists with demonstrations of his crafts' brilliant performance. By 1935 the luxurious, relatively inexpensive crossings of the *Hindenburg* and the *Graf Zeppelin* had quieted the world's doubts about the dirigible. The *Hindenburg* flew so smoothly that the pope, convinced there was no risk of spilling the consecrated wine, permitted a priest to celebrate the first mass ever said in the sky. Not even the hurricane of 1936 roiled the ship's calm progress.[7]

When it went down in flames, a hard-won sense of safe travel went with it, and no rigid dirigible ever again carried a paying passenger. In some respects this was a great setback to aerial transportation. Heavier-than-air craft did not even attempt the North Atlantic crossing until 1939, and commercial nonstop transatlantic service, which the *Hindenburg* had offered from 1937 and the *Graf Zeppelin* from 1931 (between Germany and Brazil), was not available again until 1957.[8]

The extensive and terrifying photographic coverage of the *Hindenburg* catastrophe was all too persuasive. But dirigible travel ceased for more complex reasons. After the explosion Dr. Eckener decided that passengers would never again fly in craft inflated by highly flammable hydrogen. He lobbied the U.S. for heavier, safer helium and America agreed, but the secretary of the interior held out, fearing that the Germans might convert their airships into bombers. By early 1938, when Hitler seized Austria, refusing assistance to the Germans became the politically correct decision.[9] The *Hindenburg* lived on, but only in photographs—forever burning, forever in the throes of death.

Many—too many—of the photographs that haunt our memories are war photographs, but none come from World War I. Censorship in the Great War was so stringent that for a time civilian photographers were not permitted at the front on pain of death, a rather effective regulation. In 1915 the American photojournalist Jimmy Hare, on the job in Britain, said, "Photographs seem to be the one thing that the War Office is really afraid of."[10] The Germans convinced the Allies to loosen restrictions somewhat. German propaganda photographs were so influential that the Allies could not afford to leave the photographic battlefield to the enemy; controls were eased just a bit.

Even if the pictures passed the censors, publications back home were chiefly interested in optimistic reports and not particularly hospitable to photographs. Rotogravure sections like the *New York Times's Midweek Pictorial*, established in 1914, published images of the war, and some daily papers did too, but most newspapers were not yet wholly photographic. (The first true photographic paper in America, the *Illustrated Daily News*, established 1919, had a winged camera for a logo.) Thousands upon thousands of photographs remained unpublished for the duration of the war. To judge by those in print, no American died in battle and few were wounded, but the enemy took a

beating. Photographs of heavy combat and badly wounded men were finally published after the war was over, and only then did the nature of the tragedy and the extent to which the news had been manipulated become clear.[11]

More photographers covered World War II than any previous struggle. The Armed Forces themselves employed more professionals; no less a figure than Edward Steichen, who had been in charge of aerial reconnaissance photography in France during World War I, was asked to head up navy combat photography in World War II. A high value was put on war reporting. In April 1944 General Eisenhower, supreme commander of the American Expeditionary Force, wrote: "Correspondents have a job in war as essential as military personnel. . . . Fundamentally, public opinion wins wars."[12]

But censorship, which also contributes to victories, was still extremely strict. During the first two years of the war the American government would not permit civilians to look at pictures of dead Americans, or even severely wounded Americans, for fear the realities of war would prove too demoralizing. (During the American Civil War, photography and the picture press were so new the government had not yet devised such restrictions.) Dead Germans and Japanese, even the frozen corpses of Russians, presumably had the opposite effect and were shown to the public in horrifying detail. On February 1, 1943, *Life* published Ralph Morse's picture of a screaming, helmeted Japanese skull perched on a burned-out tank. When readers complained, the editors replied: "War is unpleasant, cruel, and inhuman. And it is more dangerous to forget this than to be shocked by reminders."[13] Perhaps. At any rate, a message was being subtly broadcast that war was hell for the enemy but our side was faring well—better, in fact, than it actually was.

That same February of 1943, *Life* complained publicly about government restrictions. George Strock, a *Life* photographer in the Pacific theater, had photographed GIs in fierce combat in New Guinea and followed one of them (identified only as Bill) to his death on Buna Beach. The censors let the story through and permitted *Life* to report the man's death in battle but would not

World War I: British, Western

Front, 1917

AP/Wide World Photos,

New York

George Strock (1911–1977)

Three American Soldiers

Ambushed on Buna Beach,

1943

George Strock, *Life*

magazine © 1943, 1971

Time Warner Inc.

pass the pictures of his dead body. The magazine showed wounded, dying, and dead Japanese, but dead Americans were represented only by crosses marking their graves.

 Life's editors wrote that army policy might be right, but

nevertheless we think that occasional pictures of Americans who fall in action should be printed. The job of men like Strock is to bring the war back to us, so that we who are thousands of miles removed from the danger and the smell of death may know what is at stake. Maybe some of our politicians would think twice about their selfish interests if they could see him lying on the white sand. Maybe some of the absentee workers in war plants would make more of an effort to stay on the job if they could look at Bill. Maybe some industrialists would be more progressive if they had Bill on their minds. Maybe some housewives wouldn't be in such a hurry to raid the grocery stores, and John L. Lewis wouldn't feel so free to profiteer on the war—if they could see how Bill fell. Why should the home front be coddled, wrapped in cotton wool, protected from the shock of the fight? If Bill had the guts to take it, we ought to have the guts to look at it, face-to-face.[14]

197

Life's orotund sermon on the power of photographs was a partisan plea for the chance to print dramatic pictures and pull in more subscribers. Yet a few months later the government decided the magazine was right. On the home front, civilians were critical of rationing and wage and manpower controls. James Byrnes, chief of the Office of War Mobilization, suggested to President Roosevelt that grumbling at home might be cut and civilian morale hardened if the public saw more photographs of the ordeals faced by the American military. FDR agreed. In May the new head of the Army Pictorial Service instructed commanders in all theaters of war to facilitate frontline coverage by Signal Corps and news photographers. One of the first of the new releases showed a bleeding marine with powder burns, his face averted to prevent identification. *Newsweek* published it in May, noting that it was part of a program to stiffen the home front's morale.[15]

Life cautiously published a picture of Americans carrying a flag-draped coffin and one of a soldier next to a stretcher completely covered with a blanket that had some lumpy form beneath it. Then early in September the president, Elmer Davis (director of the Office of War Information), and the War Department decided that pictures of the dead bodies of Americans, not merely forms under blankets, ought to be published. That month *Time* reported that a psychologist who tested four thousand headlines on 109 "average persons" had concluded that headlines that in effect say "ENEMY LOSING" produce the greatest degree of civilian lethargy, whereas headlines that say "U.S. LOSING" stimulate the greatest will to win.[16] Evidently written and pictorial news produced similar results, but the government, although also concerned about the suppression of adverse reports in written news, had far greater faith in photographs to shock civilians out of their complacency.

Once the photographs were released, newspapers still hung back. The question of what was appropriate in a family paper had to be squarely confronted. Although *Time* printed a previously suppressed picture of the bullet-riddled bodies of American paratroopers in Sicily and *Newsweek* ran a photograph of a soldier with a freshly amputated leg, newspapers from Seattle to Baltimore had found these pictures too gruesome to print.[17]

In the beginning, at least, the national magazines would have to shoulder most of the new burden of reviving the country's lax morale. *Life* leapt at the chance. It finally got permission to print Bill's picture and did so on September 20. The picture was printed full page and faced a full-page editorial about the men who died and the decision to print their picture.[18]

Americans already knew what war dead looked like, as they had not in Alexander Gardner and Timothy O'Sullivan's day. The sight was shocking nonetheless, as anything once forbidden is, and as the government had supposed, it brought home a new awareness of the real business of war. The sense of identification with the battlefield dead was now given free rein, and because most adults knew someone in the military, this picture must have touched off the feeling that this could have been someone near and dear. It is a careful picture, a solemn still life of the dead. Precisely composed, it leads the eye in along diagonals, from the round helmet that is so near we could almost touch it, back along the line of the man's body to the corpse in the middle distance, whose arm points to a crumpled figure in the path of the landing craft that spit him out some time ago and then half sank in the water.

The men lie face down or with their heads turned away and are not bloated, visibly mutilated, or horribly wounded. Yet death rules the image. The faces are muffled in sand. The man on his back has one limp arm flung out lifelessly, and his dead white hand marks the exact center of the picture. The

tide is rolling in to claim these men. Their clothes are soaked where the waves have casually washed over their corpses, and sand has already half buried the legs of the foremost man. There was one gruesome detail that might not have been understood by everyone: the white spots on the back of the man in the foreground are maggots. They came to feast so quickly in that part of the world that the place was known as Maggot Beach. (In *Life*'s 1959 book, *The Second World War*, they were airbrushed out.)

"Why print this picture anyway?" *Life* asked. "The reason is that words are never enough. . . . The words do not exist to make us see, or know, or feel what it is like, what actually happens." This is the argument, already old in 1943 but still meaningful today, that pictures have a greater emotional force and directness than words. *Life* wrung every possible ounce of emotion from the picture: "It is not just these boys who have fallen here, it is freedom that has fallen." But what most people responded to was simply the dead. Three weeks later the magazine published one letter that said that "pictures of mutilated corpses make a mockery of sacrifice," but the rest of the letters called this "the greatest picture that has come out of the war" and praised *Life*'s courage in printing it. One man wrote that after he put the picture on the office bulletin board, the proportion of employees who took payroll deductions for War Bonds increased from 55 to 100 percent.[19]

Strock's picture of three dead Americans was considered a potent weapon in the War Bond drive. On Sunday, September 26, Revlon took a full-page ad in the *New York Times* reproducing the picture with the headline "THE HIGH COST OF LIVING DYING." There was no credit line or title; *Life*'s readership was so large in the war years and the picture had made so strong an impression that it was assumed it would be recognized. The copy told readers that "these boys never said, 'We can't afford the high cost of dying—not when we're so young.' . . . You might think of that when you're trying to decide if you can afford another War Bond this month." Bond sales to individuals had been lagging behind quotas throughout the country (corporations and institutions had better records), but on the day this appeal was published it was announced that Manhattan had topped its quota. Three days later the *Times* reported that the drive was exceeding its overall goal and that there had been an encouraging gain in individual sales.

People's behavior changed when their view of war was profoundly shaken. The idea that images of our dead could rouse consciences was widespread. The photograph of the mangled, bullet-riddled bodies of American paratroopers in Sicily that so many papers had refused was frequently printed in conjunction with Bond Drive appeals. Letters indicated how shocked the viewers were.[20]

War coverage grew increasingly harsh in tone. Early in 1944 *Life* ran a story called "It's a Tough War." Robert Capa's photographs of the Italian front included a wounded American tended by a medic and four images of dead Americans in the field, covered by blankets that left their legs or averted faces exposed to the elements. A soldier wrote to the magazine: "The pictures clearly portray the bitterness and grimness of the battles to be fought before we reach Berlin and Tokyo. It also brings home the realization of their responsibilities in doing all they can to support the boys with bonds and work on the home front." A civilian wrote, "We need stories like 'It's a Tough War' to slap us in the face and keep us awake to realities."[21] The tough pictures that had been withheld to keep morale high were now brought out of hiding for the very same reason, and this time they did a better job.

Emmett Till

UPI/Bettmann, New York

Emmett Till was a fourteen-year-old black boy from Chicago whose mother sent him to Mississippi for a vacation with his cousins in August 1955. He was a rambunctious kid with a northerner's ways. In his wallet was a photograph of a white girl; he bragged to the boys down south that she was his girlfriend. One day a group of them dared him to prove he knew his way around white women. Till took the dare. They were outside a local store; he went inside and approached the owner's wife. One account had it that he squeezed her hand, asked her for a date, and when she moved away, caught her at the waist and said, "You needn't be afraid of me, Baby, I been with white girls before." His terrified cousins hustled him out of the store, and as the woman went for a pistol, Till gave a parting wolf whistle. Others say the wolf whistle is the only accurate part of the story.[22]

Nothing happened for several days—Roy Bryant, the woman's husband, was away. When he returned, he and D. J. Milam, his half brother, went to the home of Till's uncle in the dead of night and took the boy away with them. Emmett Till never returned. Three days later his bloated body bobbed up in a

nearby river, despite a huge weight tied by barbed wire about the neck. The face was battered almost beyond recognition: one eye gouged out, one side of the forehead crushed, and a bullet in the skull. He was identified by a ring he was wearing.

Perhaps it was because the boy was so young that the white press paid so much attention, or because Mamie Till Bradley, the boy's mother, put the case on front pages nationwide and made sure it stayed there. When she was notified that her son's body had been found, she was told the sheriff's office had ordered an immediate funeral. She got on the phone to the sheriff, the governor of Mississippi, anyone she thought might be able to help. "I wanted that body. I demanded that body—because my thoughts were, I had to see it, to make sure, because I'd be wondering even now who was buried in Mississippi." The body was finally shipped north in a closed coffin. Mrs. Bradley insisted it be opened. "After the body arrived I knew that I had to look and see and make sure it was Emmett. That was when I decided the whole world had to see what I had seen; there was no way I could describe what was in that box. And I just wanted the world to see."[23]

Mrs. Bradley insisted her son's body be nicely dressed and displayed in an open coffin before the funeral. She would not allow a mortician to touch his face. And she tacked up on the open coffin lid a photograph taken before he went south: a good-looking boy, smooth faced, a little plump, full of good humor, brimming with life. The black community in Chicago lined up around the block for hours to get into the funeral home. Estimates of how many viewed the body ranged from a low of one hundred thousand to an improbably high six hundred thousand. Viewers wept helplessly. Several people, one of them a young minister, fainted. Mrs. Bradley delayed burial for four days so more people could view her son's body.[24] The white press in Chicago gave this unprecedented funeral enormous space, and papers across the country carried the reports.

In mid-September the black weekly magazine *Jet* published a photograph of Emmett Till in his coffin and a full-page close-up of the boy's battered face. The story included a photograph of the boy alive, with his mother, and another of her viewing the body in the morgue. But it was the sickening picture of a face rendered barely human that had the strongest effect. The black press had published pictures of lynchings before. For the most part, they were middle-distance shots of bodies hanging from trees, appalling but slightly remote, slightly repetitive, almost, after a while, interchangeable. The pictures of Emmett Till were different. The dreadful wounds and mashed-in face were only inches away, and the victim was a child. *Jet's* major emphasis had been on entertainment; these photographs made the magazine a serious contender in the news field. The images raised such a storm of interest that for the first time in its history, an issue of *Jet* went back to press.[25] Then the week after the picture appeared, *Jet* printed it again in another story about Emmett Till.

The white press never published this photograph, television did not show it, and whites did not see it until the first episode of "Eyes on the Prize," the documentary about civil rights that aired in 1988. A few black papers, the *New York Amsterdam News* for one, pirated the image from the magazine. (Although Mrs. Bradley wanted the picture of her dead son's face seen by everyone, *Jet* magazine has repeatedly refused permission to reproduce it.) Although news of the case traveled through every state, the photograph reached an almost exclusively black audience—old and young, rich and poor, northern and southern. Till's death, even without the photograph,

pierced young blacks to the marrow and taught them, some for the first time, that it was dangerous to be black. The photograph hammered this home, and the shock of seeing it remains vivid in the minds of many. Cleveland Sellers, born in 1944, writes, "Many black newspapers and magazines carried pictures of the corpse. I can still remember them. They showed terrible gashes and tears in the flesh. It gave the appearance of a ragged, rotting sponge." Charles Diggs, then the first black congressman from Michigan, says: "I did not need a picture to stimulate my interest, but the *Jet* picture certainly intensified it. . . . It was the leading stimulant of interest in the black community and elsewhere."[26]

Some reacted with anger. Muhammad Ali recalls in his autobiography: "Emmett Till and I were about the same age. A week after he was murdered. . . . I stood on a corner with a gang of boys, looking at pictures of him in the black newspapers and magazines. In one, he was laughing and happy. In the other, his head was swollen and bashed in, his eyes bulging out of their sockets, and his mouth twisted and broken. . . . I felt a deep kinship to him when I learned he was born the same year and day I was. I couldn't get Emmett Till out of my mind, until one evening I thought of a way to get back at white people for his death"—he threw stones at an "Uncle Sam Wants You" poster and put obstructions on the train tracks so the train wheels locked and the ties ripped up.[27]

Others suddenly understood the dangers white women posed to black men. In a story called "Advancing Luna—and Ida B. Wells," by Alice Walker, the narrator asks a white friend why she didn't scream when a black activist raped her. "You know why," she answers, and the narrator realizes she does know why: "I had seen a photograph of Emmett Till's body just after he was pulled from the river. . . . I knew why, all right."[28]

Many, though only children themselves, resolved to do something about it when they grew up. Joyce Ladner wrote that she and her sister ran to the white-owned grocery store each day "to be first in line to buy the Hattiesburg American. Each day we pored over the clippings of the lynching we kept in our scrapbook, and cried. Emmett Till was about our age; we cried for him as we would have cried for one of our four brothers. His corpse finally surfaced in the Tallahatchie River. When we saw the picture of his bloated body in *Jet* magazine we asked each other: 'How could they do that to him? He's only a young boy!' " Ladner's sister resolved to become a lawyer and fight to change a system that made such things possible. Ladner herself decided to become a social worker and inform people of their rights; today she is a sociologist. Having interviewed many former civil-rights activists, she says a good number of them remember that when they saw that picture, they vowed to do something to correct things when they were old enough.[29]

Henry Hampton, producer of "Eyes on the Prize," grew up in a comfortable, middle-class, sheltered environment in Saint Louis. He was fifteen when he saw Till's photograph. "That cut right through that sense of security," he says. "It was enough to tell me that the world was a dangerous place, and race was a factor." For Hampton the civil-rights movement has always begun with Emmett Till's murder—which he made the first episode on "Eyes on the Prize." For Madison Davis Lacy, another producer of "Eyes on the Prize," the photograph, the newspaper reports, his elders talking about the incident, wrenched him out of "the magical world of a child" and awakened him "to the cruelty of our existence at the hands of whites in the South." For Julian Bond, the former civil-rights activist and Georgia legislator: "It was the combination of the photo and accompanying story. . . . I was a year older,

and I can remember thinking that it could have been me."[30]

Till's death and the trial of his murderers convinced African-American leaders that in certain circumstances the white press would report black causes and that publicity could help them. Contributions to the National Association for the Advancement of Colored People's "fighting fund," which provided for victims of racial attacks and which had been uncomfortably low despite the recent Supreme Court decision on Brown v. Board of Education, reached record levels after Till's body went on view. The Montgomery bus boycott that is most frequently cited as the starting point for the movement began barely three months after the boy's funeral.[31]

Bryant and Milam were arrested and confessed to kidnapping Till but not to killing him. The community turned against them until the northern newspapers repeatedly condemned the crime as a lynching and cast blame on the state of Mississippi; then their neighbors closed ranks behind them. In a segregated courtroom, where guards at first refused to believe Charles Diggs was a congressman and did not want to let him in, the two defendants were acquitted of murder. A month later a grand jury refused to indict them for kidnapping, a crime they had confessed to.

Till's murder was one of the most publicized racial crimes of the century; Bob Dylan even wrote a song about it. For perhaps the first time, publicity was working for blacks rather than inciting new violence against them. When John Chancellor, reporting for NBC at the trial, felt himself menaced by a group of whites, he pointed to the microphone and said, "The whole world is going to see what you'll do to me."[32] The group backed off. At the moment that a still photograph was preparing some of the future leaders of the movement to take action, television gave the first indication that it could make a difference in the civil-rights struggle.

On December 1, 1955, in Montgomery, Alabama, a black seamstress named Rosa Parks refused to give up her seat to a white man on a public bus. Her feet were tired and her back was up. The black boycott of the Montgomery bus lines that followed brought the civil-rights movement and Martin Luther King, Jr., to national attention. At every stage of that conflict still photographs and, to a growing degree, television played important roles in shaping the attitudes of both African-Americans and whites. Photographs of the events in Birmingham during the spring of 1963 had particularly striking effects.

In 1963 Birmingham, Alabama's largest city, had a population of three hundred fifty thousand, 40 percent of it black. The city was notoriously racist and segregated. So many bombings had occurred in black neighborhoods during the previous six years that the city was nicknamed "Bombingham." In January 1963 George Wallace took office as governor of the state, and that spring Sheriff "Bull" Connor ran for mayor of Birmingham and lost. Connor contested the count and stayed on as sheriff. The entire losing slate refused to step down without a court ruling, so during the demonstrations Birmingham had two governments that were sometimes at odds.

The demonstrations began on April 3 with sit-ins at lunch counters and continued with more sit-ins and marches. Local black support was not overly enthusiastic, and news accounts in northern papers were relegated to back pages. The news heated up a bit when Connor called out police dogs on April 7 to meet a march on city hall and one man was attacked. A number of celebrities cabled the president to protest the use of dogs against peaceful protesters. A few days later King was arrested and held in solitary confinement; again the whole country took notice. But by the end of the month the

national media were giving Birmingham short shrift. On May 2 a bold step was taken. Birmingham students, some of them elementary-school children, marched for their civil rights. Almost a thousand children were arrested. The city was major news.[33]

On May 3 more children turned out to march. The jails were too full. Connor commanded the students to turn back, and when they did not stop, ordered firehoses turned on them. The firemen had special equipment that channeled water from two hoses through a single nozzle with a force that could tear bark off trees; it knocked over people in its path and sent them tumbling. New marchers kept coming, changing course to avoid the hoses. The police, to keep the demonstrators in a single area, rushed forward with dogs, which lunged at anyone within range and bit three teenagers badly enough to send them to the hospital. Photographers and television crews witnessed and recorded every move.

The reports of that day, and especially the images, set off a chain reaction of protests around the world and affected the movement's course. Television news programs had film of dogs hurling themselves against their leashes, even of one dog tearing a man's clothes, and of people hiding from the hoses behind trees, rolling on the ground before the powerful jets of water, or dancing in defiance. In the late 1950s and early 1960s, lightweight, easily handled 16mm camera-and-sound equipment replaced the standard bulky, hard to maneuver cameras and changed the nature of on-the-spot reporting. The film of Birmingham was frightening, chaotic, and a little confusing, with a background of dogs barking and people screaming.

The papers the next day delivered an even bigger jolt—front-page photographs that stopped the action at critical moments. At breakfast horrified readers could stare endlessly at police tactics so barbaric that most people assumed they could not occur in America. The *New York Times* of May 4 printed three large photographs atop one another on the front page. The picture of a policeman holding a nicely dressed young black man who neither grimaced nor resisted while a German shepherd lunged for his stomach had the topmost place (see frontispiece). Beneath that was a picture of demonstrators cringing against a wall as a stream of water tore into them, and below that was a picture of a "Freedom Walker" being arrested as he crossed the Alabama state line. On an inside page was a picture of a man holding a knife as a dog reared up against him. The picture of the dog about to bite a man's stomach also appeared across three columns on the front page of the *Washington Post* and in hundreds upon hundreds of other papers, along with variants of the firehose pictures. On an inside page the *Washington Post* printed a photograph of young people seated on the sidewalk, holding the backs of their heads as they'd been taught in nonviolence training, while water pounded against them. There were other photographs of the attack dogs.[34]

These photographs, but especially the picture of the lunging dog, had an immediate and stunning impact. By May 1963 it was impossible to be unaware of southern racism, but these images seemed to raise the temperature of inhumanity several degrees. The irresistible force of the water and the bestial dogs turned on young people by officers of the law struck Americans as savage and cruel. Racism had been an abstract idea, an *ism* like socialism or unionism. The photographs gave this abstraction a visible image, which was easier to hate than an idea. The morning the photograph of the lunging dog appeared, President Kennedy told a group from Americans for Democratic Action that the picture made him sick. Two days later Senator John Sherman Cooper, Republican of Kentucky, said in the Senate, "The use of

Birmingham, Alabama;

Negroes Take Refuge in

Doorway as Firemen Pour

Water on Them to Break Up

a Racial Demonstration,

May 3, 1963

UPI/Bettmann, New York

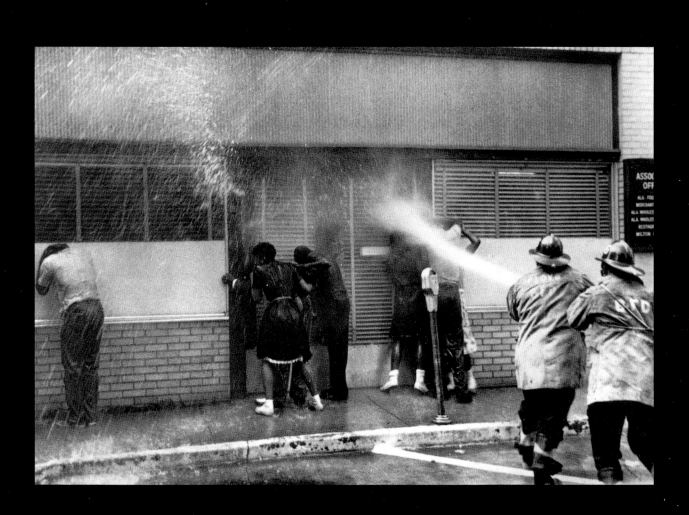

dogs against human beings . . . just seeking their constitutional rights . . . is reprehensible," and Senator Wayne Morse, Democrat of Oregon, said the spectacle in Birmingham "would disgrace a Union of South Africa or a Portuguese Angola."[35] Many Americans wrote letters to their newspapers about how appalled they were to see dogs attacking innocent people.

Within forty-eight hours of the front-page publication of the lunging-dog photograph, money began to pour in to the Southern Christian Leadership Conference (SCLC), with which King was affiliated. Three weeks later, when King spoke at a rally in Los Angeles's Wrigley Field before a crowd that included a number of Hollywood luminaries, the audience held in their hands little pamphlets with a snarling police dog on the cover. King collected seventy-five thousand dollars that evening and almost seventy thousand more at speaking engagements in five other cities.[36]

Among African-Americans everywhere, the sight of police dogs with fangs bared against men, women, and children prompted an instant sense of vulnerability, much as Emmett Till's picture had among the young. The pictures of the police dogs ignited the anger and hate that had been building in response to attacks and murders in the wake of court-ordered integration. Now for the first time, poor blacks broke out of their traditional apathy and fear. Within days there were riots in Birmingham, with bricks and bottles thrown at the police and buildings set on fire. These riots, by people who had not been trained in nonviolent tactics, were almost as hard for King and his colleagues to control as for white officials. The conflict in Birmingham stirred up similarly downtrodden communities across the nation. In the ten weeks after Birmingham exploded, the Justice Department reported at least 758 demonstrations in 186 cities, north and south.[37]

Charles Moore (born 1931)

Dog Tearing Pants of Man,

Birmingham, Alabama,

May 4, 1963

Charles Moore/Black Star

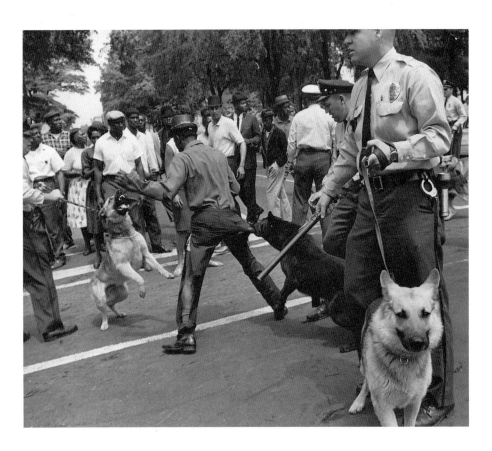

Andy Warhol (1928–1987)

Race Riot, 1964

Acrylic and silkscreen

enamel on canvas, two

panels, 114 × 164 in.

(289.6 × 416.6 cm), overall

Leo Castelli/© 1991 The

Estate and Foundation of

Andy Warhol/ARS,

New York

The change in the civil-rights movement was obvious. *Newsweek* wrote: "Everywhere plain signs arose that Birmingham had thrust the whole U.S. racial problem into a new phase—more intense, more flammable, more urgent. . . . Wherever the problem of race festered, the name of Birmingham was invoked as a warning, a symbol, and an epithet." One historian, pointing to the pressure applied on the president from the moment the photograph of the lunging dog appeared, plus the sudden surge of support for civil-rights organizations, cites the publication of this picture as the moment when the "new Negroes" emerged as a cohesive and powerful social force.[38]

Bull Connor fanned the flames he had ignited. On May 7 he ordered the firehoses used yet again. All the cameras were at the ready. This time the Reverend Fred L. Shuttlesworth, head of the Alabama Christian Movement for Human Rights, was injured. Connor arrived just afterward. "I waited a week to see Shuttlesworth get hit by a hose," he said. "I'm sorry I missed it." When he heard that an ambulance had taken the minister to the hospital, he said, "I wish they'd carried him away in a hearse."[39]

The neatly timed fugue that the weekly news magazines played with the daily papers soon brought the photographs to public view again. *Time* and *Newsweek* both ran the picture of the attacking dog once more. *Life* ran an exclusive set of photographs by Charles Moore—powerful, concentrated versions of events that had already proved their power to shock.[40]

Moore had resigned as chief photographer for a Montgomery paper the previous August. But the Alabama police assumed he was still there and,

207

knowing that a southern paper was less of a threat, they let him go where he wanted, so he could get closer than anyone else in the toughest moments.[41] His picture of a dog attacking a man is even more dramatic in outline and incident, more highly charged with coiled tensions, than the Associated Press picture that had been on so many front pages. (And it went into homes in small towns throughout the South that might not have printed all the news pictures in the papers.) In the middle distance a man is spread-eagled between ravening dogs, one leaping up with mouth open and teeth gleaming, the other tearing at his trousers from behind. One trouser leg has been ripped open from hip to ankle in an earlier assault. This terrifying image of brute attack from two directions at once, the symmetry of the leaping dogs emphasized and repeated by the man's widely spaced legs, is made all the more fearsome by the large figure of a policeman cutting across the front plane of the picture and holding another dog at the alert, heading straight for us.

Life featured Moore's pictures of people pinned down by the firehoses and printed other pictures of the German shepherds viciously going after blacks. The text quoted Bull Connor ordering his men to let white spectators approach: "I want 'em to see the dogs work. Look at those niggers run." Life's vast circulation, the large size and high quality of its reproductions in comparison to a newspaper's, the large number of pictures printed, each reinforcing the other and expanding the narrative to the semblance of a connected report—combined with Moore's quick reflexes, keen eye, and strong sense of drama—made the essay a heightened summary of the events.

The graphic power and immediacy of Moore's images ensured them a permanent place in readers' minds. Andy Warhol, who had an unerring eye for the key images of his time, made paintings and prints based on Moore's photographs of the man attacked by two dogs. In 1964 the American Society of Magazine Photographers gave Moore an award for his coverage of violence in the South. Presenting the award, Senator Jacob Javits, Republican of New York, spoke about the influence that photographs had exerted on the nation. "I know of nothing which has more keened the American people to the moral implications of the struggle called the struggle for civil rights, than the photographs which the American press and magazines have shown of actual events on the southern front. . . . It is only because pictures backed up the words, no matter how authoritative, that [this injustice] has been credited." Javits believed that the Senate, for the first time in its history, would soon vote to end a filibuster on a civil-rights bill—as indeed it did, partly in response to the impact made on voters by such photographs. A quarter of a century after Javits spoke, Moore received the first Kodak Crystal Eagle Award for Impact in Photojournalism for his civil-rights pictures. This was the first award ever given "to honor a photojournalist whose coverage of a vital social issue has changed how people live or what they believe."[42]

Reports and photographs of Birmingham received extensive coverage abroad. The dogs and firehoses were seen and condemned from Britain to France to Russia, Asia, and Africa. In May, when President Kennedy sent a message about free-world unity to a summit conference of independent African nations, Prime Minister Milton Obote of Uganda officially protested against the use of firehoses and "snarling dogs" in Birmingham. Jet reported in June that an American doctor who had returned from a year as a visiting professor in Tokyo said that "pictures of a Birmingham policeman kneeling on the throat of a Negro woman and a police dog chewing at the vitals of a Negro youth" were contributing to damage in American–Japanese relations. A foreign correspondent wrote in the Catholic magazine America that the

leading Indian papers had tried to exercise restraint but "they have had to run their headlines and report their gruesome bashings; they had to print those ghastly photos on their front pages."[43]

In July, New Jersey Democratic Representative Pete W. Rodino told a House committee that when he attended a conference in Geneva, "The incident of the police dog attacking the Negro in Birmingham was printed all over the world. One of the delegates from one of the nations represented at the conference there showed me the front page of the European edition of the *Times* and he was a little more frank than some of the others, and he asked me, 'Is this the way you practice democracy?' And I had no answer."[44]

President Kennedy and his advisers were acutely aware of the damage being inflicted on America's reputation abroad and on the country itself. On May 20 and 21 Kennedy met with his cabinet to discuss the repercussions of Birmingham, then met with his close political advisers. The future seemed to hold little but more Birminghams. The decision was made to press for a Civil Rights Act. On June 11 the president spoke to the nation on television proposing that discrimination be outlawed in places of public accommodation, in union membership and employment, in state programs receiving federal aid. "Are we to say to the world—and much more importantly to each other," he asked, "that this is the land of the free, except for Negroes; that we have no class or caste system, no ghettos, no master race, except with respect to Negroes?"[45] The bill was passed a year later. Reports from Birmingham had not only pressed Kennedy to take the lead, they had convinced many citizens and elected officials that the federal government should intervene.

Historians have detailed the extent to which the Birmingham confrontations were designed by black leaders to attract media attention. Martin Luther King and the SCLC's most recent campaign, in Albany, Georgia, had failed to attract national publicity and therefore made little headway; a media-wise sheriff had refused to crowd the jails or provoke any newsworthy confrontations. Birmingham was very carefully chosen. If this symbol of implacable segregation could be forced to change, other doors might open in the South. Bull Connor's hair-trigger temper and intransigence were well known. Wyatt Walker, executive director of the SCLC, later said, "We knew that when we came to Birmingham that if Bull Connor was still in control, he would do something to benefit our movement."[46]

No one had planned for the dogs, but many in the movement recognized what their effect would be. After the dogs were first brought out on April 7, James Forman, chairman of the Student Non-Violent Coordinating Committee, was appalled at the reaction of two SCLC members, who "were jumping up and down, elated. They said over and over again, 'We've got a movement. We've got a movement. We had some police brutality. They brought out the dogs. We've got a movement.' " But by the end of April the press had all but vanished from Birmingham, and it was then that the decision was made to call for student demonstrations. The publicity campaign was masterful. Wyatt Walker later said, "There never was any more skillful manipulation of the news media than there was in Birmingham."[47]

The events there convinced King and the SCLC that national publicity could enlist the federal government, and possibly federal legislation, on their side. Ever after, King had a keen sense of the uses of photography. One photographer who photographed extensively during the civil-rights upheaval recalled that on a march when a policeman started beating up children, it was too much for him, and he waded in. King took him aside and said: "Unless you record the injustice, the world won't know that the child got beaten. . . . I'm

not being cold blooded about it, but it is so much more important for you to take a picture of us getting beaten up than for you to be another person joining in the fray."[48]

Connor's usefulness to the movement was recognized immediately. *Life*'s report of the assault with dogs and firehoses said, "If the Negroes themselves had written the script, they could hardly have asked for greater help for their cause than City Police Commissioner Eugene 'Bull' Connor freely gave." In June, when Kennedy met with black leaders about a projected march on Washington, he said to them: "I don't think you should all be totally harsh on Bull Connor. After all, he has done more for civil rights than almost anybody else." But Connor may have had his own media plan. Some in the movement thought he was looking for publicity himself because he wanted to run for state office and needed the hard-line vote.[49]

The media, and perhaps the photographic medium and its derivatives most of all, have been exploited ever since their power was first recognized. (*Exploit* is another of those words like *propaganda*. Originally it meant to act with effect; then to turn to account; then, in the nineteenth century, to utilize for selfish purposes. By 1868 "the exploitation of the credulous public" was spoken of. By now the word has almost entirely negative connotations, but whether it is forgivable rather depends on whose ox is being exploited.) In the late nineteenth century, when the French press finally realized that a group of royalists was holding demonstrations and provoking incidents precisely to get media attention, the papers refused to print photographs of one of the provocateurs, although eleven photographers had taken his picture.[50] The carefully crafted media event is the child of the media's coming of age.

If the still camera elicited actions designed to look dramatic in photographs, the newsreel camera upped the ante. A historian suggests that "by the late 1930's and the early 1940's, many scheduled events, such as political appearances, conventions, and campaigns were staged by their protagonists in such a manner as to conform to the requirements of newsreel coverage." In the television era, election campaigns and some aspects of national government have been reduced to photo opportunities. Recurrent accusations have been leveled against photographers for unwittingly encouraging incidents of torture, execution, and rioting in many areas of the world. Sometimes the atrocities are thought to have taken place chiefly because there were cameras at the ready: British journalists say the sudden and callous murder of a captured Biafran during the Nigerian war of 1968 was probably carried out for the benefit of television; several photographers left an execution site in Bangladesh in 1972 because they suspected the event was being staged for their cameras.[51]

The civil-rights movement, which took fire at the moment that television was poised to become a worldwide medium, was the first to recognize how much a cause stood to gain by massive, global exposure in the press and on television. The lesson was quickly learned. The American antiwar demonstrations of the 1960s owed a good deal to the example of the civil-rights struggle. John Chancellor's warning to that menacing group at the Till trial in 1955—"The whole world is going to see what you'll do to me"—turned into "The whole world is watching" in Chicago in 1968, when demonstrators spontaneously began chanting that line to the police who were cracking heads outside the Democratic national convention. And on it went, and goes on still: the demonstrators in eastern Europe and in China at the end of the 1980s followed the example of the antiwar movement and courted the international picture press and especially television. In China some of the signs the students

held aloft were written in English.

One limited experimental study of the civil-rights photographs suggests that photographs of aggression do not inevitably prompt condemnation; they do so only when the attackers are perceived as *unjustly* aggressive.[52] The pictures of young people pressed to the wall by powerful firehoses or attacked by dogs were easily understood as exemplifying overwhelming force against victims poorly equipped to fight back, especially when King's nonviolent tactics had been widely publicized. The news reports had also made clear that the demonstrations were peaceful and the victims were children.

The photographers, the TV cameramen, the northern press in general were appalled by circumstances in the South and generally reported the black cause sympathetically. Whites like Bull Connor made that relatively easy. As always, forceful repression made dramatic photographs; deliberate negotiations seldom did. A picture of a law officer bashing heads with a billy club or barely restraining a ferocious dog delivered a major story at a glance and had a good chance of being published in the papers.

Since the mainstream press is predominantly (and at that time was almost exclusively) white, the point of view of white photographers influenced the reactions of the white audience. Henry Hampton has written about the position of the television cameras over the course of the movement and how that affected reception of the news. (His observations would apply to still cameras as well.) In the beginning, he says, cameras reporting the Supreme Court decision in the Brown case and the Emmett Till murder "record basically a white point of view, showing the black characters sympathetically and the white racists as they were." As the South moved more and more violently against citizens seeking their constitutional rights, the cameras took up the same positions as the marchers and often stared directly at officers and crowds that were out for blood.[53]

Southerners knew immediately that northern media reports were damaging, and by the early 1960s it was simply assumed that the northern press was against them. Some claimed the photographs were faked. In one town in Georgia, whites referred to the television networks as the Negro Broadcasting Company, the Color Broadcasting System, and the Afro Broadcasting Company.[54] News photographers, like news reporters generally, had long been expected to report objectively, and they long expected it of themselves. In the 1960s that began to change. First in the civil-rights conflict and soon in Vietnam and at the antiwar demonstrations in America, photographers found themselves taking sides—in some cases changing sides—because of what they had seen. Feeling ran so high that it was hard to keep a point of view out of the viewfinder, or at least out of the choice of subjects. Few photographers had ever been wholly without preferences or opinions or political convictions; they had only tried to photograph as if they were. Now the entire culture was moving toward a more subjective stance. The Beats and other postwar literature, the photojournalism of W. Eugene Smith, the street photographs of Robert Frank at the end of the 1950s, the journalism of Hunter S. Thompson and Tom Wolfe in the 1960s, all placed a premium on personal feeling, individual reaction, and the subjective interpretation of what appeared to be hard fact. The sympathies of photographers who covered the civil-rights conflicts were evident in the pictures they sent back.

But after Birmingham the movement began a gradual shift to a more militant stance. Over the next couple of years, more aggressive and activist leaders than King moved in, "black power" became the cry, and peaceful marches shared the news with explosive riots. The point of view changed

again. Now the press reported on blacks initiating violence, and by 1967 the cameras had taken refuge behind the police lines and were picturing the fury of black mobs.[55] The images subtly but unmistakably sent another message.

Both in custom and in law, there is a tendency to be more cautious about photographs than about written descriptions of the same experiences. The United States Supreme Court allowed James Joyce's *Ulysses* to be sold in bookstores across the country decades before photographs of sexual scenes explicitly described in that book could be sent through the U.S. mail. Photographs, which seem both more immediate and more dangerous than words, raise the issue of good taste and bad at a glance. Sensational photographs were so closely identified with the tabloids for so long that almost all a newspaper had to do to appear respectable was to limit the number of photographs of any kind on its pages.

Judgment of what is acceptable in newspaper publishing has changed over the course of this century, for the most part following the increasing permissiveness of society in general. But the question is still very much alive, and the answer varies from place to place, paper to paper, editor to editor. Editors have a good deal to say about what is and is not news. The greatest and most important news photograph can make no more noise than a tree falling in a distant forest if it is not published. In the case of Malcolm Browne's picture of a South Vietnamese Buddhist monk immolating himself in 1963, some papers would not publish the image on grounds of impropriety.

Browne's series of pictures of the event was unique; he was the only Western photographer there. That day, one of his images went out over the AP wire. The *New York Times*, although it thought the story sufficiently newsworthy to publish, decided the photograph was unfit for the breakfast table. The *Chicago Tribune* also reported the story (on page 3) but did not publish the picture; the *Los Angeles Times* ran the picture large, but on an inside page.[56] Television cameramen had not covered this suicide-protest against religious repression, but other monks later sacrificed themselves in further protest, and coverage was never again lacking. (In Ingmar Bergman's film *Persona*, a mental patient who has withdrawn from the world watches an American newscast in mounting horror as a seated figure is consumed in flames.)

Most publications, faced with an image of such undeniable force, the visual record of an event almost incomprehensible to Western minds, chose not to worry about the propriety of this picture. The editor of a Syracuse paper reportedly said that any editor who wouldn't run that photograph wouldn't have run a story on the crucifixion. *Life* gave the photograph a full page, *Time* reproduced it, newspapers and magazines all over the world ran it.[57] A group of American clergymen took out full-page ads featuring the photograph in the *Washington Post* and the *New York Times* (which thus ended up publishing this improper picture larger than it would ever have printed it on its own) with the caption "We, too, protest." American editorialists and commentators voiced shock and dismay.

South Vietnamese President Ngo Dinh Diem's Catholic regime had a history of Buddhist repression. A month before this immolation, police had broken up a nonviolent Buddhist protest, and eight people had been killed. Buddhists, who constituted 80 percent of the population, began to demonstrate all across the country. According to the photographer, key Buddhist leaders were fully aware that the Western press was crucial to their efforts; Diem exercised fairly tight control over South Vietnam's press, and United States authorities there tacitly agreed that too much publicity about the Bud-

Malcolm Browne (born 1931)

Quang Duc Immolating

Himself, June 11, 1963

AP/Wide World Photos,

New York

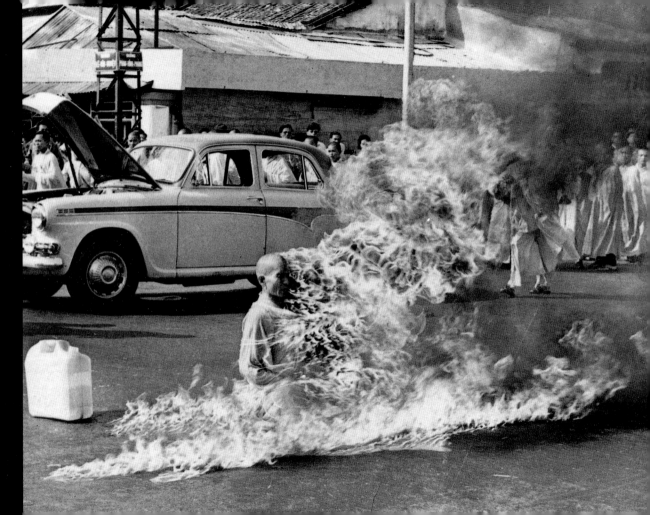

dhist crisis could impede the government's American-backed efforts against the Vietcong. At demonstrations, the signs would be in English, although the monks could not speak it.[58]

The chief monks had alerted correspondents in Saigon that two monks had volunteered to sacrifice themselves in protest if Buddhist demands were not met. But street demonstrations went on without incident until the press lost interest, and only Browne showed up on June 11 when seventy-three-year-old Thich Quang Duc sat down inside a circle of nuns and monks in the middle of a busy intersection, waited calmly while two monks poured gasoline over his head, then struck a match, lit his robes, and burned to death without uttering a sound.

Browne, an AP photographer, later said he did not photograph this event for political reasons but because it was his job to report the news, a profession he believes prohibits political involvement. "I had no point of view," he said. "I was concerned that [the photographs] be properly exposed, but since the subject was self-illuminated that wasn't much of a problem."[59]

Whatever his motivation, Browne's pictures, and subsequent reports, played a role in Vietnamese history. His photograph of Quang Duc was an early marker of the power of photographs to play a significant role in the Vietnamese conflict. Repression of Buddhism had already been written about extensively in the West, but the photograph galvanized feelings as words had not. Henry Cabot Lodge said, "No news pictures in recent history had generated as much emotion around the world as that one had." The Diem government, conscious of how badly it had been damaged by the publicity, clamped down ever harder on the press. (Mme Nhu, Diem's sister-in-law—who asked the American ambassador if Browne had bribed the monks to murder one of their fellows—later referred to this and subsequent suicides as a "barbecue," complained of a lack of self-sufficiency on the part of monks who had to use imported gasoline, and offered to supply a match if certain Western reporters would follow Quang Duc's example.) It became so difficult to get news out of Vietnam that correspondents resorted to smuggling. The government began arresting Western photographers and insisting they expose their film. The *New York Times* reporter David Halberstam was beaten when the police realized that a television cameraman filming another immolation had surrendered a false roll to them and secretly passed the actual pictures to Halberstam. The South Vietnamese government let it be known that it had a list of correspondents who were marked for assassination.[60]

Buddhist leaders in Vietnam had Browne's picture blown up and hand-colored to be carried in processions as the demonstrations continued. Crying men and women bowed down in prayer before it. The Communist Chinese reprinted it in great numbers for distribution in Southeast Asian countries with a caption describing the suicide as the work of "U.S. imperialist aggressors and their Diemist lackeys." (Clearly the picture's shocking impropriety had its uses. Clearly the meaning of a photograph can be radically changed by a caption.) Similar suicides were reported all over Asia. Browne said he received letters telling him that "back-alley vendors of 'feelthy pictures'" were selling copies of his photographs in places like Lisbon and Dar-es-Salaam.[61]

American attitudes toward Diem were hardened by this stupefying visual evidence of harsh religious repression. Browne was told that when Henry Cabot Lodge was called in to speak to President Kennedy about assuming the ambassadorship to Vietnam, he saw the photograph of Quang Duc on Kennedy's desk. Browne himself, however scrupulously apolitical his stance, was entirely conscious of the political impact of his picture. "Had a western

newsman with a camera not been present at Quang Duc's suicide," he wrote, "history might have taken a different turn."[62]

The photograph, and subsequent televised immolations, reverberated in other ways. In 1965 Norman R. Morrison, a Quaker and critic of the war, burned himself to death before the Pentagon. The North Vietnamese issued a stamp with Morrison's picture on it. In 1969 a Czech student named Jan Palach immolated himself in Prague to protest what the 1968 Soviet occupation had done to his country; in 1990 the Czechs renamed Red Army Square for him. Quang Duc himself is still honored in South Vietnam; there is a shrine to his memory, and Browne's picture is still on display in many homes.[63]

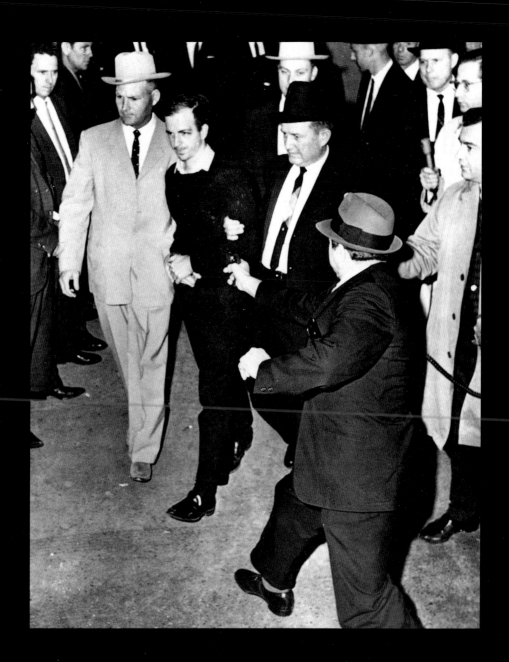

Jack Beers (1923–1975)

Jack Ruby Shoots Lee Harvey Oswald, November 24, 1963

AP/Wide World Photos, New York

NEWS PHOTOGRAPHS AS CATALYSTS

THE TELEVISION ERA

New technologies do not necessarily drive out the old, nor do new means of picturing the world wipe the old slate clean. When stereographs grew popular, the old-fashioned photograph was not taken off the wall; when movies came in, movie buffs did not give up their family albums. Television may dominate a dismaying number of the day's hours, but it has by no means slowed the march of stills, which advance on us from every side. During the 1960s still photography and television news played off one another, boosting the power of images yet another notch.

The history of television news rapidly recapitulated the history of photography. In the beginning there was only a live portrait of the news announcer. Within a year he (it was always *he* then) added still pictures of events, sometimes held in his hand. Film was soon brought in and after that live broadcasts. Television producers purposefully tried to incorporate the power of the print media within their own medium. When Roone Arledge initiated ABC's "Wide World of Sports" in 1961, he introduced slow motion, the instant replay, and the freeze frame in an effort to match the capacity of movies and magazines to capture a dramatic moment.[1] Television continues to slow down the action and to show stills when moving pictures are not available, which is no longer so frequent. On the other hand, the recent trend toward shorter articles; the increase in photographic illustration, much of it in color; and the abrupt juxtaposition and jazzy overlaps of images in some magazines are attempts to compete with television by adopting its means. The world now has a built-in expectation that everything should move as fast as television does.

The first stages of national television hookups were in place by the early 1950s. In January 1961 the first live telecast of an American presidential news conference went on the air; in 1962 another was partially broadcast live to Europe on the pioneering communications satellite; and in June 1963, when Kennedy went to Europe, film was relayed back to the U.S. by *Telstar II*.[2] (Kennedy was the first president to play television for what it was worth, but TV was not quite ready to give him the kind of coverage it would shortly deliver.) By 1963 television could claim priority; it would usually precede the accounts of breaking news in the morning papers. (Then, as now, television took up to 90 percent of its news from the print media, but it still had that critical 10 percent.)

The TV audience grew at dizzying speed. In 1953 there were twenty-one million sets in America; in 1957, forty-two million; in 1960, fifty-four million. When Kennedy held his first live press conference in 1961, the audience was

217

estimated at twenty-four million people. Television already had the power to deliver a larger *simultaneous* audience than any other medium, but if the measurement was taken over time, the magazines did better. By 1950 *Life*'s estimated audience amounted to sixty-two million people who saw one or more issues over a period of three months—over half the American population ten years old or older. If this estimate is correct, then as *Life*'s circulation approached seven million in 1961, its extended readership would have reached at least eighty-two million. The magazine's circulation continued to grow until 1969.[3] Photographs still had an edge in the distribution network. The wire services also made certain images visible nationally, even internationally, in thousands of newspapers with many millions of readers.

Photographs had additional advantages. The most important images would be regularly repeated at well-spaced intervals, giving them far more opportunities to etch their outlines on memory. In 1963 many people took both a morning and an afternoon paper; a major photograph would appear in both. The Sunday paper often republished it. The weekly news magazines—many households subscribed to more than one—followed a few days later, often with better reproductions. Once an image appears in a magazine or a book, it is instantly retrievable. The owner of a printed image has control over the timing and duration of its appearance; the owner of a television does not. (Such recent developments as the VCR, CNN, and continuous crisis coverage like that at the outbreak of war against Iraq in January 1991 have all altered the potential for repetition of television imagery, cutting into but not cutting off photography's advantage in this area.) Even magazines that a subscriber throws away tend to hang around; at idle moments, in doctors' offices and barber shops, a photograph comes to view again. Like a film, a photograph can make you nervously avert your eyes out of fear, or disgust, or the excessive pleasures of voyeurism. But when you steal another look, the image is still there, offering itself to your guilty curiosity, whereas the videotape long ago zipped by on a pulse of electrical energy.

Television viewers habitually pay only partial attention. They read or iron, they exercise or talk while watching. A photograph has at least a better chance of winning a concentrated look. As long ago as 1859 the English photographer Francis Frith thought photographs could give a better insight into a scene than actual experience did: "Very commonly, indeed, we have observed that these faithful pictures have conveyed to ourselves more copious and correct ideas of detail than the inspection of the subjects themselves had supplied; for there appears to be a greater aptitude in the mind for careful and minute study *from paper, and at intervals of leisure*, than when the mind is occupied with the general impressions suggested by a view of the objects themselves, accompanied, as inspections usually are, by some degree of unsettlement, or of excitement, if the object be of great or unwonted interest."[4] This may be one of the first declarations that photography is better than reality, a dubious proposition at best, but the still photograph does preserve details better than most minds and most memories of a rapidly moving event.

Experience suggests that although television news has produced many memorable moments and exerted untold influence, photographs are, by and large, more fully and easily remembered. Just as it is simpler to memorize a proverb than an essay, so it is easier to recall one moment than a string of fifty frames. The human mind has only a limited ability to remember motions. We recognize the gait of people we know, but extended sequences of motions are hard to retain with any precision. (We think we recall more, because imagina-

tion readily re-creates actions, with varying degrees of accuracy.) In general, memory entails recalling details of form and position that are available only if an object is static. Once you have read a page of text, you can recognize it for the next three or four weeks, but not if you saw it only in motion and could not read it. The static presentation the photograph offers is simply better suited to the procedure by which we store images in memory.[5] (Movies give extra clues for recall, including plot.)

Like a person, a still photograph can be famous for being seen in all the right places. This kind of fame feeds on itself. Editors reach for the picture automatically, knowing that a well-known photograph will make their point easily; it then becomes even better known. There is a certain power in redundancy. Walter Benjamin, in "The Work of Art in the Age of Mechanical Reproduction," said that the photograph would destroy the aura of the unique work of art, but photography itself confers a new kind of aura. The work of art that is photographically reproduced in every textbook has greatness stamped upon it through mere repetition in an authoritative context, and the photograph that is repeated often enough can become both symbolic and essential.

Yet wide distribution is not enough to guarantee catalytic power. Some photographs, seen over and over, become part of the historical baggage everyone totes around, but they make no other noticeable impression on the world. Bill Eppridge's moving photograph of Robert F. Kennedy dying on a hotel floor in Los Angeles in 1968 can still call up grief, but it did not measurably affect the election (although the killing obviously did) or help pass anti-handgun legislation. Similarly, a photograph of a hooded terrorist on a balcony at the 1972 Olympic Games in Munich is packed with menace, but the picture's emotional force never translated into any kind of action.

According to a Roper survey of American attitudes toward television from 1959 to 1976, 1963 was the first year in which respondents cited TV as their number-one source of news, by the close margin of fifty-five to fifty-three over newspapers. That margin increased in each successive year of the survey, but in 1963 the race was still neck and neck. Society persistently clung to long-established habits of acquiring information through newspapers and magazines. From 1961 on, TV was named the most believable of the mass media, but the circulation of the big papers continued to grow. The Roper survey may not have taken adequate account of some of the twists and turns in the public's trust in television, and it has been criticized for overestimating the popular reliance on television for news,[6] but 1963 was undeniably a year of change. NBC and CBS both expanded their evening news reports from fifteen minutes to half an hour in September of that year, immensely bolstering the importance of the news. (ABC, which was much smaller, did not follow until 1967.) Limited satellite transmission between Europe and America began in 1962 and expanded somewhat the next year.

However, as the survey notes, in 1963 and for nine years afterward newspapers were still the main source of news for the college educated, who supply most of the nation's leaders, educators, elected officials, and commentators. The influence an image exerts depends not just on how many see it but also on who they are. President Kennedy said he felt sick over a photograph of Birmingham he'd seen in the paper, not on television, and protests from abroad focused on the still images.

Two years later many members of Congress first learned about the civil-rights campaign in Selma, Alabama, from the *Washington Post* or the *New York Times*. (Elected officials had grown up with newspapers, not television.) Yet during the two months of demonstrations and confrontations in Selma,

television finally proved itself crucial even to this influential group. One writer has traced six dozen congressional references to news sources and public reactions to those sources over this period; the majority of the references were to newspapers, and, interestingly, most referred to the photographic coverage rather than to the written reports. After Bloody Sunday, when the Selma police galloped on horseback with flailing clubs through a crowd of fleeing demonstrators at the Pettus Bridge, the references were mainly to television films of the attack. TV had begun edging into the territory staked out by newspaper reports and still photographs.[7]

Not that photographs lost their power; they did not. Even today a single image can strike the heart harder than any kind of broadcasting. But by 1963 the still photograph was sharing the world's stage with the television camera, and the two would have little choice but to interact. The turning point came in the fall of 1963, when President Kennedy was assassinated; after that the question of how news is distributed, received, and perceived must include the new medium as well.[8]

President Kennedy's assassination took place at a moment when the entire globe was becoming electronically interconnected, and the news spread faster and farther than any in history. The shots were fired in Dallas on Friday, November 22, at 12:30 Central Standard Time. Radio and TV interrupted their soap operas and other daytime programs for bulletins. Radio, especially car radio, was probably the prime source of information, but the news raced across sidewalks and telephone wires—the phone system in New York City was so swamped with calls it blacked out. By one o'clock, when the president was pronounced dead, 68 percent of adult Americans had heard the news. An hour later, 92 percent knew, and by six o'clock, 99.8 percent. Polling organizations say it is extremely rare for more than 80 percent of the public to know *any* kind of news; there is always an ignorant remnant. Yet by noon on Saturday 99 percent of the population of Athens, Greece, knew that John F. Kennedy had died.[9]

National television and radio networks and independent stations soon shut down all regular programming and canceled all commercials through Monday, when the funeral took place. For those four days television became the primary medium to an unprecedented extent. The Nielsen report on television viewing in America from November 22 to 25 said the average home tuned in for 31.6 hours; 166 million Americans (some reports say 175 million) in 51 million homes tuned in at some point, and one-sixth of those homes had the set on for more than eleven hours a day. Television spanned the globe. On Friday night, NBC sent a fifteen-minute news program on the assassination by satellite relay to Japan. Moscow had a five-minute report by Sunday. All of Europe and parts of Asia, twenty-three countries in all, received the news by satellite from America.[10]

Americans, even those who had never previously paid much attention to television, watched endlessly. The TV reviewer for the *New York Times* wrote, "The viewing ordeal was almost uncannily strange; a battle within one's self not to bear more and an uncontrollable hunger to obtain additional information."[11] The "terrible fascination" of the photographs of the Civil War dead had been transmuted to a different death in a new medium. An entire generation would have the same memories of Kennedy's funeral, acquired at almost exactly the same time, like a mass indoctrination in mourning. The electronic community had become a reality.

The news created a huge desire for every scrap of information in every

medium. Many papers and magazines put out extra editions; many set all-time sales records. Where satellite television could not yet reach, printed news became an urgent matter. In Munich, throngs that had waited a long time for first editions of the paper broke into scuffles when too few copies arrived; in Rio, news vendors frightened by the crowds called for police protection. Newspapers everywhere gave the assassination extensive coverage—on November 23 the *New York Times* devoted its first sixteen pages to it—and increased the usual percentage of space devoted to photographs. In twelve papers surveyed on Saturday, 35 percent of the assassination reportage was devoted to pictures, as opposed to 16 percent of other news. On a comparable Saturday the previous year, 19 percent of the news in these papers had been photographic.[12] These print images, some repeated from television, continue to flash through the mind: Lyndon Johnson, drawn with sorrow, being sworn in on Air Force One beside Jacqueline Kennedy in her blood-spattered suit; the president's three-year-old son saluting his father's coffin.

The images that would have the most explicit consequences were taken by an amateur. They had the gripping immediacy that was television's chief advantage but they did not appear on TV, and although important chiefly because they were motion pictures, they were seen by the public as single-frame stills. Abraham Zapruder's film of the president's motorcade just before and at the very moments when Kennedy was hit appeared in the November 29 issue of *Life*. The magazine published sixteen frames, showing both Kennedy and Texas Governor John Connally as they were hit and Jackie Kennedy crawling onto the trunk of the car to seek help (or, in some accounts, to retrieve a piece of the president's skull) and a Secret Service man leaping onto the back of the car to get her back to a safer spot.

The film is so graphic that *Life* edited out or retouched the bloodiest frames. Even though somewhat indistinct, the images brought the scene home with the force of a blow. On November 30 the *New York Times* published pictures from *Life*'s sequence on an inside page; on December 6 *Time* published four frames; on December 7 *Paris-Match* ran a series in color. *Life* could not meet the demand for the issue with Zapruder's pictures. Single copies sold for as much as ten dollars in San Francisco.[13] (The next week's issue on the funeral met a similar demand. People wanted some permanent record of the scenes they'd wept over during that fateful weekend. *Life* put out a special memorial edition combining the two issues; many magazines published memorial editions.)

Both ABC and NBC had opportunities to bid on the film after Zapruder had shown it to the police and before *Life* bought it. They did not do so. Two ABC employees saw it in Dallas; one said, "It's the greatest news film I've ever seen, but I think it would be in bad taste to show it." All three networks later said they might have aired the film had it been immediately available, when it would have registered as breaking news. But news is one of civilization's shortest-lived creations; it scarcely survives for twenty-four hours. By the day after the assassination, when the screen was filled with solemnity and grief, the film's explicit and bloody depiction of murder would have seemed grisly and sensationalist. Its value, as one writer points out, had changed from news to history. With history, tastefulness becomes an issue; the news by this time was becoming a little less delicate.[14]

The film soon entered another category: evidence. It was the only reliable eyewitness (the many others contradicted each other frequently) to have been there the entire time and thus be able to deliver unimpeachable testimony. The Warren Commission depended heavily on the film's visual testimony and on

calculations based on camera speed to prove there had been only one assassin, who fired from the Texas Book Depository. The conspiracy theorists relied on it equally to prove there had been more. Other evidence was also weighty: the medical examination in Dallas, autopsy reports in Bethesda, acoustical records, still photographs, eyewitnesses. Some saw in one frame of the film (or in photographs of the grassy knoll facing the car) a man with a gun, a face, a pointing gun, a dart gun, a head wearing a German army helmet. Photo analysis and time calculations eliminated the guns and the helmet but not the doubts.[15]

A counsel to the commission, who saw the original photographs and X rays in 1975, wrote that the conspiracy theories would have been demolished had the actual photographs been shown rather than drawings after them.[16] But this may be a controversy that mere photographs could never quell. The photographic record, once hailed as unassailable, here became the basis for conjecture. Where once the populace had marveled at photography's precise detail, now no one was certain how to interpret its ambiguous marks. If Eadweard Muybridge's photographs of motion had raised the question of whether photographic evidence was preferable to optical experience, these pictures dramatized the issue of how that evidence was to be read.

In 1966 Michelangelo Antonioni's *Blow-Up*, a film about a photographer, ran rings around this dilemma. The protagonist, who has some reason to believe that a murder has been committed, takes a picture that, when blown up, reveals an indistinct form that may or may not be a corpse. Seeing and believing have come unglued. The Kennedy assassination divided people into those who believe in conspiracy and those who don't; the investigations cast doubt on the evidence of the eyes, even on the evidence of the camera.

No matter how equivocal their evidence, film and photographs were still central, still crucial to the news. And at the moment of communal grief television, too, became indispensable.

In the middle of the long weekend of Kennedy's death, on Sunday, November 24, the accused assassin was himself murdered while millions looked on. Lee Harvey Oswald was being transferred from one Dallas jail to another at about eleven in the morning. One network had just switched from an update on the condition of Kennedy's ailing father in Hyannisport, Massachusetts, another had shifted from a studio report to Dallas.

Since 1951 television had taught viewers to consider an instantaneous move between cities a standard experience. This impression of being present at different locations in impossibly short order was a gift bestowed by photography. Stereographs and lantern slides had shown how it could be done in the middle of the nineteenth century. It became commonplace in movies, where it was clearly fictional, and in newsreels, where the time was always past, but television gave us the visual equivalent of that science-fiction staple the teleportation of bodies across space instantly and without effort.

In Dallas a crowd of reporters, photographers, and TV camera crews waited in a basement for Lee Harvey Oswald to be brought down for transfer. After Oswald and two detectives came out of the elevator, viewers saw a man lunge forward. A shot rang out. Oswald, visible only for an instant, cried out once and disappeared, then pandemonium broke loose. "He's been shot! He's been shot!" the announcer cried. "Lee Oswald has been shot. There is absolute panic."

Panic was almost the only thing that was entirely clear. Television viewers were horror-struck and incredulous. Had they really seen one man shoot another? It went by too fast to be certain, but the announcer's reaction made it

unmistakable. Oswald was not dead, but he would be shortly. Television ordinarily served a steady diet of murders for home consumption, but most people never witness and never expect to witness a real murder; they hope, without thinking about it, that they never will. Now life was imitating television, and it chose to do so on the very medium it was copying, as if existence had turned into some gruesome, fateful, cop show. It was stupefying to have reality copy illusion so faithfully.

The timing was unbearably close to Kennedy's murder, and the killing immediately raised questions about conspiracies, about the impossibility of answering all the questions surrounding the president's death, about the fate of a country trapped in a cycle of violence.

NBC broadcast the episode live. Less than a minute later CBS broadcast film made on the scene. ABC did not have a live camera on the spot but did have film. Their camera angle was better than that of the two live reports, but the film arrived after Kennedy's funeral procession had begun, and the network thought it inappropriate to air it right away.[17] NBC and CBS rebroadcast their footage time and again, sometimes in slow motion, while a reporter told viewers what to watch for in the confusion.

Within an hour of the shooting four out of five television sets in America were tuned in.[18] This was partly due to the enormity of the news, partly to the aura of immediacy and necessity that TV had acquired first with Kennedy's assassination and now with Oswald's. Later, television stations in other countries would also broadcast the tapes.

Many accused the media of contributing to the murder. The crowd of reporters, photographers, and camera crews had made the site hard to control; the clamor for access had supposedly forced the Dallas police to stage this transfer publicly despite warning that an attempt might be made on Oswald's life. Probably the police were more at fault for lax security, but the media's evident power and omnipresence, newly visible on TV, made the public uneasy.

No murder had ever been witnessed on TV as it happened, but there was a close forerunner. In October 1960, when Inejiro Asanuma, the Japanese socialist leader, was stabbed and killed on a public stage in Tokyo, television cameras recorded it. A mere ten minutes later the tapes were aired on Japanese television stations. In this instance also, a larger potential audience was available than could have been reached even a year earlier. In 1959, when the crown prince married, the rituals and festivities leading up to the wedding were televised live; ownership of television sets had increased from two to four million.[19] A riveting photograph of the murderer and his victim just after the assailant has pulled his sword out of Asanuma's body memorialized this assassination for the rest of the world.

Still photographs of Jack Ruby murdering Oswald also fixed an image in the mind more lastingly and precisely than television had been able to do. Two photographers caught graphic instants along the fleeting course of murder. Jack Beers snapped the shutter just as Ruby plunged out of the crowd with his pistol aimed at the prisoner. The approach (and the photographer's response) was so fast that neither Oswald nor the two detectives had yet noticed a man about to pull a trigger. (Someone in the crowd did. A man yelled, "Jack, you son of a bitch!"[20]) Photographs are tiny moments sliced from the flow of time. Every photograph is an artificial present; it implies a past and a future, a moment before and a moment after. Rarely has a photograph held the future in such suspension as this one does. The knowledge of how momentous the next few seconds would be makes this image seem to

have captured history holding its breath. The picture went out over the wire and was reproduced over and over—on inside pages of both the *New York Times* and the *London Times* on November 25, for instance—frequently in a cropped version that showed only the upper part of Ruby's body.

The other photograph, a mere fraction of time later, caught the moment when Oswald reacted to being shot. Chance is a major factor in the making of great news photographs. So many elements have to come together: being there, having the best angle, having an unobstructed view. Bob Jackson was not even certain he got the picture. He tried to take a second photograph immediately, but his equipment failed. By the time he got back to his paper, Beers's photograph was already out on the wire network.[21] But a tiny fragment of time had made the difference between imminence and occurrence, between danger and death.

This picture is often cropped in various ways to focus in on the central event; sometimes the detective on the left is cut out almost entirely. Oswald doubles up in pain at the center of the frame, the detective cuffed to his right hand recoils at the unexpected attack. In the cropped versions particularly, the picture is the perfect image of a murder: swift, painful, horribly fascinating, and viewed in stopped time like this, inevitable and deeply frustrating—

Yashusi Nagao (active 1960s)

Assassination of Inejiro

Asanuma, October 12, 1960

UPI/Bettmann, New York

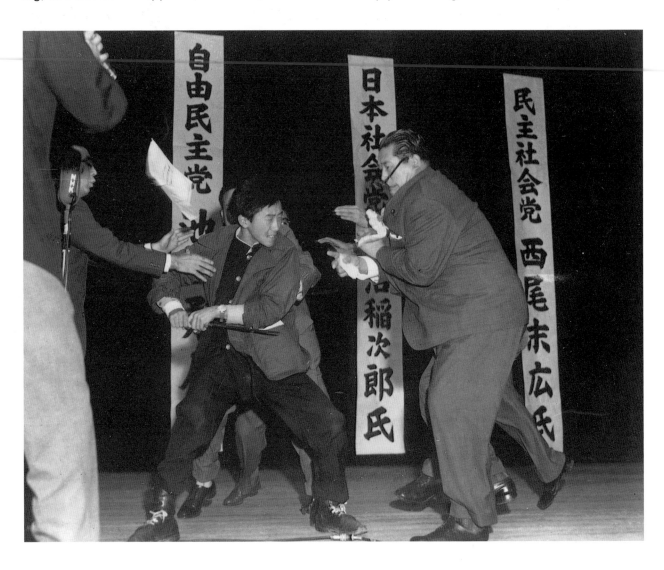

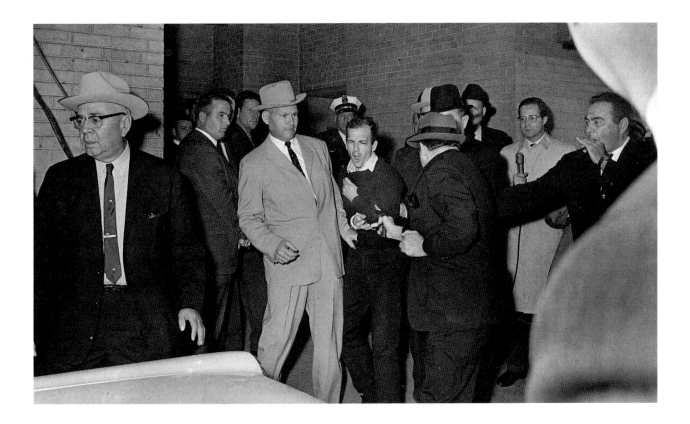

Bob Jackson (born 1934)

Jack Ruby Shooting

Lee Harvey Oswald,

November 24, 1963

© 1963 Bob Jackson

the cool and mesmerizing display of an event that changed history while millions watched helplessly. This photograph was printed large on many front pages; one or the other of the two pictures of the shooting appeared in papers across the world and was then repeated in magazines. Jackson won the Pulitzer Prize. His original still bears its press stamp dated November 22, 1963, although it was taken on November 24. Events unfolded so rapidly in Dallas that weekend that no one thought to change the date on the stamp.[22]

The Beers and Jackson photographs have had the standard advantages over television of standing still and of being repeated for weeks, months, years in books and memorial issues of magazines. They have an even greater advantage: both of them show the killing much more clearly than anything that flashed across the TV screen. They not only concentrate the moment, they reveal it. The TV tapes are as chaotic and confusing as the scene must have been to those who were there. They make clear what has happened but not exactly how. The television *experience* is unforgettable, the sense of having been implausibly present at a shocking and momentous event. But the photographs provide the details, and they give the mind images to hang on to.

For the first twenty-five years or so of television, TV gave still photographs an even greater importance. Television supplied the overview, photographs filled in the details. Because most events have no crystal clear progression as they are unfolding, viewers became all the more eager to have their impressions compressed and clarified into one image. In a sense, the TV footage set the stage for the photographs and made them necessary; in a sense, the photographs fulfilled the mission of the telecast.

The photographs of Ruby and Oswald established a pattern for stills and television tapes. Television would have the priority in time; still photographs, which had long preserved the look of actual events, would now make them

intelligible and anchor the memory of events witnessed in another medium. Sometimes the newspapers would excerpt one frame from a TV tape to explain what went by so fast. From November 24, 1963, onward, the influence of photographs would be inextricably tied to the influence of television, but by and large, throughout the 1960s photographs provided the more telling, the longer-lasting images of our history. After all the miles of television film that stuttered across the screen during the Vietnam war, the images that lodged in memory and held the center of the emotions were primarily still photographs.

No one is shocked any more to find death on the front page of the morning papers. Still, on February 2, 1968, it was profoundly disturbing to wake up to a photograph of a man putting a bullet into another man's brain. The victim's face was contorted by the impact; we were witnessing the instant of his death. Perhaps we had witnessed that moment once before, in Robert Capa's photograph of a falling Spanish loyalist in 1936, but that picture had not made the front pages of newspapers around the world.

Eddie Adams (born 1933)

General Loan Executing a

Vietcong Suspect,

February 1, 1968

AP/Wide World Photos,

New York

Eddie Adams's picture of South Vietnam's chief of national police, General Nguyen Ngoc Loan, summarily executing a Vietcong prisoner on the street in Saigon provided antiwar forces with a searing image. The picture outlasted the event, becoming a key memory and a potent symbol of a war that harshly divided Americans and left a bitter legacy. The initial power of this photograph was due partly to its far-flung distribution, partly to its timing.

The Tet offensive began on January 30, 1968. North Vietnamese and Vietcong forces simultaneously attacked major American and allied military bases in South Vietnam as well as most cities and towns, including Saigon, a presumed safehold. The first real jolt was the report that the American embassy in Saigon had come under attack; for a while it was not clear that the invaders had been repelled. On the afternoon of February 1 General William C. Westmoreland exuded confidence at a news briefing in Saigon, but within hours the images had upstaged him. That evening, on NBC-TV news, John Chancellor showed seven still photographs that had come over the wire service, including one of a South Vietnamese officer holding his dead child, murdered by the Vietcong. "There was awful retribution," Chancellor said, moving on to Adams's photograph. "Here the infamous chief of the South Vietnamese national police, General Loan, executed a captured Vietcong officer. Rough justice on a Saigon street as the charmed life of the city of Saigon comes to a bloody end."

The next morning the New York Times, in an effort to present atrocities on both sides, printed the picture of the execution four columns wide on the front page above the officer and his child, but then on page twelve printed the execution yet again, bracketed by photographs that Adams had taken of the prisoner before and after. The New York Daily News gave the execution the bottom half of the front page, the Washington Post printed it across five columns on page one, the Los Angeles Times gave it three columns, the Chicago Tribune relegated it to page three but printed Adams's three-photograph sequence of the killing. The central image was so powerful that newspapers of every political persuasion played it large. It was reprinted and shown on television all over the world.[23]

That evening both NBC and ABC aired film of the execution. NBC executives had found the footage so difficult to take that the network blacked out the screen for three seconds after the victim died, a move so unusual for TV news it surely increased the impact of the event. Local affiliates all over the country picked up the film and replayed it, then NBC distributed it to foreign

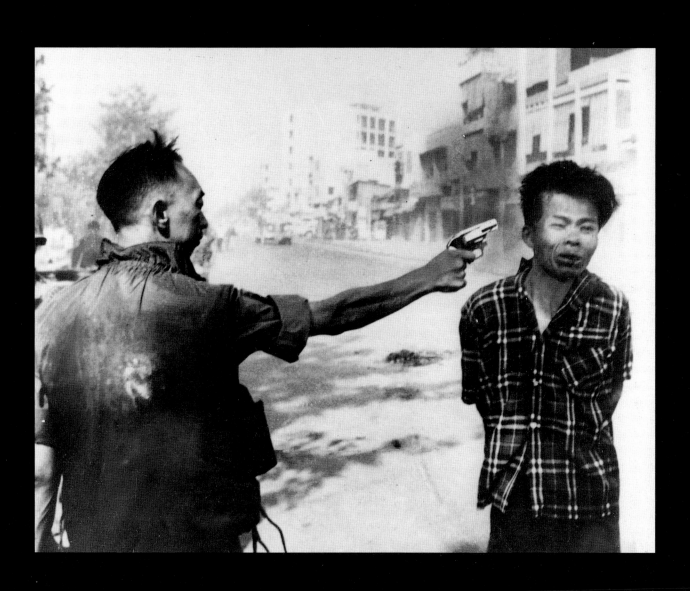

news organizations. (The BBC did not run the film but did show the photograph.) ABC had its own footage, but the film stopped just before the crucial moment of the shooting and recommenced with the dead body in the street. (The ABC cameraman, a South Vietnamese, later said he'd stopped the camera because he was afraid of General Loan.) ABC ran the sequence as far as it went, then cut to Adams's black-and-white photograph, then returned to moving pictures of the corpse. The photograph kept reappearing. *Time* and *Newsweek* both printed it again later that month.[24]

It was not only the power of Adams's image of an apparently casual and obviously brutal murder that kept this photograph alive. Early in 1962, when President Kennedy was increasing the number of American military advisers but U.S. ground troops had not yet been committed to South Vietnam, another American photographer had taken a photograph of a similar execution: a South Vietnamese soldier with his gun drawn, standing over a captured Vietcong prisoner he was about to kill. This photograph was published only once, in an obscure little magazine few people ever saw.[25] Neither editors nor audience was ready for it.

The Tet offensive came hard on the heels of an extensive public relations campaign by President Johnson's administration to convince the nation that our side was winning at last. At a November 17, 1967, press conference, the president told reporters, "We are making progress." Other officials concurred. On November 21 in a speech at the National Press Club in Washington, General Westmoreland said, "I am absolutely certain that whereas in 1965 the enemy was winning, today he is certainly losing." When the first bulletins on Tet came over the wire, CBS's Walter Cronkite exclaimed, "What the hell is going on? I thought we were winning the war." On January 31 Cronkite reported that Ho Chi Minh had described the attacks as an answer to Johnson's statement that America was winning.[26]

The media generally reported Tet as a series of military losses to our side. In fact, on the whole the offensive failed militarily but succeeded psychologically, perhaps more important in guerrilla warfare. Many have considered Tet the turning point in the American public's support for the war, although public backing had been declining for a couple of years. LBJ probably lost more support than the war effort did. The apparent effectiveness of the offensive was generally blamed on the weaknesses of the Saigon government (long a sore point in American news reports): official corruption, military rule, and lack of popular support. Two days into Tet, Cronkite reported that Secretary of Defense Robert S. McNamara had told Congress that one of the main problems of the war was the South Vietnamese themselves.[27]

Behind all these accounts loomed a stark and graphically powerful image of a murder, the vision of a South Vietnamese general, the highest ranking police officer in the country, executing an unidentified man without a trial. The man, whose hands were tied behind his back and who was wearing a sport shirt, was said to be a terrorist; he had been caught carrying a pistol in a city wracked by gunfire. The photographer, returning to his car after covering a battle nearby, saw members of the national police leading a man down a street and stopped to find out what was going on. He was told the man was Vietcong and had killed a police officer. When General Loan reached for his pistol and waved it to get onlookers out of the way, Adams, uncertain what was going to happen, raised his camera; he pressed the shutter at the moment Loan squeezed the trigger. The papers reported that after the killing General Loan said, "They killed many Americans and many of my people."[28]

"They" had, but that did not seem to mitigate the fierce negative power

the image exerted across the political spectrum. Harry McPherson, a speech-writer for President Johnson and one of his confidants, later remembered the despair he'd felt while watching TV: "I watched the invasion of the American embassy compound, and the terrible sight of General Loan killing the Viet-cong captive. You got a sense of the awfulness, the endlessness, of the war and, though it sounds naive, the unethical quality of a war in which a prisoner is shot at point-blank range. I put aside the confidential cables. I was more persuaded by the tube and by the newspapers. I was fed up with the optimism that seemed to flow without stopping from Saigon."[29] After Tet, American approval of President Johnson's overall performance fell from 48 to 36 per-cent. Approval of his handling of the war fell from 40 to 26 percent. On March 31, 1968, he announced he would not run for president again.

The antiwar movement continued to use the photograph as a weapon in its own campaigns. It appeared in books, magazines, posters. In 1969 Eddie Adams won a Pulitzer Prize for the picture, which was then widely reproduced again. While the war was still in progress, Adams's picture was often elabo-rated on by Japanese magazine illustrators. Years later, the photograph shows no more sign of disappearing than does the memory of Vietnam. In Woody Allen's *Stardust Memories*, an entire wall of the film director–protagonist's office is covered with a huge blow-up of this photograph, providing an enlarged moment of death as a background for dialogue about human suffering and the complaint that "everything's over so quickly, and you don't have any idea was it worth it or not." Today the photograph is said to be the largest picture in the war museum in Saigon.[30]

In May 1968 General Loan was seriously wounded in Saigon. When South Vietnam fell and the United States refused to fly him out, he managed to flee and eventually paid his own fare to America. In time he opened a restaurant in a shopping mall in Burke, Virginia. Late in 1978 it was disclosed that the Immigration and Naturalization Service had begun proceedings against him leading to possible deportation on grounds of "moral turpitude" for having committed a war crime. The execution had violated both South Vietnamese and international law. The victim, dressed in civilian clothes, was not even a prisoner of war under the rules of the Geneva Convention.[31] General Loan stayed in America.

In 1983, when Adams did a story in *Parade* on his Vietnam photographs, he spoke of deep regrets about General Loan: "In taking that picture, I had destroyed his life. For General Loan had become a man condemned both in his country and in America because he had killed an enemy in war. People do this all the time in war, but rarely is a photographer there to record the act." The victim had never been identified in the Western press other than as "Vietcong terrorist" or "Vietcong officer." From time to time, rumors surfaced to the effect that the man wasn't a terrorist at all but someone the general had a grudge against. After Adams wrote his story, he received several letters from U.S. military officers informing him that the victim was indeed a Vietcong lieutenant, known to his captors, who had killed a South Vietnamese major, his wife, and their children. Adams said again that his picture "wasn't meant to do what it did." This was hardly the first time that a photograph broke loose from its moorings and took on a meaning of its own.[32]

The massacre at My Lai occurred on March 16, 1968. The men of Charlie Company, under the command of Captain Ernest Medina, with First Lieuten-ant William L. Calley, Jr., as platoon leader, expected strong opposition from a Vietcong battalion. They met no opposition, no enemy soldiers—only old

229

men, women, and little children. The men of Charlie Company killed them all. Estimates of the dead eventually ranged from one to five hundred. On March 17 several American papers, following official releases, reported that a Vietcong unit had been caught in a pincer movement and 128 enemy soldiers had died. There were no reports of civilian casualties.

The real story might have remained untold if Ronald Ridenhour had not been too disturbed to keep it to himself. Although not in Charlie Company, Ridenhour heard the story in Vietnam, and in March 1969, several months after his discharge from the army, he wrote thirty letters about it to the White House, the Pentagon, the State Department, and Congress. Only two members of Congress responded; both wrote to the army, which initiated an investigation.[33]

On September 5, one day before his army stint was up, charges of murder were preferred against Lieutenant Calley. Still the story attracted only limited attention. An AP release was printed, small, in many papers, and the Huntley-Brinkley nightly news program on NBC announced that Calley had been charged with murdering a number of South Vietnamese citizens. Then the incident temporarily sank from view until Seymour M. Hersh, a reporter acting on a tip, interviewed Calley in early November. *Life* and *Look* were not interested in his story, so he gave it to a fledgling news dispatch service in Washington, which placed it in thirty-five papers on November 13. By this time, other papers were also following up on the My Lai story.[34]

Ron Haeberle, an army photographer, had gone into My Lai with the troops on March 16. After the raid he turned in a few black-and-white pictures of infantrymen and Vietnamese huts, but he was also carrying his own cameras with color film that day, and he held on to his pictures of villagers about to die and bodies heaped up in the road. He was mustered out a couple of weeks after the incident and went home to Cleveland, where he began to give lectures about Vietnam on the Kiwanis and Lions Club circuit. He always included a few photographs of the massacre to see what the audience reactions would be. Mostly, people didn't believe them, but they didn't ask what had happened either.[35] In August 1969 the army's Criminal Investigation Division asked for his photographs; he gave them copies. When he saw newspaper articles about My Lai, he decided it was time to go public with his pictures.

Although the army prosecutor on the Calley case asked him not to publish the photographs because they might seriously jeopardize the rights of anyone on trial, Haeberle called Joe Eszterhas, then a reporter at the *Cleveland Plain Dealer*. Eszterhas interviewed him, and the two of them decided to give the *Plain Dealer* rights to first black-and-white publication with the stipulation that no one else could publish them, then sell the other rights for a handsome fee. Eszterhas told the night managing editor he had a world scoop. "Aw, fuck the scoop," the editor said. "We've got a moonwalk tomorrow." Eszterhas showed him the photographs. "Fuck the moonwalk," said the editor. "It's just a routine moonwalk."[36]

Just before midnight, as the photographs were going to press, David Douglas Duncan, famous for his *Life* magazine photographs of the Korean War, called the *Plain Dealer* to say the pictures did not prove that anything had happened, the story was probably a hoax, and for the sake of the national interest, the pictures should not be published. But by this time, the paper had confirmed their authenticity.[37]

On the morning of November 20 the paper printed, at the top of the front page, an unusually large picture of a tangle of dead bodies in the road. Some

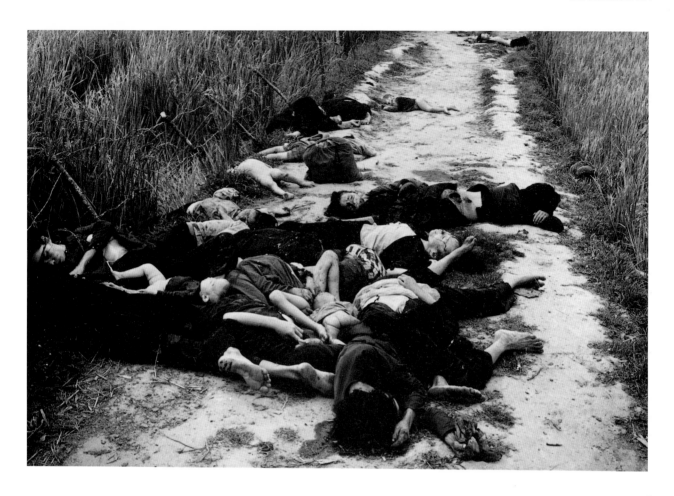

Ron Haeberle (born 1941)

"And Babies?,"

March 16, 1969

Ron Haeberle, *Life* magazine

© 1969 Time Warner Inc.

were clearly young children and babies. The paper wrote, "This photograph will shock Americans as it shocked the editors and staff of The Plain Dealer," and printed seven more photographs on a double-page inside spread. Most of the pictures were of more dead bodies. One was of a woman with a look of anguish on her face trying to hide her daughter behind her back. Moments earlier the soldiers had started stripping the girl and "playing around." Haeberle said the troops had been ready to shoot when he said "Hold it"—he wanted to take a picture. Then he turned his back so he wouldn't have to look, and two M16s on automatic fire opened up.

Later on the day of publication a man came to the *Plain Dealer*'s office and said he had flown in from London to get fifty copies of the paper with the famous pictures. Nothing like that had ever happened to the paper before. They gave him his copies free of charge, and he flew back home. The English papers simply copied the *Plain Dealer*'s photographs and pirated the pictures before anyone else.[38]

Eszterhas and Haeberle had flown to New York that day and were dickering with *Life*. That evening CBS news put four of the photographs on the air. Rephotographed directly from the Cleveland paper, they were black and white and the quality was poor, but nothing could weaken the impact of those images. The report began with a view of the *Plain Dealer*'s front page with the banner head and the vivid heap of bodies, then came close in on the woman protecting her daughter. Then a dead man and a boy, then another dead body, then a dead child, then the tangle of bodies again, the camera slowly

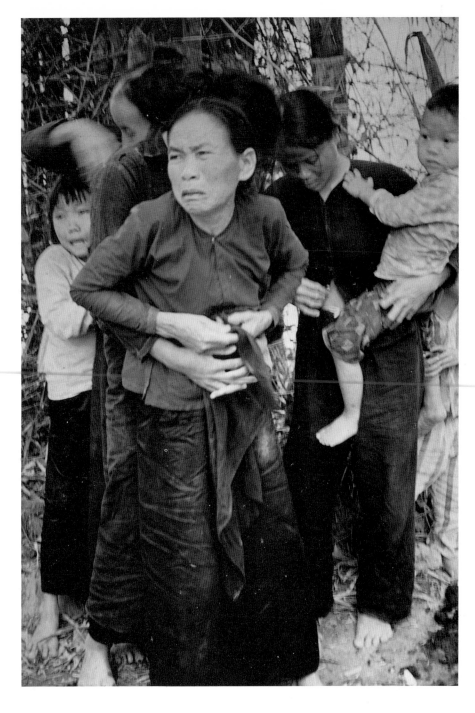

Ron Haeberle (born 1941)

My Lai Massacre,

March 16, 1968

Ron Haeberle, *Life* magazine

© 1969 Time Warner Inc.

coming in close on the barefoot corpses toppled one upon another. There was total silence as the camera passed from one image of corpses to another and remained on them for disturbingly long times. Six seconds on one picture, ten on another, twenty-two seconds of utter silence on that image of heaped-up bodies. No voice-over, no music, nothing but pictures of death. Even in 1969 such a long pause in total silence on a still image was surprising enough to suggest that no words could deal with the incident. After the pictures were shown, a soldier who took part in the raid was interviewed; he said he had seen about a hundred bodies.

The country was stunned, and curiously quiet. On Friday the 21st the *New York Times* had a front-page story about a congressman requesting a study of the alleged massacre and also reported that the *Plain Dealer* had published the photographs, which could not be published elsewhere. Before dawn that morning Eszterhas and Haeberle had an offer of five hundred dollars from a Japanese paper. The Japanese suggested that it would be wise to sell, because otherwise they would merely steal the pictures. When this offer was refused, they were as good as their word. Before noon *Life* informed Eszterhas that the *New York Post* was about to reach the newsstands with front-page pictures rephotographed from the *Plain Dealer*; *Life* bought the rights anyway. *Der Stern* and the *London Sunday Times* also bought rights, although some foreign papers declined because of the *Post*. The *Post* came out with four photographs. The next day the *New York Times* printed the picture of the heap of bodies across four columns on an inside page. There were obvious legal questions here, but the *Post* reasoned that Haeberle, being an army photographer, had only a dubious right to the photographs himself, and besides, publication was in the national interest. The *Times* decided that by the time they went to press newspaper and TV coverage had made the incident a matter of public interest.[39]

The horrors kept unfolding. On November 24 Paul Meadlo, who had been at My Lai, was interviewed by Mike Wallace on CBS-TV. During the interview Meadlo said they rounded up forty or forty-five people, Calley wanted them killed, so they shot them all. "Men, women, and children?" Wallace asked. "Men, women and children," Meadlo answered. "And babies?" "And babies." The transcript of the interview was printed in the *New York Times* the next day. Meadlo's mother said, "I sent them a good boy, and they made him a murderer."[40]

Ten days after Meadlo's chilling confession, Secretary of the Army Stanley R. Resor showed some of Haeberle's photographs to the Senate and House Armed Services Committees. The congressmen were badly shaken; at least one walked out before Resor's presentation was finished. Knowing these photographs had been available to investigators, the congressmen assumed there had been a cover-up. Senator Richard S. Schweiker, Republican of Pennsylvania, told a reporter, "If you saw the pictures that are to be printed next week in *Life*, you had to be convinced something happened." People did see them. On November 28 *Time* published the photograph of all the bodies piled on the road, plus two other pictures of dead bodies. *Newsweek* ran the picture of the group of bodies in a reprint from the *Plain Dealer*. *Life*'s December 5 issue gave a full page to the picture of the woman trying to shield her daughter. The picture of the heap of bodies was spread out over a page and a third.[41]

The effect of these pictures depended on their power as evidence of a brutal event. A heap of tangled bodies, a frightened woman: the plentiful wars in our time have produced many such photographs, and many are more dramatically composed. Haeberle's pictures do not have the stark graphic power and the fierce grip on memory of Joe Rosenthal's *Iwo Jima* or Eddie Adams's *General Loan*—it is only that they record the heart of darkness.

When accounts of the massacre first appeared, many had thought them implausible, but *Newsweek* said, "It was only after photographs purporting to show the alleged massacre had appeared in the Cleveland Plain Dealer—and had been snapped up by Life magazine—that editors and readers began to feel reasonably convinced that the episode had occurred at all," and "The grisly photographs, the many interviews with eye witnesses, the memories of

participants command belief."[42] Yet reaction to the photographs was much more complex than simple conviction. As more details came to light, the foreign press was increasingly critical of the United States. In America much of the criticism was directed at the press for publishing the photographs.

The day after the *Plain Dealer* broke the story, the paper's switchboard was tied up with calls, 85 percent of which said the pictures should not have been printed. "Your paper is rotten and anti-American," one woman said. Many of those approached by a reporter on the street were unwilling to be named or photographed; a few said they didn't believe it. When the photograph of the heap of bodies appeared on the front page of the *Washington Star*, readers complained of obscenity because some of the bodies (of children) were nude. Enormous numbers of people simply refused to believe any of the reports, including the photographs. In Alabama ex-Governor George Wallace put it succinctly: "I can't believe an American serviceman would purposely shoot any civilian . . . any atrocities in this war were caused by Communists." A *New York Times* survey of GIs in service near My Lai found most of them unwilling to believe that a massacre had taken place. A poll of six hundred people in Minnesota reported that 49 percent believed the reports were false; other reports said some believed that the press had exaggerated the whole thing.[43]

These responses were similar to the initial reactions to eyewitness accounts of the concentration camps in World War II—only now the implications hit closer to home. Comparisons were made to Lidice, the Czech village destroyed by the Nazis as a reprisal in 1942. The moral import was so unbearable that denial was widespread, and a majority claimed they had not even been upset by the reports. When *Time* polled sixteen hundred households, 65 percent said they believed that every war produced similar results. A 1946 survey of German opinion had turned up almost no evidence of emotional reactions toward Jews or sympathy for concentration camp victims.[44]

Aside from the fact that Americans did not want to believe their soldiers capable of such acts, the crucial difference between the nation's responses to pictures of the camps in 1945 and of My Lai in 1969 was that at the end of World War II people had still been fully convinced by photographs. Although distrust of written accounts in the press had long been rampant, trust in the camera was then intact. In the twenty-four years since the war, and particularly in the 1960s, television, world events, and the American administration had changed the climate of belief.

At the exact moment that the My Lai story broke, a smoldering resentment of the press was ignited by the Nixon administration, which had long been vocally dissatisfied with the media. On November 13, the day the papers printed Hersh's interview with Lieutenant Calley, Vice President Spiro Agnew, on TV, lambasted the "small and unelected elite" of privileged men who packaged and presented the news on television and lived by the law that "bad news drives out good news." On November 20, the day the *Plain Dealer* published Haeberle's photographs, Agnew delivered another blistering attack, this time against "the liberal establishment press." The press's immunity from criticism, he said, was coming to an end.[45] Americans, and American presidents, have resented the press at least since Thomas Jefferson's days, but the Nixon administration waged a highly organized attack.

The vice president struck a resounding chord in "middle America," which was already deeply uneasy about what seemed like endless disturbing reports on Vietnam, riots, civil-rights marches, antiwar demonstrations, and the feminist movement. Over and over the news depicted the cherished vision of

America disrupted and cracking apart. Television and the press, which had earlier tended to reiterate the government line, had recently swung toward the antiwar movement. Now the public wished to kill the bearer of bad news.

Besides, the news was thought to be causing the trouble. "How many marches and demonstrations would we have," Agnew asked with some justification, "if the marchers did not know that the ever-faithful TV cameras would be there to record their antics?" Phone calls to all three networks after Agnew's first speech ran heavily in his favor; they ran thirty-five to one at his office. A letter to *Newsweek* from Miami summed up the popular resentment that Nixon's wily vice president had played to: "Mr. Agnew is speaking for a majority of Americans who are sick and tired of the wave of anti-Americanism that is so popular in the country today. Students and revolutionaries are praised in the press today as if they were the only hope for the country. The middle-class working man is looked down upon as if he were some sort of bug to be squashed and kicked away. The press had better remember that it is the law-abiding, hard-working middle class that holds the country together and Vice President Agnew speaks our language!"[46]

The major change in the postwar years was that television had made frighteningly clear the media's power to influence events. The civil-rights struggle alone had convinced much of the world that news reports and images could alter the course of history. By 1969 press coverage of the Vietnam War and antiwar protests seemed to be doing the same. This realization was not an entirely happy one. After the 1960s passed across the screen and front pages like some kind of circus in a charnel house and the Nixon administration gave the public permission to criticize the fourth estate, the media never regained the high standing they had intermittently held before. Television and newspapers were already slipping in public esteem by 1968,[47] which Agnew surely sensed. TV rose again quickly, and the Watergate investigations restored print journalism to general admiration, but only temporarily. Photography could not stay entirely clear of this growing distrust.

The *New York Times* reported that reactions to the My Lai story apparently paralleled the way people felt about the war. If prowar, they said the American soldiers had simply been responding to enemy atrocities; if antiwar, they viewed the massacre as evidence of how Vietnam was tearing the United States apart.[48] Reactions to the My Lai pictures may well have been tied to feelings about the media as well as to feelings about the Vietnam War. Indeed, the two were probably related. Agnew had merely made it easier for "middle Americans" who supported the war to dismiss Haeberle's photographs as another instance of the distortions they perceived in the news, which kept showing an alien America of hippies and rednecks and brutal GIs.

The photographs figured heavily in the army prosecution of Calley and others; there they struck the jury as incontrovertible evidence. Although none pictured an actual instance of murder, they did show identifiable soldiers, and the eyewitness testimony corroborated the evidence of the photographs. The "And Babies?" photograph was brought forward several times. The jury counted and recounted the bodies, but the corpses were so intertwined that the jury finally settled for "an unknown number, no less than one."[49]

The ugly incident had an ugly enough resolution. Forty-six soldiers were accused, plus fourteen career officers, all the way up the line to a major general and a brigadier general, both implicated in suppression of the massacre report. Only Lieutenant Calley, who had led the killings, was seriously prosecuted. Many thought him a scapegoat, then a martyr, then a hero. After the longest court-martial in military history, he was convicted of premeditated

murder and sentenced to hard labor for life. The polls showed nearly 80 percent of respondents were bitterly opposed, and letters to the court, the media, and the White House ran more than one hundred to one against the conviction and the sentence. Calley served three days in the stockade, then President Nixon transmuted his sentence to house arrest until all appeals should be exhausted. Three years later he was released on parole.[50]

These photographs had an afterlife, becoming a new touchstone for the antiwar movement. At a meeting of representatives from the Museum of Modern Art in New York and the Art Workers' Coalition—a group of artists who had been protesting MoMA's unwillingness to take a stand on the war—the museum and the artists agreed to cooperate on an antiwar poster. Money was donated, Haeberle's photograph of the heap of bodies was copied, the words "And babies?" from the *New York Times* transcript of the interview with Paul Meadlo were superimposed above the bodies. At the last moment the museum's trustees refused to endorse the poster, and the AWC published it on its own. It was distributed by hand, disbursed in small packages carried by artists wherever they were going. The poster turned up on walls and in antiwar protests across America and in Europe.[51]

The "And Babies?" photograph got loose in the culture as an easily recognized symbol of what was wrong with America. It was used on the cover of an exhibition called *Kunst und Politik* (Art and Politics) in Karlsruhe, Germany, in 1970 and on the cover of Yoko Ono's record *Now or Never*. Once when Joe Eszterhas was at the Whiskey à Go Go in Los Angeles, a slide show accompanying the music of Iron Butterfly flashed pictures of John and Yoko, a Chicago policeman wielding his billy club, Bonnie and Clyde, and the photograph called "And Babies?"[52]

News photographs often amount to propaganda. Like all propaganda, they most easily persuade prepared minds; a picture that bolsters one side of a divisive issue may become an icon to only one part of the populace. Eddie Adams's image of General Loan was printed everywhere, and its message was so ambiguous—did it represent one barbarous South Vietnamese official? an unstable ally? man's inhumanity to man?—that the image became available to every political cast of mind. Two years further into the Vietnam War, the Kent State killings produced a photograph that spoke differently to different parts of the political spectrum and was not quite so uniformly presented by the press.

On Thursday, April 30, 1970, President Nixon announced on television that American ground troops had attacked enemy installations in Cambodia. Not only had the decision to invade been made without congressional authority, probably in breach of executive powers, but it came hard on the heels of Nixon's assurances that peace was within sight and that he was committed to ending the war.[53] Demonstrations and riots began on campuses on Friday. That night, students torched the ROTC building at Kent State University in Ohio. The governor of Ohio called in the National Guard on Saturday, when most of the students had left for the weekend, but on Monday, May 4, a large crowd of students gathered, shouting insults and obscenities. Some threw stones. The guardsmen were ordered to don gas masks and load their weapons. Ohio was one of several states that equipped its National Guard with live ammunition; students were either unaware of this fact or simply did not believe it.

When the guard laid down a tear-gas barrage, the crowd of students retreated but did not disperse. Some picked up tear-gas canisters and threw

Peter Brandt and

Ron Haeberle

Q. And Babies?

A. And Babies, 1970

Poster

The Museum of Modern Art,

New York; Gift of the Benefit

for the Attica Defense Fund

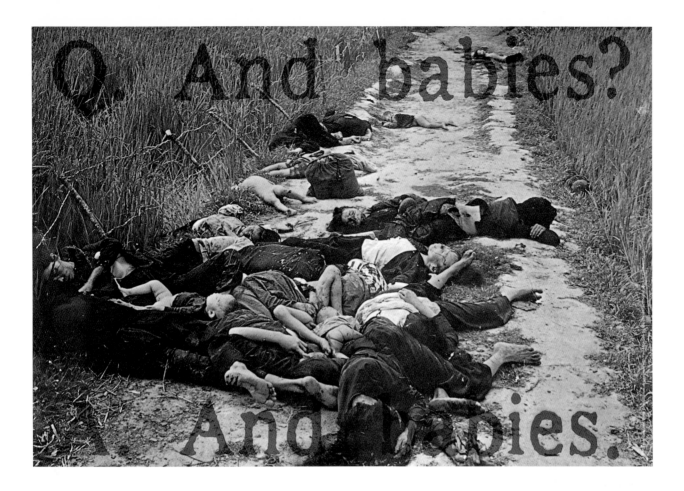

them back. The guardsmen advanced up a rise and found themselves with their backs to a fence. Sixteen men knelt in unison and aimed at the students below but did not fire. Demonstrators waved flags and jeered as the troops regrouped and marched to the top of a hill, where they turned and, without warning, opened fire. In a moment four students lay dead and up to eleven others were wounded, one to be paralyzed for life.[54]

John Paul Filo, a photography student, snapped a series of pictures of a young woman kneeling in incomprehension, anguish, and finally horror over the body of a dead student. "I didn't react visually," Filo said. "This girl came up and knelt over the body and let out a God-awful scream that made me click the camera." The scream in this image seems almost mythical, a pure image of despair far beyond words. Yet the people around her do not react; many among those present did not immediately believe that live ammunition had been used.[55]

Newspapers everywhere ran this photograph on the front page. The *New York Daily News* gave it the lower half of the first page, the *Los Angeles Times* spread it over three columns, the *Chicago Tribune* over four, the *New York Times* over three. The *London Times*, the *Daily Express* and the *Daily Mirror* all made it front-page news. Hundreds of other photographs and many feet of motion-picture film were taken at Kent State, but this arrested scream seemed to symbolize a nation's shock that its children were dying at the hands of its protectors. The Huntley-Brinkley news program on NBC on May 5 showed a still of a flag-waving student, then this picture; the photograph of the young

237

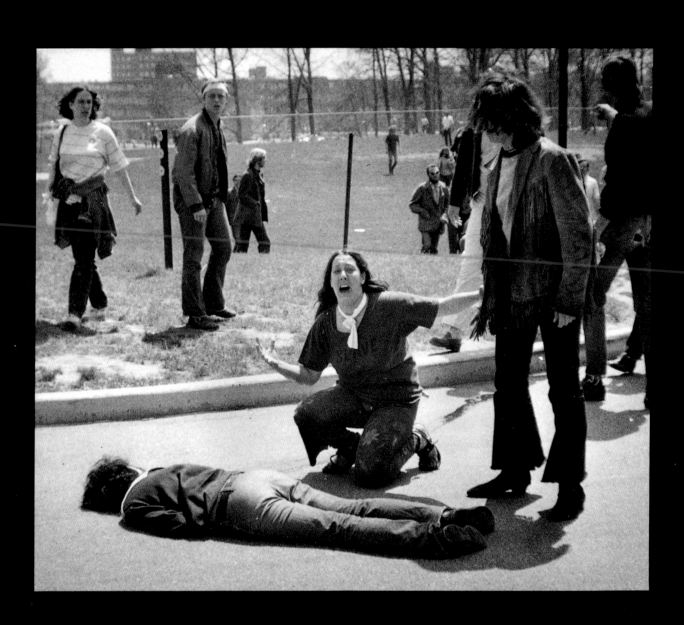

woman's horror was kept on screen for approximately seven seconds while the newscaster talked over it, then for another twelve seconds in utter silence—her scream filled the TV screen, without sound, without motion, as time ticked by. A student's film of guardsmen, students, and the chaos when shots sounded followed, but it was as confusing as the crisis must have been; it could neither distill nor symbolize the events as the still picture did.

In February 1968 police had killed three students demonstrating at a small college for blacks in South Carolina. That did not get much play on the front pages of many white-owned papers. Later that same year one young white man was killed by police during a student protest in People's Park in Berkeley, California; still the nation was not so aroused as it was by Kent State. Kent State was shocking because of the numbers, because it was heartland white America, and because Nixon's Cambodia policy constituted a national crisis that escalated after these killings. The incident's newsworthiness could only be magnified by a gripping photograph. On Sunday, May 10, the *New York Times* cropped Filo's picture close in until there was nothing but the girl's screaming face and printed it more than half a page deep on the front of the *News of the Week in Review.*

Kent State revivified the antiwar movement, which many had thought moribund beneath the weight of Nixon's peace promises. The president himself proceeded to fan the fires he had set with his announcement of the war's expansion. Unknown to Nixon, he had been taped the morning after the invasion, immediately after a Pentagon briefing, talking about "bums blowing up campuses," and after the killings at Kent State his press secretary, carefully programmed, had shown so little remorse as to say only, "When dissent turns to violence, it invites tragedy."[56]

Campuses across the nation shut down in protest. It was estimated that two-thirds of the colleges in New England closed, and Governor Ronald Reagan shut down the 121 branches of the California state college system for fear of bloodshed. Demonstrators marched on Washington the weekend after the killings and at one point surrounded the White House; the administration secretly moved troops into the basement in case of an "invasion." The photograph of the scream became an emblem of the newly galvanized antiwar movement. It appeared on posters and broadsides; students carried blowups of the picture with the word AVENGE written across it in dripping letters. The image was so graphic, so easily rendered in lights and darks, that the central figure turned up on T-shirts, record-album covers, buttons, and a Canadian postage stamp. Students in Europe and England took up the picture as Kent State came to symbolize all that was wrong with American leadership. So closely was the kneeling girl identified with the event and the cause that when the *Nation* printed an article ten years later about Kent State's effect on the erosion of the First and Fifth Amendments, the piece was illustrated with a woodcut of a hairless, genderless figure kneeling and screaming.[57]

Intellectual leaders, congressmen, and press commentators came out against the Cambodian invasion, and previously apolitical students were radicalized. "A few days after the shooting," the *New York Times* reported, "a young man at Kent was asked if he would again throw rocks at the Guard knowing that they would shoot. 'If that's all I had, I would,' he said. 'I wasn't very political before, but now I'm dedicated.'" Some say Kent State marked the beginning of Nixon's decline toward Watergate.[58]

But the antiwar movement died down again once the spring semester ended in 1970. The girl had been screaming about death, too high a price for most to pay for protest. And the country, shocked as it was, never united

John Paul Filo (born 1948)

Kent State—Girl Screaming

over Dead Body,

May 4, 1970

John Paul Filo

behind the students. In times of crisis a nation tends to back its leader: a Gallup poll taken immediately after Nixon's announcement of the Cambodia invasion found 57 percent of the populace supported the president. Even more telling, a *Newsweek* poll published three and a half weeks later not only reported 50 percent of those polled approved of Nixon's decision but 58 percent thought the demonstrating students were responsible for the deaths at Kent State and only 11 percent blamed the National Guard. In the press and on TV ordinary Americans said the killings at Kent State were justified. In New York, when Mayor John Lindsay ordered the flag over city hall flown at half-mast for the Kent State students and several hundred students staged an antiwar protest in the Wall Street district, a couple of hundred construction workers beat up the marchers while police stood by, then marched to city hall and raised the flag to the top of the pole.[59]

The divisions in the nation were subtly reflected in the picture magazines. *Time*'s major photograph on this story was a picture (also by Filo) of a long-haired young man from the back, brandishing a black flag before the troops, who are kneeling and pointing their rifles toward him and his fellow demonstrators. This is a more ambiguous image than the screaming girl; there is menace in it, but chiefly provocation. Although *Time* also showed photographs of people yelling and fallen students, none had the power or instant recognizability of Filo's photograph of the screaming woman. *Newsweek* also featured the photograph of the flag waver but in six pages of pictures did not reproduce the scream. *Life* gave a page and a quarter to the picture of the flag-waving student taunting the guard. On the facing page was a small photograph of a student throwing a gas canister, and the text said, "Before [the demonstration] ended, Kent State had become a symbol of the fearful hazards latent in dissent, and in the policies that cause it." That may be good, balanced reporting, but it does make dissent the first hazard. Across the entire next spread, however, *Life* published a frightening image of force: a line of National Guardsmen wearing gas masks and firing their rifles. Following that were three pictures of the kneeling girl, although not the image that had been seen on every front page. The last one showed her anguished, as if just realizing what had happened. In a 1979 issue on the 1970s *Life* published the canonical picture at last, and gave it a full page and a half.[60]

Although editors' and publishers' politics do play a role in the slant of stories, it is not likely that all three news magazines were making a forthright political statement with their choice of pictures. Possibly the magazines were making an effort to present their readers with images they had not seen before. But editors cannot avoid getting caught up in their times any more than readers can, and mass magazines start with an idea of what their subscribers want. Consciously or not, the major news magazines reflected the opinions of their audience—a country that had been riven by the war.

The photographs alone do not reveal that none of the dead students was a radical or even intensely involved in politics. But the effects of Filo's photograph, as of so many others, were felt not just by the audience but by the photograph's subject as well. The kneeling girl was Mary Ann Vecchio, fourteen years old at the time—not a student at Kent State but a runaway child, a fact that heightened the controversy over the events. (Identified by the photograph, the girl returned to her parents.) The governor of Florida said she had been planted at the university by the Communists, and when the National Guardsmen went on trial—they were not convicted—the defense attorney used Filo's photograph to buttress his claim that outside agitators had sparked the Kent State conflict. The sudden fame thrust upon Mary Ann

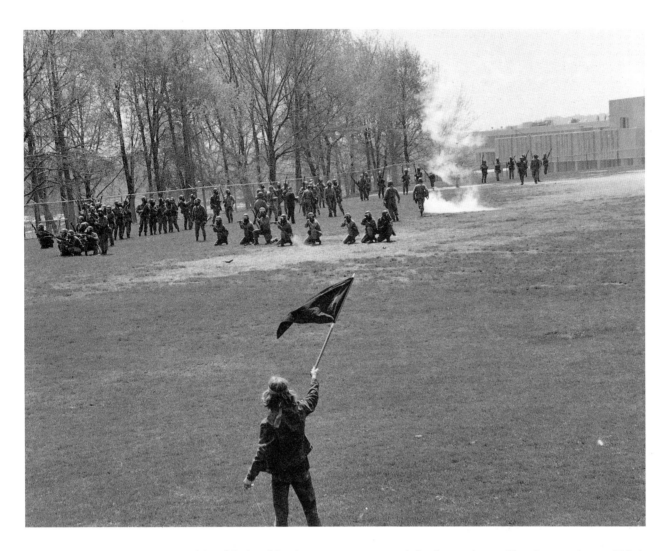

John Paul Filo (born 1948)

Kent State—Student Waving

Flag at National Guardsmen

with Rifles, May 4, 1970

John Paul Filo

Vecchio by this picture was too much for her to bear. She dropped out of high school and took various jobs as a switchboard operator and cruise-ship cook, had several brushes with the law and was once fined fifty dollars for prostitution. By 1980 she had married and appeared to be building a stable life.[61] She screams still in Filo's photograph, a mordant reminder of a time when guns abroad and at home wrenched the nation apart.

On June 8, 1972, the nightly television news broadcast a story about an accidental bombing in South Vietnam. South Vietnamese pilots trying to dislodge Vietcong troops in the village of Trangbang mistakenly dropped napalm canisters next to a pagoda where villagers had taken refuge. The ABC announcer, in the calm, portentous tone telecasters assume for sad news, said at least four children had been severely burned. Behind him appeared the proof: a black-and-white photograph of children and soldiers running toward us down a road. The girl in the center had torn off all her clothes because of the searing napalm jelly.

That same evening CBS showed several stills of the "deadly accident," beginning with a picture of the explosion in the distance and proceeding to several pictures of injured children and women. Huynh Cong (Nick) Ut's picture of the running children was one of them. NBC also began with this

241

photograph, cropped at the right so that only the screaming boy and the naked girl were in the picture. Anyone who watched the news that night would have seen the twenty-one-year-old South Vietnamese photographer's image of the little girl. As with My Lai, television was disseminating the most telling still images throughout the culture.

NBC also had film. Planes flew over, bombs fell, then the naked girl and the others in the photograph ran toward us rather slowly, like people finishing their run. They passed the camera, it followed from behind. The girl's back and arm were seen to be completely covered with black patches of burned skin, no longer resembling flesh. American soldiers gave her a drink and poured water over her. Even more horrifying was a prolonged image of a woman carrying a very young child with flaps of charred skin trailing off him.

The next morning the picture of the naked girl was on every breakfast table and newsstand. The Associated Press guesses that possibly every paper in America printed it. It was spread across four and five columns on the front page of the *Washington Post*, the *New York Times*, and the *London Times*. As the *New York Times* pointed out, accidental bombings were not uncommon in Vietnam, but reporting them was. The day before the fire fell on Trangbang, South Vietnamese planes had mistakenly bombed their own paratroopers

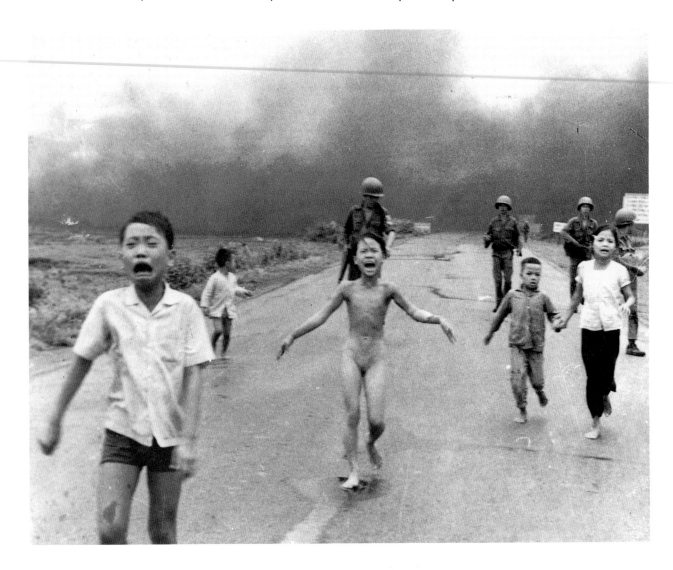

near Hue, an event that was not even officially announced.[62] The *Times* did not say why the incident at Trangbang drew an official notice, but several members of the press had witnessed it, and it would have been hard to deny in the face of the photographs and the tape.

The story continued. That evening, after the papers had printed the image of the naked, running girl, CBS put the photograph on the evening news again in order to report that she was still alive. Two days later it was reprinted in many Sunday papers. Not long after, *Newsweek* and *Life* both published it. *Life*, which also printed the picture of the woman carrying the burned baby, spread the picture of the running girl across one and a third pages.[63]

The picture of the girl struck home. It became one of the most memorable images of a war that counted its history in images. The photograph plots a progression of helpless suffering in the wake of war. As the boy in the left-hand corner screams, his mouth turns down in the classic expression of extreme woe, like the tragic mask of theater. The children on the right hold hands and run, a younger child on the left looks back at the flames, soldiers come up behind. In the exact center, a girl crying out in pain runs toward us in desperation, her arms extended to both sides in a gesture that at once links all the children in a chain of misery and mimics the crucifixion. She is stark naked, a sight so uncommon in newspapers and on TV that it would have attracted attention in any circumstances. Her nakedness adds to the picture's tension and the discomfort induced by our fascination. Her body seems unblemished; a viewer scans it closely to find her injuries. (One AP staff member, worried that papers would not use the photograph because of the nudity, delayed sending out the picture but was overruled.[64] It seems unlikely that a picture of a full frontal male nude, even a nine-year-old male, would have appeared on so many front pages, at least in America.) In 1973, when the picture won the Pulitzer Prize, it was extensively reprinted. The AP still gets requests for it; they say it is a picture "that doesn't rest."

In the spring of 1972, while peace talks were under way in Paris, President Nixon had withdrawn almost half a million American troops, and the war slipped from the top of the list of public concerns. Then North Vietnam stepped up its attacks and the U.S. steeply escalated bombing missions and mined harbors in the north. Protests, occasionally violent, resumed in America, Europe, South and Central America, but they hadn't the breadth or stamina of earlier years, and there was broad support for Nixon's display of American might.[65] But for that large portion of weary, frustrated, and bitter people everywhere who thought Vietnam was eating away at America's moral foundations, the picture of a little girl running from napalm she could not escape became a vivid symbol of the war and temporarily renewed the antiwar fervor. This photograph became the last major icon of the movement. It was made into a poster that was plastered on walls across America and Europe.

Both what the picture so clearly showed—innocent children devastated by war—and the fact that they had been bombed by their own troops with napalm gave this photograph instant and lasting shock value. The thought of children injured by war is repugnant to the common sense of humanity. Photographs had underlined this kind of horror before. The My Lai poster had been tellingly labeled "And babies?" In 1937, when the Japanese bombed Shanghai, a photographer snapped a picture of a screaming baby sitting in the wreckage of the railroad station. The picture went across the world to an estimated 136 million people. The U.S., Britain, and France protested Japanese bombing of civilians, and the Japanese threatened the photographer's

Huynh Cong (Nick) Ut

(born 1951)

Children Fleeing a Napalm

Strike, June 8, 1972

AP/Wide World Photos,

New York

life. In the U.S. the picture became a symbol of war's insanity, even in a medium directed at children: a bubble gum card reproduced the image with the caption "To know the horrors of war is to want peace."[66]

That the girl in Ut's picture had been burned by napalm added immensely to public revulsion. Napalm was discovered in 1943 and used in both World War II and Korea. No one protested until Vietnam, when reporting was freer and feelings ran high against the war. After American demonstrations against the Dow Chemical Company and boycotts of its products, Dow abandoned production of napalm in 1969. Manufacture was taken over by another firm, protests quieted down, and America virtually stopped using napalm in Vietnam, but the South Vietnamese continued to use it to some extent. The stark photographic evidence of children burned by the sticky balls of fire that could eat through to the bone revived the anger and revulsion that had motivated the demonstrations against Dow; reactions to the image were intensified by this added emotional load. In 1971 the United Nations asked its secretary general to report on the legality of napalm use; the report, appealing for its prohibition, was commended and released in the fall of 1972.[67]

The enigmatic power of Ut's image, the instant sense that it means more than it depicts, combined with a photograph's innate inability to define its own meaning precisely, made it clear that the picture was symbolic but not entirely clear what it symbolized. The combination of specific horror and elastic meaning helped to make this photograph a kind of icon of the war. It could touch many regions of experience. *Life* thought that a photograph of the woman carrying the child with charred, flapping skin and Ut's picture raised an ethical question about war, imperialism, and children: "Would you feel any easier had the children been *North* Vietnamese?" One woman responded by saying that all readers should ask themselves, "If these were *my* children, would I have put an end to this war sooner?" Six months later, when *Life* reprinted the picture, it shifted the emphasis from children to civilians in general: "It seemed to speak for every one of the millions of civilians who have fled down Vietnam's highways in search of haven from the hounds of war."[68]

By 1979, when the monthly *Life* reviewed the 1970s, Ut's photograph still symbolized the high cost of that war in general: "This 1972 photograph—more than any other single image—made America conscious of the full horror of the Vietnam war." And in 1989, when the U.N. hosted an exhibition on war and peace in support of the World Disarmament Campaign, the photograph was included as evidence of the horror of all wars.[69]

The girl was named Phan Thi Kim Phuc—Kim Phuc means "Golden Happiness." She was in the hospital for fourteen months. Scar tissue had welded her chin to her chest and her left arm to her rib cage and so tightened the skin on her back that she could not straighten up. She required several operations. She was famous the world over, but in Vietnam her fame did not last long; there were too many like her. *Der Stern* located her in 1982 and published a story on her with the famous picture; she was sent to Germany for treatment in 1985. The picture has come back in television stories about Vietnam, cover articles about her history, a film made about her in Amsterdam. Kim Phuc wanted to be a doctor but suffers from fevers, headaches, enormous fatigue, sudden panics, and an inability to concentrate; she could neither complete the course nor follow the nursing regimen. In 1986 she moved to Cuba, where she has been studying English and Spanish in hopes of becoming a pharmacologist. An American organization has been set up to raise funds for her medical assistance.[70]

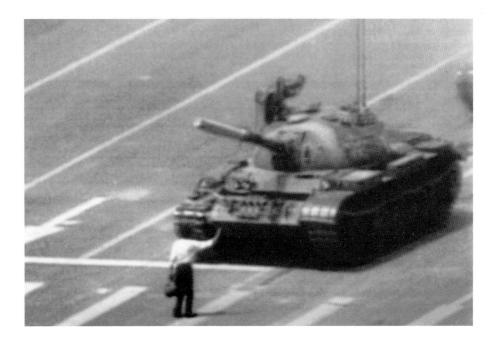

this picture, held up his hand to stop a Romanian tank. Politicians routinely cite the Chinese man's example, political cartoons freely redraw his act, knowing how unmistakable the reference is. In 1990 Barbara Walters showed the photograph to Jiang Zemin, general secretary of the Communist Party, and asked what had become of the man. Jiang said he did not know but was certain he had not been executed. Persistent but unsubstantiated rumors say he has been, but no one is even certain of his identity, much less of his fate.[77]

This photograph is not shown only in the West. The Chinese exhibit it too. In the summer and fall of 1989 the Chinese government mounted photographic exhibitions in most fair-sized cities to support the official version of the crackdown, even providing buses to bring people in from the countryside. Television also showed film of the student unrest. All the pictures concentrated on student violence, and on dead soldiers. These images were not faked. Whoever did the killing, some soldiers did die. The Chinese government contends that it was forced to call in the troops to contain student violence. The picture of the man who held up his hand to stop a tank is exhibited to show the restraint of the troops, who chose not to run over a lone man blocking the march of an entire line of tanks.[78] The photograph tells that story just as faithfully and honestly as it tells another story in the West, for photographs do not give us truth—we give truth to them.

Man Stopping Tank, Beijing,

June 1989

Color slide photographed

from video

© 1989 ABC News/Capitol

Cities

AFTERWORD

In the year and a half since this book first went to press, confidence in images has reached a peculiar, perhaps even a critical juncture. Utmost trust exists side by side with mounting unease and suspicion as the credibility of photographically generated imagery, both moving and still, comes under pressure. On the one hand, the world lives by images and depends on them for information, probably more so now than at any previous time in history. As television tightens its lock on communications, newspapers and magazines resort to more and bigger pictures at the expense of text. On the other hand, awareness of the potential for manipulation and misrepresentation of images keeps growing, along with public distrust of the media in general and of image purveyors in particular, from advertisers to politicians.

Sophisticates long ago learned to deny whatever faith they still had in the camera, but it no longer takes elaborate rhetoric to convince most people that images do not necessarily have hard and fast meanings. A beauty magazine like *Allure,* not exactly a high-brow publication, publishes pages of amusing computer montages—Ronald Reagan as a woman, Nancy as a man, that sort of thing. News magazines run computer-altered pictures with explanatory captions. Commercials bring special effects like "morphing"—the computer-generated transformation of one form into another (a technique brought to a high pitch in *Terminator 2*)—right into the living room to sell standard household products. A subtler but no less pervasive indication that things are not always what they seem is the general acknowledgment that in politics the photo op, like the sound bite, is both engineered and radically excerpted from its context.

Yet despite attacks on many fronts, belief in the camera's ability to provide evidence remains in some respects inviolable, and for good reasons. Photographs and technologically engineered images, from satellite pictures to videotapes of breaking news, from CAT scans to scandalous pictures of British royalty, continue to enlarge upon photography's traditional tasks of detection and discovery. Detection, in fact, is advancing. In a bit of sleuthing made possible by recent scientific advances, archaeologists, explorers, and scientists studied images taken from satellites and found an ancient city in the sands of Oman, on the Arabian peninsula. This city is almost certainly Ubar, fabled center of the frankincense trade over two thousand years ago.

Scientists specializing in spacecraft imaging systems at the Jet Propulsion Laboratory in Pasadena, California, had discovered in the early 1980s, much to their surprise, that the Shuttle Imaging Radar system, working at wavelengths longer than the eye could see, could detect features just below the Earth's surface, if the covering material was very thin and extremely dry.[1] Looking for the lost city of Ubar, which was believed to lie close to the so-called "Empty Quarter" of the Oman desert, they commissioned high-resolution images of the region from an unmanned Landsat satellite and a French SPOT satellite, plus remote sensing data from the Shuttle Imaging Radar. Drs. Charles Elachi, Ronald G. Blom, and Robert E.

Crippen combined the black-and-white and color images on a computer and enhanced them sufficiently to highlight ancient tracks invisible from the ground. The tracks converged on one area.

In the last days of 1991 archaeologists finally began to dig at a spot that had been visited before but dismissed as unimportant because visible ruins at the site dated only to the seventeenth century. If the images from space and subsequent land exploration had not pointed to this location, the lost city of Ubar might still be hidden beneath the sands.

Ordinary aerial photographs would not have covered so large a territory or provided the necessary clues, though pictures taken by the shuttle-based Large-Format Camera, which have the disadvantage of limited regional coverage, did contribute. (These photographs were the only data that were not originally in digital form.) Nor would the satellite images

Satellite view of the ancient

city of Ubar, in Oman

Newell Color Lab

have yielded so much information had the Jet Propulsion Laboratory not devised new techniques of image-enhancement. The images worked partly because they penetrated the realm of the invisible, where computers ultimately can produce more information than either the eye or the lens.

Actual photographs as well as engineered images from space continue to be so valuable for gathering intelligence that the U.S. government has engaged in a series of thorny, high-level debates about whether to sell spy satellites to foreign countries. And evidence from high above earth is already changing certain estimates of the planet's surface. U.S. government scientists compared satellite photographs of American forests in the Pacific Northwest and rain forests in Brazil and concluded that clear-cutting posed a greater threat to woodlands in the States than to the tropical forests that have received so much media attention. Along the same lines, some environmentalists believe that if the CIA opens its thirty-year archive of satellite photographs, scientists will be able to study changes in the environment caught inadvertently by cameras set up to spy.[2]

One rather bizarre result of the spread of video cameras—as of 1991, one of every six American families owned one—and the consequent documenting of major life events as they happen is that some criminals have begun to tape their own crimes. This odd effort to preserve self-incriminating evidence speaks to a kind of lust for images that videocams and TV have magnified. Andy Warhol's prediction that everyone would be famous for fifteen minutes has seeped into the culture, with millions apparently believing that TV is the touchstone of reality and you're nobody till somebody sees you there. Being preserved on tape is next best: a simulacrum of the small-screen simulacrum that always looks so much better than life. Rapists and chain snatchers, unwitting semioticians, want to be the stars of their own lives.[3]

Incriminating evidence on film or tape is being cross-examined these days more rigorously than ever before. In Michael Crichton's 1991 novel, *Rising Sun,* the solution of a murder hinged on surveillance tapes that had been tampered with in a particularly sophisticated manner. Readers were instructed in the arcane and difficult methods of detecting such alterations.

It was another work of fiction, this one tightly interwoven with fact, that threw the whole issue of evidence into new turmoil: Oliver Stone's film *JFK.* As if the eyewitness, medical, ballistic, and photographic evidence of President Kennedy's assassination were not already sufficiently controversial, Stone mixed actual and fake footage (as well as actual and invented incidents), with no indication of which was which. Moving pictures go by fast, and only the most knowledgeable observer would have been able to mentally interrupt the flow of images and label each frame fact or fiction. The movie's fabrications and conjectures were made all the more convincing by the framework of fact in which they were embedded, including well-known images from the original Zapruder film of the assassination. This mingling of the authentic and the fictional—truth by association—served to elevate theory to a level of high probability.

The photographic evidence related to Kennedy's death is already lodged at a peculiar emotional nexus. Anyone who lived through that event has certain images permanently etched in memory and does not doubt their essential truthfulness, but many cannot accept the official interpretations of particular photographs. The images are thus perfectly explicit and

highly ambiguous at the same time, and on top of that they carry a heavy burden of feeling.

Millions—especially among the young, who had not lived through Kennedy's killing or studied the history—were apparently convinced by Stone's version, though it was based on one of the more easily discredited conspiracy theories. The American public had never fully accepted the Warren Commission's report attributing the assassination to a lone gunman, and since then the public has had ample reason to distrust the institutions of government. In a *New York Times*/CBS poll of 1,281 people questioned in January 1992, 77 percent said that Lee Harvey Oswald had not acted alone, and 75 percent said there had been an official coverup.[4] The film, which may have influenced this poll, had the advantage of an audience that wanted to believe its message.

JFK was influential both for good and for ill. Damaging as the film no doubt was to the faith of citizens already alienated from government and political process, it stirred so much discussion that there was a move in Congress to open the assassination files at last, which nothing else had ever succeeded in doing. Opening the files will not quiet the conspiracy theorists, but at least it should muffle the cries of cover-up.

Some months before *JFK* opened, a true-crime film played on home screens everywhere, with consequences that strained belief in other ways. George Holliday's amateur videotape of the beating of Rodney King by the Los Angeles police on March 3, 1991, seemed to almost everyone who saw it on television irrefutable proof of police culpability. Holliday just happened to live nearby and presumably had no reason and probably no means to doctor his tape. Amateur videotapes such as his, imperfectly focused and taken by a chance witness, have momentarily assumed the mantle of truthful objectivity with which still photography was long cloaked. This tape became so well known that the trial of the four police officers accused of using undue force in the King beating was moved from L.A. to Simi Valley, supposedly to avoid the effects of undue publicity. When the jury acquitted the police, the nation was stunned; it did not seem possible to contradict such coruscating visual evidence. Los Angeles burned while the world watched.[5]

A lot had happened before Holliday started taping. Police had chased King's car at close to one hundred miles an hour until he pulled over. When ordered to get out of the car and lie prone, King's two passengers complied, were searched for weapons, handcuffed, and later released. King refused to lie down or submit to being cuffed and could not be searched. He danced around, smiled and waved at a police helicopter hovering overhead, wiggled his hips at the police, and finally got down on all fours rather than lying prone as ordered.

One officer held each of King's feet and one took each of his arms to handcuff him in the all-fours position. King is a big man, six feet three and weighing about 230 pounds, and somehow he shook off all four policemen and stood up. Sergeant Stacey Koon then ordered him to lie down or be Tasered. (The Taser gun delivers an electric shock that knocks grown men to the ground.) King advanced at Koon, who fired the Taser; King groaned but did not go down. (Neither the defense nor the prosecution witnesses at the first trial had any substantial disagreements with this account of events that occurred before the tape started.) Ordered to lie flat and warned once more, he remained standing, was Tasered a second time, and finally fell down. He jumped up yet again and lunged at Officer Laurence Powell,

who struck the first blow with a baton and knocked King down.

The prosecution would later acknowledge that King might have been attacking Powell rather than trying to get away, and no dispute was offered at that trial to the claim that Powell's first blow was made in self-defense. The officers said they thought that King was under the influence of PCP, which can produce violence and near superhuman strength. Lab tests made after King's arrest showed no trace of PCP, though they did indicate that he was legally drunk.

The videotape begins about the time King leapt up and lunged. For ten or eleven seconds at the beginning, the tape is out of focus, though his rising and plunging forward is visible. Close to half of the eighty-one-second tape was made after King was cuffed and has little bearing on the case. Still, it is odd that television stations other than CNN seldom, if ever, showed the tape in its entirety; relevant segments that were *not* played on the news are longer than segments that were. What the networks showed repeatedly was five- or ten-second clips showing the police raining blows on King as he lay on the ground. The public, having seen these same horrifying actions over and over, tended to believe that it had seen the full tape, or at least all that mattered.

Roger Parloff, whom the editor of the *American Lawyer* described as "a careful, liberal-leaning lawyer," wrote an article in that magazine in which he concluded, to his own amazement and chagrin, that the jury in the first case might have made the correct legal judgment. One juror said—ridiculously, shockingly—that King, who was struck fifty-six times and kicked six times while twenty-nine uniformed officers (including two in the copter) looked on, was in full control of the situation.

Parloff points out that though the police constantly yelled at King to get into a prone, spread-eagle position, he never did. He was finally cuffed by force in a sitting position. Up to that time the police had not been able to search him and could not know whether he was armed. Time and again, the defense used slow-motion replays of the tape or still frames to show that the two officers who beat King with their batons did so when he moved his arm toward his waistband or got into positions from which he could have risen. "The juror," Parloff writes, "meant that King could have avoided or stopped the beating by assuming a prone position. I agree. Every time King assumed that position, the beating stopped."[6]

Subsequent events suggest that almost all the millions upon millions who saw only the portions of the tape played on TV saw excessive, brutal force on the cops' part, made worse by the fact that all the accused officers were white and King black, and worse yet by the racist remarks the police were said to have made. Sometimes it seemed that in all of America there were only twelve people who did not believe that the tape proved the cops guilty, and all twelve of them were in the Simi Valley jury pool.

Racism in the justice system could not have surprised anyone in the black community; the King tape only made it horribly obvious to those who already expected it—and to those who did not. The fact that the trial of the officers who beat Rodney King was moved to Simi Valley—a preponderantly white, working-class community where a number of retired police officers live—suggested to many that the jury was predisposed to acquit the police, and the defending lawyers were clever enough to give them a rationale.

The defense lawyers employed a canny strategy of almost literally deconstructing the tape by slowing it down to change its import and impact, breaking it into units so small that they no longer supported the

overall thrust of the whole, and insisting that a tiny excerpt from a large movement can have an entirely different interpretation than the entire action does. (The defense also used glassine overlays on still photographs and re-created some episodes.) In effect, the defense contended that meaning was elusive and undefined, that it did not inhere in a simple reading of the "text" but could be extracted from snippets of that text and must be understood in relation to other "texts," such as the code of what constitutes acceptable force during an arrest. The truth, or at least a reasonable doubt, may indeed be in the details, as the defense maintained. It is possible, too, that the tape was played so often that repetition alone began to drain it of meaning, as a phrase repeated enough times begins to sound senseless.

I recently watched the tape in its entirety, with all the arguments in mind. The full tape does raise doubts that the portion shown on TV never did, but to someone unfamiliar with police procedures and conscious of the racial underpinnings of the situation, the beating still looks brutal. Our eyes did not deceive us, though we may not have seen enough. On the stand, the police said their work sometimes *is* brutal. And no one ever claimed that *legal* and *moral* were precise synonyms. Against the background of South-Central Los Angeles in flames and tapes of black men beating whites during the riots, it is troubling but essential to remember that people see through a scrim of their own opinions and that videotapes are as subject to rigorous questioning as any other witness. (As this goes to press, the jury in a second trial, on civil-rights charges, has just convicted two and acquitted two.)

Perhaps the most blatant instance of controlled and interpreted imagery in recent American history was the Gulf War. The country saw a sanitized version of that conflict, with lights that went "pop" in the sky and laser-guided weapons that closed in on their targets with computer precision as an automatic camera clicked away. "It's like a Nintendo game," one newscaster remarked on CNN. It was clear at the time that the U.S. military and the government were supervising the image of this war as tightly as they had in Grenada and Panama, that the media were rather cravenly cooperating, and that the populace overwhelmingly approved of the restrictions on the press.

Very little actual censorship occurred, because the military realized that it was just as effective to deny access. Bad news was simply placed off limits. Cameras were banned from Dover Air Force base when coffins began to arrive. An AP photo editor who looked over many thousands of photographs by more than forty photographers in the field said he never saw any pictures of dead Iraqi soldiers. When an Iraqi Scud missile hit an American barracks in Dhahran and an AP photographer raced to the scene, fifteen U.S. and Saudi military police officers beat and handcuffed him. One of his cameras was smashed, and the police demanded his film.[7]

News that did not fit the military's official outlook, or the administration's, or the networks', was held back. A *Los Angeles Times* reporter was shown videotapes made by automatic camera in a helicopter as the chopper's Gatling gun cut down Iraqi soldiers. After he reported on the tapes in the *Times*, TV stations requested them, but by then the Army had decided that showing them wasn't such a good idea. The tapes were not released, and all reporting on helicopter activity was restricted. After a filmmaker under contract to NBC recorded some disturbing wartime scenes of Iraq

Aerial image of trucks, origi-

nally described as "eleven

Iraqi vehicles loaded with

Scuds, seen from the plane

about to destroy them"

Cable News Network, Inc.

under bombardment, the network not only refused to show the film but fired the photographer.[8]

Over time, more and more information has leaked out indicating that the squeaky clean spectacle witnessed on television was a lot dirtier than it appeared. In sum, the information, especially the visual information, was incomplete, slanted, manipulated. Mark Crispin Miller exposed one instance of out-and-out lying with pictures from the Gulf. In a January 30, 1991, briefing broadcast worldwide from Riyadh, Saudi Arabia, film of an F-15E air-to-ground sortie against "erector launchers—mobile Scuds" was presented. Seven small, dark, roughly rectangular objects out of eleven said to be in the area could be seen on a highway for a few seconds before being blown to smithereens. General Norman Schwarzkopf commented that "there's a little argument in the community as to how much damage we did in this film" but added that "at least three mobile erector launchers, four Scud missiles on Scud-servicing vehicles and three more Scud-servicing vehicles" and possibly seven mobile erector launchers had been knocked out.

But Miller reports that "an allied military analyst, who insisted on anonymity," told him that the putative Scud launchers were actually field trucks, most likely smuggling in fuel from Jordan. When the tape was shown at a top-level military meeting, an expert on Scuds and a photo analyst both unequivocally identified the bombed objects as trucks, though the generals overruled them and several other analysts went along. The tape was then dispatched to a U.S. intelligence agency, which, applying computer-enhancement techniques, confirmed that the vehicles were certainly not Scuds but trucks, only trucks. By then, however, General Schwarzkopf had publicly branded them vanquished missiles, and no one

in the military was about to retract his statement in the interest of mere truthfulness.[9]

People pick and choose what they want (or are willing) to see and what they consider worth believing. Even those who distrusted the Gulf War reports were moved by the TV and still images of Kurdish refugees shown afterward; public outrage influenced the American government to take action on the Kurds' behalf. Then, in 1992, extensive media coverage exposed the horrors of the civil war in Bosnia and Herzegovina to a wide public, but until summer the war in Somalia and the resulting famine that threatened to kill upwards of a million people was only intermittently reported. During July the print media paid some attention, and then on July 22, ABC's "World News Tonight" told the nation that United Nations aid to Somalia was insufficient because the public, largely unaware of the scope of the problem, had brought little pressure to bear. The program broadcast images of a kind that would soon become archetypal: a starving mother and child, a long line waiting for food, grave diggers.

TV went silent again, but newspapers and magazines took up the slack. In the beginning of August, U.N. Secretary General Boutros Boutros-Ghali charged the U.N. with favoring a European conflict over black Africa's needs. By August 12, ABC news had begun in earnest the pictorial coverage that helped convince the Bush administration it had to act, and NBC soon followed suit. The print media, which apparently got on track first, kept pace, but TV had the audience and the clout.[10]

When the target audience is limited and specific, still photographs can have as much force as ever. From November 16 to December 4, 1992, an exhibition of *Life* magazine photographs of Somalia was on view at the U.N. On December 3, when the Security Council voted to authorize the use of U.S. troops in Somalia, Boutros-Ghali told ABC's "Nightline" that the exhibition had contributed to "the mobilization of public opinion. With the mobilization of public opinion, we have been able to obtain the resolution that was decided by the Security Council."[11]

The current visual culture demands great sophistication. Audiences must be aware that they may not be seeing all there is to see, may not be hearing the truth about what they are seeing, and, considering the increasingly unstable nature of the content of photographs, may not be seeing images with much claim on truth to begin with. The American public seems increasingly cynical about many of its institutions, including the media it relies on constantly. This is a troubling position, to live daily with and depend heavily on communications that are not entirely trustworthy, like a child brought up by a slightly mad parent.

The meaning of photographic images has always been elusive; it is only becoming more so. People of different backgrounds, cultures, and psychological mind-sets respond differently to the same images even before the presenting medium puts a spin on the picture and even if the photograph is pristine and unmanipulated. The very few photographs or still frames of movies or brief snatches of video that achieve some wide consensus seem to do so by slipping into the realm of the symbolic, where fewer questions are asked. Much of the world may already be in the position of believing images that reason suggests should not be believed; the looming issue is what will be believed once a wide public is convinced that photographs are no longer a reliable means of communication.

NOTES

I wish to thank the Writer's Room for providing work space that made it possible to write this book.

The sources for each paragraph in the text are consolidated into one note. The subject of each source is identified either by a key word or by the first and last words of the relevant quote.

INTRODUCTION: UNDER THE INFLUENCE OF PHOTOGRAPHY

1. Tryst: Richard Rudisill, *Mirror Image: The Influence of the Daguerreotype on American Society* (Albuquerque: University of New Mexico Press, 1971), p. 113. Scot: *Photographic News*, February 5, 1869; in Bill Jay, "The Romance of Photography: Advice on Love and Marriage from the Nineteenth Century Photographic Press," *British Journal of Photography* 128 (July 31, 1981): 776.

2. David Freedberg, *The Power of Images: Studies in the History and Theory of Response* (Chicago: University of Chicago Press, 1989), p. 157. This is a penetrating exploration of material that is seldom studied.

3. Michel Melot, *The Art of Illustration* (New York: Skira, Rizzoli, 1984), p. 231.

4. J. M. Coetzee, "Into the Dark Chamber: The Novelist and South Africa," *New York Times Book Review,* January 12, 1986, p. 13.

5. Larry Collins and Dominique LaPierre, *Freedom at Midnight* (New York: Avon, 1975), pp. 130–32.

6. Literacy: *Encyclopaedia Britannica,* 11th ed., s.v. "education." American newspapers: Michael Schudson, *Discovering the News: A Social History of American Newspapers* (New York: Basic, 1978), p. 13.

7. On public life and the press, see Schudson, *Discovering the News,* p. 60.

8. *Observer, Weekly Chronicle:* Clement K. Shorter, "Illustrated Journalism: Its Past and Its Future," *Contemporary Review* 75 (April 1899): 484.

9. *Penny Magazine,* December 18, 1832; in Edward W. Earle, ed., *Points of View: The Stereograph in America—A Cultural History* (Rochester, N.Y.: Visual Studies Workshop, 1979), p. 10.

10. Elizabeth L. Eisenstein, *The Printing Press as an Agent of Change: Communications and Cultural Transformations in Early Modern Europe* (Cambridge: Cambridge University Press, 1982), pp. 84–85. My thanks to A. D. Coleman for referring me to this source.

11. Jules Janin, in Rudisill, *Mirror Image,* p. 42.

12. *Sunday-School Photographs:* Bill Jay, "Photography, God and the Devil," *British Journal of Photography* 129 (May 14, 1982): 516–17. *New York Journal:* Marcus M. Wilkerson, *Public Opinion and the Spanish-American War: A Study in War Propaganda* (New York: Russell and Russell, 1967), p. 46. "The . . . sky": William M. Ivins, Jr., *Prints and Visual Communication* (Cambridge, Mass.: MIT Press, n.d., replicating the first edition of 1953), p. 94.

13. Robert S. Kahan, "The Antecedents of American Photojournalism," 1969; in Caroline Dow, "The Response of the Law to Visual Journalism: 1839–1978" (Ph.D. diss., Michigan State University, 1985), p. 31.

14. A daguerreotype could be rephotographed, even reproduced by a special process that never caught on, but in essence each was an unrepeatable apparition. "Our . . . metal": Charles Baudelaire, "The Salon of 1859," 1859; in Vicki Goldberg, *Photography in Print* (Albuquerque: University of New Mexico Press, 1988), p. 124. "To . . . forever": Elizabeth Barrett, letter, 1843; in Helmut Gernsheim, *Creative Photography* (New York: Bonanza, 1972), p. 28.

15. "In . . . close": *Edinburgh Review,* 1843; in Goldberg, *Photography in Print,* p. 65. "Daguerrian . . . expenses": *Humphrey's Journal,* January 15, 1854; in Rudisill, *Mirror Image,* p. 220. Spirit photographs—double exposures that purported to show the departed hovering near—were quite popular for a time.

16. One million pictures: Beaumont Newhall, *The History of Photography from 1839 to the Present* (New York: Museum of Modern Art, 1982), p. 115. "A . . . produced": Oliver Wendell Holmes, "The Stereoscope and the Stereograph," *Atlantic Monthly,* June 1859; in Goldberg, *Photography in Print,* p. 107.

17. Ibid.

18. Wendy Wick Reaves, *American Portrait Prints,* Proceedings of the Tenth Annual American Print Congress (Washington, D.C.: National Portrait Gallery, Smithsonian Institution; Charlottesville: University of Virginia, 1984), p. 85. My thanks to William Stapp for this source.

19. Balzac: Nadar, *My Life as a Photographer,* 1899; in Goldberg, *Photography in Print,* p. 128. "of . . . them": *Photographic News,* August 29, 1890; in Jay, "Photography, God and the Devil," p. 517.

20. John Baskin, foreword to Hal Morgan and Andreas Brown, *Prairie Fires and Paper Moons: The American Photographic Postcard, 1900–1920* (Boston: David R. Godine, 1981), p. xi.

21. Vachel Lindsay, *The Art of the Motion Picture,* 1915; in Earle, *Points of View,* p. 86.

22. Shorter, "Illustrated Journalism," p. 489.

23. "The . . . thought": G. Stanley Hall, "The Ministry of Pictures," *Perry Magazine* 2 (February 1900): 243. "We . . . illustrations": *Harper's Weekly,* July 29, 1911; in Neil Harris, "Iconography and Intellectual History: The Half-Tone Effect," in *New Directions in American Intellectual History* (Baltimore: Johns Hopkins University Press, 1979), pp. 204–5.

1. THE UNIMPEACHABLE WITNESS

1. *Edinburgh Review,* January 1843; in Vicki Goldberg, *Photography in Print* (Albuquerque: University of New Mexico Press, 1988), pp. 64–65.

2. "Show . . . one": Courbet, in John Canaday, *Mainstreams of Modern Art* (New York: Simon and Schuster, 1959), p. 103.

"We . . . imagination": *Cosmos*, July 14, 1854; in André Jammes and Eugenia Parry Janis, *The Art of French Calotype* (Princeton, N.J.: Princeton University Press, 1983), p. 247.

3. Lewis Hine, "Social Photography: How the Camera May Help in the Social Uplift," in Alexander Johnson, ed., *Proceedings of the National Conference of Charities and Corrections* (Fort Wayne, Ind.: Fort Wayne Publishing Co., 1909), p. 356.

4. Magazine circulations: Frank Luther Mott, *The History of American Magazines* (Cambridge, Mass.: Harvard University Press, 1938), vol. 2, *1850–1865*, p. 10. No war had been so extensively reported. In the 1840s the Mexican War had been photographed, but the pictures were not distributed. Wars in the Far East had some coverage, and in the mid-1850s the English photographer Roger Fenton was sent to the Crimea to counter damning newspaper reports of the war with his camera. Fenton was not permitted to photograph dead bodies. (John Hannavy, "The Camera Goes to War," *British Journal of Photography* 122 [October 17, 1975]: 930.)

5. 1863 press report: "Union Prisoners at Richmond," *Harper's Weekly*, December 5, 1863, p. 779. Exchanges: James M. McPherson, *Battle Cry of Freedom: The Civil War Era* (New York: Oxford University Press, 1988), pp. 567, 792–93.

6. Congressional committee: Joint Committee on the Conduct and Expenditures of the War, *Returned Prisoners*, 38th Cong., 1st sess., May 9, 1864, rept. 67. "Spread . . . land": *Congressional Globe*, January 26, 1865, p. 432. Half a million copies: Peter B. Hales, *William Henry Jackson and the Transformation of the American Landscape* (Philadelphia: Temple University Press, 1988), p. 15.

7. "They . . . exaggeration": "The Diabolical Barbarities of the Rebels in the Treatment of Union Prisoners," *Frank Leslie's Illustrated Newspaper*, June 18, 1864, p. 199. "They. . . . pictures": "Further Proofs of Rebel Inhumanity," *Harper's Weekly*, June 18, 1864, p. 387. On the pictures, see also Kathleen G. Collins, "Living Skeletons: Cartes-de-Visite Propaganda in the American Civil War," *History of Photography* 12 (April–June 1988): 103–20, and Collins, "The Camera as an Instrument of Persuasion" (Ph.D. diss., Pennsylvania State University, 1985), pp. 14–15, 116ff.

8. "Further Proofs," *Harper's*, p. 386.

9. *Narrative of Privations and Sufferings. . . . Being the Report of the Commission of Inquiry, Appointed by the United States Sanitary Commission* (New York: Loyal Publication Society, 1864), p. 4; also William Best Hesseltine, *Civil War Prisons: A Study in War Psychology* (New York: Frederick Ungar, 1964), pp. 198–99.

10. George Augustus Sala, *My Diary in America in the Midst of War* (London: Tinsley Brothers, 1865), pp. 319–24.

11. *Congressional Globe*, January 25, 26, 1865, pp. 410, 432. See also January 28 and 29.

12. Trial: House of Representatives, *Trial of Henry Wirz: Proceedings of a Military Commission, Convened at Washington, D.C., August 23, 1865*, 40th Cong., 2d sess., Ex. Doc. 23, pp. 86, 152. "The . . . witness": ibid., p. 731. See also "Trial of Capt. Wirz," *New York Times*, August 30, 1865, p. 5. "Numerous . . . sketches": General N. P. Chipman, *The Horrors of Andersonville Prison: Trial of Henry Wirz, The Andersonville Jailer; Jefferson Davis' Defense of Anderson Prison Fully Refuted* (San Francisco: Bancroft, 1891), p. 66.

13. "A . . . magazine": Dan Longwell, in Loudon Wainwright, "Life Begins: The Birth of the Late, Great Picture Magazine," *Atlantic Monthly*, May 1978, p. 61. *Leslie's*

Weekly: Beaumont Newhall, "Criticism in Photography," *Afterimage* 3 (November 1975): 5. Three hundred photographers: Josephine Cobb, "Photographers of the Civil War," *Military Affairs* 26 (Fall 1962): 129.

14. Frederic Hudson, *Journalism in the United States*, 1872; in Michael Schudson, *Discovering the News: A Social History of American Newspapers* (New York: Basic, 1978), p. 67.

15. Cobb, "Photographers of the Civil War," p. 128.

16. *Vanity Fair*, "little . . . farce": W. Fletcher Thompson, Jr., *The Image of War: The Pictorial Reporting of the American Civil War* (New York: Thomas Yoseloff, 1959), p. 138.

17. William A. Frassanito, *Antietam: The Photographic Legacy of America's Bloodiest Day* (New York: Charles Scribner's Sons, 1978), pp. 17, 51, 53, 256.

18. Ibid., p. 54.

19. "Brady's Photographs: Pictures of the Dead at Antietam," *New York Times*, October 20, 1862, p. 5.

20. Oliver Wendell Holmes, "Doings of the Sunbeam," *Atlantic Monthly* 12 (July 1863): 11–12.

21. Sales: Frassanito, *Antietam*, p. 286, and Jan Zita Grover, "Philosophical Maneuvers in a Photogenic War," *Afterimage* 10 (April 1983): 8. On the impossibility of pinning down an influence, see William Stapp, "Subjects of Strange . . . and of Fearful Interest," in Marianne Fulton, *Eyes of Time: Photojournalism in America* (Boston: New York Graphic Society; Rochester, N.Y.: International Museum of Photography at George Eastman House, 1988), p. 20.

22. Reproduced in 1865: *Harper's Weekly*, July 22, 1865, p. 242; see Stapp, "Subjects," pp. 21–23. "Such . . . nation": Alexander Gardner, *Gardner's Photographic Sketchbook of the Civil War* (1866; reprint, New York: Dover, 1959), p. 36.

23. Gardner: William A. Frassanito, *Gettysburg: A Journey in Time* (New York: Charles Scribner's Sons, 1975), particularly pp. 187–92. Spanish-American War: Martha Rosler, "Image Simulations, Computer Manipulations: Some Considerations," *Afterimage* 17 (November 1989): 7.

24. Twenty-five thousand dollars, "people" were prevented: James D. Horan, *Mathew Brady: Historian with a Camera* (New York: Crown, 1955), pp. 83, 85. Three hundred broken: Roy Meredith, *Mr. Lincoln's Camera Man: Mathew B. Brady* (New York: Charles Scribner's Sons, 1946), p. 246. Face-plates: Ken Burns, "The Painful, Essential Images of War," *New York Times*, January 27, 1991, sec. 2, p. 35.

25. "Fleeting effects": Naomi Rosenblum, *A World History of Photography* (New York: Abbeville, 1984), p. 259. Oliver Wendell Holmes, "The Human Wheel, Its Spokes and Fellowes," *Atlantic Monthly* 11 (May 1863); also, Beaumont Newhall, *The History of Photography from 1839 to the Present* (New York: Museum of Modern Art, 1982), p. 117.

26. Gordon Hendricks, *Eadweard Muybridge: The Father of the Motion Picture* (New York: Grossman, 1975), p. 155.

27. Eadweard Muybridge, *Muybridge's Complete Human and Animal Locomotion*, 1887, introduction to the Dover edition by Anita Ventura Mozley, 3 vols. (New York: Dover, 1979), vol. 1, pp. xii, xv, xvii. The 1877 engraving was actually a photographic reproduction of a painting. The negative may not have been good enough to print. See also Beaumont Newhall, "Muybridge and the First Motion Picture," *Image* 5 (January 1956): 8.

28. Michel Frizot, *Etienne-Jules Marey* (Paris: Centre National de la Photographie, 1984), n.p.

29. "To . . . appearance": *Gazette des Beaux-Arts*, February 1882; in Aaron Scharf, *Art and Photography* (Harmondsworth, England: Penguin, 1975), p. 216. "Thanks . . . clearly": Valéry,

in Alan Trachtenberg, ed., *Classic Essays on Photography* (New Haven, Conn.: Leete's Island, 1980), p. 192.

30. Muybridge's influence: Hendricks, *Father of the Motion Picture*, p. 168; Van Deren Coke, *The Painter and the Photograph* (Albuquerque: University of New Mexico Press, 1964), pp. 159ff.; Scharf, *Art and Photography*, pp. 205–6.

31. *Philadelphia North American:* Coke, *Painter and the Photograph*, p. 156.

32. Stillman: ibid., p. 158. "It . . . suspended": Rodin, in Scharf, *Art and Photography*, p. 226.

33. Picasso, in George Heard Hamilton, *Painting and Sculpture in Europe, 1880–1940* (Harmondsworth, England: Penguin, 1972), p. 15.

34. W. Eugene Smith, interview by Paul Hill and Thomas Cooper, in Hill and Cooper, *Dialogue with Photography*, 1970; in Goldberg, *Photography in Print*, pp. 435–36.

35. Susan Sontag, *On Photography* (New York: Farrar, Straus and Giroux, 1977), p. 20.

36. Jean Prouvost, *Paris-Soir*, May 2, 1931; in Maria Morris Hambourg and Christopher Phillips, *The New Vision: Ford Motor Company Collection at the Metropolitan Museum of Art* (New York: Metropolitan Museum of Art, 1989), p. 103.

37. On the documentary ideal, see Alfred Kazin, *On Native Grounds* (New York: Reynal and Hitchcock, 1942), pp. 492–95.

38. Simon Michael Bessie, *Jazz Journalism: The Story of Tabloid Newspapers* (New York: E. P. Dutton, 1938), p. 236.

39. David S. Wyman, *The Abandonment of the Jews: America and the Holocaust, 1941–1945* (New York: Pantheon, 1984), pp. 19–28, 323.

40. Deborah E. Lipstadt, *Beyond Belief: The American Press and the Coming of the Holocaust, 1933–1945* (New York: Free Press, 1986), pp. 240, 242.

41. *Midstream*, May 1968, also October 1982; in Wyman, *Abandonment*, pp. 40–41.

42. *Editor and Publisher*, May 5, 1945; in Lipstadt, *Beyond Belief*, p. 243.

43. "No . . . them": *New York Times*, April 22, 1945, p. 13. "It . . . understatements": *Editor and Publisher* 78 (May 5, 1945): 34.

2. THE EYE OF DISCOVERY

1. Draper: Robert Taft, *Photography and the American Scene: A Social History, 1839–1889* (1938; reprint, New York: Dover, 1964), p. 199. "The. . . . all": Janssen, in Peter Turner, *History of Photography* (New York: Exeter, 1987), p. 190. "The . . . knowledge": George Didi Huberman, "Photography—Scientific and Pseudo-scientific," in Janet Lloyd, trans., and Jean-Claude Lemagny and André Rouillé, eds., *A History of Photography: Social and Cultural Perspectives* (Cambridge: Cambridge University Press, 1987), p. 72.

2. Gerald Needham, "Manet, 'Olympia,' and Pornographic Photography," in Thomas B. Hess and Linda Nochlin, eds., *Woman as Sex Object: Studies in Erotic Art, 1730–1970* (London: Allen Lane, 1973), p. 83.

3. Degas, in Elizabeth Anne McCauley, *A.A.E. Disdéri and the Carte de Visite Portrait Photograph* (New Haven, Conn.: Yale University Press, 1985), p. 146.

4. 1833, 1851: William H. Goetzmann, *Exploration and Empire* (New York: Alfred A. Knopf, 1966), p. 368. *Country Gentleman:* Peter E. Palmquist, *Carleton E. Watkins: Photographer of the American West* (Fort Worth: Amon Carter Museum; Albuquerque: University of New Mexico Press, 1983), p. 14. *Tribune, Transcript:* Pauline Grenbeaux, "Before Yosemite Art Gallery: Watkins' Early Career," *California History* 18 (Fall 1978): 226.

5. Hans Huth, "Yosemite: The Story of an Idea," *Sierra Club Bulletin* 33 (March 1948): 65.

6. Goupil's: Palmquist, *Watkins*, p. 19. "One. . . . Nature": Oliver Wendell Holmes, "Doings of the Sunbeam," *Atlantic Monthly* 12 (July 1863): 7–8.

7. Robert Cahn, "Evolving Together: Photography and the National Park Idea," in Robert Cahn and Robert Glenn Ketchum, *American Photographers and the National Parks* (New York: Viking, 1981), p. 125; Huth, "Yosemite," p. 66.

8. Palmquist, *Watkins*, p. 20.

9. See Barbara Novak, *Nature and Culture: American Landscape and Painting, 1825–1875* (New York: Oxford University Press, 1980), p. 145.

10. Nathaniel P. Langford, *Scribner's Monthly* 2 (May and June 1871): 1–17, 113–28. See also *New York Times*, October 23, 1871; in Aubrey L. Haines, *Yellowstone National Park: Its Exploration and Establishment* (Washington, D.C.: U.S. Department of the Interior, National Park Service, 1974), pp. 104–5.

11. See Haines, *Yellowstone*, pp. 111, 114; Hales, *Jackson*, p. 108.

12. William Henry Jackson, *Time Exposure* (New York: G. P. Putnam's Sons, 1940), pp. 202–3.

13. Jackson's son: Clarence S. Jackson, *Picture Maker of the Old West: William Henry Jackson* (New York: Bonanza, © 1947 by Charles Scribner's Sons), p. 145. Exaggeration, individual photographs: Howard Bossen, "A Tall Tale Retold: The Influence of the Photographs of William Henry Jackson on the Passage of the Yellowstone Park Act of 1872," *Studies in Visual Communication* 8 (Winter 1982): 98–102; Hales, *Jackson*, pp. 109, 310 n. 29.

14. "Collect . . . etc.": Haines, *Yellowstone*, p. 99. "Now . . . visual": Hales, *Jackson*, p. 110. "While . . . picture": *New York Times*, April 27, 1875; in Beaumont Newhall and Diana E. Edkins, *William Henry Jackson* (Dobbs Ferry, N.Y.: Morgan and Morgan; Fort Worth: Amon Carter Museum, 1974), p. 13.

15. Proposed bills: Donald Culross Peattie, "The Nature of Things," *Bird-Lore* 42 (May–June 1940): 255. Local opposition, state highway: Ben H. Thompson, "The Proposed Kings Canyon National Park," *Bird-Lore* (July–August 1935): 239–41.

16. Ansel Adams: interview with Victoria and David Sheff, *Playboy* 30 (May 1983): 86. New York, Washington: Nancy Newhall, *Ansel Adams: The Eloquent Light* (Millerton, N.Y.: Aperture, 1980), p. 124.

17. "Yesterday . . . him," "I. . . . artistry": Cahn, *Evolving Together*, p. 132; also in Mary Street Alinder and Andrea Gray Stillman, *Ansel Adams: Letters and Images, 1916–1984* (Boston: New York Graphic Society, 1988), p. 111. Congress decided it was not desirable to name a national park after an individual. (*Congressional Record*, vol. 84, pt. 9 [July 17, 1939]: 9434–54.)

18. See *Congressional Record*, vol. 84, pt. II (Appendix): 892, 1085–88, 3881–83. One congressman remarked that he had seen a picture of the place, another mentioned that the Sierra Club distributed one hundred thousand bulletins, another described them as "highly artistic." See *Congressional Record*, vol. 84, pt. 9 (July 17, 1939): 9450, 9443; pt. 5 (May 2, 1939): 5037. A 1939 Sierra Club pamphlet, "The Kings River Region Should Be a National Park," was

profusely illustrated, but only one photograph was by Adams. My thanks to Phoebe Adams at the Sierra Club Library for locating this pamphlet.

19. Cammerer, in Cahn, *Evolving Together*, p. 132.

20. The first bills to protect the Tongass were introduced in 1986. In 1987 the bills' sponsors invited influential legislators to a book signing in the Capitol for Ketchum's *The Tongass: Alaska's Vanishing Rain Forest*. Blow-ups of the photographs were displayed on easels, and copies of the book were given out. *Life* published the photographs (November 1987), *Sports Illustrated* published other photographs of the area (August 14, 1988), and when speakers gave slide lectures around the country, letters poured in to Congress. Both Ruth Fleischer, former legislative assistant to Senator William Proxmire, and Steven Richardson, who wrote the first book on the Tongass for the Wilderness Society, believe the photographs had an effect on the legislation. (Telephone interviews with author, February 14, 1991.)

When real-estate developers submitted plans for high rises in the Marin hills in California, Ansel Adams made blow-ups of one of his pictures of the hills, had an architect draw pictures of the proposed development over it, and placed it in store windows. He said it played a part in the preservation of the Golden Gate Recreation Area. (Victoria and David Sheff, interview with Ansel Adams, *Playboy* 30 [May 1983]: 86.)

Since 1980 Mark Chamberlain has been making photographic displays and conceptual pieces focusing on the highway into Laguna Beach, California. Chamberlain says his projects, often collaborative and actively involving the community in the work of art, have helped stave off construction of a mammoth shopping center, a business park, and a housing development. (Telephone interview with author, February 11, 1991.)

21. Pasteur, in René Vallery-Radot, *The Life of Pasteur*, 1927. For information on Röntgen and his discovery, I have relied principally on Otto Glasser, *Dr. W. C. Rontgen* (Springfield, Ill.: Charles C. Thomas, 1945). See also Arthur W. Fuchs, "Radiography of 1896," *Image* 9 (March 1960): 4–17; Jon Darius, *Beyond Vision* (Oxford: Oxford University Press, 1984), pp. 14, 48–49; Gail Buckland, *First Photographs: People, Places, and Phenomena as Captured for the First Time by the Camera* (New York: Macmillan, 1980), p. 260.

22. Glasser, *Rontgen*, p. 62.

23. Fuchs, "Radiography," p. 16.

24. *Time*, November 23, 1926, p. 63. My thanks to Jeremy Bernstein for suggesting this photograph, to Daniel Jaffe for recommending some source material, and to Dr. Anderson for his helpful communication. Anderson's articles on the positron are in *Science*, September 9, 1932, pp. 238–39, and *Physical Review*, March 15, 1933, pp. 491–94. For further information, see Niels H. de V. Heathcote, *Nobel Prize Winners in Physics: 1901–1953* (New York: Henry Schuman, 1953), pp. 345–52; *Nobel Lectures, Physics: 1920–1941* (Amsterdam: Elsevier, 1965), pp. 354–67; Yataro Sekido and Harry Elliott, eds., *Early History of Cosmic Ray Studies* (Dordrecht, Netherlands: D. Reidel, 1985), pp. 117–32.

25. Bohr and Rutherford: Norwood Russell Hanson, *The Concept of the Positron* (Cambridge: Cambridge University Press, 1963), p. 142.

26. "Once. . . . loose": Fred Hoyle, *The Nature of the Universe*, rev. ed. (New York: Harper and Brothers, 1960), pp. 9–10; he made the comment in a 1948 lecture. "Well. . . . space": Hoyle, in Donald G. Clayton, *The Dark Night Sky* (New York: Quadrangle/New York Times Book Co., 1975), p. 127.

27. Stevenson, in Lynton K. Caldwell, *In Defense of Earth: International Protection of the Biosphere* (Bloomington: Indiana University Press, 1972), p. 147. Caldwell cites the use of the term *spaceship earth* by Kenneth E. Boulding, Barbara Ward, R. Buckminster Fuller, and William G. Pollard.

28. T. H. Watkins, telephone interview with author, February 14, 1991.

29. Buckland, *First Photographs*, p. 95.

30. "NASA . . . Fuller," "Who. . . . instructor": Stewart Brand, "Why Haven't We Seen the Whole Earth?" 1969; in Lynda Rosen Obst, ed., *The Sixties: The Decade Remembered Now, by the People Who Lived It Then* (New York: Random House/Rolling Stone Press, 1977), p. 168.

31. Brand, telephone interview with author, May 8, 1990.

32. *Lunar Orbiter*: Darius, *Beyond Vision*, p. 142. "The . . . it": Frank K. Kelly, guest editorial, *Saturday Review*, November 18, 1967.

33. Beaumont Newhall, *Airborne Camera* (New York: Hastings House, 1969), p. 122.

34. John Noble Wilford, "Apollo Nears Moon on Course," *New York Times*, December 24, 1968, p. 1.

35. Lovell, in John Noble Wilford, "Three Men Fly around the Moon," *New York Times*, December 25, 1968, p. 1.

36. "Earth . . . space": *New York Times*, December 26, 1968; in Clayton, *Dark Night Sky*, pp. 19–20. "I . . . care": Darius, *Beyond Vision*, p. 142.

37. J. E. Lovelock, *Gaia: A New Look at Life on Earth* (Oxford: Oxford University Press, 1979), p. 6. My thanks to Chris Crawford for directing me to this writer.

38. James Lovelock, *The Ages of Gaia: A Biography of Our Living Earth* (New York: W. W. Norton, 1988), p. 29.

39. Lewis Thomas, "Beyond the Moon's Horizon—Our Home," *New York Times*, July 15, 1989, op-ed page.

3. SOMEONE IS WATCHING

1. Swiss police, California: André A. Moenssens, "The Origin of Legal Photography," *Fingerprint and Identification Magazine* 43 (January 1962): 4–6. "The . . . grimaces": *Philadelphia Public Ledger*, November 30, 1841; in Harris B. Tuttle, Sr., "History of Photography in Law Enforcement," *Fingerprint and Identification Magazine* 43 (October 1961): 4.

2. Parliament: John Tagg, "Power and Photography: Part One—A Means of Surveillance: The Photograph as Evidence in Law," *Screen Education* 30 (Autumn 1980): 21–22. Galton: Larry K. Hartsfield, *The American Response to Professional Crime, 1870–1917*, Contributions in Criminology and Penology, no. 8 (Westport, Conn.: Greenwood, 1985), pp. 63–64; also Allan Sekula, "The Body and the Archive," *October* 39 (Winter 1986): 18–19.

3. Sing Sing: Sekula, "Body and the Archive," p. 13. French penal system: Elizabeth Anne McCauley, *A.A.E. Disdéri and the Carte de Visite Portrait Photograph* (New Haven, Conn.: Yale University Press, 1985), p. 27. English prisoners: John Tagg, *The Burden of Representation: Essays on Photographies and Histories* (Houndmills, England: Macmillan Education, 1988), p. 7.

4. Alinari: "Extraordinary Application of Photography," *Harper's Weekly*, February 25, 1865; in *History of Photography* 3 (October 1979): 373–74. Russia: Bill Jay, "Images in the Eyes of the Dead," *British Journal of Photography* 128 (January 30, 1981): 124–26, 133.

5. 1873 parliamentary report: Tagg, *Burden of Repre-*

sentation, p. 7. Tichborne: Gail Buckland, *First Photographs: People, Places, and Phenomena as Captured for the First Time by the Camera* (New York: Macmillan, 1980), p. 131.

6. Hall of Fame: Hartsfield, *American Response*, pp. 46–56. Rogue's Gallery: *New York Morning Journal*, April 23, 1883; in Maren Stange, *Symbols of Ideal Life: Social Documentary Photography in America, 1850–1950* (Cambridge: Cambridge University Press, 1989), p. 19.

7. First police photo studio: Buckland, *First Photographs*, p. 160. "No . . . lies": Henry T. F. Rhodes, *Alphonse Bertillon: Father of Scientific Detection* (New York: Greenwood, 1956), p. 103; see pp. 82–107 for Bertillon's system.

8. Robert McFadden, "Man Wanted as the Killer of 6 Is Caught Because of TV Show," *New York Times*, April 11, 1988, p. B1. In 1943 the New York police had decided not to broadcast "wanted" pictures over the police television system because anyone with a television receiver might pick them up, but pictures of missing persons were broadcast to neighboring states. (*New York Times*, September 30, 1943, p. 23.)

9. Sekula, "Body and the Archive," p. 56.

10. See Tagg, *Burden of Representation*, and "Power and Photography," particularly pp. 42–47; also Tagg, "The Burden of Representation: Photography and the Growth of the Surveillance State," *Ten-8* 14 (1984): 10–12. Tagg, whose work depends heavily on Michel Foucault, has contributed fundamentally to an understanding of photography's connections to social change and has markedly influenced one branch of contemporary photographic history. However, he tends to deny photography any existence outside its ties to historical forces, and he overemphasizes the negative effects of regulation and record keeping, which are not only essential in the modern state but can be and sometimes are benignly used for the good of citizens.

11. France: McCauley, *A.A.E. Disdéri*, p. 27. America: *Photographic News*, 1885; in Helmut Gernsheim, *The Rise of Photography, 1850–1880: The Age of Collodion* (New York: Thames and Hudson, 1988), p. 201. Vienna: Tuttle, "Photography in Law Enforcement," p. 7. Tuttle says that identification photographs were placed on season passes for the Berlin Photographic Exposition in 1865 and the Paris Exposition in 1867.

12. Diamond: Sander L. Gilman, ed., *The Face of Madness: Hugh W. Diamond and the Origin of Psychiatric Photography* (New York: Brunner/Mazel, 1976). Medical records: Georges Didi-Huberman, "Photography—Scientific and Pseudo-scientific"; in Janet Lloyd, trans., and Jean-Claude Lemagny and André Rouillé, eds., *A History of Photography: Social and Cultural Perspectives* (Cambridge: Cambridge University Press, 1987), p. 73. "Like . . . Headquarters": Stange, *Symbols of Ideal Life*, p. 22.

13. Melissa Banta and Curtis M. Hinsley, *From Site to Sight: Anthropology, Photography, and the Power of Imagery* (Cambridge, Mass.: Peabody Museum Press, 1986), p. 103.

14. See Alan Trachtenberg, *Reading American Photographs: Images as History, Mathew Brady to Walker Evans* (New York: Hill and Wang, 1989), pp. 53–56.

15. Donald E. English, *Political Uses of Photography in the Third French Republic, 1871–1914* (Ann Arbor, Mich.: UMI Research Press, 1984), p. 70. Most of my information about the Commune photographs is taken from this excellent book. See also Claude Dimock, "Twice Defeated: Photographs of the Paris Commune by Auguste B. Braquehais," *Views* 6 (Spring 1985): 21; Jean-Claude Gautrand, "Les Photographes et la Commune," *Photo-ciné Revue* (February 1972): 53–63;

Helmut and Alison Gernsheim, *The Recording Eye: A Hundred Years of Great Events as Seen by the Camera, 1839–1939* (New York: G. P. Putnam's Sons, 1960), pp. 62–65; James A. Leith, "The War of Images Surrounding the Commune," in Leith, ed., *Images of the Commune* (Montreal: McGill-Queens University Press, 1978), pp. 101–47; Mary Warner Marien, "The Rhetoric of the Image," *Afterimage* 13 (October 1985): 10–13.

16. English, *Political Uses*, p. 70.

17. Bill Gifford and Rick Hornung, "You Probably Are in Pictures," *Village Voice*, March 21, 1989, p. 24. My thanks to Mel Rosenthal for this reference.

18. *L'Anti-juif illustré*: English, *Political Uses*, pp. 195–96. "Jewish. . . . photographed": Sybil Milton, "The Camera as Weapon, Voyeur, and Witness: Photography of the Holocaust as Historical Evidence," in Martin Taureg and Jay Ruby, eds., *Visual Explorations of the World*, Selected Papers from the International Conference on Visual Communication (Aachen, Germany: Edition Herodot, 1987), p. 86. My thanks to Sybil Milton for giving me a copy of her paper.

19. Czechoslovakia: Speech by Pavel Stecha, Houston Fotofest, February 14, 1990. Clandestine videotapes: "The Koppel Report: Television, Revolution in a Box," ABC-TV, September 13, 1989.

20. Frank B. Gilbreth, *Fatigue Study* (London: George Routledge and Sons, 1919), p. 31. My thanks to Max Kozloff for suggesting Taylorism as a subject for study.

21. Edna Yost, *Frank and Lillian Gilbreth: Partners for Life* (New Brunswick, N.J.: Rutgers University Press, 1949), p. 105.

22. Movie camera: Frank B. Gilbreth and Lillian Moller Gilbreth, *Motion Study for the Handicapped* (London: George Routledge and Sons, 1920), p. 6. See also Ralph M. Barnes, *Motion and Time Study*, 3d ed. (New York: John Wiley and Sons, 1949), p. 110. "High priced men," "With . . . on": Lillian Gilbreth, *Psychology of Management* (New York: Sturgis and Walton, 1914), pp. 42, 39.

23. Muybridge, grids: Yost, *Frank and Lillian Gilbreth*, p. 223. Chronocyclegraph: Gilbreth, *Fatigue Study*, p. 119.

24. Samuel Haber, *Efficiency and Uplift: Scientific Management in the Progressive Era, 1890–1920* (Chicago: University of Chicago Press, 1964), p. 39 and n. 19. See also Allan Sekula, "Photography between Labour and Capital," in Benjamin H. D. Buchloh and Robert Wilkie, eds., *Mining Photographs and Other Pictures, 1948–1968: A Selection from the Negative Archives of Shedden Studio, Glace Bay, Cape Breton, Photographs by Leslie Shedden* (Halifax, Canada: Press of the Nova Scotia College of Art and Design; University College of Cape Breton Press, 1983), pp. 239–49. Sekula's is a wide-ranging and penetrating study.

25. Gilbreth, *Fatigue Study*, p. 31.

26. "Cameras. . . . men": *Providence Labor Advocate*, November 30, 1913; in David Montgomery, *The Fall of the House of Labor: The Workplace, the State, and American Labor Activism, 1865–1925* (Cambridge: Cambridge University Press, 1987), pp. 220–21. Worker-activated apparatus: Sekula, "Photography between Labour and Capital," p. 246.

27. See R. F. Hoxie, "Why Organized Labor Opposes Scientific Management," pamphlet, n.d. [soon after 1916], p. 82, Tamiment Library in Bobst Library, New York University.

28. Less accurate: Haber, *Efficiency and Uplift*, p. 40. Stopwatch as symbol: Montgomery, *House of Labor*, p. 221. "Speed-up": Hugh G. J. Aitken, *Scientific Management in Action: Taylorism at Watertown Arsenal, 1908–1915*

(Princeton, N.J.: Princeton University Press, 1985), p. 30.

29. Montgomery, *House of Labor*, p. 440. Ralph M. Barnes, *Motion and Time Study Applications* (New York: John Wiley and Sons, 1942), preface and pp. 35–37. Harry Braverman, *Labor and Monopoly Capitalism: The Degradation of Work in the Twentieth Century* (New York: Monthly Review, 1974), pp. 173ff, 180.

30. Edward Steichen, "Aerial Photography at the Front," *Camera*, 1919; in Beaumont Newhall, *Airborne Camera: The World from the Air and Outer Space* (New York: Hastings House, 1969), p. 54.

31. "A. . . . deadly": "Aero Photography," *Abel's Photographic Weekly*, December 21, 1918, pp. 533, 537. Von Fritsch: Constance Babington Smith, *Evidence in Camera: The Story of Photographic Intelligence in World War II* (London: Chatto and Windus, 1958), p. 17.

32. Arthur M. Schlesinger, Jr., *A Thousand Days: John F. Kennedy in the White House* (Boston: Houghton Mifflin, 1965), p. 800.

33. De Gaulle, in Robert F. Kennedy, *Thirteen Days: A Memoir of the Cuban Missile Crisis* (New York: W. W. Norton, 1965), p. 51.

34. For the evolution of the crisis, see: *New York Times*, October 23, 1962, pp. 1, 19, 20; October 24, 1962, p. 1; October 25, 1962, p. 1; October 16, 1962, p. 1; *Life*, November 2, 1962, pp. 34ff; "CBS Special News Report," CBS-TV, October 25, 1962.

35. John W. Finney, "Aerial Cameras Traced Cuban Missile Build-Up," *New York Times*, October 24, 1962, p. 21.

36. James G. Blight and David A. Welch, *On the Brink: Americans and Soviets Reexamine the Cuban Missile Crisis* (New York: Hill and Wang, 1989), p. 251. This volume is extremely useful, especially pp. 334–83.

37. "The. . . . print": in Newhall, *Airborne Camera*, p. 54. "I. . . . field": Kennedy, *Thirteen Days*, p. 24.

38. Steven R. Weisman, "Japan's Urban Underside Erupts, Tarnishing Image of Social Peace," *New York Times*, October 11, 1990, p. 10.

39. Maxine Hong Kingston, "San Francisco's Chinatown," *American Heritage* 30 (December 1978): 47.

4. POLITICAL PERSUADERS & PHOTOGRAPHIC DECEITS

1. Thomas C. Leonard, *The Power of the Press: The Birth of American Political Reporting* (New York: Oxford University Press, 1986), p. 100. Some say it was Mathew Brady who recognized him.

2. Richard Rudisill, *Mirror Image: The Influence of the Daguerreotype on American Society* (Albuquerque: University of New Mexico Press, 1971), p. 74.

3. Naomi Rosenblum, *A World History of Photography* (New York: Abbeville, 1984), p. 67.

4. "The. . . . objects": Donald E. English, *Political Uses of Photography in the Third French Republic, 1871–1914* (Ann Arbor, Mich.: UMI Research Press, 1984), p. 87. "They. . . . ridiculous": Michel R. Braive, *The Photograph: A Social History*, trans. David Britt (New York: McGraw Hill, 1966), pp. 167–71.

5. English, *Political Uses*, p. 121.

6. "Insisted. . . . knowledge": F. B. Carpenter, *Six Months in the White House with Abraham Lincoln* (New York: Hurd and Haughton, 1866), p. 46. "Brady . . . President": interview with

Mathew Brady in the *New York World*, April 12, 1891; in Vicki Goldberg, *Photography in Print* (Albuquerque: University of New Mexico Press, 1989), pp. 199–206.

7. Alan Nevins, *The Emergence of Lincoln* (New York: Charles Scribner's Sons, 1950), p. 197.

8. Marvin L. Hayes, *Mr. Lincoln Runs for President* (New York: Citadel, 1960), p. 20.

9. Roy Meredith, *Mr. Lincoln's Camera Man: Mathew B. Brady* (New York: Dover, 1974), p. 58.

10. Marcus Aurelius Root, *The Camera and the Pencil*, 1864; in Alan Trachtenberg, *Reading American Photographs: Images as History, Mathew Brady to Walker Evans* (New York: Hill and Wang, 1989), p. 17.

11. *Charleston Mercury*, *Houston Telegraph*: Emerson David Fite, *The Presidential Campaign of 1860* (New York: Macmillan, 1911), p. 210.

12. Harold Holzer, Gabor S. Boritt, Mark E. Neely, Jr., *The Lincoln Image: Abraham Lincoln and the Popular Print* (New York: Charles Scribner's Sons, 1984), p. 2.

13. "While . . . speech" and *Tribune*: Hayes, *Mr. Lincoln Runs*, pp. 24, 27–28. On the reprinted speech, see Nevins, *Emergence of Lincoln*, pp. 183–87, 242, and Stephen B. Oates, *With Malice toward None: The Life of Abraham Lincoln* (New York: Harper and Row, 1977), p. 173.

14. The . . . conversation": *Harper's Weekly*, November 14, 1863; in Trachtenberg, *Reading American Photographs*, p. 39. One hundred thousand: Frederick Hill Meserve and Carl Sandburg, *The Photographs of Abraham Lincoln* (New York: Harcourt, Brace, 1944), p. 27.

15. Tintype campaign pins: Robert A. Mayer, "Photographing the American Presidency," *Image* 27 (September 1984): 8. Daguerreotype medals: David C. Mearns, *The Lincoln Papers*, 1948; in Holzer, Boritt, Neely, *Lincoln Image*, p. 70.

16. On Currier and Ives' sales outlets and political banners, see Walton Rawls, *The Great Book of Currier and Ives' America* (New York: Abbeville, 1979), pp. 21, 37. Prices: Holzer, Boritt, Neely, *Lincoln Image*, p. 30.

17. "Every . . . electioneering": Holzer, Boritt, Neely, *Lincoln Image*, p. 67. Quick step, etc.: ibid., pp. 25, 27, 28.

18. Ibid., p. 67.

19. E. H. Brown: ibid., p. 11. Portrait carried in: ibid., p. 13. "Attempts . . . life": ibid., p. 78.

20. All information on Ruef and this photograph comes from George E. Mowry, *The California Progressives* (Berkeley: University of California Press, 1951), pp. 25–119; and C. P. Connolly, "Big Business and the Bench: The Part the Railways Play in Corrupting Our Courts," part 2, *Everybody's Magazine* 26 (March 1912): 291–306.

21. Richard M. Nixon, *Six Crises* (Garden City, N.Y.: Doubleday, 1962), p. 256.

22. William Safire, *Before the Fall: An Inside View of the Pre-Watergate White House* (Garden City, N.Y.: Doubleday, 1975), pp. 3–5. My thanks to Phillip Block for suggesting this subject.

23. "There. . . . home": Jack Raymond, "A Political Gain for Nixon Is Seen, Capital Views Soviet Events as Aiding His '60 Hopes—Some Fear Loss by U.S.," *New York Times*, July 26, 1959, pp. 1, 4. "How . . . Gromyko": ibid., sec. E, pp. 1, 3.

24. Despite requests for delays from the American embassy in Moscow, the program was broadcast by all three networks on the 11:00 news on July 25. See "Nixon Meets Khrushchev: Plain Talk in Moscow," CBS-TV, July 26, 1959. Ad: *New York Times*, July 28, 1959, p. 7.

25. "Encounter," *Newsweek*, August 3, 1959, pp. 15–20. *Life*, August 3, 1959, pp. 16–20. "The New Diplomacy," *Time*, August 3, 1959, pp. 11–16.

26. Reagan, in Stephen E. Ambrose, *Nixon: The Education of a Politician, 1913–1962* (New York: Simon and Schuster, 1987), pp. 532–33.

27. Nixon–Rockefeller: *Time*, August 10, 1959, p. 9. Nixon–Kennedy: Charles P. Henderson, Jr., *The Nixon Theology* (New York: Harper and Row, 1972), p. 118.

28. "Was. . . . waver": Safire, *Before the Fall*, p. 5; see Fawn Brodie, *Richard Nixon, The Shaping of His Character* (New York: W. W. Norton, 1981), p. 386, for a general agreement. Nixon himself: Nixon, *Six Crises*, p. 254. Spot-check: "Moscow Debate Stirs U.S. Public," *New York Times*, July 27, 1959, p. 13.

29. "Make . . . objective": "Encounter," p. 20. Safire, *Before the Fall*, p. 5. Elliott Erwitt, telephone interview with author, December 4, 1989.

30. My thanks to Fred W. Klose, archivist of the Los Angeles branch of the National Archives, for locating this material. The second item spelled Khrushchev's name correctly.

31. My thanks to James Hill at the John F. Kennedy Library in Boston for information on television use of the photograph. The ads were recalled by Kathleen Hall Jamieson (letter to author, February 1990) and Erwitt. Magnum settlement: Erwitt, telephone interview with author, December 4, 1989.

32. *RN: The Memoirs of Richard Nixon* (New York: Grosset and Dunlap, 1978), p. 209.

33. Michael Baruch Grossman and Martha Joynt Kumar, *Portraying the President: The White House and the News Media* (Baltimore: Johns Hopkins University Press, 1981), pp. 27–28.

34. Horace Busby to President Johnson, January 24, 1964; in Grossman and Kumar, *Portraying the President*, p. 229.

35. Oliver Sacks, "The President's Speech," *New York Review of Books*, August 15, 1985, p. 29.

36. Leslie Stahl, speaking at "Projecting the Image: The White House and the Media," November 1, 1987, 92nd St. YMHA, New York City; in Carol Squiers, ed., *The Critical Image: Essays on Contemporary Photography* (Seattle: Bay, 1990), pp. 128, 125.

37. The Pope: Braive, *Photograph: A Social History*, p. 179. "The . . . floating": Kathleen Collins, "Photography and Politics in Rome: The Edict of 1861 and the Scandalous Montages of 1861–1862," *History of Photography* 9 (October–December 1985): 297. Bonaparte: Gérard Le Marec, *Les Photos trucquées: Un Siècle de propaganda par l'image* (Paris: Editions Atlas, 1985), p. 17.

38. English, *Political Uses*, p. 199.

39. Ibid., pp. 33–34.

40. William and Estelle Marder, *Anthony: The Man, the Company, the Cameras: An American Photographic Pioneer* (Plantation, Fla.: Pine Ridge, 1982), p. 90.

41. "Vell . . . here": David Halberstam, *The Powers That Be* (New York: Alfred A. Knopf, 1979), p. 117. Hitler: Le Marec, *Photos trucquées*, p. 112. The filmmaker was John Grierson, who coined the term *documentary*.

42. "A . . . people": Roberta Strauss Feuerlicht, *Joe McCarthy and McCarthyism* (New York: McGraw Hill, 1972), p. 66. "Whitewashing . . . republic": John G. Adams, *Without Precedent: The Story of the Death of McCarthyism* (New York: W. W. Norton, 1983), pp. 24–25. Could scarcely sleep: Jack Anderson and Ronald W. May, *McCarthy: The Man, the Senator, the "Ism"* (Boston: Beacon, 1952), p. 296.

43. Bazy Miller: Helen Fuller, "Political Murder, Inc.," *New Republic* 125 (April 2, 1951): 14. Smith: Anderson and May, *McCarthy*, pp. 297–98. Tankersley: Thomas C. Reeves, *The Life and Times of Joe McCarthy* (New York: Stein and Day, 1982), p. 339.

44. Campaign volunteer: Anderson and May, *McCarthy*, p. 299. Caption: Feuerlicht, *McCarthy and McCarthyism*, p. 77, and Adams, *Without Precedent*, p. 30.

45. Tydings's defeat: Robert Griffith, *The Politics of Fear: Joseph R. McCarthy and the Senate* (Lexington: University Press of Kentucky, 1970), pp. 129–30. Fellow senators: Fred J. Cook, *The Nightmare Decade: The Life and Times of Senator Joe McCarthy* (New York: Random House, 1971), p. 311.

46. Tydings's testimony: *Newsweek*, March 5, 1951, p. 25. Smith, Kerr: in Cook, *Nightmare Decade*, p. 307. Tankersley: in Reeves, *Life and Times*, p. 339.

47. "Infamous . . . picture" and cartoon: *Progressive* 18 (April 1954): 66–67.

48. Anderson and May, *McCarthy*, p. 371.

49. Roland Barthes, "The Photographic Message," in Susan Sontag, ed., *A Barthes Reader* (New York: Hill and Wang, 1982), p. 200. In 1938 a similar photographic incident had damaged a candidate. A man named Walter A. Quigley, who had been called in to help Harold Stassen defeat Minnesota Governor Elmer A. Benson, produced a tabloid with a photograph of Benson sitting in an open car as he led a parade in New York City in 1936. Evidently a New York newspaper had published the picture at the time with text saying that "a detail of Communists ran beside the governor's car and offered three cheers at every street corner." The Minnesota tabloid added a man in a running position beside the car; his cap said "Young Communist League." Quigley himself later said he thought the picture was a composite but he'd had nothing to do with it. Benson lost the election. Frank H. Jones, ed., *Political Dynamiting* (Salt Lake City: University of Utah Press, 1970), p. 27.

50. *U.S. News and World Report*, May 7, 1954, p. 118.

51. Ibid., p. 120.

52. "It Should Not Appear in *Life* Magazine," *Life*, May 3, 1954, p. 23.

53. French and Belgian children: Le Marec, *Photos trucquées*, p. 12. Alsatian women: Richard Whelan, *Robert Capa: A Biography* (New York: Alfred A. Knopf, 1985), p. 101.

54. "Started. . . . forth": Bill Ganzel, "Arthur Rothstein, an Interview," *Exposure* 16 (Fall 1978): 3. Stryker letter: F. Jack Hurley, *Portrait of a Decade: Roy Stryker and the Development of Documentary Photography in the Thirties* (Baton Rouge: Louisiana State University Press, 1972), p. 86.

55. Ganzel, "Rothstein, an Interview," p. 3.

56. *Fargo Forum*, in "The Press: Fargo Fakery," *Time*, September 7, 1936, p. 36.

57. Stryker: "Stryker on FSA, Sonj, J & L," interview conducted by Robert J. Doherty, F. Jack Hurley, Jay M. Cloner, and Carl G. Ryant, 1972; in *Image* 18 (December 1975): 14. *New York Herald Tribune* and *New York Sun*, August 29, 1936. *Time*, September 7, 1936, p. 36.

58. "That . . . history": Roy Emerson Stryker and Nancy Wood, *In This Proud Land: America 1935–1943 as Seen in the FSA Photographs* (New York: Galahad, 1973), p. 14. "The. . . . men": in Hurley, *Portrait of a Decade*, p. 88.

59. Pegler, in Arthur Rothstein, "The Picture That Became a Campaign Issue," *Popular Photography* 49 (September 1961): 49.

60. Hurley, *Portrait of a Decade*, pp. 90, 92. In 1951 Senator Bourke Hickenlooper (Republican, Iowa) brought Rothstein's photograph and its bad repute back by comparing it with the composite of Tydings and Browder and charging the Democratic administration with misleading the press. (See Rothstein, "Picture," p. 79.) Old photographs never die.

61. Charles Morgan, Jr., *A Time to Speak* (New York: Harper and Row, 1964), pp. 86, 95.

62. On computers and photography, see Fred Ritchin, *In Our Own Image: The Coming Revolution in Photography* (New York: Aperture, 1990), passim. Olshwanger: Elizabeth Rogers, "Now You See It, Now You Don't," *News Photographer* 44 (August 1989): 16–18. My thanks to Fred Ritchin for his assistance.

5. FAME & CELEBRITY

1. On being famous: Daniel Boorstin, *The Image: A Guide to Pseudo-Events in America* (New York: Atheneum, 1961), pp. 57–61. Arnold, Emerson quotes: *The Shorter Oxford English Dictionary*, 3d, rev. ed., s.v. "celebrity."

2. Helmut Gernsheim, *The Rise of Photography, 1850–1880: The Age of Collodion* (New York: Thames and Hudson, 1988), p. 200.

3. Elizabeth Anne McCauley, *A.A.E. Disdéri and the Carte de Visite Portrait Photograph* (New Haven, Conn.: Yale University Press, 1985), p. 45. This book is the most comprehensive source on the subject, and I am greatly in its debt.

4. William C. Darrah, *Cartes de Visite in Nineteenth Century Photography* (Gettysburg, Pa.: W. C. Darrah, 1981), p. 19. Gernsheim, *Rise of Photography*, p. 183, says hundreds of thousands of albums sold.

5. Beaumont Newhall, *The History of Photography from 1839 to the Present* (New York: Museum of Modern Art, 1982), p. 64. The "domestication" of royalty was already evident in Sir Edwin Landseer's *Queen Victoria, the Prince Consort, and the Princess Royal* of 1843, but paintings were obviously less accessible than cartes.

6. Sold in bookstores, etc.: Robert Taft, *Photography and the American Scene: A Social History, 1839–1889* (1938; reprint, New York: Dover, 1964), p. 149. "Sure cards": Helmut and Alison Gernsheim, *The History of Photography*, 1969; in Ben L. Bassham, *The Theatrical Photographs of Napoléon Sarony* (Kent, Ohio: Kent State University Press, 1978), p. 10.

7. *Humphrey's Journal* 12, no. 9 (March 1, 1861), and 14, no. 26 (1862); in Darrah, *Cartes de Visite*, p. 43.

8. See Warren Susman, *Culture as History: The Transformation of American Society in the Twentieth Century* (New York: Pantheon, 1984), p. 262.

9. On Truth, see Kathleen Collins, "Shadow and Substance: Sojourner Truth," *History of Photography* 7 (July–September 1983): 183–205; also Collins, "The Camera as an Instrument of Persuasion: Studies of Nineteenth Century Propaganda Photography" (Ph.D. diss., Pennsylvania State University, 1985), pp. 76–109. "A . . . Truth": Hertha Pauli, *Her Name Was Sojourner Truth* (New York: Appleton-Century-Crofts, 1962), p. 201. "Sojourner. . . . photograph": Olive Gilbert, *Narrative of Sojourner Truth* (New York: Arno; New York Times, 1968), pp. 200–201.

10. "The . . . Europe": V. Darthenay, *Les Acteurs et les actrices de Paris: Biographie complète* (Paris: Chez les Editeurs, 1853), p. 22. Five hundred copies: Robert A.

Sobieszek, *Masterpieces of Photography from the George Eastman House Collections* (New York: Abbeville, 1985), p. 306. My thanks to Robert Sobieszek for his advice on Mlle Rachel. Lind: *Photographic Art Journal*, May 1851; in William and Estelle Marder, *Anthony: The Man, the Company, the Cameras: An American Photographic Pioneer* (Plantation, Fla.: Pine Ridge, 1982), p. 60. Montez: Ishbel Ross, *The Uncrowned Queen: Life of Lola Montez* (New York: Harper and Row, 1972), p. 307.

11. Paul Lewis, *Queen of the Plaza: A Biography of Adah Isaacs Menken* (New York: Funk and Wagnalls, 1964), pp. 98, 104. My thanks to William Stapp for suggesting Menken as a possible subject.

12. On Menken: Allen Lesser, *Enchanting Rebel: The Secret of Adah Isaacs Menken* (n.p.: Jewish Book Guild, 1947), pp. 75–80. "So . . . see": ibid., p. 175. The play was adapted by Henry Milner from Byron's poem.

13. "Why . . . young": Comstock, 1872; ibid., p. 206. "An . . . stage": Greeley, 1862; in Lewis, *Queen of the Plaza*, p. 140. Shorts, loincloth: Wolf Mankowitz, *Mazeppa: The Lives, Loves, and Legends of Adah Isaacs Menken* (New York: Stein and Day, 1982), p. 130. Mankowitz says (p. 175) that the photograph of her nude, which he reproduces, was thought a forgery but is not. Menken hats, etc.: Lesser, *Enchanting Rebel*, p. 192.

14. Pictures and scandal: ibid., pp. 199–205. Foreign papers, Victoria: Lewis, *Queen of the Plaza*, p. 254. Lesser, p. 199, says Pierre Petit took the picture of Dumas with his arm around her waist.

15. "There. . . . shame": Horace Wyndham, *Victorian Sensations* (London: Jarrolds, 1933), pp. 184–85. *La Vogue parisienne*: F. W. Hemming, *Alexandre Dumas: The King of Romance* (New York: Charles Scribner's Sons, 1979), p. 208.

16. Sand, Verlaine: Lewis, *Queen of the Plaza*, p. 256.

17. Lesser, *Enchanting Rebel*, p. 205; Mankowitz, *Mazeppa*, p. 178.

18. Swinburne: Jean Overton Fuller, *Swinburne: A Critical Biography* (London: Chatto and Windus, 1968), pp. 163, 165. Menken's earnings: Donald Thomas, *Swinburne: The Poet in His World* (New York: Oxford University Press, 1979), p. 146.

19. Lesser, *Enchanting Rebel*, p. 230.

20. Eiffel Tower: William Emboden, *Sarah Bernhardt* (London: Studio Vista, 1974), p. 143. Costume: Cornelia Otis Skinner, *Madame Sarah* (Boston: Houghton Mifflin, 1966), p. 98.

21. "Patience": Lloyd Lewis and Henry Justin Smith, *Oscar Wilde Discovers America* (New York: Harcourt, Brace, 1936), p. 238. The photographer was Melandin. "I . . . Bernhardt": Skinner, *Madame Sarah*, p. 98.

22. Kendal: *Theatre*, October 1884; in Alan Thomas, *Time in a Frame: Photography and the Nineteenth-Century Mind* (New York: Schocken, 1977), p. 99. Fees: Bassham, *Theatrical Photographs*, p. 4.

23. *Tribune*: Boorstin, *Image*, p. 13. "The. . . . periodicals": Albert Shaw, "The Opportunity of the Publicist in Relation to Efforts for Social Betterment," in Alexander Johnson, ed., *Proceedings of the National Conference of Charities and Correction* (Fort Wayne, Ind.: Press of the Fort Wayne Printing Co., 1909), p. 321.

24. "Gossip . . . effrontery": Morris L. Ernst and Alan U. Schwartz, *Privacy: The Right to Be Let Alone*, Milestones of Law Series (New York: Macmillan, 1962), p. 50. Garfield: James E. Pollard, *The Presidents and the Press*, 1947; in Caroline Dow, "The Response of Law to Visual Journalism:

1839–1978" (Ph.D. diss., Michigan State University, 1985), p. 92.

25. Roberson v. Rochester Folding Box Co., 171 N.Y. 542–545, 563–564 (1902), is the source for all quotes from this case. My thanks to Leon Polsky for his assistance. See also Ernst and Schwartz, *Privacy*, pp. 3–4, 108–47.

26. Ernest and Schwartz, *Privacy*, pp. 125–26.

27. Ibid., pp. 123–130.

28. *New York Times*, July 6, 1972, p. 1. See also January 11 and February 17.

29. Arrington v. New York Times Co., 55 N.Y. 433–442 (2d Cir. 1982). A New York law was subsequently passed that protects all photographs published as news, no matter what the source.

30. See Richard Dyer, *Stars* (London: British Film Institute, 1979), p. 16, referring to Leo Lowenthal, "Triumph of Mass Idols," in *Literature, Popular Culture and Society* (Englewood Cliffs, N.J.: Prentice-Hall, 1961), pp. 109–40.

31. Screen credits, Laemmle: Richard Schickel, *His Picture in the Papers*, 1974; in Dyer, *Stars*, p. 9.

32. *Photoplay*, Chaplin: Richard Schickel, *Intimate Strangers: The Culture of Celebrity* (Garden City, N.Y.: Doubleday, 1985), pp. 35, 41.

33. Riots: Charles Samuels, *The King: A Biography of Clark Gable* (New York: Coward-McCann, 1962), p. 183. Undershirt: Lyn Tornabene, *Long Live the King: A Biography of Clark Gable* (New York: G. P. Putnam's Sons, 1976), p. 189.

34. 75 percent: Warren G. Harris, *Gable and Lombard* (New York: Simon and Schuster, 1974), p. 37; less exact figures are given by other authors. *Life* article: *Life*, February 13, 1939.

35. Fashions: Tornabene, *Long Live the King*, p. 189. *Detroit Times* reporter: *Detroit Times*, March 23, no year (probably 1939), Gable files MLL + n.c. 2619, New York Public Library, Lincoln Center. Other clips in the file indicate that Gable topped the list of Hollywood's best-dressed men.

36. English and German manufacturers: Charles Eckert, "The Carole Lombard in Macy's Window," *Quarterly Review of Film Studies* 3 (Winter 1978): 4. The author says this is "according to Benjamin Hampton." My thanks to Sally Stein for this reference. Sportswear: ibid., pp. 7–8; also Christopher Finch and Linda Rosenkrantz, *Gone Hollywood* (Garden City, N.Y.: Doubleday, 1979), pp. 358, 361. Colbert: pressbook, *It Happened One Night*, MEL n.c. 764–765, New York Public Library, Lincoln Center.

37. *Newsweek*, August 2, 1943, p. 42.

38. "In . . . women": *Time*, July 31, 1944, p. 50. Armed Forces units: Doug Warren, *Betty Grable: The Reluctant Movie Queen* (New York: St. Martin's, 1981), p. 96.

39. "Pilots . . . radar": Jeffrey Gorney, "Betty Grable, 1916–1973," *Films in Review* 24 (August–September 1973): 389. German, Japanese soldiers: Spero Pastos, *Pin-Up: The Tragedy of Betty Grable* (New York: G. P. Putnam's Sons, 1986), p. 58.

40. "You. . . . for": in *This Fabulous Century*, vol. 5, *1940–1950* (New York: Time-Life Books, 1969), p. 122. "You. . . . responsibility": *New Yorker*, June 26, 1943.

41. *Modern Screen*: Jane Marie Gaines, "The Popular Icon as Commodity and Sign: The Circulation of Betty Grable, 1941–5" (Ph.D. diss., Northwestern University, 1982), p. 502. "There. . . . for": Pastos, *Pin-Up*, p. 59.

42. "We . . . women": *Saturday Evening Post*, August 12, 1944; in Gaines, "Popular Icon," p. 121. Harry James: *Boston Daily Globe*, May 13, 1944; ibid., p. 293.

43. Powolney: Warren, *Reluctant Movie Queen*, p. 78. War bonds: *Newsweek*, October 4, 1943, p. 50. Grauman's: *Minneapolis Star*, September 21, 1943; in Gaines, "Popular Icon," p. 495. "Mickey . . . legs": Jerry Oster, "Why a Queen Wore Tights," *New York Daily News*, July 5, 1973, p. 4. Beauty manual: Eleanor King, *Glorify Yourself*, 1942; in Gaines, "Popular Icon," p. 458.

44. Number one: Pastos, *Pin-Up*, p. 50. "The . . . 1941": *Miami Daily News*, February 2, 1942; ibid., p. 484. "Strictly. . . . war": *New Yorker*, June 26, 1943, pp. 13–14. On Grable's father, see *Movie Life Yearbook* 1 (1954): 5, New York Public Library, Lincoln Center, Lester Sweyd Collection.

45. College boys: Undated, untitled newspaper clip, New York Public Library, Lincoln Center, Chamberlain and Lyman Brown Theatrical Agency Collection. Pinup contests: Gaines, "Popular Icon," pp. 151–52, 189–91. Different pinups of Grable went with different films, but Grable was always identified as a pinup.

46. Griffith, in Schickel, *Intimate Strangers*, p. 93.

47. Greenberg, in "Art," *Nation*, January 24, 1948; in Steven Naifeh and Gregory White Smith, *Jackson Pollock: An American Saga* (New York: Clarkson N. Potter, 1989), p. 556. My thanks to Ellen Landau, Francis V. O'Connor, Bernard H. Friedman, and Paul Brach for their generous assistance on the subject of Pollock.

48. "A *Life* Round Table on Modern Art," *Life*, October 11, 1948, p. 62.

49. The *Life* photographer was Martha Holmes. Ellen G. Landau, *Jackson Pollock* (New York: Harry N. Abrams, 1989), p. 182, says Pollock only pretended to paint for Newman and for Rudolph Burckhardt's photographs for *Artnews* as well.

50. "A . . . noire": E. C. Goossen, in Vivien Raynor, "Jackson Pollock in Retrospect—'He Broke the Ice,' " *New York Times Magazine*, April 1967, p. 66. Letters to *Life*: Robert T. Elson, *The World of Time Inc.: The Intimate History of a Publishing Enterprise* (New York: Atheneum, 1973), vol. 2, *1941–1950*, p. 422. Fan letters: Naifeh and Smith, *Pollock*, p. 596.

51. Francine du Plessix and Cleve Gray, "Who Was Jackson Pollock?" *Art in America* 55 (May–June 1967): 53.

52. "Each. . . . in": *Time*, November 20, 1950, pp. 70–71, and December 11, 1950, letters column. The critic, Bruno Alfieri, had ended by saying that Pollock might be more avant-garde than Picasso, but *Time* did not quote that part: see Naifeh and Smith, *Pollock*, p. 606. Beaton: *Vogue*, March 1951, pp. 158ff.

53. "Jack the Dripper": "The Wild Ones," *Time*, February 20, 1956, pp. 70–75. Pollock's measured technique: Naifeh and Smith, *Pollock*, p. 619. Camera defect: Namuth, in Barbara Rose, ed., *Pollock Painting: Photographs by Hans Namuth* (New York: Agrinde, 1980), n.p.

54. Jeffrey Potter, *To a Violent Grave: An Oral Biography of Jackson Pollock* (New York: G. P. Putnam's Sons, 1985), p. 130.

55. Rose, *Pollock Painting*. Rose's astute comment on "the work of art in the age of mechanical reproduction" is a welcome reminder of how slanted the knowledge of art obtained through photographs may be.

56. "Rebel Artist's Tragic Ending," *Life*, August 27, 1956, p. 56. Dorothy Seiberling, who wrote about art for *Life*, remembers being shocked to receive a long-distance call from her editor requesting a story on Pollock's death. If *Life*'s

editors wanted a story, they obviously assumed he was both generally known and a major figure. Seiberling, interview with author, May 26, 1990.

57. "At. . . . be": Harold Rosenberg, "The American Action Painters," *Artnews* 51 (December 1952): 22–23, 48. Pollock's belief: Landau, *Pollock*, p. 16; Rose, *Pollock Painting*.

58. "It . . . off": Namuth, in Rose, *Pollock Painting*. Art history departments: Francis V. O'Connor, telephone interview with author, February 1990. My thanks to Nadine Covert for information on the Picasso film.

59. The painter Paul Brach says that Pollock's influence hardly touched New York, where other influential artists were present in person, but that it did spread across the country. Telephone interview with author, September 9, 1989. Pollock's drunken binge: Potter, *To a Violent Grave*, pp. 131–32; see also Landau, *Pollock*, pp. 204–5. The doctor who had been treating Pollock's alcoholism had just died.

60. *Evergreen Review* 1 (1957). *Life*, November 9, 1959. 1960 book: Bryan Robertson, *Jackson Pollock* (New York: Harry N. Abrams, 1960). India: Raghubir Singh, conversation with author, December 9, 1989. See Rose, *Pollock Painting*, n.p.

61. "The . . . touch": Allan Kaprow, "The Legacy of Jackson Pollock," *Artnews* 57 (October 1958): 25, 56. 1966 book: Kaprow, *Assemblage, Environments and Happenings* (New York: Harry N. Abrams, 1966), especially plates 8, 109–111, and p. 165. "A. . . . actions": Kaprow, in "Jackson Pollock: An Artists' Symposium, Part 1," *Artnews* 66 (April 1967): 169.

62. Andre, etc.: Rose, *Pollock Painting*, n.p. 1970 article: "Fling, Dribble, and Drip," *Life*, February 27, 1970, pp. 62–66.

63. Richard Prince, *Why I Go to the Movies Alone* (New York: Tanam, 1983), p. 69.

64. Pastos, *Pin-Up*, p. 51. Pastos says the photograph exists and is a collector's item.

65. Lanie Kazan: "Tonight Show," NBC-TV, September 11, 1986; in Stuart Ewen, *All-Consuming Images: The Politics of Style in Contemporary Culture* (New York: Basic, 1988), p. 89.

6. ICONS

1. The question of mental imagery and its uses is very knotty; one school of psychology insists there is no such thing. My emphasis here on visual imagery as idea relies heavily on ideas communicated by Howard Shevrin, a psychoanalyst, in a telephone interview on July 2, 1990. For an interesting discussion of the two major branches of psychological research, see Eva Brann, "Mental Imagery," Homecoming Lecture, St. John's College, Annapolis, Md., September 1985. My thanks to Edward Weinberger for providing me with this paper and to Stanley Fisher for assistance with bibliography.

2. Karin Becker Ohrn, *Dorothea Lange and the Documentary Tradition* (Baton Rouge: Louisiana State University Press, 1980), p. 49. The reports were by Paul Schuster Taylor.

3. "A. . . . her": George P. Elliott, "Things of This World," *Commentary* 34 (December 1962): 542. "To. . . . immortal": Roy Emerson Stryker and Nancy Wood, *In This Proud Land: America 1935–1943 as Seen in the FSA Photographs* (New York: Galahad, 1973), p. 19.

4. Dorothea Lange, "Migrant Mother, The Assignment I'll Never Forget," *Popular Photography* 46 (February 1960): 42, 126. She mentioned only five negatives, but six exist.

5. Paul Taylor, "Migrant Mother: 1936," 1970; in Vicki

Goldberg, *Photography in Print* (Albuquerque: University of New Mexico Press, 1988), pp. 355–56.

6. Stryker and Wood, *In This Proud Land*, p. 353.

7. Publications: Milton Meltzer, *Dorothea Lange: A Photographer's Life* (New York: Farrar, Straus and Giroux, 1978), p. 134. "The . . . mine": Lange, "Migrant Mother," p. 126.

8. 1978: Martha Rosler, "In, Around, and Afterthoughts (on Documentary Photography)," in *Martha Rosler: Three Works* (Halifax, Canada: Press of the Nova Scotia College of Art and Design, 1981), p. 75. Fifteen thousand dollars: *New York Times*, September 17, 1983, p. 8.

9. Hartley E. Howe, "You Have Seen Their Pictures," *Survey Graphic* 29 (April 1940): 236.

10. Exhibitions: Maren Stange, "American Documentary Photography: The Mode and Its Style, 1900–1934" (Ph.D. diss., Boston University, 1981), p. 204. Universities, newspapers, magazines: ibid., p. 238.

11. Reprint: Robert Coles, "The Human Factor, The Life and Work of Dorothea Lange," *Camera Arts* (February 1983): 47. RA's regional office: Meltzer, *Dorothea Lange*, p. 166. "If . . . country": Pare Lorentz, "Dorothea Lange: Camera with a Purpose," 1941; in Meltzer, *Dorothea Lange*, p. 203.

12. Focused attention, *Gone with the Wind*: Meltzer, *Dorothea Lange*, p. 202. Eighty-three thousand copies: Nelson Valjean, *John Steinbeck, The Errant Knight: An Intimate Biography of His California Years* (San Francisco: Chronicle, 1975), p. 65. In the mid-1930s, when Erskine Caldwell wrote his novels about southern sharecroppers and was accused of exaggeration, he collaborated with a photographer, Margaret Bourke-White, on a book about the subject, to erase all doubts.

13. Worked as a migrant: Jackson J. Benson, *The True Adventures of John Steinbeck, Writer* (New York: Viking, 1984), p. 359. Bristol says Steinbeck had agreed to do a book with him but dropped it to write a novel; *Life*, February 19, 1940, p. 11, bears this out. See David Roberts, "Travels with Steinbeck," *American Photographer* 22 (March 1989): 45. Benson, *True Adventures*, p. 371, and Keith Ferrell, in *John Steinbeck: The Voice of the Land* (New York: M. Evans, 1986), p. 103, say *Life* dropped the story because Steinbeck wouldn't temper the language or his accounts of corporate greed.

14. "Tragic . . . faces": Stryker and Wood, *In This Proud Land*, p. 14. On Steinbeck and Lange, see D. O. Kehl, "Steinbeck's 'String of Pictures' in *The Grapes of Wrath*," *Image* 17 (March 1974): 2.

15. *Life*, February 19, 1940, p. 11.

16. Meltzer, *Dorothea Lange*, p. 103.

17. "This . . . here": in *Life*, March 12, 1945, p. 34. Statistics: David E. Scherman, ed., *Life Goes to War: A Picture History of World War II* (Boston: Little, Brown, 1979), p. 290.

18. *Time*, March 5, 1945, p. 15.

19. "Achieved . . . flag": *New York Herald Tribune*, April 10, 1945, p. 14. "In . . . nation": "Joe Rosenthal," *Current Biography*, 1945; in Marianne Fulton, *Eyes of Time: Photojournalism in America* (Boston: New York Graphic Society; Rochester, N.Y.: International Museum of Photography at George Eastman House, 1988), p. 161. "Schoolboys . . . statues": *Life*, March 26, 1945, pp. 17–18. Times Square: "Times Square," *New Yorker*, April 7, 1945, p. 17.

20. Widely reproduced, "It . . . hamburger": Joe Rosenthal with W. C. Heinz, "The Picture That Will Live Forever," *Collier's*, February 1955, p. 62. Marine photographer: Joe Rosenthal, telephone interview with author, May 24, 1990.

21. Rosenthal's account: *New Yorker,* April 17, 1945, p. 17. Flag measurements, unposed picture, 1947: Rosenthal and Heinz, "Picture," pp. 65–66. Craig T. Norback and Melvin Gray, *The World's Great News Photos: 1840–1980* (New York: Crown, 1980), p. 119, say the scene was reenacted for Rosenthal after the marine photographer's camera was smashed.

22. Robert T. Elson, *The World of Time, Inc.: The Intimate History of a Publishing Enterprise* (New York: Atheneum, 1973), vol. 1, 1923–41, p. 56.

23. Identities, three died: *New York Herald Tribune,* April 10, 1945, p. 14. "Because. . . . wanted," "emblem . . . triumphant": Paul Fussell, *The Boy Scout Handbook and Other Observations* (New York: Oxford University Press, 1982), pp. 230, 232.

24. My thanks to Marianne Fulton for the information about *Granta* (Autumn 1984).

25. Gregg Herken, *The Winning Weapon: The Atomic Bomb in the Cold War, 1945–1950* (New York: Alfred A. Knopf, 1980), p. 11.

26. Lewis Wood, "Steel Tower 'Vaporized' in Trial of Mighty Bomb," *New York Times,* August 7, 1945, p. 5.

27. "Target Chosen at Last Minute," *New York Times,* August 8, 1945, p. 3.

28. Vincent Leo, "The Mushroom Cloud Photograph: From Fact to Symbol," *Afterimage* 13 (Summer 1985): 6–12.

29. Japanese film crews: Erik Barnouw, "The Case of the A-Bomb Footage," *Studies in Visual Communication* 8 (Winter 1982): 7–14. Fireball, test pictures: Leo, "Mushroom Cloud Photograph," p. 7.

30. "As . . . area": Lowell Thomas, in Paul Boyer, *By the Bomb's Early Light: American Thought and Culture at the Dawn of the Atomic Age* (New York: Pantheon, 1985), p. 5. My thanks to Betty Jean Lifton and Robert J. Lifton for this reference. Caron: John Faber, *Great News Photos and the Stories Behind Them,* 2d, rev. ed. (New York: Dover, 1978), p. 94. The photographic officer had been denied permission for the flight and had given his camera to Caron.

31. Spencer R. Weart, *Nuclear Fear: A History of Images* (Cambridge, Mass.: Harvard University Press, 1988), p. 402. On the associations of mushrooms, he quotes Robert G. Wasson and V. P. Wasson, *Mushrooms, Russia, and History* (New York: Pantheon, 1957). My thanks to Peter B. Hales for this reference. Leo, "Mushroom Cloud," p. 9, says that it was not until the Bikini Atoll test of 1946 that *mushroom cloud* became a household phrase, but the visual symbol emerged earlier.

32. See *The Atomic Cafe* (film) and Boyer, *Bomb's Early Light,* pp. 11, 87. My thanks to Jean Giguet for information on Miss Atomic Bomb.

33. *Post-Dispatch, Herald Tribune, Collier's:* Boyer, *Bomb's Early Light,* pp. 109, 156. Man of the Year: *Time,* December 31, 1945.

34. Bill Keller, "Siberians Cling to Dream of Change Despite Shabby Lives and Shortages," *New York Times,* November 22, 1989, p. 16.

35. Personality cult, wartime: Ross Terrill, *Mao: A Biography* (New York: Harper and Row, 1980), p. 161. 1949: Edgar Snow, *The Long Revolution* (London: Hutchinson and Company, 1972), p. 170. I am particularly indebted to Michael Gasster and Roderick MacFarquhar for their informed and generous assistance on the subject of Mao.

36. 1966 rally: Stanley Karnow, *Mao and China: From Revolution to Revolution* (New York: Viking, 1972), pp. 194–

202. "The . . . Mao," *Peking Review,* 1966; in Stuart Schram, *Mao Tse-Tung* (London: Allen Lane, Penguin, 1967), p. 316.

37. Michael Gasster, letter to author, May 1990.

38. Gordon A. Bennett and Ronald N. Montaperto, *Red Guard,* 1971; in Karnow, *Mao and China,* p. 206.

39. 1964–65: Snow, *Long Revolution,* p. 68. Mao's residence: Karnow, *Mao and China,* p. 55. More often than Stalin: Schram, *Mao Tse-Tung,* p. 314. Shrines, buses, theaters, peasants: M. Yakovlev, "The Making of an Idol," 1968; in George Urban, ed., *The Miracles of Chairman Mao: A Compendium of Devotional Literature, 1966–1970* (London: Tom Stacey, 1971), pp. 174–76.

40. Red Guards, "With . . . sea": Yakovlev, "Making of an Idol," pp. 174–76, 146. Pinned buttons to the skin: Michael Gasster, telephone interview with author, May 1990. By 1969: Dennis Bloodworth, *The Messiah and the Mandarins: Mao Tse-Tung and the Ironies of Power* (New York: Atheneum, 1982), pp. 258–59.

41. *New York Times,* October 8, 1971; in Karnow, *Mao and China,* p. 467.

42. Pictures and statues: Nicholas D. Kristof, "Legacy of Mao Called 'Great Disaster,' " *New York Times,* February 7, 1989. Sun Yat Sen: Michael Gasster, letter to author, May 1990. Legitimacy: Emily and Roderick MacFarquhar, interview with author, January 16, 1990. Architect: Kristof, "Mao's Portrait in the Plaza: Is It Next to Go?" *New York Times,* March 12, 1989. My thanks to Michael Gasster for both articles by Kristof.

43. Splattered: Christopher Lehmann-Haupt, review of Bette Bao Lord, *Legacies: A Chinese Mosaic,* in *New York Times,* March 26, 1990. Sentences: "Teacher Who Defaced Mao Portrait Gets Life," *New York Times,* August 12, 1989, p. 3.

44. Giuliana Scime, "Moments of the History," *El Progreso fotografico,* June 1983. My thanks to Alberto Korda for a copy of this article and to Sandra Levinson for carrying the messages to and from Cuba.

45. Alberto Korda, letter to author, January 3, 1990.

46. "We . . . men": Che's letter "Man and Socialism," in Hans Koningsberger, *The Future of Che Guevara* (Garden City, N.Y.: Doubleday, 1971), p. 117. "The . . . parallel": ibid., p. 53. "If . . . Che": Andrew Sinclair, *Che Guevara* (New York: Viking, 1970), pp. 15, 80.

47. Sinclair, *Che Guevara,* p. 102.

48. Luis J. González and Gustavo A. Sánchez Salazar, *The Great Rebel: Che Guevara in Bolivia,* trans. Helen R. Lane (New York: Grove, 1969), p. 232.

49. Cuban homes: David Kunzle, "Uses of the Portrait: The Che Poster," *Art in America* 63 (September–October 1975): 73. Father Ruiz: Martin Ebon, *Che: The Making of a Legend* (New York: New American Library, 1969), p. 7. Halo: Edmundo Desnoes, "El Che y los Ojos del Mundo," *Cuba Internacional,* April 1971, p. 23. My thanks to Mr. Desnoes for a copy of this article. Half Che: Arthur Ollmann, interview with author, August 1989.

50. Brilliant posters, anniversary: Kunzle, "Uses of the Portrait," pp. 66–73.

51. Puerto Rico: John Berger, in Marianne Alexandra, ed., *¡Viva Che!,* Third World Series (London: Lorrimer, 1968), p. 89. Mexico City, T-shirts: Sandra Levinson, interview with author, January 1990. Socks: Arthur Ollmann, interview with author, August 1989. Students: Sinclair, *Che Guevara,* pp. 102–4; also *Una Foto recorre al mundo,* a film about Korda's photograph, available at the Center for Cuban Studies in New York. U.C. strike poster: Kunzle, "Uses of the Portrait,"

p. 72. Guatemala: *Cuba: A View from Inside, A Multimedia Project of the Center for Cuban Studies* (New York: Center for Cuban Studies, 1985), p. 26.

7. SOCIAL REFORM

1. "Needy victims": Kathleen Collins, "Photographic Fundraising: Civil War Philanthropy," *History of Photography* 11 (July–September 1987): 173. Confederate Army: Collins, *The Camera as an Instrument of Persuasion: Studies of Nineteenth Century Propaganda* (Ph.D. diss., Pennsylvania State University, 1985), p. 149. Emancipated children: Brooke Evans Baldwin, "The Stereotyped Image of Blacks in American Popular Photography," *Exposure* 19 (1981): 14.
2. "Charitable . . . dismissal": Oliver Wendell Holmes, "Doings of the Sunbeam," *Atlantic Monthly* 12 (July 1863): 11. Subscribers, collection boxes: Alan Thomas, *Time in a Frame: Photography and the Nineteenth-Century Mind* (New York: Schocken, 1977), p. 144.
3. Gillian Wagner, *Barnardo* (London: Weidenfeld and Nicolson, 1979), pp. 44, 140–59.
4. Hugh Welch Diamond, "On the Application of Photography to the Physiognomic and Mental Phenomena of Insanity," read before the Royal Society, May 22, 1856; in Sander L. Gilman, ed., *The Face of Madness: Hugh W. Diamond and the Origin of Psychiatric Photography* (New York: Brunner/Mazel, 1976), p. 21.
5. On nineteenth-century attitudes to poverty, see Roy Lubove, *The Progressives and the Slums: Tenement House Reform in New York City, 1890–1917* (Pittsburgh: University of Pittsburgh Press, 1962), pp. 5, 248, and Robert H. Bremner, *From the Depths: The Discovery of Poverty in the United States* (New York: New York University Press, 1956), pp. 3–5, 29–30. Pasteur and Koch: Lubove, *Progressives*, p. 83. Fear for the republic: ibid., p. 248.
6. Enlightened electorate: William Johnson, "Mighty Ms.," *Afterimage* 3 (May–June 1975): 13. Illustrated articles: Peter B. Hales, *Silver Cities: The Photography of American Urbanization* (Philadelphia: Temple University Press, 1984), pp. 185–90.
7. Jacob A. Riis, *The Making of an American* (New York: Macmillan, 1901), pp. 35, 78–125, 266–68.
8. Ibid., pp. 265, 268–71. See also Maren Stange, "Gotham's Crime and Misery: Ideology and Entertainment in Jacob Riis's Lantern Slide Exhibitions," *Views* 8 (Spring 1987): 7.
9. First halftone: Gail Buckland, *First Photographs: People, Places, and Phenomena as Captured for the First Time by the Camera* (New York: Macmillan, 1980), p. 165. *Tribune:* Estelle Jussim, "'The Tyranny of the Pictorial': American Photojournalism from 1880 to 1920"; in Marianne Fulton, *Eyes of Time: Photojournalism in America* (Boston: New York Graphic Society; Rochester, N.Y.: International Museum of Photography at George Eastman House, 1988), p. 44.
10. Lectures, *Scribner's*, book: Riis, *Making of an American*, pp. 298–303. Eleven printings: Ferenc M. Szasz and Ralph F. Bogardus, "The Camera and the American Social Conscience: The Documentary Photography of Jacob A. Riis," *New York History* 55 (October 1974): 422.
11. "Is . . . at": in Robert S. Klein, "The Antecedents of American Photojournalism," 1970; in Jussim, "'Tyranny of the Pictorial,'" p. 43. "The . . . examination": Jacob Riis, interview, *New York Morning Journal*, December 12, 1988; in

Maren Stange, *Symbols of Ideal Life: Social Documentary Photography in America, 1850–1950* (Cambridge: Cambridge University Press, 1989), p. 16.
12. Riis, *Making of an American*, p. 328.
13. Dickens: Charles Dickens, *American Notes*, 1842; in Bremner, *From the Depths*, p. 5. "When. . . . satisfied": Riis, *Making of an American*, pp. 272–73. A beachfront park in Queens, New York, was named after Riis; unfortunately, in recent years it has fallen upon hard times.
14. Lincoln Steffens, autobiography, 1931; in Edith Patterson Meyer, *"Not Charity, but Justice": The Story of Jacob A. Riis* (New York: Vanguard, 1974), p. 58.
15. Riis, *Making of an American*, p. 228. Szasz and Bogardus, "Camera and Social Conscience," p. 411, say faded copies of these photographs still exist in the Riis manuscript collection in the Library of Congress.
16. Several scholars, Stange at greatest length, have pointed out that Riis was not so selfless as once thought. This may be, but in the long run it makes little difference to the success of his reforms or the force of his photographs.
17. Szasz and Bogardus, "Camera and Social Conscience," p. 429.
18. Two hours, one hundred slides, painting of Jesus: ibid., pp. 429–31. Stereo, dissolve, cornet: Stange, *Symbols of Ideal Life*, pp. 2–3, 13.
19. Hales, *Silver Cities*, p. 193.
20. Obituaries: Sally Stein, "Making Connections with the Camera: Photography and Social Mobility in the Career of Jacob Riis," *Afterimage* 10 (May 1983): 9. Alland: Alexander Alland, Sr., *Jacob A. Riis: Photographer and Citizen* (Millerton, N.Y.: Aperture, 1974), p. 15, and letter to the author, June 10, 1987; also *PM*, July 21, 1940, pp. 48–49. Hine: Stein, "Making Connections," p. 15.
21. This history is reported in detail in John Tagg, "God's Sanitary Law: Slum Clearance and Photography," in Tagg, *The Burden of Representation: Essays on Photographies and Histories* (Houndmills, England: Macmillan Education, 1988), pp. 121–52.
22. *Cowley v. People*, 83 N.Y. 464 (1881); in George Chernoff and Hershel Sarbin, *Photography and the Law* (New York: Amphoto, 1965), p. 94.
23. Declining birthrate: Walter I. Trattner, *Crusade for the Children: A History of the National Child Labor Committee and Child Reform in America* (Chicago: Quadrangle, 1970), p. 46. Riis, education: Verna Posever Curtis and Stanley Mallach, *Photography and Reform: Lewis Hine and the National Child Labor Committee* (Milwaukee: Milwaukee Art Museum, 1984), p. 16.
24. 1870, 1900: Curtis and Mallach, *Photography and Reform*, p. 14. Articles: Trattner, *Crusade for the Children*, p. 48.
25. Mill owners, higher proportion: Trattner, *Crusade for the Children*, pp. 36–37, 40. 1900, pamphlets: Hugh C. Bailey, *Edgar Gardner Murphy: Gentle Progressive* (Coral Gables, Fla.: University of Miami Press, 1968), pp. 65, 82–83.
26. Trattner, *Crusade for the Children*, p. 75.
27. Lewis Hine to Paul Kellogg, August 14, 1937, University of Minnesota Social Welfare History Archives, Study Associate Papers; in Curtis and Mallach, *Photography and Reform*, p. 43.
28. Lewis Hine, "Social Photography"; in Alexander Johnson, ed., *Proceedings of the National Conference of Charities and Correction* (Fort Wayne, Ind.: Press of the Fort Wayne Printing Co., 1909), p. 355.

29. Hine, "Social Photography," p. 356.

30. Naomi Rosenblum, biographical notes on Hine, in *America and Lewis Hine: Photographs, 1904–1940* (Millerton, N.Y.: Aperture, 1977), n.p.

31. John A. Kingsbury, "Right Publicity and Public Health Work," in Johnson, *Proceedings*, p. 333.

32. Hine, "Social Photography," p. 356.

33. Susan Sontag, *On Photography* (New York: Farrar, Straus and Giroux, 1977), p. 21.

34. "I. . . . possible": "Notes on Early Influence," Elizabeth McCausland Papers; in Rosenblum, *America and Lewis Hine*. "There. . . . communities": *Birmingham Age-Herald*, March 11, 1911; in John A. Kemp, ed., *Lewis Hine: Photographs of Child Labor in the New South* (Jackson: University Press of Mississippi, 1986), p. 10. "The. . . . problems": *PM's Weekly*, August 25, 1946; in Robert Doty, "The Interpretative Photography of Lewis W. Hine," *Image* 6 (May 1957):115–16.

35. Trattner, *Crusade for the Children*, pp. 87, 98, 107.

36. Opposition to federal regulation: Bremner, *From the Depths*, p. 224. National laws: Elizabeth Sands Johnson, "Child Labor Legislation"; in John R. Commons et al., *History of Labor in the United States: 1896–1932* (New York: Macmillan, 1935), vol. 3, pp. 440–49.

37. Pittsburgh Survey, U.S. Steel: Peter Seixas, "Lewis Hine: From 'Social' to 'Interpretive Photographer,' " *American Quarterly* 39 (Fall 1987): 389. "The . . . reform": Jane Addams, *The Second Twenty Years at Hull House*, 1930; in Bremner, *From the Depths*, p. 156.

38. Taylor, in Milton Meltzer, *Dorothea Lange: A Photographer's Life* (New York: Farrar, Straus and Giroux, 1978), pp. 93–94.

39. Paul Taylor, "Migrant Mother: 1936," 1970; in Vicki Goldberg, *Photography in Print* (Albuquerque: University of New Mexico Press, 1988), p. 357.

40. Taylor, in Eugenia Parry Janis and Wendy MacNeil, eds., *Photography within the Humanities* (Danbury, N.H.: Addison House, 1977), p. 29. Washington: Meltzer, *Dorothea Lange*, p. 101. Lange and Taylor divorced their spouses and married each other in late 1935.

41. Jackson J. Benson, *The True Adventures of John Steinbeck, Writer* (New York: Viking, 1984), p. 337.

42. Photographs: "Nurse-Midwife," *Life*, December 3, 1951, pp. 134–45. Photographer donated: Jim Hughes, *W. Eugene Smith: Shadow and Substance, The Life and Work of an American Photographer* (New York: McGraw Hill, 1989), p. 282.

43. "Letters," *Life*, December 24, 1951.

44. April 1953: "Maude Gets Her Clinic," *Life*, April 6, 1953, p. 139. $18,500, 1954: Stanley Rayfield, *How Life Gets the Story* (Garden City, N.Y.: Doubleday, 1955), p. 57. 1986: *Life*, Fall 1986.

45. "I. . . . bigoted": Smith, in Ben Maddow, "The Wounded Angel," in *Let Truth Be the Prejudice—W. Eugene Smith: His Life and Photographs* (New York: Aperture, 1985), p. 128. State health department: Hughes, *W. Eugene Smith*, p. 275. "This. . . . issues": "W. Eugene Smith: 'Who I am is the way I work,' " interview by Peter Wollheim, *Photographer Magazine*, Summer 1976, p. 36.

46. Statistics: Alfred Politz, *A Study of the Accumulative Audience of Life*, 1950; in Otha C. Spencer, "Twenty Years of Life: A Study of Time Inc.'s Picture Magazine and Its Contribution to Photojournalism" (Ph.D. diss., University of Missouri, 1958), p. 285. "Literally . . . years": *Life*, July 26, 1954, p. 103.

47. Gordon Parks, *Flavio* (New York: W. W. Norton, 1978), pp. 22–33.

48. Preliminary layout, tore up letter: ibid., pp. 62–65; a slightly different version is in Gordon Parks, *Voices in the Mirror: An Autobiography* (New York: Doubleday, 1990), pp. 93–94. *Life* article: "Freedom's Fearful Foe: Poverty," *Life*, June 16, 1961, pp. 86ff.

49. *Life*, July 7, 1961, pp. 151–58.

50. Parks, *Flavio*, p. 91.

51. Ibid.

52. *Life*, "Flavio's Rescue," July 21, 1961, pp. 24–35.

53. Parks, *Flavio*, pp. 36, 78, 119–23.

54. Ibid., pp. 107–18, 126–97, 7, 198.

55. Flavio, in *Life*, Fall 1986, p. 154.

56. Mary Ellen Mark, telephone interview with author, September 6, 1989.

8. NEWS PHOTOGRAPHS AS CATALYSTS: THE MAGAZINE ERA

1. Simon Michael Bessie, *Jazz Journalism: The Story of Tabloid Newspapers* (New York: E. P. Dutton, 1938), pp. 238, 84.

2. Luce, in Vicki Goldberg, *Margaret Bourke-White: A Biography* (New York: Harper and Row, 1986), pp. 174–75.

3. Wilson Hicks, "The News Photographer," January 14, 1948; ibid., p. 269.

4. Twenty-two photographers: Beaumont Newhall, *The History of Photography from 1839 to the Present* (New York: Museum of Modern Art, 1982), p. 258. Bad weather, newsreels: John Toland, *The Great Dirigibles: Their Triumphs and Disasters* (New York: Dover, 1972), pp. 313, 323.

5. Picture newspapers: Newhall, *History of Photography*, p. 258. By noon: Toland, *Great Dirigibles*, p. 336.

6. Toland, *Great Dirigibles*, pp. 319–22.

7. Ibid., pp. 23, 9, 10.

8. Harold G. Dick with Douglas H. Robinson, *The Golden Age of the Great Passenger Airships* (Washington, D.C.: Smithsonian Institution Press, 1985), p. 166.

9. Ibid., pp. 151–64. During World War I, a Zeppelin had dropped bombs on London. Eventually, the remains of the *Hindenburg* were melted down and used in Nazi planes. (Michael MacDonald Mooney, *The Hindenburg* [New York: Dodd, Mead, 1972], pp. 38, 262.)

10. Hare, in Lewis L. Gould and Richard Greffe, *Photojournalist: The Career of Jimmy Hare* (Austin: University of Texas Press, 1977), p. 123.

11. Optimistic reports: Jorge Lewinski, *The Camera at War* (London: W. H. Allen, 1978), p. 63. No American died: Susan Moeller, *Shooting War: Photography and the American Experience of Combat* (New York: Basic, 1989), pp. 18, 136.

12. Eisenhower, in Moeller, *Shooting War*, p. 191.

13. "Letters to the Editors," *Life*, February 22, 1943, p. 8.

14. Ibid., p. 124.

15. "Morale Photography," *Newsweek*, May 24, 1943, pp. 15, 27.

16. Coffin: *Life*, July 5, 1943, cover. Stretcher: *Life*, August 2, 1943. Headlines: "Headlines and Heartbeats," *Time*, September 4, 1943, p. 54.

17. Paratroopers: "Victory for Elmer," *Time*, September 13, 1943, p. 50. Amputated leg: "Realism for Breakfast," *Newsweek*, September 20, 1943, p. 98.

18. "Picture of the Week," *Life*, September 20, 1943, pp. 34–35.

19. "Letters to the Editors," *Life*, October 11, 1943, p. 4. In *Signs of Life* (New York: Alfred A. Knopf, 1983), p. 12, Alfred Appel, Jr., writes that enlistments dropped the week after the picture was published. I have not located weekly enlistment figures for the period. Voluntary enlistments did decline from August to September, as did inductions, but both had declined more precipitously in August and by a large amount in July as well. From December 1941 to August 1945, enlisted men constituted just over 10 percent of all army personnel. (*Statistical Review: World War II* [Statistics Branch, Control Division, Headquarters, U.S. Army Service Forces, War Department, n.d.], kindly supplied by John J. Slonaker, chief, Historical Branch, U.S. Army Military History Institute, Carlisle Barracks, Pennsylvania. My thanks also to Ralph Graves for his assistance.)

20. "Realism for Breakfast," p. 98.

21. "It's a Tough War," *Life*, January 31, 1944, pp. 17–44. "Letters to the Editors," *Life*, February 21, 1944, p. 11.

22. The owner's wife: William Bradford Huie, "The Shocking Story of Approved Killing in Mississippi," *Look*, January 24, 1956, p. 46. Only accurate part: William M. Simpson, "Reflections on a Murder: The Emmett Till Case," *Southern Miscellany: Essays in History in Honor of Glover Moore* (Jackson: University Press of Mississippi, 1981), p. 178.

23. Mamie Till Bradley Mobley, in Henry Hampton and Steve Fayer, *Voices of Freedom: An Oral History of the Civil Rights Movement from the 1950s through the 1980s* (New York: Bantam, 1990), p. 5.

24. Mortician: "Nation Horrified by Murder of Kidnapped Chicago Youth," *Jet*, September 15, 1955, p. 8. One hundred thousand: "Will Mississippi Whitewash the Emmett Till Slaying?" *Jet*, September 22, 1955, p. 11; "Hundreds Weep, Faint at Sight," *Chicago Defender*, September 17, 1955, p. 2. Delayed burial: Juan Williams, *Eyes on the Prize: America's Civil Rights Years, 1954–1965* (New York: Viking, 1989), p. 37.

25. Simeon Booker, telephone interview with author, February 1990.

26. Pirated the image: *New York Amsterdam News*, September 17, 1955, p. 1. Simeon Booker of *Jet* says the *Detroit Chronicle* published it. (Telephone interview with author, January 1990.) Mrs. Margerie Adkins, at the *Chicago Defender*, says that paper also published it on the front page and that she believes many other papers did so. (Telephone interview with author, February 21, 1990.) "Many. . . . sponge": Cleveland Sellers, with Robert Terrell, *The River of No Return*, 1973; in Stephen J. Whitfield, *A Death in the Delta: The Story of Emmett Till* (New York: Free Press, 1988), p. 95. "I. . . . elsewhere": Charles Diggs, letter to author, March 28, 1990. My thanks to Stephen Whitfield, Robert Lavelle, and John Dittmer for their generous assistance, and to Judith Vecchione, Laurie Kahn-Leavitt, and Susan Levine.

27. Muhammad Ali, with Richard Durham, *The Greatest: My Own Story* (London: Hart-Davis, MacGibbon, 1976), p. 34.

28. Alice Walker, *You Can't Keep a Good Woman Down*, 1981; in Whitfield, *A Death in the Delta*, p. 119.

29. Joyce Ladner, "The South: Old-New Land," *New York Times*, May 17, 1979, p. 23; also telephone interview with author, May 15, 1990.

30. "That. . . . factor": Henry Hampton, telephone interview with author, May 15, 1990. "The. . . . South": Madison Davis Lacy, telephone interview with author, March 19, 1990. "It. . . . me": Julian Bond, letter to author, March 23, 1990.

31. On black resistance, see Whitfield, *Death in the Delta*, p. 107; for a mild demurral, Simpson, *Reflections on a Murder*, p. 199. NAACP: Williams, *Eyes on the Prize*, p. 49.

32. John Chancellor at "Covering the South: A National Symposium on the Media and the Civil Rights Movement," April 3, 1987; in Whitfield, *Death in the Delta*, p. 145.

33. Black support, dogs: Taylor Branch, *Parting the Waters: America in the King Years, 1954–68* (New York: Simon and Schuster, 1988), pp. 709–19. Celebrities: Thomas R. Brooks, *Walls Came Tumbling Down: A History of the Civil Rights Movement, 1940–1970* (Englewood Cliffs, N.J.: Prentice-Hall, 1974), p. 205. National media, students: David J. Garrow, *Bearing the Cross: Martin Luther King, Jr., and the Southern Christian Leadership Conference* (New York: William Morrow, 1986), p. 247.

34. *New York Times*, May 4, 1963, pp. 1, 8. *Washington Post*, May 4, 1963, pp. 1, 4. Ironically, the young man being attacked had not taken part in or supported the demonstration. Convinced that the incident meant he was "mixing with a bad crowd," he resolved to stop hanging out on the streets and prepare himself for college. (*Jet*, October 10, 1963; in Branch, *Parting the Waters*, p. 761.)

35. Kennedy: Arthur M. Schlesinger, Jr., *A Thousand Days: John F. Kennedy in the White House* (Boston: Houghton Mifflin, 1965), p. 959. "The . . . reprehensible," "would . . . Angola": "Birmingham's Use of Dogs Assailed," *New York Times*, May 7, 1963, p. 32.

36. Louis Robinson, "50,000 Jam L. A. Ball Park for Biggest Rights Rally," *Jet*, June 13, 1963, pp. 54–60.

37. Poor blacks: Charles E. Silberman, *Crisis in Black and White* (New York: Random House, 1964), pp. 143–44. Ten weeks after: Brooks, *Walls Came Tumbling Down*, p. 210. The entry of the poor also shifted the movement's focus from civil rights to jobs.

38. "Everywhere. . . . epithet": "The Jitters," *Newsweek*, p. 27. "New Negroes": Arthur I. Waskow, *From Race Riot to Sit-In, 1919 and the 1960s: A Study in the Connections between Conflict and Violence* (Garden City, N.Y.: Doubleday, 1967), p. 234.

39. Connor, in Claude Sitton, "Rioting Negroes Routed by Police at Birmingham," *New York Times*, May 8, 1963, p. 28.

40. "Dogs, Kids, and Clubs," *Time*, May 10, 1963, p. 19. "Birmingham, U.S.A.: 'Look at Them Run,' " *Newsweek*, May 16, 1963, pp. 27–29. "They Fight a Fire That Won't Go Out: The Spectacle of Racial Turbulence in Birmingham," *Life*, May 17, 1963, pp. 26–36.

41. Flip Schulke, interviewed by Larry Hawthorne Spruill, in Spruill, "Southern Exposure: Photography and the Civil Rights Movement, 1955–1968" (Ph.D. diss., State University of New York at Stony Brook, 1983), p. 263. Moore was injured by a thrown object in Birmingham, arrested shortly afterward with the *Life* writer, and released on bail. They were advised to jump bail, and did. Charles Moore, telephone interview with author, January 19, 1990.

42. Warhol: The artist had not asked permission, and when his "borrowing" from Moore came to Black Star's attention, he had to settle with the agency. (Howard Chapnick, telephone interview with author, June 13, 1990.) "I. . . . credited": *American Society of Magazine Photographers Bulletin*, May 17, 1964, n.p. "To . . . believe": Kodak press release.

43. Obote: Branch, *Parting the Waters*, p. 807. "Pictures . . . youth": "Racism Hurts U.S. Abroad—Dr. Ira DeA. Reid," *Jet*, June 13, 1963, p. 22. "They . . . pages": Ian Travers-Bull,

"India and the Negro Question: Here's How Birmingham and Montgomery Look to People around the World," *America* 109 (July 13, 1963): 44.

44. House Committee on the Judiciary, *Civil Rights Hearings before Subcommittee No. 5, 1963*; in David J. Garrow, *Protest at Selma: Martin Luther King, Jr., and the Voting Rights Act of 1965* (New Haven, Conn.: Yale University Press, 1978), p.169.

45. May 20–21: Branch, *Parting the Waters*, pp. 807–8. "Are . . . Negroes": in Anthony Lewis and the *New York Times*, *Portrait of a Decade: The Second American Revolution* (New York: Random House, 1964), p. 121.

46. Walker, in Garrow, *Bearing the Cross*, pp. 227–28.

47. "We've. . . . movement": James Forman, *The Making of Black Revolutionaries*, 1972; in Garrow, *Bearing the Cross*, p. 239. "There . . . Birmingham": ibid., p. 264.

48. Flip Schulke, in Spruill, "Southern Exposure," pp. 271–72.

49. "If . . . gave": "They Fight a Fire," *Life*, May 17, 1963, p. 30. "I. . . . else": Garrow, *Bearing the Cross*, pp. 271, 250.

50. *Exploit*: *The Shorter Oxford English Dictionary*, 3d, rev. ed., s.v. "exploit." French press: Donald E. English, *Political Uses of Photography in the Third French Republic, 1871–1914* (Ann Arbor, Mich.: UMI Research Press, 1984), p. 174.

51. "By . . . coverage": Raymond Fielding, *The American Newsreel, 1911–1967* (Norman: University of Oklahoma Press, 1972), p. 149. Biafra: "Television: The Power of Pictures," NBC, 1990.

52. Alan Lincoln and George Lovinger, "Observers' Evaluations of the Victim and Attacker in an Aggressive Incident," May 1972; in Garrow, *Protest at Selma*, p. 153. Garrow points out that the research subjects were all college students (as they often are).

53. Henry Hampton, "The TV Camera as Double-Edged Sword," *New York Times*, January 15, 1989, p. 39.

54. Hedrick Smith, *New York Times*, August 15, 1962; in Lewis and *New York Times*, *Portrait of a Decade*, p. 93.

55. On shifts in camera point of view, see Garrow, *Protest at Selma*, pp. 164–65, and Hampton, "TV Camera," p. 39.

56. Only Western photographer: Malcolm W. Browne, "Vietnam Reporting, Three Years of Crisis," *Columbia Journalism Review*, Summer 1964, p. 6. *New York Times*: John Morris, in Eugenia Parry Janis and Wendy MacNeil, eds., *Photography within the Humanities* (Danbury, N.H.: Addison House, 1977), p. 14. *Chicago Tribune*, June 11, 1963, p. 3. *Los Angeles Times*, June 11, 1963, p. 4. Ibid., June 12, 1963, p. 2.

57. Syracuse paper: Morris, *Photography within the Humanities*, p. 14. *Life*, June 21, 1963, pp. 24–5. *Time*, June 21, 1963, p. 32.

58. Browne, "Vietnam Reporting," p. 6. On the language, see "Vietnam: A History," WGBH-TV, 1983, episode 3.

59. Browne, interview with Susan D. Moeller, 1987; in Moeller, *Shooting War*, p. 355.

60. "No . . . had": ibid., p. 404. Mme Nhu: "Vietnam: A History," and Moeller, *Shooting War*, p. 404. Smuggling: Browne, "Vietnam Reporting," p. 8. Halberstam: Moeller, *Shooting War*, p. 363. List of correspondents: Browne, "Vietnam Reporting," p. 5.

61. Browne, "Vietnam Reporting," p. 7.

62. Ibid.

63. Morrison: Paul Hendrickson, "Daughter of the Flames," *Washington Post*, December 2, 1985, sec. C, pp. 1, 11, 12. Palach: Craig R. Whitney, "Prague Honors Martyred Student," *New York Times*, January 17, 1990. Quang Duc: Malcolm W. Browne, telephone interview with author, March 26, 1990.

9. NEWS PHOTOGRAPHS AS CATALYSTS: THE TELEVISION ERA

1. Arledge, on "Television: The Power of Pictures," one of an eight-part PBS series hosted by Edwin Newman and broadcast on Channel 13, New York, in 1990. My thanks to Carolyn Baehr for making copies of this and several other programs available to me.

2. Elmer E. Cornwell, Jr., *Presidential Leadership of Public Opinion* (Bloomington: Indiana University Press, 1965), p. 266.

3. 1953, 1957: David Halberstam, *The Powers That Be* (New York: Alfred A. Knopf, 1979), p. 416. Kennedy: "Historic Conference," *Newsweek*, February 6, 1961; in Cornwell, *Presidential Leadership*, p. 192. *Life* in 1950: Alfred Politz, *A Study of the Accumulative Audience of Life*, 1950; in Otha C. Spencer, "Twenty Years of *Life*: A Study of Time Inc.'s Picture Magazine and Its Contribution to Photojournalism" (Ph.D. diss., University of Missouri, 1958), p. 285. My thanks to Elaine Felsher, head of the Time Inc. Archives, for additional Time Inc. Audit Bureau circulation figures.

4. Francis Frith, "The Art of Photography," *Art Journal*, London (March 1, 1859): 72. The italics are in the original.

5. I owe these ideas entirely to Julian Hochberg, a psychologist at Columbia University in New York. Telephone interview with author, January 19, 1990.

6. Survey: Roper Organization, *Changing Public Attitudes toward Television and Other Mass Media, 1959–1976* (New York: Television Information Office, 1977). Survey criticized: *Columbia Journalism Review* 16 (January–February 1978): 12–14.

7. David J. Garrow, *Protest at Selma: Martin Luther King, Jr., and the Voting Rights Act of 1965* (New Haven, Conn.: Yale University Press, 1978), pp. 161–63.

8. This is seldom done. Photographic historians have been less interested in—or less comfortable with—television than they might be. In part that is because it is so difficult to research television news. The networks seldom kept broadcasts before 1968, and after that little is properly cataloged; much is on film rather than tape and therefore of limited access; and the networks are not often eager to assist researchers. ABC says they have nothing before the early 1980s. CBS and NBC both made their card files available to me, which was helpful. The Museum of Broadcasting in New York was very cooperative, but their collection, particularly of news broadcasts, is extremely spotty. The best source by far was the Vanderbilt Television Archive, which began collecting news tapes in August 1968. My thanks to Michael Gibson for much assistance.

9. Phone system: Tom Wicker, "Kennedy Is Killed by Sniper . . . ," *New York Times*, November 23, 1963, p. 2. Percentages: Paul B. Sheatsley and Jacob J. Feldman, "The Assassination of President Kennedy," *Public Opinion Quarterly* 28 (Summer 1964): 192. Athens: William Manchester, *The Death of a President: November 20–November 25* (New York: Harper and Row, 1967), p. 499.

10. Nielsen report: William Schramm, "Communication in Crisis," in Bradley S. Greenberg and Edwin B. Parker, eds., *The Kennedy Assassination and the American Public: Social Communication in Crisis* (Stanford, Calif.: Stanford University Press, 1965), p. 14. Japan, Moscow: Val Adams, "Networks Drop Regular Shows," *New York Times*, November 23, 1963, p. 9. Twenty-three countries: "As 175 Million Americans Watched," *Newsweek*, December 2, 1963, p. 90.

11. Jack Gould, "TV Personalizes Grief," *New York Times,* November 24, 1963, p. 9.

12. Sales records: John Horn, "What Was Seen and Read: Television: A Transformation," *Columbia Journalism Review* 2 (Winter 1964): 20. Munich, Rio: "Covering the Tragedy," *Time,* November 29, 1963, p. 84. Percentages: Edwin B. Parker and Bradley S. Greenberg, "Newspaper Content on the Assassination Weekend," in Greenberg and Parker, *Kennedy Assassination,* p. 48.

13. Ten dollars: William L. Rivers, "The Press and the Assassination," in Greenberg and Parker, *Kennedy Assassination,* p. 52. On the morality of printing these pictures, see Letters and Editors' Note, *Life,* December 13, 1963, p. 3.

14. Ruth Leeds Love, "The Business of Television and the Black Weekend," in Greenberg and Parker, *Kennedy Assassination,* pp. 83–85.

15. Man with a gun: "NOVA," Channel 21, November 5, 1988. German army helmet: David W. Belin, *Final Disclosure: The Full Truth about the Assassination of President Kennedy* (New York: Charles Scribner's Sons, 1988), p. 178.

16. Belin, *Full Truth,* p. 45. Conspiracy theorists are legion and do not agree on many points other than that the Warren Commission reached the wrong conclusion and someone covered up. Among the best known are Mark Lane, *Rush to Judgment* (New York: Holt, Rinehart and Winston, 1966), and Edward Jay Epstein, *Inquest: The Warren Commission and the Establishment of Truth* (New York: Viking, 1966).

17. Elmer W. Lower, "A Television Network Gathers the News," in Greenberg and Parker, *Kennedy Assassination,* p.70.

18. Newman, host, "Television."

19. Asanuma: Jack Gould, "Millions of Viewers See Oswald Killed on Two TV Networks," *New York Times,* November 25, 1963, p. 1. Wedding: Newman, host, "Television."

20. John Faber, *Great News Photographs and the Stories Behind Them,* 2d, rev. ed. (New York: Dover, 1978), p. 134.

21. Ibid., p. 134.

22. Lawrence Schiller (owner of the original), telephone interview with author, January 1990.

23. Peter Braestrup, *Big Story: How the American Press and Television Reported and Interpreted the Crisis of Tet 1968 in Vietnam and Washington* (Boulder, Colo.: Westview, 1977), vol. 2, pp. 266–67, 272, 462, 655ff., 671.

24. NBC, BBC, ABC: ibid., pp. 274–77. Photograph: *Time,* February 29, 1968, pp. 24–25; *Newsweek,* February 12, 1968, p. 29.

25. John G. Morris, "This We Remember," *Harper's,* September 1972, p. 76. The photographer was Dickey Chapelle.

26. "We . . . progress": Braestrup, *Big Story,* 54. "I . . . losing": ibid., p. 3. Cronkite: quoted by Don Oberdorfer, *Tet,* 1971; in Braestrup, *Big Story,* p. 53. Ho Chi Minh: Braestrup, *Big Story,* p. 599.

27. Saigon government, Cronkite: Braestrup, *Big Story,* vol. 1, p. xxx; vol. 2, p. 601. Braestrup believes the media distorted the enemy's success. For a response, see Peter Arnett, "Tet Coverage: A Debate Renewed," *Columbia Journalism Review* 16 (January–February 1978): 44–47, and Stanley Karnow, *Vietnam: A History* (New York: Viking, 1983), p. 545.

28. Photographer's account: "Moment of Truth," *American Photographer* 4 (November 1980): 34. "They . . . people": *New York Times,* February 2, 1968, p. 12; *Washington Post,* February 2, 1968, p. 1.

29. McPherson, Karnow, *Vietnam,* p. 548.

30. Japanese illustrators, Saigon war museum: Eddie Adams, telephone interview with author, September 13, 1989.

31. Seriously wounded: Eddie Adams, "The Pictures That Burn in My Memory," *Parade Magazine,* May 15, 1983, p. 9. "Moral turpitude": *Newsweek,* November 13, 1978, p. 70. Geneva Convention: William Buckley, Jr., "Deport General Loan?" *National Review* 30 (December 8, 1978): 1562.

32. "In . . . act": Adams, "Pictures That Burn," p. 9. Several letters: Adams, telephone interview with author, September 13, 1989. "Wasn't . . . did": "Today" show, April 26, 1985.

33. Seymour Hersh, *My Lai 4: A Report on the Massacre and Its Aftermath* (New York: Random House, 1970), pp. 79, 105–6. My Lai is also referred to as Song My and Pinkville.

34. September 5, AP, NBC: Hersh, *My Lai 4,* pp. 128–33. Thirty-five papers: "The Press—Miscue on a Massacre," *Time,* December 5, 1969, p. 75.

35. Ron Haeberle, telephone interview with author, March 22, 1990.

36. Army prosecutor: Hersh, *My Lai 4,* p. 137. Eszterhas: Joe Eszterhas, "The Selling of the My Lai Massacre," *Evergreen Review* 15 (October 1971): 42.

37. Duncan: Eszterhas, "Selling," p. 66. Authenticity: Hersh, *My Lai 4,* p. 137. My thanks to William F. Miller for his kind assistance with the background story of the *Plain Dealer* publication.

38. Eszterhas, "Selling," p. 69.

39. *Plain Dealer:* ibid., pp. 69–70. *New York Times* and public interest: "Pictures and Questions," *Newsweek,* December 1, 1969, p. 57. Eszterhas and Haeberle originally asked one hundred twenty thousand dollars from *Life,* which offered ninety thousand dollars. They refused and *Life* took an option till noon on the 21st. When *Life* discovered that the *Post* would print the pictures, the offer was changed to twenty thousand dollars; this time it was accepted. The photographs were published in the *New York Post,* November 21, 1969, p. 1, and the *New York Times,* November 22, 1969, p. 3.

40. "War Veteran Says He Killed 35 to 40 in Songmy Sweep," *New York Times,* November 25, p. 1, transcript p. 16. "I . . . murderer": "The Killings at Song My," *Newsweek,* December 8, 1969, p. 33.

41. Resor: "Killings at Song My," p. 33. "If . . . happened": Robert M. Smith, "White House Says U.S. Bars Any Mass Slaying," *New York Times,* November 27, 1969, p. 18.

42. "It . . . all": "Song My: A U.S. Atrocity?" *Newsweek,* December 1, 1969, p. 35. "The . . . belief": Kenneth Crawford, "Song My's Shock Wave," *Newsweek,* December 15, 1969, p. 30.

43. *Plain Dealer:* "Callers Say PD Shouldn't Have Used Pictures of Civilian Slaughter in Viet" and "Readers Puzzled by Viet Pictures," *Plain Dealer,* November 21, 1969. *Washington Star:* Hersh, *My Lai 4,* p. 152. "I . . . Communists": Wallace, in Edward M. Opton, Jr., and Robert Duckles, "Mental Gymnastics on Mylai," *New Republic* 162 (February 21, 1970): 15. *New York Times:* Hersh, *My Lai 4,* pp. 152–53.

44. Lidice: Anthony Lewis, "What Are We Doing to Ourselves?" *New York Times,* November 22, p. 36, and "Song My," *Newsweek,* December 1, 1969, p. 35. *Time,* German opinion: Opton and Duckles, "Mental Gymnastics," pp. 14–15.

45. "Small . . . news": "Agnew's Complaint: The Trouble with TV," *Newsweek,* November 24, 1969, p. 88. "The . . . press": Jules Witcover, *White Knight: The Rise of Spiro Agnew* (New York: Random House, 1972), p. 317.

46. Phone calls: "Agnew's Complaint," p. 89. "Mr. . . . language": "Letters to the Editors," *Newsweek*, December 8, 1969, p. 4. At least one man supported *Newsweek*; he said he was thinking of canceling his subscription to the vice president.

47. See Roper Organization, *Changing Public Attitudes*, p. 13.

48. "Songmy 1: American Troops Are Accused of a Massacre," *New York Times*, November 23, 1969, sec. 4, p. 2.

49. Richard Hammer, *The Court-Martial of Lt. Calley* (New York: Coward McCann and Geoghegan, 1971), p. 361.

50. Fourteen officers: "The Generals Accused," *Newsweek*, March 30, 1970, p. 18. Forty-six soldiers, Calley prosecuted: "Remember Mylai," "Frontline," PBS, May 22, 1989. Scapegoat, 80 percent, Nixon: Hammer, *Court-Martial*, pp. 374–80.

51. Irving Petlin, interview with author, February 1990. The poster was Petlin's idea.

52. Karlsruhe, Yoko Ono: Jon Hendricks, interview with author, September 1990. Whiskey à Go Go: Eszterhas, "Selling," p. 71.

53. Karnow, *Vietnam*, pp. 608–10.

54. May 4 events: *New York Times*, May 5, 1970, p. 1; Milton Viorst, *Fire in the Streets: America in the 1960s* (New York: Simon and Schuster, 1979), pp. 535–39. Most sources give differing counts of the wounded.

55. Harold Evans, *Pictures on a Page: Photo-Journalism, Graphics and Picture Editing* (London: Heinemann, 1978), p. 231.

56. Karnow, *Vietnam*, p. 611.

57. Campuses: *U.S. News and World Report*, May 18, 1970, p. 28. "Invasion": William Shawcross, *Sideshow: Kissinger, Nixon, and the Destruction of Cambodia* (London: Hogarth, 1986), p. 153. T-shirts, etc.: John Filo, telephone interview with author, May 18, 1990. *Nation*: James Munves, "More Than People Died at Kent State," *Nation* 230 (April 16, 1980): 493.

58. A. . . . dedicated": John Kifner, *New York Times*, May 10, 1970, sec. 4, p. 1. Nixon's decline: H. R. Haldeman and Joseph Dimona, *The Ends of Power*, 1978; in Joseph Kelner and James Munves, *The Cover Up at Kent State* (New York: Harper and Row, 1980), p. 14.

59. 57 percent: *New York Times*, May 10, 1970, p. 20. *Newsweek* poll: *Newsweek*, May 25, 1970, p. 30. Lindsay: Viorst, *Fire in the Streets*, p. 540.

60. *Time*, May 18, 1970, cover and pp. 13ff. *Newsweek*, May 18, 1970, pp. 31–33; *Life*, May 15, 1970, pp. 30–35; *Life*, December 1979, pp. 36–37.

61. Runaway: *New York Times*, May 23, 1970, p. 13. Returned to parents: *New York Times*, May 24, 1970, p. 70. The *Times* said she was fifteen, all other sources fourteen. Communists: "Kneeling With Death Haunted a Life," *New York Times*, May 6, 1990. Defense attorney: Kelner and Munves, *Cover Up*, p. 75. Fame: *Newsweek*, April 18, 1980, p. 17.

62. Every paper: Axel Kessler, Associated Press, telephone interview with author, March 28, 1990. Accidental bombings: Fox Butterfield, "South Vietnamese Drop Napalm on Own Troops," *New York Times*, June 9, 1972, p. 9.

63. *Newsweek*, June 19, 1972, p. 42; *Life*, June 23, 1972, pp. 4–5.

64. Judith Coburn, "The Girl in the Photograph," *Los Angeles Times*, August 20, 1987, p. 13.

65. "Doesn't rest": Horst Faas, in Coburn, "Girl in the Photograph," p. 37. Protests: "Upsurge of War Protests, But Support for Nixon Too," *U.S. News and World Report*, May 22, 1972, p. 35.

66. 1937: "The Camera Overseas: 136,000,000 People See This Picture of Shanghai's South Station," *Life*, October 4, 1937, p. 102. Protested, threatened: John Faber, *Great News Photos*, p. 74. My thanks to Donald Kaplan for the information about the bubble-gum card, confirmed by two of his acquaintances. The Japanese at the time and others since then claimed the photograph was a fake. Wong himself took film of a man placing the child on the platform; he said he saw him (but did not direct him to) pick up the baby from the track. (See Faber, ibid.)

67. Until Vietnam: "The Man Who Invented Napalm," *Time*, January 5, 1968, pp. 66–67. Dow abandoned, manufacture taken over: "Dow Bows Out," *Newsweek*, December 1, 1969, p. 78. America stopped using: "The Fire This Time," *New York Times*, June 11, 1972, sec. 4, p. 4. United Nations: Homer A. Jack, "To Outlaw Napalm," *Christian Century* 40 (February 28, 1978): 264–67.

68. "Would . . . Vietnamese": "The Beat of Life," *Life*, June 23, 1972, p. 4. "If . . . sooner": "Letters to the Editors," *Life*, July 14, 1972, p. 29. "It . . . war," *Life*, December 29, 1972, p. 55. In 1972 the op ed page of the *New York Times* printed a cartoon by O. Blechman that used the figure of the little girl to represent the war and the burden of American guilt that Nixon could not avoid, no matter how far ahead he was in the race for the presidency.

69. "This . . . war": *Life*, December 1979, p. 185. 1989: Merle E. Ratner, telephone interview with author, April 2, 1990. Contemporary American artists, many of whom borrow the language of highly publicized photographs, have used Kim Phuc as a sign of America's moral degradation and the horrors of war in general. See, for instance, Erika Rothenberg's "There's No Better Country on Earth."

70. Hospital: Coburn, "Girl in the Photograph," p. 13. 1982: *Der Stern* 50 (1982): 47–48. Amsterdam film: "Kim Phuc" was directed by Manus Van der Kamp.

71. Westmoreland, in "Viet War Photo Is Challenged," *Washington Post*, January 19, 1986. My thanks to Mel Rosenthal for information on Westmoreland and to Merle E. Ratner for locating this article.

72. More TV than ten years earlier: George Comstock, Steven Chaffee, Natan Katzman, Maxwell McCombs, and Donald Roberts, *Television and Human Behavior* (New York: Columbia University Press, 1978), p. 5. 1974: *U.S. News and World Report*, April 22, 1974; in Michael Crozier, Samuel P. Huntington, Joji Watanuki, *The Crisis of Democracy: Report on the Governability of Democracies to the Trilateral Commission* (New York: New York University Press, 1975), p. 98. On a scale of 1 to 10, television had 7.2, the White House and the Supreme Court 6.9 each, newspapers 6.4, and so on.

73. Richard Schickel, *Intimate Strangers: The Culture of Celebrity* (Garden City, N.Y.: Doubleday, 1985), pp. 279–80.

74. Newspaper pictures: Lisa Grunwald, text, Jennifer Wolff, reporting, "What Saddam Has Done," *Life's Special Weekly Edition*, March 4, 1991, p. 44. Pakistan: "Pro-Iraq Fervour on the Wane in Pak," *Indian Express* (New Delhi), February 25, 1991, p. 6. Kuwait: "Kuwaiti's Tryst with Destiny," *Times of India* (Jaipur), March 4, 1991, p. 2.

75. 1972, 1990: study by Lisa Donneson, a newspaper analyst at County NatWest Bank in New York; in Alex S. Jones, "Papers Urged to Include Minorities," *New York Times*, April 25, 1990, p. D23. 100 percent: quoted by John Scully on

"World Without Walls: Culture in the Communications Age," part 3 of a PBS series, June 12, 1990.

76. Daniel Sheridan, "The Trouble with Harry," *Columbia Journalism Review* 28 (January–February 1990): 4–6.

77. Bucharest (AP photograph): *New York Times*, January 25, 1990. 1990: Barbara Walters, "A Smile, and Eyes That Go Cold," *New York Times*, May 18, 1990, p. 31. Identity: Nicholas D. Kristof, "China's Untold Story: Who Died in the Crackdown?" *New York Times*, June 3, 1990, p. 20.

78. Information from Michael Gasster and Roderick MacFarquhar.

AFTERWORD

1. Dr. Ronald G. Blom, telephone conversation with author, August 11, 1992. On Ubar, see John Noble Wilford, "On the Trail from the Sky: Roads Point to a Lost City," *New York Times*, February 5, 1992, pp. 1, 14; and Robin J. Williams, "In Search of a Legend: The Lost City of Ubar," *P.O.B.* 17 (August–September 1992): 10–24.

2. See Timothy Egan, "Citing Space Photos, Scientists Say Forests in the Northwest Are in Danger," *New York Times*, June 11, 1992, p. A13; and "Spy Satellites May Aid in Global Environmental Study," *New York Times*, May 7, 1992, p. B10.

3. One of every six American families: *Los Angeles Times*, July 25, 1991; in John Gregory Dunne, "Law and Disorder in Los Angeles," *New York Review of Books*, October 10, 1991, p. 23. Rapists and chain snatchers: see "Man Is Sentenced in Videotape Rape Case," *New York Times*, July 29, 1992, p. 21; and "2 Held in Taping of Queens Mugging," *New York Times*, November 24, 1991, p. 44.

4. Bill Carter, "Rather Pulls CBS News Back to the Assassination," *New York Times*, February 4, 1992, p. C11.

5. Though part of this tape and single frames excerpted from it once blanketed the media, the visual evidence has since become nearly invisible. Holliday has brought suit for copyright infringement against many who have already broadcast his tape or printed an image from it, and he currently charges high fees for reproduction rights.

6. Roger Parloff, "Maybe the Jury Was Right," *American Lawyer*, June 1992, p. 80. The trial was carried on Court TV, which produced a one-hour-and-fifty-six-minute tape of major moments in the trial.

7. Coffins began to arrive: Jason DeParle, "Keeping the News in Step: Are the Pentagon's Gulf War Rules Here to Stay?" *New York Times*, May 6, 1991, p. A9. Dead Iraqi soldiers: John J. Fialka, *Hotel Warriors: Covering the Gulf War* (Washington, D.C.: Woodrow Wilson Center Press, 1991), p. 5. Police demanded his film: Ibid., p. 56.

8. Reporting on helicopter activity: Fialka, *Hotel Warriors*, p. 59. Fired the photographer: "Media Engulfed" (editorial), *Nation*, May 17, 1991, p. 687.

9. Mark Crispin Miller, "Operation Desert Sham," *New York Times*, June 24, 1992, Op-Ed page, and telephone conversation, July 25, 1992. Mr. Miller is writing a book on the Gulf War. On this sortie, see the *Washington Post*, January 31, 1991, pp. A21, 22.

10. My thanks to ABC Audience Relations and to J. J. Ramberg at NBC for information on the broadcasts.

11. Time Warner News, Corporate Communications, December 7, 1992.

INDEX

Page numbers in *italic* refer to illustrations.

A

ABC, 83, 217, 219, 221, 223, 226, 228, 241; referred to as Afro Broadcasting Company, 211
Abraham Lincoln (photo, Berger), *80*
Abraham Lincoln (photo, Brady), *74*
Abstract Expressionism, 131
Acheson, Dean, 71
action painting, 129, 131–32
Adams, Ansel, 45, 47; photo by, *46*
Adams, Eddie, 226–29; on his photo of General Loan, 229; photo by, *227*
Addams, Jane, 178
advertising: Che Guevara poster as, *160*; endorsement by stars in, 119; invasion of privacy by, 113–16; Iwo Jima flag-raising poster as, *146*, 147
Aerial image of trucks, originally described as "eleven Iraqi vehicles loaded with Scuds, seen from the plane about to destroy them" (photo, CNN), 258
Aerial Photograph, Cuba, 73
aerial photography, 70–73, 149, 252–54
Afro Broadcasting Company, 211
Agassiz, Louis, 62
Agnew, Spiro, 234–35
Alamogordo atomic bomb test, 148
Albert, Prince, 104
albums, 14, 77, 103, 104, 105
Ali, Muhammad, 202
Alinari, 60
Alland, Alexander, Sr., 169
Allen, Woody, 115, 229
amateur photography, 73, 173; of Kennedy assassination, 221; by Edgar Gardner Murphy, 173; by Ron Olshwanger, 99; by George Holliday, 255–57
America (magazine), 208–9
"American Action Painters, The" (article, Rosenberg), 131
American Lawyer (magazine), 256
American Society of Magazine Photographers, 208
"America's Most Wanted" (TV program), 61
Amsterdam News (newspaper), 201
"And Babies?" (photo, Haeberle), *231*, 243

Anders, William, 56; photo by, *56*
Anderson, Carl David, 50–52; photo by, *51*
Anderson, Major Robert, 105
Andersonville Prison (Georgia), 20, 24
Anthony and Company, 25, 105
Antietam, Battle of (Maryland), 25–27
L'Anti-juif illustré (newspaper), 63; fake photos in, 89
Anti-Slavery Standard (newspaper), 107
antiwar movement: and Che Guevara image, 161; civil-rights movement's influence on, 210; Kent State killings' influence on, 239–40; and General Loan's shooting of Vietcong suspect, 229; My Lai massacre's influence on, 235–36; and photograph of napalmed girl, 243
Antonioni, Michelangelo, 222
AP. *See* Associated Press
Appert, Eugène, 89
Archer, Frederick Scott, 12
Arledge, Roone, 217
Army-McCarthy hearings, 94–95
Army Pictorial Service, 198
art photography: controversy over, 246–47; emergence of, 40, 44, 47; increase in, 249
Artnews (magazine), 131
arts sponsorship affected by controversial photos, 246
Art Workers' Coalition (New York), 236
Asanuma, Inejiro, 223, 224
assassination, 90, 194; of Inejiro Asanuma, 223, 224; of John F. Kennedy, 220–21, 254–55; of Robert Kennedy, 219. *See also* murder
Assassination of Inejiro Asanuma (photo, Nagao), *224*
Associated Press (AP), 87, 96, 142, 194, 208, 212, 214, 230, 242, 243, 249, 257; and "kitchen debate," 82–83, 86, 87
astronauts, 54–56
astronomy, 39
Atlantic Monthly (magazine), 42
atomic bomb, 147–52, *149–51*
Atomic Bombing of Hiroshima (photo, Caron), *149*

B

Ball, Lucille, 70
Baltimore Sun (newspaper), 35

Balzac, Honoré de: reluctance to be photographed, 14
Bananas (film, Allen), 115
banners, political, 78
Barnardo, Dr. Thomas John, 163–64; photos by, *162*
Barthes, Roland, 17; on Browder-Tydings fake photo, 94
Baudelaire, Charles: on daguerreotype portraits, 11
Baxter Street Alley, Rag Picker's Row (photo, Riis), *166*
BBC, 228
Beall, C. C.: poster by, *145*
Beard, Richard, 165
Bedaux, Charles, 70
Beers, Jack, 223–25; photo by, *216*
before-and-after photos, 62, *162–64*
Before and After Photographs of a Young Boy (Barnardo), *162*
Beijing, China, 250, 251
Benjamin, Walter, 219
Bergen-Belsen (concentration camp, Germany), 33
Berger, Anthony: photo by, *80*
Bergman, Ingmar, 212
Berliner Illustrierte Zeitung (newspaper), 191
Bernhardt, Sarah, 112
Bertillon, Alphonse, 60–61
Betty Grable (photo, Powolny), *122*
Bikini Atoll Cake Celebration (photo, Jacobus), *150*
Bikini Atoll test bomb, *150*; and Hayworth pinup, 125
Bill (GI killed in combat), 196–97, 198–99
biosphere, 54
Birmingham, Alabama, 247; civil-rights demonstration in, *2*, 203–9, *205*, *206*
Birmingham, Alabama; Negroes Take Refuge in Doorway as Firemen Pour Water on Them to Break Up a Racial Demonstration (photo), *205*
Black and White (magazine), 16
Black Panthers' Newspaper, 138, *141*
black power, 211
black press, 201–2, 208
Blom, Ronald G., 252
Blow Up (film, Antonioni), 222
Bobby's Camera (film), 113
Bohemia venezolana (magazine), 138, *141*
Bond, Julian, 202

Booth, John Wilkes: most-wanted poster for, *58, 59*; photos of prohibited, 90
Bosnia and Herzegovina, 259
Boston Evening Transcript (newspaper), 41
Boulanger, Georges, 76
Bourke-White, Margaret, 36–37; photo by, *36*
Boutros-Ghali, Boutros, 259
Bradley, Colonel Jack, 95
Bradley, Mamie Till, 201
Brady, Mathew: books of photos by, 28; and Civil War photos, 25; and Gallery of Illustrious Americans, 103; Lincoln portraits by, 16, 74, 76–81; New York gallery of, 25–26; prison portraits by, 59
Brand, Stewart, 53–54
Brandeis, Louis, 114
Brandt, Peter: poster by, *237*
Braquehais, Auguste B., 63; photo by, *66*
Brewster, Sir David, 12
Bristol, Horace, 141
broadsides, 78
Browder, Earl, 91–92, 93, 94
Brown, E. H., 78
Browne, Malcolm, 212, 214; photo by, *213*
Browning, Elizabeth Barrett: on daguerreotype portraits, 11
Bryant, Roy, 200, 203
bubble-gum card, 244
Buchenwald (concentration camp, Germany), *36*
Buddhism, 212, 214
Buddhist monk, 212, *213*, 215
Buna Beach (New Guinea), 196–97, 198–99
Bush, President George, 147
Butler, John Marshall, 91–92
Byrnes, James, 198
Byrnes, Thomas, 60

C

cabinet cards, 14, 104, 107
Calder, Alexander, 131
calendars, 53
Callen, Maude, 182–84, *183*
Calley, Lieutenant William L., Jr., 229–30, 233–36
calling cards, 104
calotypes, 11
Cambodian invasion, 236, 239–40
cameras: disguised, 113; history of, 10; technological development of, 40–41, 113
camera lucida, 10
camera obscura, 10
Cameron, Dr. James Spottiswode, 170–72
Cammerer, Arno, 47
campaign buttons, 77–78

camps for migrant workers, 179, 182
candid photography, 113; of Franklin D. Roosevelt, 87
Capa, Robert, 95, 199, 226
captions, 95, 214; of "kitchen-debate" photo, 86; of steer-skull photo, 96; of Tydings and Browder fake photo, 92
Carabiniers, Les (film, Godard), 15
Caron, George R., 149; photo by, *149*
Carpenter, F. B., 76
Carson, Rachel, 53
carte de visite, 12–14, 20, 77; of celebrities, 103–5, 107, 118; of Adah Isaacs Menken, *108–9*; of Napoleon III, *102*; used in social reform, 163; of emancipated slaves, *164*; of Queen Victoria, *14*
Carte de Visite of Adah Isaacs Menken and Algernon Swinburne, 109
Carte de Visite of Adah Isaacs Menken as Mazeppa (Sarony), *108*
Carte de Visite of Adah Isaacs Menken on the Lap of Alexandre Dumas, Père (Liébert), *109*
Carte de Visite of Emancipated Slaves Brought from Louisiana by Colonel George H. Hanks (Kimball), *164*
Carte de Visite of Napoleon III (Disdéri), *102*
Carte de Visite of Queen Victoria (Disdéri & Co.), *14*
cartomania, 104, 118. *See also* collecting
cartoons: by Herblock, 92, 93; of Lincoln portrait, 78; of Nelson Rockefeller, 83; of steer-skull photo, 98
Castro, Fidel, 156
catalyst: photos as, 16
Cathedral (painting, Pollock), 127
CBS, 83, 88, 219, 223, 228, 231, 233, 241, 243, 255; referred to as Colored Broadcasting System, 211
Ceaucescu, Nicolae, 75, 246
celebrity, 101–33; definition of, 103; *People* (magazine) and, 249
censorship, 7, 67, 86, 257–58; of art photography, 246–47; of news, 248; of World War I photos, 195; of World War II photos, 196–98. *See also* prohibition of photography
Challenger explosion, 247
Chancellor, John: on Emmett Till, 203; on the Vietnam War, 226
"Chaos, Damn It" (article), 128
Chaplin, Charlie, 70, 118
Charade (film), 50
Charities and Commons (magazine), 178
charity. *See* social reform
Charleston Mercury (newspaper), 77
Charlie Company (Vietnam), 229–30
Che Guevara. *See* Guevara, Che
Che Guevara (photo, Korda), *156*

"Che Guevara"—*Poster Advertisement for "Evergreen" Magazine* (Davis), *160*
Chelmno (concentration camp, Poland), 35
Chesterton, G. K., 103
Chicago and Milwaukee Railway Company, 61
Chicago Sun-Times (newspaper), 125
Chicago Tribune (newspaper), 212, 226, 237
Child in Carolina Cotton Mill or *The Little Spinner* (photo, Hine), *175*
child labor, 172–75, *175–76*, 177–78
Children Fleeing a Napalm Strike (photo, Ut), *243*
Chinese Baby (photo, Wong), *245*
Chinese immigrants' reluctance to be photographed, 73
Chipman, Norton, 24
chronocyclegraph, 68, 69
Chronocyclegraph of Woman Staking Buttons (photo, Gilbreth), *68*
CIA, 254
cinema. *See* motion pictures
civil-rights movement: Birmingham, Alabama, demonstrations, 2, 203–9, 205–6; bus boycott in, 203; global exposure of, 210; influence of Emmett Till's murder on, 201–2; newspaper versus TV coverage of, 219–20
Civil Rights Act, 209
Civil War: photographic record of, 20–29, 196; prisoners of war in, 22–23
Clean Air Act of 1963, 53
Cleveland Plain Dealer (newspaper), 230–31, 233–34
close-ups, 117, 119
CNN (TV), 218, 247–48, 256, 257
Colbert, Claudette, 118, *120*
collecting of photographs, 14, 26; of cartes de visite, 12, 104, 105, 108
Collier's (magazine), 140, 152
Collins, Tom, 142
collodion-on-glass negative process, 12
Colored Broadcasting System, 211
commercial use of photos: permission required for, 115
Communards, 62, 66; fake photos of, 89
communications satellites, 217, 219; and Gulf War coverage, 247; and John F. Kennedy assassination, 220
composite photo. *See* fake photography
computer-graphics machine (Harry), 250
computer image-enhancement, 254, 258
computer-imaging system, 99
computer manipulation, 99–101: of Lanting cowboy photo, 99, *100*; of TV images, 250; of video still, 99
Comstock, Anthony, 108

concealed camera. *See* hidden camera

concentration camps, 32–37, 247; Buchenwald, *36*; incredulity about, 33–35, 234; for Japanese POWs, 32–33; Nordhausen, *33*

Connally, John, 221

Conness, John, 43

Connor, Sheriff "Bull," 203, 207–11

conservation, 43, 47, 53, 57

Cooper, Sherman, 204–5

Cooper Institute (New York), 76–77

Corliss v. E. W. Walker Co., 114

cosmic rays, 50

"Country Doctor" (photoessay, Smith), 182

Country Gentleman (magazine), 41

Courbet, Gustave, 19, 104, 165

Cowboy at Dawn, Yellowstone (photo, Lanting), *100*

Crater of the Castle Geyser, Wyoming (photo, Jackson), *45*

credibility of photography, 19, 21, 25, 28, 31–36, 50, 61, 94, 98, 99, 101, 110, 144, 172, 174, 211, 222, 230, 234, 250, 251. *See also* fake photography

Crichton, Michael, 254

Crick, Francis, 50

crime detection, 59–60

criminal types, 59–60

Criminals of America (book, Farley), 60

Crippen, Robert E., 252–53

Cronkite, Walter, 228

cropping, 90, 94–95, 96, 155, 224

Croton Watershed (New York), 168

Cruise, Tom, 16

Cuban missile crisis, 71–72, *73*

Cuban revolution, 156

Cultural Revolution (China), 152–54

Current History (magazine), 140

Currier and Ives, 78, *79*

Curtin, Phyllis, 185

D

Dachau (concentration camp, Germany), 33, 247

Daguerre, Louis-Jacques-Mandé, 6, 10

Daguerreotype (magazine), 10

Daguerreotype of Dead Child, *12*

Daguerreotype Portrait of Louis-Jacques-Mandé Daguerre (Sabatier-Blot), *6*

Daguerreotype Portrait of Drana, Country Born, Daughter of Jack Guinea, Plantation of B. F. Taylor, Columbia, S.C. (Zealy), *65*

Daguerreotype Portrait of Renty, Congo, B. F. Taylor, Columbia, S.C. (Zealy), *64*

daguerreotypes, 10–11; of Daguerre, *6*; of dead child, *12*; of moon, 39;

mug shot, 59; of slaves, 64–65

Dancer, J. B., 39

da Silva, Flavio, 185–88, *186*

Davis, Elmer, 198

Davis, Paul: poster by, *160*

Day, Doris, 125

Day in the Life of America, A (book), 99, *100*

Dead of Stonewall Jackson's Brigade by Rail Fence on the Hagerstown Pike, Antietam, Maryland (photo, Gardner), *27*

dead, photographs of the, 11, 161; Che Guevara, *158*; child, *12*; in Civil War, 25–28, *27*, *29*; at Kent State, 237, *238*, *239*; at My Lai, *231*, *237*; in World War II, *33*, *37*, 196–99, *197*

Death Picture of Che Guevara (photo), *158*

deceptive photos, 95, 96, 116, 163–64, 167. *See also* computer manipulation; fake photos; staging of events to be photographed

Degas, Edgar, 31; on "photo opportunity," 31

Delacroix, Eugène, 40

Delaroche, Paul, 10

demonstrations: civil rights, 2, 203–4, 205–6, *206–8*; at Kent State, *1*, 236–41, *238*, *241*; photos used to identify participation in, 63; in Tian An Men Square, *155*, 250, *251*; in Tompkins Square Park, 66. *See also* student protest

Demonstrators in Tian An Men Square (photo, Akatsuka), *155*

dependence of photos on context, 16–17, 44, 94, 95–96, 111, 114, 168–69, 172, 251

Depression, the, 136–41

detective camera, 113. *See also* hidden camera

Detroit Free Press (newspaper), 248

Detroit Times (newspaper), 119

Diamond, Dr. Hugh Welch, 61, 164, 177

Dickens, Charles, 112

Diem, Ngo Dinh, 212, 214

Diggs, Charles, 202–3

Dirac, Paul A. M., 52

dirigibles, 195; *Hindenburg* explosion, 190, *192*, *193*, 194–95

Discovery of the Positive Electron of "Positron" (photo, Anderson), *51*

Disdéri, André-Adolphe-Eugène, 104; photos by, *14*, *102*

Dispatch Herald (newspaper), 98

Doctorow, E. L., 192

Dog Tearing Pants of Man, Birmingham, Alabama (photo, Moore), *206*

domination embodied in photos, 62

Dos Passos, John, 34

Dow Chemical Company, 244

Draper, Henry, 39

Duchamp, Marcel, 31

Dumas, Alexandre, *fils*, 110

Dumas, Alexandre, *père*, 109–11

Duncan, David Douglas, 230

Dylan, Bob, 203

E

Eakins, Thomas, 30

Early, Stephen, 87

Earth, 52–57

Earth, as Viewed from ATS Satellite (photo), *55*

Earthrise (photo, Anders), *56*

earthquake, 194

Eastlake, Lady: on photography, 19

Eckener, Dr. Hugo, 195

ecology movement, 52–54, 57

Edgerton, Harold, 16

Editor and Publisher (magazine), 35

efficiency experts: *see* time and motion studies

Eiffel Tower (Paris), 125

Eisenhower, General Dwight D.: on concentration camps, 36; on war photography, 196

Elachi, Dr. Charles, 252

Emerson, Ralph Waldo, 103

Emmett Till (photo), *200*

English, Don: photo by, *151*

English, Donald, 63

engravings, 9, 13, 21, 23, 39, 40, 103

Enola Gay (airplane), 147, 149

environmental protection, 53, 57; landscape photography and, 47. *See also* ecology movement

Eppridge, Bill, 219

Erwitt, Elliott, 83, 86–87; photo by, *85*

Esquire (magazine), 122

Eszterhas, Joe, 230–31, 233, 236

Evergreen Review (magazine), 131, 160

Everybody's Magazine, *81*, 82

evidence, photography as, 19–37; court issues and, 50, 59; in Parliament, 172

execution, 226, *227*, 228–29. *See also* assassination; lynching; massacre; murder

exhibitions of photographs, 21, 24, 249; by Hine, 174; of Lange's migrant-worker photos, 140; of Ut's photo of napalmed children, 244

exploration and expeditions, 41–47

Explosion of the Hindenburg (photo, Shere), *190*

explosions: of *Challenger*, 247; of *Hindenburg*, *190*, *192*, *193*, 194–95

"Eyes on the Prize" (TV documentary, Hampton), 201–2

F

Fair Labor Standards Act, 178
Fairbanks, Douglas, 118
Fairman Rogers Four-in-Hand, The (painting, Eakins), 30
fake photography, 89–90, 155; of Hitler victory jig, *91*; McCarthy's use of, 90–95; by Chinese, 155; of Menken and Dumas, 110; of Puerto Rican family, 187; Rothstein's photo accused as, 93; of Queen of Naples, 89; by yellow press, 174. *See also* computer manipulation; credibility of photography; deceptive photos
Falkenburg, Paul, 129
Falklands War, 248
fame, definition of, 103. *See also* celebrity
fan magazines, 117, 119
Fargo Forum (newspaper), 98
Farley, Phil, 60
Feltrinelli (Italian publisher), 156
Figaro, Le (newspaper), 110
films. See motion pictures
Filo, John Paul, 237, 239–40; photos by, *1, 238, 241*
five-dollar bill, *80, 81*
flash photography, 30, 166–67
Flavio (photo, Parks), *187*
Flavio. *See* da Silva, Flavio
"Flavio's Rescue" (article), 187
Florea, Johnny: photo by, *33*
Focus of Attention, The (photo, Smith), *94*
Ford, John, 141–42
Forman, James, 209
Fortieth Parallel Expedition (King), 43
Franklin Mills Company, 113
Frassanito, William, 26
"Freedom's Fearful Foe: Poverty" (photoessay, Parks), 185
freeze frame (TV), 217
Frith, Francis, 218
From the Record (tabloid), 91–92, *93*
Fuller, Buckminster, 54
fund-raising: photos used for, 105–7, 112, 163–64
Fussell, Paul, 145, 147

G

Gable, Clark, 118–19, *120–21*
Gaia hypothesis, 57
Galella, Ron, 116
Galerie contemporaine (book), 104
Gallery of Illustrious Americans (lithographs, Brady), 103
Galloping Horse, Motion Study— "Sallie Gardner" (photo, Muybridge), *18*
Galton, Francis, 59

Gambetta, Léon, 75–76
Gardner, Alexander, 25, 28, 198; photos by, *27, 29*
Garfield, President James A., 113
Gate of the Heavenly Peace (Beijing), 153, 156
Gazette des Beaux-Arts (magazine), 30
General Loan Executing a Vietcong Suspect (photo, Adams), 227
genre photos, 165
Genthe, Arnold, 73, 194
Gerry Society (U.S.), 62
Gettysburg, Battle of (Pennsylvania), 28, 29
Gilbreth, Frank B., 67–70; photos by, *68, 70*
Gilbreth, Lillian, 68
Gillett, James Norris, 81–82
glass negatives, 28, 41, 104
Godard, Jean-Luc, 15
Grable, Betty, 122–25, *123*
Graf Zeppelin, 195
Granta (magazine), 147
Grapes of Wrath, The (book, Steinbeck), 140–41, *142*
Grapes of Wrath, The (film, Ford), 141–42
Great Debate, The (photo), *84*
Greeley, Horace, 108
Greenberg, Clement, 127
Grenada, invasion of, 248, 257
Griffith, D. W., 117; on artist as hero, 126
Guevara, Che, 156–61, *157, 158, 159, 160*
Gulf War, 247, 257–59

H

Haeberle, Ron, 230–31, 233–35; photos by, *231–32, 237*
Halberstam, David, 214
halftone, 13, 14, 15, 49, 165, 167–68
Hampton, Henry: on effect of TV coverage of civil-rights movement, 211; on Emmett Till, 202
Hampton Institute (Virginia), 62
Happenings, 132
Hare, Jimmy: on the War Office's fear of photos, 195
Harper's Weekly, 16, 21, 26, 28, 77–78
Harry (computer-graphics machine), 250
Hart, Gary, 111, 246
Harvard Lampoon (magazine), 124
Harvard Law Review (magazine): on gossip, 113; on invasion of privacy, 114
Harvest of Death, Gettysburg, Pennsylvania, A (photo, Sullivan/Gardner), *29*
Havana's Plaza de la Revolución, with Che Guevara's Image in the Background (photo, Meiselas), *159*
Hayden, Ferdinand V., 43–45
Hayworth, Rita, 125
Hearst, Patty, 72
Herald Tribune (newspaper), 98
Herblock, 93; cartoon by, *93*
Hersh, Seymour M., 230, 234
Hicks, Wilson, 192
hidden camera, 72–73, 99, 113, 194
Hindenburg (dirigible), *190*, 192, *193*, 194–95
Hine, Lewis: and child-labor photos, 173–75; influence of Riis on, 170; on truth in photography, 19; works by, *175, 176*
Hiroshima, Japan, 147–48; bombing of, *149*
Hitler, Adolf, 90, *91*, 95, 195
Hitler Does a Victory Jig after Signing the Peace Treaty with France in 1940—Campiègne, France (still), *91*
Hoffman, Dustin, 99
Holliday, George, 255–57
Holmes, Oliver Wendell: on charity, 163; on Civil War photos, 26; on photography, 29; on stereographs, 12–13; on Yosemite, 42
Hot Springs on the Gardiner River Upper Basin, Thomas Moran Is with His Back to the Camera, Yellowstone (photo, Jackson), *13*
Houston Telegraph (newspaper), 77
How the Other Half Lives (book, Riis), 167–69
Hoyle, Fred, 52
Huntley-Brinkley TV news, 237, 239

I

Ickes, Harold, 47
icons, photos as, 135–61, 247
identification, photos used as, 61–62; of Communards, 63; of criminals, 59–61; for political repression, 63
Idiot's Delight (film), 119, *121*
Illustrated Daily News (newspaper), 191, 195
Illustrated London News (newspaper), 16
illustrated press, 8–10, 15–16, 25, 191 *See also* picture magazines
infrared photography, 41
"*Inside a church . . . Maude Callen checks a patient in a clinic*" (photo, Smith), *183*
instant replay (TV), 217
instantaneity of TV, 222
institutional photography, 61–62
interpretation of photographs, 17, 21, 72, 96, 154, 155, 222, 250–51
It Happened One Night (film), 118–19, *120*
"It's a Tough War" (article), 199

Iwo Jima, Japan: flag raising on, 142–47, *143*, *145–46*

Iwo Jima—"Old Glory goes up on Mt. Suribachi" (photo, Rosenthal), *143*; adaptations of, *145, 146, 147*; image on poster, *145*

J

Jack Ruby Shooting Lee Harvey Oswald (photo, Jackson), *225*

Jack Ruby Shoots Lee Harvey Oswald (photo, Beers), *216*

Jackson, Bob, 224–25; photo by, *225*

Jackson Pollock (photo, Namuth), *130*

Jackson Pollock (photo, Newman), *128*

Jackson, William Henry, 41, 43–44; photos by, *13, 38, 45*

Jacobus: photo by, *150*

James, Harry, 124

Janssen, P.J.C., 39

Javits, Senator Jacob: on impact of photos, 208

Jet (magazine), 208; Emmett Till photos in, 201–2

Jet Propulsion Laboratory, 252–54

Jewish Frontier (newspaper), 35

JFK (film, Stone), 254–55

Jiang Zemin, 251

Jinnah, Mohammed A, li, 8

John Muir National Park (California), 47

Johnson, Don, 101

Johnson, Lyndon, 88, 221, 228–29

K

Kamenev, Lev Borisovich: cropped out of photos, 90

Kaprow, Allan: on Pollock, 132

Kazan, Lainie: on photographs of herself, 133

Kendal, Mrs. Madge, 112

Kennedy, Jacqueline. *See* Onassis, Jacqueline Kennedy

Kennedy, John F.: assassination of, 220–21, 254–55; and civil-rights movement, 204, 209; and Cuban missile crisis, 71–72; and TV, 217

Kennedy, Robert: on aerial photography, 72; assassination of, 219

Kent State—Girl Screaming over Dead Body (photo, Filo), *238*

Kent State—Student Waving Flag at National Guardsmen with Rifles (photo, Filo), *241*

Kent State University, *1*, 236–41, *238, 241*

Kerr, Jean, 92–93

Ketchum, Robert Glenn, 47

Khomeini, Ayatollah, 247

Khrushchev, Nikita, 82–87, *84–85*

Kimball, M. H.: photo by, *164*

King, Clarence, 43

King, Martin Luther, 203, 206, 209, 211

King, Rodney G., 66, 255–57

King, Thomas, 99

Kings Canyon National Park (California), 45, *46, 47*

"kitchen debate" (Nixon and Khrushchev), 82–87, *84–85*

Kitchen Debate, The (photo, Erwitt) *85*

Knobelspiess, Roger, 246

Kodak, 14, 40

Kodak Crystal Eagle Award for Impact in Photojournalism, 208

Koon, Sergeant Stacey, 255–56

Korda, Alberto, 156, 159, 161; photo by, *157*

Korean War, 89

Krasner, Lee, 129

Kunkel, John, 36

L

Lacy, Madison Davis, 202

Ladner, Joyce, 202

Laemmle, Carl, 117

Land of the Free (book, MacLeish), 137

land preservation. *See* conservation

Landry, Bob, 125

Landsat Satellite, 252–54

landscape photography, 38, 41–43, *42, 45, 46*; environmental protection and, 41–43, 47

Lange, Dorothea, 136–41, 179; photos by, *134, 138–39, 180–81*

Langford, N. P., 44

Langtry, Lillie, 112

lantern slides, 169, 174

Lanting, Frans: photo by, *100*

Last Whole Earth Catalogue (book), 57

Lawrence, Florence, 117

Leeds, England, *170–71, 172*

"Legacy of Jackson Pollock, The" (article, Kaprow), 132

Leo, Vincent, 148

Leslie's Illustrated Newspaper, 21, *23, 24*, 78, *79*

Leslie's Weekly (magazine), 16

Liébert, Alphonse, 109–10; photo by, *109*

Life (magazine) 24, 99, 119, 179, 182, 184–85, 194, 218, 243, 248; Birmingham demonstration photos in, 207–8; Browne's photo of monk's self-immolation in, 212; Buchenwald photo in, 37; circulation of, 185, 218; Earth photos in, 56; and Hiroshima and Nagasaki bombings, 148; Iwo Jima flag raising in, 142–44; and Kennedy assassination film, 221; Kent State photos in, 240; "kitchen debate" in, 83; Latin America series in, 185–88; Mark's photos of street people in, 189; migrant photos in, 140, 141; My Lai photos in, 230, 231–33; on news photography, 95; photoessays in, 182–88; photos of napalmed children in, 243, 244; picture editing in, 99; Pollock photos in, 127–28, 130–32; on World War II photo restrictions, 196–99

Lincoln, Abraham, 16, 59, 74, 76–81, *79–80*

Lincoln-Douglas debates, 76

Lincoln penny, 81

Lind, Jenny, 107

Lindsay, Vachel: on films, 16

Literary Digest (magazine), 140

lithographs, 13, 78, *79*, 140

Little Spinner (photo, Hines), 174, *175*

Loan, General Nguyen Ngoc, 226–29, *227, 247*

Lodge, Henry Cabot, 214

London Chronicle (newspaper), 48

London Daily Express (newspaper), 237

London Daily Mail (newspaper), 36

London Daily Mirror (newspaper), 237

London Labor and the London Poor (book, Mayhew), 165

London Times (newspaper), 33–34, 224, 237, 242

Long View of Bodies on the Ground Arranged for Burial, Nordhausen (photo, Florea), *33*

Look (magazine), 140, 179, 184, 191, 230, 248

Lorentz, Pare, *140*

Los Angeles Times (newspaper), 212, 226, 237, 257

Lovell, James A., 56

Lovelock, James, 57

Luce, Henry: on *Life*, 192

Lumière, Louis, 32

Lunar Orbiter 5, 54

lynching, 201–3

M

McCall's (magazine), 140

MacArthur, Douglas, 8, 136

MacLeish, Archibald, 56, 137

McLuhan, Marshall, 195

magazines: era of photography in, 191–215; rise of weekly, 20; use of computer-altered photos in, 99

Magnum Agency, 83

Maidanek (concentration camp, Poland), 35

Making Human Junk (poster, Hine), *176*

Malik: picture by, *141*

Mammoth Hot Springs (Wyoming), 44

Man Stopping Tank, Beijing (video image), *250*

Mandela, Nelson, 76
Mao Tse-tung, 152–56, *153, 155;*
 badges of, *152*
Mao Tse Tung (photo), *153*
Mapplethorpe, Robert, 246–47
marches for civil rights, 203–4
March of Time newsreels, 90, 179, 249
Marey, Etienne-Jules, 30, *31*
Mark, Mary Ellen, 188–89
Mars, 7, 57
massacre, My Lai, 229–36, *231–32,*
 237
"Maude Gets Her Clinic" (article), 183
Mayall, J. E., 104
Mayer Brothers, 104
Mayhew, Henry, 165
Mazeppa: Adah Isaacs Menken as,
 108
McCarthy, Senator Joseph, 90–95, *94*
McCormick, Colonel Robert R., 91
McPherson, Harry, 229
Meadlo, Paul, 233, 236
Medina, Captain Ernest, 229
Meiselas, Susan: photo by, *159*
Meissonier, Ernest, 25, 30
memory: aided by photos, 218–19,
 225–26
Menken, Adah Isaacs, 107–11, *108–9*
"Mensonges de la photographie"
 (newspaper supplement), 89
mental patients and photography, 61,
 164
merchandising, Hollywood influence
 on, 119
Miami Herald (newspaper), 248
Migrant Mother, Nipoma, California
 (photo, Lange), *134,* 136–40,
 138–39; image borrowed, 138, *140–*
 41
migrant workers, *134,* 136–37, *138–*
 39, 140–41, 178–82, *180–81*
Migrant Workers (photos, Lange),
 180–81
Milam, D. J., 200, 203
Miller, Mark Crispin, 258
Miller, Mrs. Ruth "Bazy" McCormick,
 91
Millikan, Robert A., 51
Miranda, Carmen, 133
Miss Atomic Bomb (photo, English),
 151
Modern Merchandizing Bureau, 119
Modern Screen (magazine), 122
Modern Times (film, Chaplin), 70
Monroe, Marilyn, 125–26
Montez, Lola, 13, 107
moon, 54–57; daguerreotype of, *39;*
 photos of moon walk, 57
Moore, Charles, 207–8; photo by, *206*
morale: photography's effect on,
 during World War II, 198
Moran, Thomas, *13,* 43–44
"morphing," 252
Morrison, Herbert: on *Hindenburg*
 explosion, 192, 194

Morrison, Norman R., 215
Morse, Ralph, 196
Morse, Senator Wayne, 206
most-wanted poster, *58, 59*
motion pictures, 15–16, 69, 117–26;
 Bobbie's Camera, 113; of
 concentration camps, 35; *Grapes of*
 Wrath, The, 141–42; *Idiot's Delight,*
 119, *121;* industrial training, 68, 70;
 It Happened One Night, 118–19,
 120; of Pollock, 129–30, *131;*
 precursors to, *32; Seven-Year Itch,*
 The, 125, *126. See also* newsreels
Mount Clarence King, Pool, Kings
 Canyon National Park, California
 (photo, Adams), *46*
mug shots, 59–60
Muir, John, 45, 47
Mulberry Bend (New York), 168
Münchener Illustrierte Presse
 (newspaper), 191
murder: of Guevara, 156; of Till,
 201–3; of Oswald, 216, 222–25,
 247. *See also* assassination
Murphy, Edgar Gardner, 173, 178
Museum of Modern Art (New York),
 131, 132, 136, 137, 140, 236
mushroom cloud, 147–52, *149*
Muybridge, Eadweard, 16, 29–32, 41,
 69, 144, 169, 222; photos by, *18, 31*
My Lai massacre, 229–36, *231–32, 237*
My Lai Massacre (photo, Haeberle),
 232

N

Nagao, Yashusi: photo by, *224*
Nagasaki, Japan: bombing of,
 147–48
Namuth, Hans, 129–32; photo by, *130*
napalm, 241–45
Naples, Queen of, 89
Napoleon III, *102,* 104
Nation (magazine), 239
National Aeronautics and Space
 Administration (NASA): 56, 57
National Association for the
 Advancement of Colored People
 (NAACP), 203
National Child Labor Committee
 (NCLC), 173–75, 177–78
National Geographic (magazine), 99
National Guard, U.S., 236–41
Nation's Business (magazine), 140
Native Americans, 62
Nazis, 33, 35, 36, 63, 234
NBC, 83, 219, 221, 223, 226, 230,
 237–39, 241–42, 250, 257–58;
 referred to as Negro Broadcasting
 Company, 211
Nègre, Charles, 107, 165
Negro Broadcasting Company, 211
Newman, Arnold, 127; photo by, *128*
Newsday (newspaper), 248

newspapers, 9, 15, 16, 25, 34, 35,
 112–13, 212, 248–49; rotary press
 used by, 112–13. *See also*
 reproduction methods for
 photography; *individual names of*
 papers
newsreels, 34, 36, 90, 144, 179, 192,
 194
Newsweek (magazine), 83, 99, 140,
 198, 207, 233, 235, 240, 243
Newton John, Olivia, 125
New York Daily News (newspaper),
 191, 194, 195, 237
New Yorker (magazine), 122, 124,
 128
New York Herald Tribune (newspaper),
 98, 152
New York Journal (newspaper), 10
New York Post (newspaper), 92, 233
New York Sun (newspaper), 98, 167
New York Times (newspaper), 20, 35,
 45, 139, 178, 185, 195, 199, 204, 212,
 214, 219, 224, 237, 239, 242–43,
 255; on atomic bomb, 147, *148,*
 151–52; on John F. Kennedy
 assassination, 220–21; on "kitchen
 debate," 83, 86; on My Lai
 massacre, 233, 235–36; on photos
 as invasion of privacy, 115
New York Tribune (newspaper), 41, 76,
 77, 112, 167
New York World (newspaper), 10, *15*
Nhu, Mme, 214
Nielsen report, 220
Nixon, Richard: and Kent State killings,
 239–40; and Khrushchev, 82–87,
 84–85; and Vietnam War, 243
Nobel Prize, 48, 51, 52
Non-Composite Campaign Picture
 (cartoon, Herblock), *93*
Nordhausen (concentration camp,
 Germany), *33*
Nude Descending a Staircase
 (painting, Duchamp), *31*
"Nurse-Midwife" (photoessay, Smith),
 182–84, *183*

O

Obote, Milton, 208
O Cruzeiro (magazine), 187
Oldenburg, Claes, 132
Olmsted, Frederick Law, 42
Olshwanger, Ron, 99
Onassis, Jacqueline Kennedy: and
 John F. Kennedy assassination, 221;
 suit against Ron Galella by, 116
Osaka, Japan: surveillance photos in,
 73
O'Sullivan, Timothy, 28, 41, 43, 198;
 negative by, *29*
Oswald, Lee Harvey, 216, 222–25,
 255

P

painting and photography, 30–31, 32, 43; photos of Pollock painting, 127–32, 130; Warhol's use of photographic image, 207, 208
Pajama Game, The (play), 70
Palach, Jan, 215
Panama, invasion of, 257
Parade (magazine), 215
Paris Commune, 62, 66
Paris-Match (magazine), 221
Paris Medico-Physiological Society, 61
Parks, Gordon, 185–88; photo by, 186
Parks, Rosa, 203
Parloff, Roger, 256
Pegler, Westbrook, 98
Peking Radio, 154
Peking Review (magazine), 153
Penny Magazine, 9
penny press, 8–9, 103
People (magazine), 249
People's Daily (newspaper), 154
periodicals. *See* magazines and individual names of publications
peripheral photography, 72
Persona (film, Bergman), 212
personality cult: enhanced by photos, 112, 152
Philadelphia North American (newspaper), 31
Philadelphia Photographer (magazine), 43
photoessays, 184; in *Life* (magazine): "Country Doctor," 182; "Freedom's Fearful Foe: Poverty," 185–88, 186; "Nurse-Midwife," 182–84, 183; "Spanish Village," 182
Photographic Sketchbook of the Civil War (Gardner), 28
photomicrograph, 39
Photoplay (magazine), 117–18
Phuc, Phan Thi Kim, 242, 243, 244–45
physiognotrace, 11
Picasso, Pablo, 32, 127, 131
picture editing by computer, 99
picture magazines, 184; growth of, 191–92, 194; television's impact on, 248; war dead and wounded shown in, 198–99. *See also individual names of publications*
Picture Post (magazine), 191
picture postcards, 14–15
Pictures from Life: Mill Children in Alabama (pamphlet, Murphy), 173
Pierson's Paris studio, 104
Pin-Up Girl (film), 122
Pin-Up Girl (plane), 122
pinups: Betty Grable as, 122–25, 123; Rita Hayworth as, 125; Marilyn Monroe as, 125–26
Pittsburgh Survey (report), 178
Plaza de la Revolución, Havana, 159
PM (newspaper), 169

police brutality, 66, 257
police dogs, 203–4, 206–9
police tactics, 59–60, 204, 206–9
political repression, 63, 66–67
politicians, 75–88, 90–95
Pollock, Jackson, 127–32, 128, 130
Porter, Edwin S., 117
Portfolio (magazine), 131
Portrait of Lincoln after Mathew Brady's Photograph (lithograph, Currier and Ives), 79
portrait photography, 11, 107; in cartes de visite, 104–5, 107; of criminals, 59–60; fees charged for, 112; institutional, 61–62; for political purposes, 75–88, 152–56; for publicity, 118–19, 125; of slaves, 62
positron, discovery of, 51–52
posters, 58, 109, 143, 145–46, 156, 159, 160, 174–76, 237, 239, 243
Powell, Officer Lawrence, 255–56
Powers, Francis Gary, 71
Powolney, Frank, 124, 133; photo by, 123
Presse (newspaper), 48
Prince, Richard: on Pollock, 132
prisoners of war, 20–24, 22–23
prisoners: photos of, 59
privacy: invasion of and right to, 113–17
Professional Criminals of America (book, Byrnes), 60
prohibition of photography, 7–8, 113; of Georges Boulanger, 76; of John Wilkes Booth, 90; in Czechoslovakia, 66–67; of Léon Gambetta, 76; of Nelson Mandela, 76; privacy law cases, 116; in Vietnam, 214. *See also* censorship
propaganda, 152; exploration photo used for, 43; fake photos as, 89; news photos as, 236; prisoner-of-war pictures as, 24
Prouvost, Jean, 34
Providence Labor Advocate (publication), 69
public health, 168, 170, 174
publicity, 112, 137, 246; for Bernhardt, 112; for Menken, 107–11; for motion pictures, 117–26; pinups used as, 122–24
Pulitzer, Joseph, 10; on Buchenwald, 36
Pulitzer Prize winners: Adams, 229; Jackson, 225; Olshwanger, 99; Rosenthal, 147; Ut, 243

Q

Q. And Babies? A. And Babies (poster, Brandt/Haeberle), 236
Quang Duc Immolating Himself (photo, Brown), 213
Quang Duc, Thich, 213, 214–15

Quarry Hill, Leeds, England— Insanitary Housing Conditions (photos), 170–72, 171

R

Race Riot (prints and paintings, Warhol), 207, 208
Rachel, Mlle, 107
radio, 192, 194, 220
Raft, George, 124
Reagan, Ronald, 75, 84, 88–89, 252
Reagan, Nancy, 252
Rear Window (film, Hitchcock), 40
reconnaissance photos, 71
Red Guard, 153–54
reenactment in TV news, 249
Released Federal Prisoner, Richmond, Virginia—From Belle Isle or Libbey (photo), 22
religions, image's impact on, 7
reproduction methods for photography, 11, 12, 13, 14, 21, 78, 165, 167, 191, 194
Resettlement Administration (Farm Security Administration), 96, 98, 136, 140, 179
Resor, Stanley T., 233
Reston, James: on atomic bomb, 151–52
retouching, 122, 133, 199, 221
Revlon, 199
Ridenhour, Ronald, 230
Riis, Jacob, 165–69, 173, 175; on his photos, 167; photo by, 166
Rising Sun (book, Crichton), 254
Roberson, Abigail, 113–15
Roberson v. Rochester Folding Box, 113–16
Rockefeller, Nelson, 83
Rodin, Auguste, 31
Rodino, Pete W., 209
Rogue's Gallery, 60, 62
Romero, Caesar, 133
Röntgen, Frau, 48, 49
Röntgen, Wilhelm Conrad, 48–49; photo by, 49
Roosevelt, Franklin Delano, 96–98, 136, 178, 198; treatment by news photographers, 87–88
Roosevelt, Theodore, 168–69
Roper survey: on Americans' atttitudes toward TV, 219, 245
Rose, Barbara, 130, 132
Rosenberg, Harold, 131–32
Rosenthal, Joe, 142–47; photo by, 143
Rossetti, Dante Gabriel, 111
rotary press, 112, 167
Rothstein, Arthur, 96, 98; photo by, 97
"Royal Album" (cartes, Mayall), 104
Ruby, Jack, 216, 223–25, 247
Ruef, Abraham ("Curly Boss"), 81–82
Ruiz, Father González, 159

S

Al-Sabah, Sheik Jaber Ahmad, 247
Sabatier-Blot, Jean-Baptiste;
 daguerreotype by, 6
Sacks, Oliver, 88
Saddam Hussein, 89, 247
Safire, William, 82–83, 86
St. Louis Post-Dispatch (newspaper),
 99, 101, 152
Salisbury, Harrison, 82
Sand, George: on Dumas, 110
Sands of Iwo Jima (film), 143
San Francisco Call (newspaper), 81
San Francisco Chronicle (newspaper),
 54
San Francisco earthquake, 194
San Francisco News (newspaper), 137,
 141, 179
Sarony, Napoléon, 112; photo by, *108*
Sartre, Jean Paul, 156
*Satellite view of the ancient city of
 Ubar, in Oman* (photo, Newell Color
 Lab), 253
satellites: photos from, *55, 72,* 253
Saturday Evening Post (magazine), 140
Saturday Review (magazine), 54
scandal caused by photos, 110–12
scene-of-the-crime photography, 61
Schine, G. David, *94,* 95
Schwarzkopf, General Norman, 258
Schweiker, Richard S., 233
scientific discovery through
 photography, 39–41, 47–57
Scitex machine, 99
Scott, Winfield, 75
Sellers, Cleveland, 202
Selma, Alabama, 219–20
sensationalism, 113, 212
series photography, *18, 31, 68, 70,* 212
Serrano, Andres, 246
7th War Loan: Now—All Together
 (poster, Beall), *145*
Seven-Year Itch, The (film), 125; still
 from (Zimmerman), *126*
sex symbol: Gable as, 118–19,
 120–21; Grable as, 122–25, *123;*
 Hayworth as, 125; Monroe as,
 125–26
Shame of California, The (photo),
 81–82
Shearer, Norma, 119, *121*
Shere, Sam: photo by, *190*
Shriver, Sargent, 188
Shunsuke Akatsuka: photo by, *155*
shutter-speed mechanism, 30–31
Shuttle Imaging Radar System, 252–54
Shuttlesworth, Fred L., 207
Sierra Club, 45, 47, 53
Sierra Nevada (California), 45
*Sierra Nevada and the John Muir Trail,
 The* (book, Adams), 47
Silent Spring (book, Carson), 53
Sinclair, Upton, 90

16mm camera, 204
slaves: photos of, *62, 64–65*
slide lecture, 169
slums: in Brazil, 185–88; immigration
 and, 165–68, *166;* in Quarry Hill
 (Leeds, England), 170–72, *171*
Smith, Adolphe, 165
Smith, Frank M., 91–92
Smith, Tony, 128
Smith, W. Eugene, 32; "Nurse-
 Midwife" by, 182–84; photos by,
 183
Smith, William J.: photo by, *94*
Snyder, Ruth, 194
Sochurek, Howard, 83
social reform, 163–89
Sojourner Truth Seated with Knitting
 (photo), *106*
Somalia, 259
Sontag, Susan: on concentration-camp
 photos, 33; on surfeit of
 photographic images, 177
Southern Christian Leadership
 Conference (SCLC), 206, 209
Southern Pacific Railroad, 81–82
space exploration, 52–57
spaceship Earth, 53
Spanish-American War, 28
Spanish Civil War, 138
Spanish Mother: The Terror of 1938
 (lithograph, Thorne), 138, *140*
"Spanish Village" (photoessay, Smith),
 182
SPOT satellite, 252
Springtime in the Rockies (film), 133
staging of events to be photographed,
 17, 28, 40, 99, 144, 210, 235, 249
Stahl, Leslie, 88
stamps, *80, 81, 143, 145*
Stardust Memories (film, Allen), 229
Steer Skull (photos, Rothstein), 96–98,
 97
Steffens, Lincoln, 168
Steichen, Edward, 196; on aerial
 photography, 71–72
Steinbeck, John, 140–41
stereographs, 12, *13,* 20, 26, 44
stereoscope, 12, 26
stereo vision, 169
Stern, Der (magazine), 244
Stevens, Robert T., 94–95
Stevenson, Adlai E., 72; on spaceship
 Earth, 53
Stillman, Dr. J.D.B., 31
still photography: versus moving
 images, 218–20, 223; waning
 popularity of, 246, 249; used on
 television, 217
still video camera, 99
Stone, Oliver, 254
stopwatch, 69–70
Street Life (book, Smith), 68
Strock, George, 196–97, 199; photo
 by, *197*
Stryker, Roy, 96, 98, 141; and

Dorothea Lange, 136–37, 140
student protests, 161, 204, 236–41,
 251; photos used to identify
 participants in, 63. *See also*
 demonstrations
subjectivity of photographers, 211, 249
suicide as protest, 212, *213,* 214, 215
Sunday School Photographs
 (pamphlet), 10
"sure cards," 105
Suribachi, Mount (Iwo Jima, Japan),
 142, *143,* 144
Surrey Country Lunatic Asylum
 (England), 61
surveillance, 63, 67, 68–69, 73
Survey Graphic (magazine), 137, 140
*Survivors behind
 Barbed Wire, Buchenwald,*
 (photo, Margaret Bourke-White), 36
Swinburne, Algernon, *109,* 111

T

tabloids, 34, 191, 194
Tagg, John, 170, 172; on institutional
 photography, 61
Talbot, William Henry Fox, 10, 22, 30,
 39, 59; on cameras, 40
Tankersley, Garvin E., 91–92
Taylor, Frederick Winslow, 67, 69
Taylor, Paul Schuster, 178–79
Taylorism, 67, 69
technological advances in cameras
 and photography, 29–31, 40–41,
 52–53, 99, 113; aerial, 72
Teilhard de Chardin, Pierre, 54
telephoto lens, 116
television, 67, 119, 247; Army-
 McCarthy hearings on, 95; Inejiro
 Asanuma's stabbing on, 223; and
 civil-rights movement, 211; Kent
 State shootings on, 237, 239;
 "kitchen-debate" film on, 83–84,
 86–87; General Loan's shooting of
 Vietcong on, 226–29; napalmed
 children on, 241–43; Oswald
 shooting on, 222–25; as a
 propaganda tool, 152; surveys on
 influence of, 245–46; use of still
 photos on, 217, 226, 228, 231–32,
 237, 239, 241–42, 246, 248
Telstar II (communications satellite),
 217
Tet offensive, 226, 228
textile mill workers, 172–73, 175
Their Blood Is Strong (pamphlet,
 Steinbeck), 140
therapy: photos as, 164
Thiers, Adolphe, 62
35mm camera, 40, 191
Thomas, Lewis: on Earth
 photographed from space, 57
Thomas, Lowell: on atomic bomb, 148

Thompson, Florence, *134*, 136–39, *138–39*
Thomson, John, 165
Thorne, Diana: lithograph by, *140*
Three American Soldiers Ambushed on Buna Beach (photo, Strock), 196–98, *197*
Tian An Men Square (Beijing), 63, 153–56, *155*, 250–51
Tibbets, Paul, 147
Tichborne, Roger, 60
Till, Emmett, 200–203
Time (magazine), 86, 122, 128–29, 140, 142, 148, 152, 187, 198, 207, 212, 221, 233, 240
time and motion studies, 67–70, *68*
tintype, 12, 78
Tompkins Square Park (New York), 66
Tongass National Forest (Alaska), 47
Tower Falls, View from Base, Wyoming (photo, Jackson), *38*
Trangbang (Vietnam), 241–43
Trotsky, Leon: cropped out of photos, 90
"True Face of Alsace, The" (article), 96
Truth, Sojourner, 105–7, *106*
Tugwell, Rexford Guy, 96
Turner, Lana, 118
Twentieth-Century Fox, 122
"Twin Peaks" (TV series), 60
Tydings, Millard, 90–95, *92*

U

Ubar (Oman), 252–54
undershirts, 118–19
United Press International (UPI), 137, 249
U.S. Camera (magazine), 98, 137, 140
United States Air Force, 73
United States Geological Survey, 38, 45
U.S. News and World Report (magazine), 245
United States Sanitary Commission (Civil War), 21
U.S. Steel, 178
Untitled (Paris Commune) (photo, Braquehais), 66
Us (magazine), 125
Ut, Huynh Cong (Nick), 241, 243–44; photo by, *242*

V

Valéry, Paul, 30
Vance, Robert H., 41
Vanity Fair (magazine), 25
Vecchio, Mary Ann, *1*, *238*, 240–41
veracity of photographs. *See* credibility
Verlaine, Paul, 110
Vernal Falls—300 Feet, Yosemite

(photo, Watkins), *42*
Victoria, Queen, *14*, 104
video: amateurs' use of, 66–67, 250, 251, 254–56
Vietcong, 226, 227, 228–29
Vietnam War, 89, 226–36, 241–44
Vogue (magazine), 129
Vogue parisienne, La (magazine), 110
Vu (magazine), 96, 191

W

Walker, Alice, 202
Walker, Wyatt: on Birmingham, 209
Wallace, George, 234
Wallace, Mike, 233
Walters, Barbara, 251
war bond drives, 199
war correspondents, 196
Warhol, Andy, 154, 208, 254; painting by, *207*
War Museum (Saigon), 229
war photography, 8, 89; censorship of, 195; in Civil War, 20–29; in World War I, *196*; in World War II, 32–37, 196–99
Warren, Samuel, 114
Warren Commission, 221, 255
Washington Post (newspaper), 92, 93, 193, 204, 212, 219, 226, 242
Washington Star (newspaper), 234
Washington Times-Herald (newspaper), 91
Watkins, Carleton, 41–43; photo by, *42*
Watkins, T. H., 53
Watson, James, 50
Weed, Charles Leander, 41
Welch, Joseph N., 95
Westmoreland, General William C., 228, 245
White House photographer, 88
Whole Earth, 53–54, 57
Whole Earth Catalogue (book), 54, 57
Why I Go to the Movies Alone (book, Prince), 132
"Wide World of Sports" (TV program), 217
Williams, Vanessa, 133
Wilson's Photographic Magazine, 50
wire transmission of photos, 194
wire services, 83, 194, 249
Wirz, Henry, 24
Woman Office Worker, Motion Study (photo series, Gilbreth), 70
Wong, H. S. "Newsreel": photo by, 245
woodburytype, 165
woodcuts, 78, 165, 167
wood engravings, 103, *166*
Woodstock (New York), 131
Wordsworth, William: on his contempt for "pictured page," 10

"Work of Art in the Age of Mechanical Reproduction, The" (essay, Benjamin), 219
World's Fair (book, Doctorow), 192
World Telegram (newspaper), 194
World War I: aerial photography in, 71; journalists' credibility in, 34; censorship in, 195; motion studies used in, 69; Western Front, 196
World War I: British, Western Front (photo), *196*
World War II, 32–37, 196–99; censorship in, 196–98; dead soldiers photographed in, *197*; Iwo Jima, 142–47; Nordhausen, *33*; pinups as morale boosters in, 122
Worthington, A. M., 16

X

X-ray diffraction, 50
X Ray of Frau Röntgen's Hand with Ring (photo, Röntgen), *49*
X rays, 48–50, *49*

Y

yellow press, 28, 113, 174
Yellowstone National Park (Wyoming), *13*, 43–45
Yosemite Valley (California), 41–43, *42*

Z

Zapruder, Abraham, 221, 254
Zealy, J. T., 62; photos by, *64–65*
zeppelin. *See* dirigibles
Zimmerman, Matthew: photo by, *126*
zoopraxiscope, 32, 169
Zoopraxiscope Disk (Muybridge), *31*, 32

PHOTOGRAPHY CREDITS

The photographers and the sources of photographic material, other than those indicated in the captions, are as follows:

Photograph by Ansel Adams, copyright © 1991 by the Trustees of the Ansel Adams Publishing Rights Trust, Carmel, Calif.; all rights reserved: p. 46. Copy photographs by Hillel Burger, Peabody Museum, Harvard University, Cambridge, Mass.: pp. 64, 65. Courtesy of the Center for Creative Photography, University of Arizona, Tucson: p. 183. Courtesy of the Center for Cuban Studies, New York: 157. Copyright © 1968 Paul Davis, New York: p. 160. Copyright © Elliott Erwitt/Magnum Photos Inc., New York: p. 85. Carol M. Haggerty, New York: p. 80 bottom right, p. 146 top, p. 152 top, middle, bottom. Copyright © Susan Meiselas/Magnum Photos Inc., New York: p. 159. Copyright © 1982 The Oakland Museum, Oakland, Calif.: p. 141 right. Photograph courtesy of Pollock-Krasner House and Study Center, East Hampton, N.Y.: p. 128. Copy photograph by Adam Reich/Daniel Wolf, Inc., New York: p. 66. Photograph courtesy of University Microfilms, Ann Arbor, Mich.: p. 193. Copyright © 1987 Dorothy Zeidman/Leo Castelli: p. 207.